ASIA

ASIA

FROM THE URALS TO THE PACIFIC

VICTORIA BURROWS

First published in 2025

Copyright © 2025 Amber Books Ltd

All rights reserved. No part of this publication may be reproduced, stored in a retrieval system, or transmitted in any form or by any means, electronic, mechanical, photocopying, recording, or otherwise, without prior written permission of the copyright holder.

Published by
Amber Books Ltd
United House
London N7 9DP
United Kingdom
www.amberbooks.co.uk
Facebook: amberbooks
YouTube: amberbooksltd
Instagram: amberbooksltd
X(Twitter): @amberbooks

ISBN: 978-1-83886-518-4

Project Editor: Anna Brownbridge
Designer: Keren Harragan
Picture Research: Adam Gnych

Printed in Malaysia

Picture Credits

Alamy: 33 (Jon Arnold Images Ltd), 35 (Allen Brown), 40/41 (robertharding), 48 (AGAMI Photo Agency), 49 (Design Pics Inc), 50 (dpa picture alliance), 51 (Ivan Vdovin), 56/57 & 61 right (imageBroker.com), 74 (J Marshall Tribaleye Image), 75 (Melvyn Longhurst), 84 (Vasca), 90 (Filip Jedraszak), 97 (Juergen Ritterbach), 100 left (Jo Kearney), 100 right (Mark Eden), 101 (imageBROKER.com), 104 (Ryhor Bruyeu), 111 (robertharding), 117 (Media Drum World), 127 (Westend61 GmbH), 130 (Daniel Valla FRPS), 146 (Inge Johnsson), 150 (Stockinasia), 157 (Imaginechina Limited), 173 (Cavan Images), 193 (travelstock44), 198 (RooM the Agency), 213 (XPB Images Ltd), 214 (Julio Etchart), 215 (Antony Ratcliffe)

Creative Commons Attribution 2.0 licence: 156 (Banco de Imágenes Geológicas)

Dreamstime: 10 (Said Mammadov), 12 (Oscar Espinosa), 13 (Demerzel21), 14/15 (Xantana), 26 (Mdurinik), 27 (Itpow), 36 (Egunes), 42 (Erandalx), 43 (Delstudio), 44 (Prescott09), 46 (Mail2355), 47 left (Mail2355), 52 (Mathes), 53 (Frenta), 61 left (Bigmax), 62/63 (Nhungbuocchan), 64 (Toiletroom), 66 (Byheaven87), 67 (Kairi Aun), 76 (Turfantastik), 77 (Curiosopl), 78 (Monticelllo), 83 (Mail2355), 86 (Dmitrio), 89 (Enrico01), 110 (Snehalpailkar), 112 (Saiko3p), 120 (Extradeda), 131 (Keongdagreat), 141 (Noppakun), 149 (Delstudio), 154 (Serjio74), 171 (Rudi Ernst), 187 (Juliengrondin), 188 (Thawats), 199 (Donsimon), 202 (Dmosreg), 206 (Tim7945), 207 (Rodrigolab), 217 (Kjorgen)

Getty Images: 39 (Ismael Adnan)

NASA (Public Domain): 34 (Robert Simmon), 60 (Johnson Space Center)

Shutterstock: 6 (Travel Stock), 7 (Luciano Mortula LGM), 8 (Vaidotas Grybauskas), 11 (YuG), 15 top (Mazur Travel), 15 bottom (Mikhail Kayl), 16 (Standret), 17 (Serhii Derkach), 18 (Milosz Maslanka), 19 (Andrew Mayovskyy), 20 (ozgur oral), 21 (Nejdet Duzen), 22 (Santi Jantararen), 23 (Vadim N), 24/25 (Joshua Haviv), 25 top (Gil.K), 25 bottom (maziarz), 28 (Dunia Production Company), 29 (Leo Morgan), 30 (Dunia Production Company), 31 (Nesru Markmedia), 32 (Qais Al Ghaithi), 37 (yunus oz), 38 (Nastya Smirnova RF), 45 (Delphotos), 47 right (MartinRejzek), 54 (Efired), 55 (Frantisek Staud), 58 (Nowak Lukasz), 65 (GTW), 68 (mehdi33300), 69 top (AleksSafronov), 69 bottom (MarBom), 70 (MehmetO), 71 (Igor Zuikov), 72 (Lukas Bischoff Photograph), 73 (MehmetO), 78/79 (tache), 80/81 (Iwanami Photos), 82 (Nowak Lukasz), 85 (Vladimir Tretyakov), 88 (paul prescott), 91 (maodoltee), 92 (Vivek BR), 93 (CherylRamalho), 94/95 (Dmitry Rukhlenko), 96 (imagesef), 98 (saiko3p), 99 (Luciano Mortula LGM), 102/103 (Pikoso.kz), 105 (saiko3p), 106 (NiAk), 107 (Soumitra Pendse), 108 (Lloyd Vas), 109 top (Mazur Travel), 109 bottom (Lloyd Vas), 113 (PhotopankPL), 114 (Dmitry Rukhlenko), 115 (Giban), 116/117 (Katja Tsvetkova), 118 (sittitap), 119 left (Michal Knitl), 119 right (klublu), 121 (Radchuk O.S), 122 (MoLarjung), 123 (Kurkul), 124 (Pikoso.kz), 125 (Kumud888Photos), 126/127 (Martin Gillespie), 128 (s jakkarin), 129 (Khanthachai C), 132 (mapman), 134 (gu3ree), 135 (Masterlu), 136 (Puripat Lertpunyaroj), 137 (Pinglabel), 138/139 (Sean Pavone), 139 (Sean Pavone), 140 (cowardlion), 142 (Nattee Chalermtiragool), 143 (Paul James Quinn), 144/145 (Sean Pavone), 147 (Sean Pavone), 148 (Bule Sky Studio), 151 (kikujungboy CC), 152 (Daniel Ferreira Leites), 153 (Sean Pavone), 155 (Storm Is Me), 158 (Peter John Watson), 159 (saiko3p), 160 (Top Virtual Tours), 161 (Zen S Prarom), 162 (Efired), 162/163 (Patrick Foto), 164 (Frank Wagner), 165 (Daniel Andis), 166 (Sean Pavone), 168 (R.M. Nunes), 169 (hecke61), 170 (Ikunl), 172 (Sean Pavone), 174/175 (Bule Sky Studio), 176 (Dmitry Rukhlenko), 177 (Jixin Yu), 178 (Elena Ermakova), 179 (saravutpics), 180/181 (naihei), 182 (Ikunl), 183 (Day2505), 184 (Sean Pavone), 185 (Studio22K), 186 (nuwatphoto), 189 (travelwild), 190 (ploypemuk), 191 (Nelson Antoine), 192 (happystock), 194 left (nipastock), 194 right (Daniel Ferryanto), 195 (Marco Saracco), 196 (Lukasz Janyst), 197 (Shutter K), 200 (319photo), 201 (Jon Chica), 203 (Cahaya Images), 204 (PhotoRoman), 205 (R.M. Nunes), 208/209 (miroslav chytil), 210 (Heiko Jetzkowitz), 211 (Donnchans), 212 (Sergii Figurnyi), 216 (BorneoRimbawan), 218 top (DSlight_photography), 218 bottom (Chui Wui Jing), 219 (muhd fuad abd rahim), 220 (cktravels.com), 221 (CHEN WS), 222 (Reggie Lee), 223 (jamesteohart)

Contents

Introduction	6
Western Asia	8
Central and Northern Asia	58
South Asia	86
East Asia	132
Southeast Asia	166
Index	224

Introduction

When it comes to Asia, it is impossible not to speak in superlatives. It is both the biggest continent and the most populous. It has the highest point (Mount Everest) and the lowest (the Dead Sea) on Earth, and the world's longest coastline. The continent's climatic extremes mean it has the most varied forms of vegetation and animal life on the planet.

Asia's fertile lands nurtured many of humankind's earliest civilizations, including Mesopotamia in today's Iraq, the Indus Valley straddling parts of India and Pakistan, and the world's oldest continuous civilization, China. Asia is the birthplace of most of the world's prevailing religions, from Buddhism to Judaism, and Hinduism to Islam.

The most diverse continent is home to a vast array of peoples, from those of Turkey to Japan, and Mongolia to Malaysia. The variety of languages and ways of life of these more than 4.5 billion people is nothing short of mind-boggling.

While some areas, such as Central Asia, have only in recent years begun to reveal their marvels, others have thrilled visitors for decades. The continent will no doubt continue its appeal: from the ancient temples of Cambodia to the skyscrapers of Dubai, and from the aquamarine waters of the Philippines to the icy peaks of the Pamirs, Asia is truly a continent of contrasts.

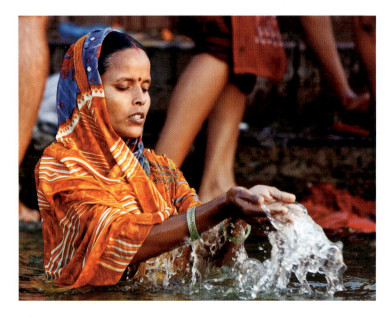

ABOVE:
A woman takes a ritual bath in the Ganges at Varanasi, India.

OPPOSITE:
View of the Hong Kong skyline from Victoria Peak.

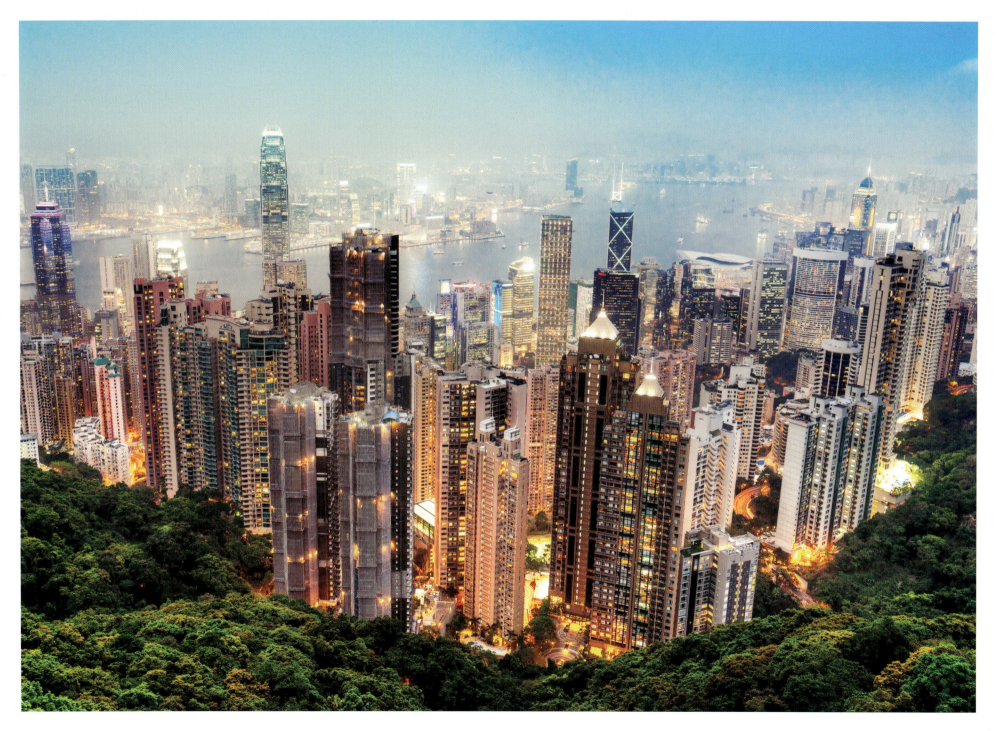

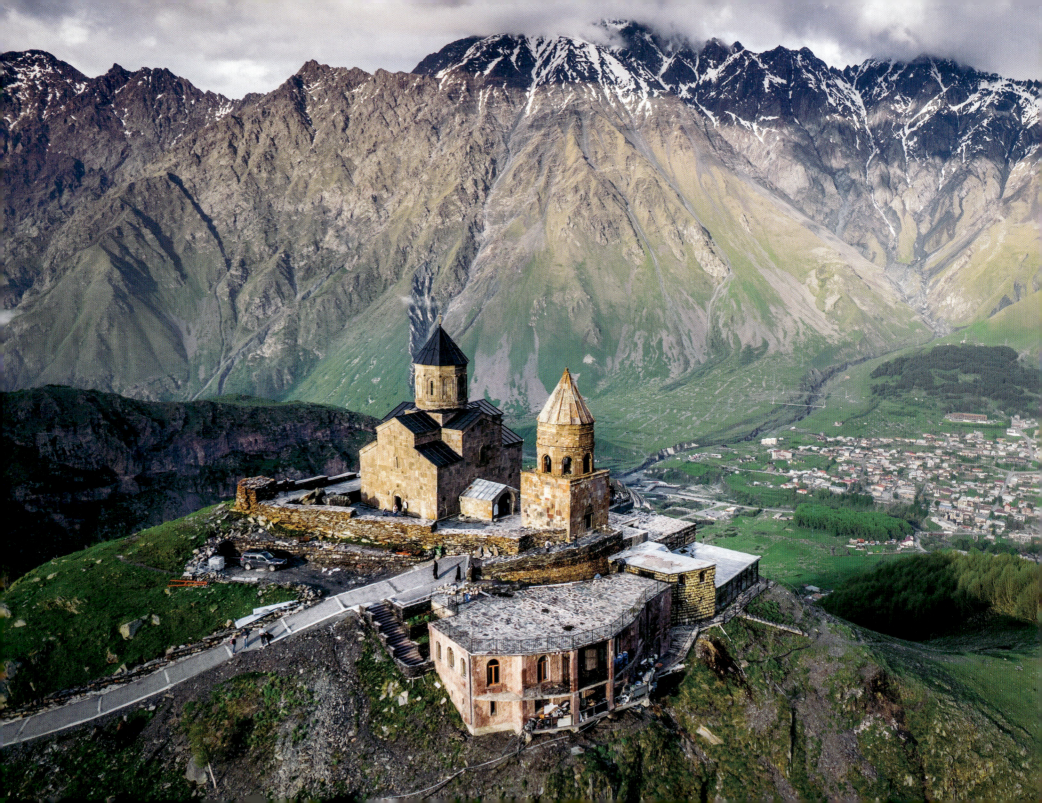

Western Asia

A region of profound historical, cultural, and geopolitical significance, Western Asia is home to some of the world's earliest civilizations. Powerful empires, from the Mesopotamian Sumerians and Akkadians to the Persians and the Ottomans, have risen in glory, only to fall in the relentless march of time.

The ancient sites of the region, stretching from Turkey and Israel in the west to Iran and Oman in the east, are testament to the region's rich history and cultural legacy. It is also the birthplace of major world religions, including Judaism, Christianity, and Islam, each of which has deeply influenced global culture and history.

The landscape of the area is diverse, with parched deserts, fertile valleys, precipitous mountains, and expansive plateaus. From the permanently snow-capped peaks of the Zagros to the fertile seas of Yemen's Socotra islands, the region's natural habitats are spectacular.

Today Western Asia, a mosaic of nations, has continuing strategic importance due to its central location at the crossroads of Europe, Asia, and Africa. The region faces complex contemporary challenges, including political instability, social upheaval, and environmental issues. But despite these challenges, the region continues to be a dynamic and influential part of the world, shaping and being shaped by the global currents of change.

OPPOSITE:
Gergeti Trinity Church, Georgia
Holy Trinity Church, known as Gergeti Trinity Church, perches at 2170m (7119ft) above the picturesque village of Stepantsminda in northeastern Georgia. Dwarfed by the towering peaks of the Khokh Range of the Caucasus Mountains, with the dark flanks of Mount Kazbek rising up to 5054m (16581ft) behind it, the fourteenth-century church is one of Georgia's most iconic sites.

RIGHT:
Petroglyphs dating to 10,000BCE, Gobustan, Azerbaijan
Inscribed on the UNESCO World Heritage List in 2007, the more than 6000 rock carvings in eastern Azerbaijan's Gobustan State Historical and Cultural Reserve date back 5000-20,000 years. The petroglyphs depict people, animals, and the stars, and a variety of scenes, including battles, ritual dances, and bullfights.

OPPOSITE:
Sunrise over Mount Ararat and Khor Virap Monastery, Armenia
Mount Ararat, which according to the biblical account is where Noah's Ark came to rest after the Great Flood, rises up behind Armenia's Khor Virap Monastery. Mount Ararat overlooks the borders of Turkey, Iran, Armenia, and the Nakhchivan exclave of Azerbaijan – to which nation the mountain belongs has been a matter of contention for centuries. Today, the mountain lies in Turkey.

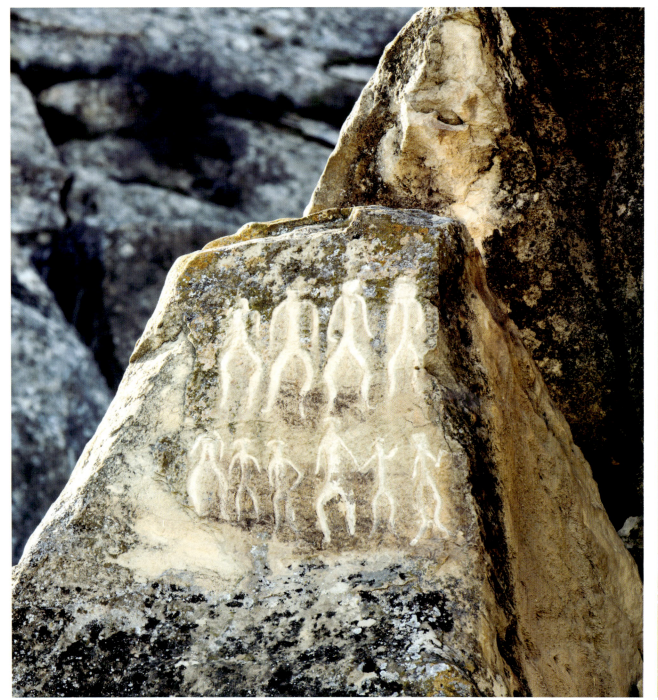

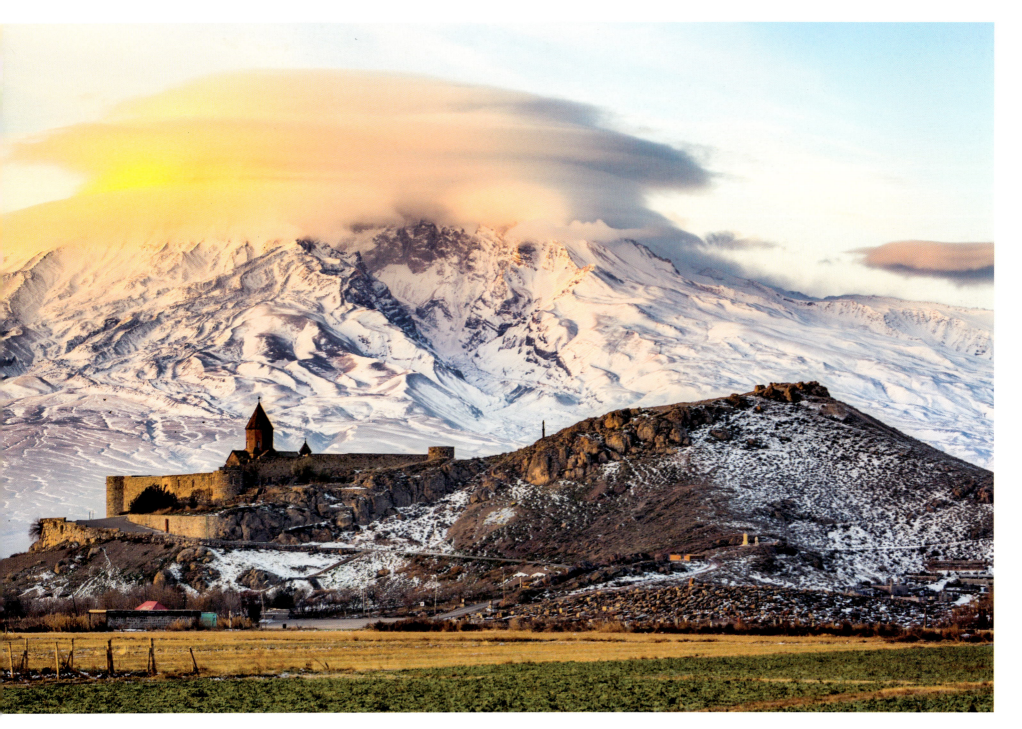

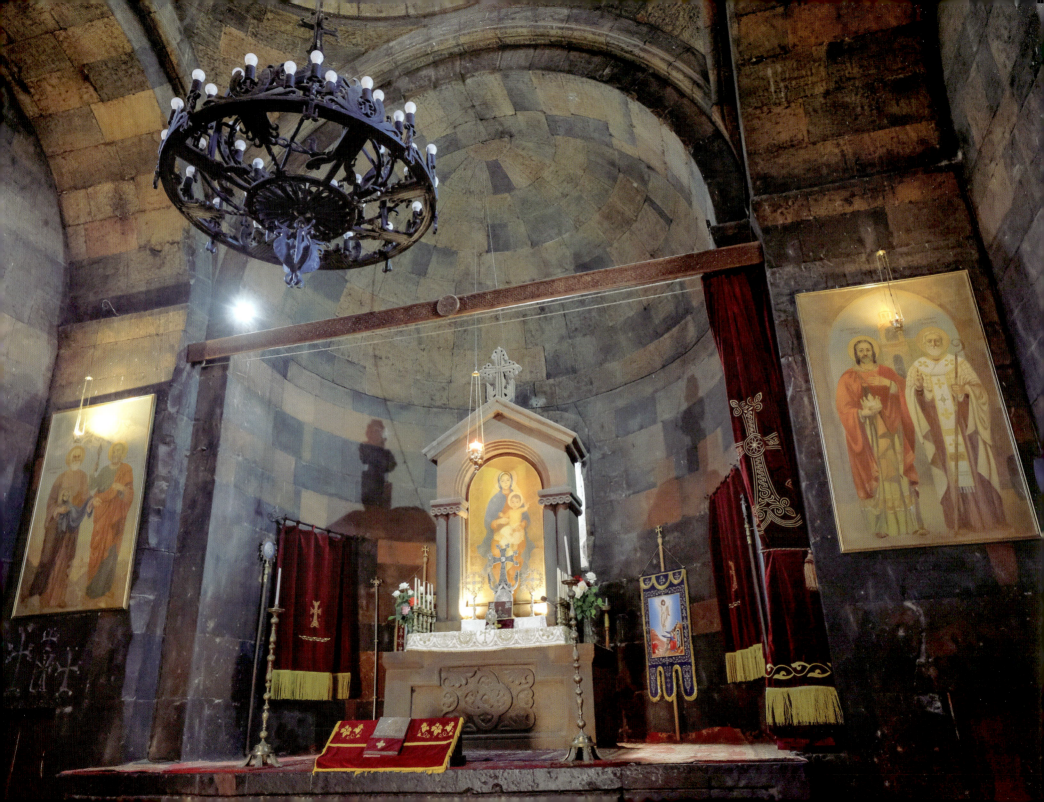

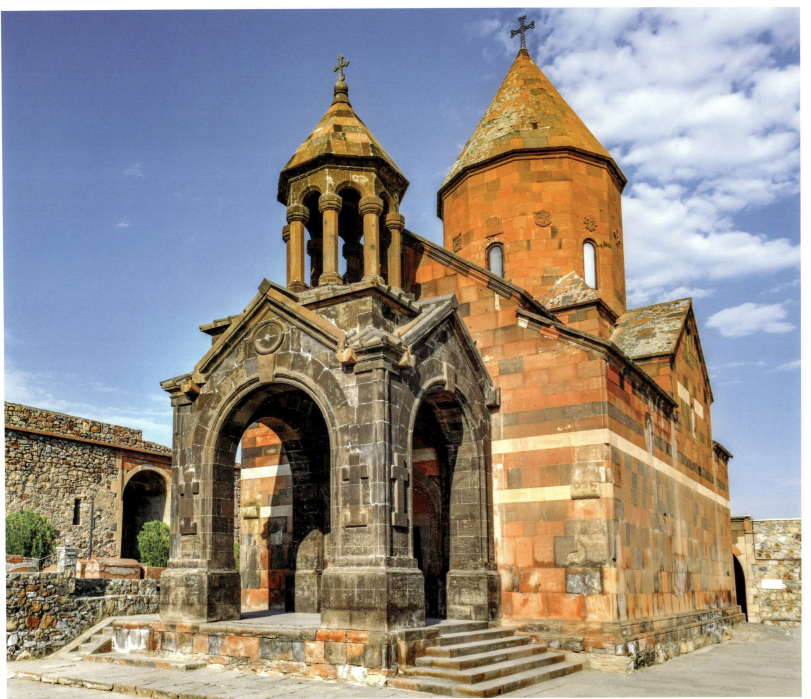

OPPOSITE:

St Astvatsatsin chapel, Khor Virap Monastery, Armenia

There are two chapels at Khor Virap: the larger St Astvatsatsin (Holy Mother of God) chapel, which was built in the seventeenth century, and the simple St Gevorg Chapel, which gives access to two deep wells, one of which St Gregory is believed to have been imprisoned in for 12 long years.

LEFT:

Khor Virap Monastery, Armenia

Khor Virap was built by Armenia's King Trdat I in the first century CE. Legend states King Trdat III kept St Gregory the Illuminator (Grigor Luisavorich) imprisoned in Khor Virap ('deep dungeon'). St Gregory later converted Armenia from Zoroastrianism to Christianity, making this monastery an important pilgrimage site.

RIGHT:
Old Town, Tbilisi, Georgia
Founded in the fifth century CE by Vakhtang I of Iberia, Georgia's multicultural capital tells a long, complex story, with periods under Persian and Russian rule. The charming cobblestoned Old Town is watched over by Narikala, a reconstructed fourth-century fortress, and Kartlis Deda, a statue of the 'Mother of Georgia', erected to celebrate the city's 1500th birthday.

OPPOSITE TOP:
Fabrika Hostel, Tbilisi, Georgia
Tbilisi's architecture is a mix of medieval, neoclassical, Beaux Arts, Art Nouveau, Stalinist, and Modern styles – and, increasingly, it is old-meets-new. The famed Fabrika was once a Soviet sewing factory, but is now a hip multi-functional space that includes a hostel, bar, cafes, co-working space, and events facilities.

OPPOSITE BOTTOM:
A serving of khachapuri, Georgia
Georgia's national dish, locals take their khachapuri seriously. The 'khachapuri index', based on the price of making the dish, is used as a measure of inflation in different Georgian cities. Made from leavened bread moulded into various shapes and filled with a special cheese, eggs, and other ingredients, it is served hot, straight from the oven.

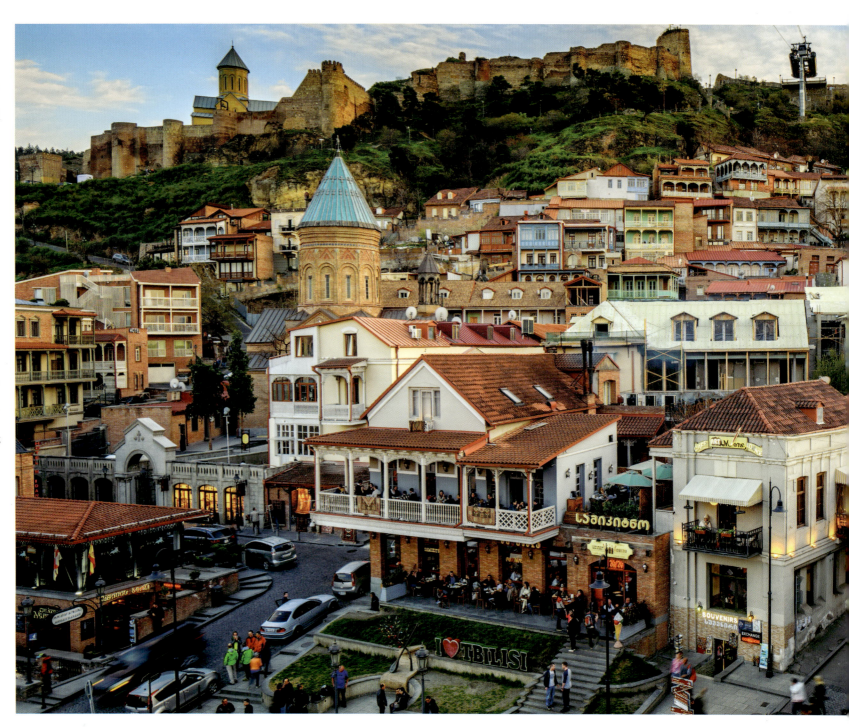

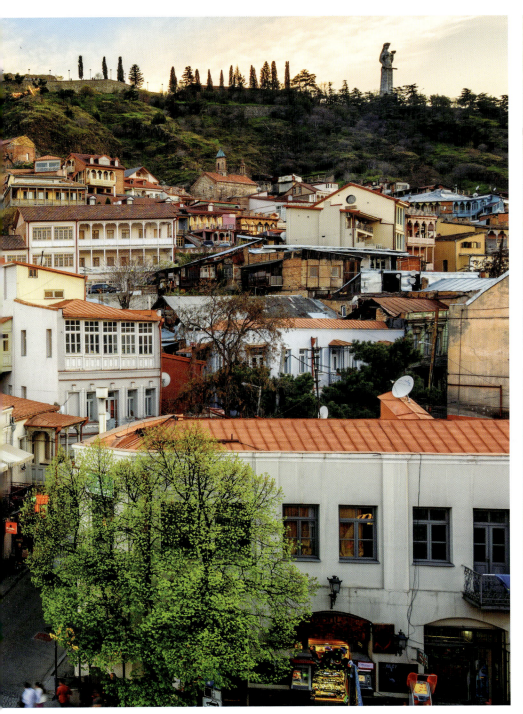

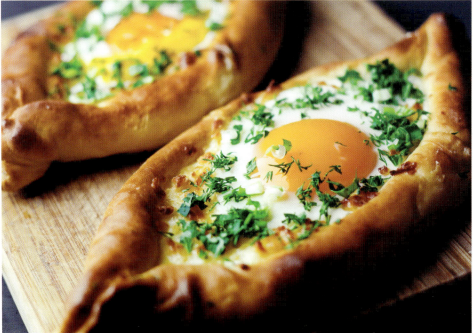

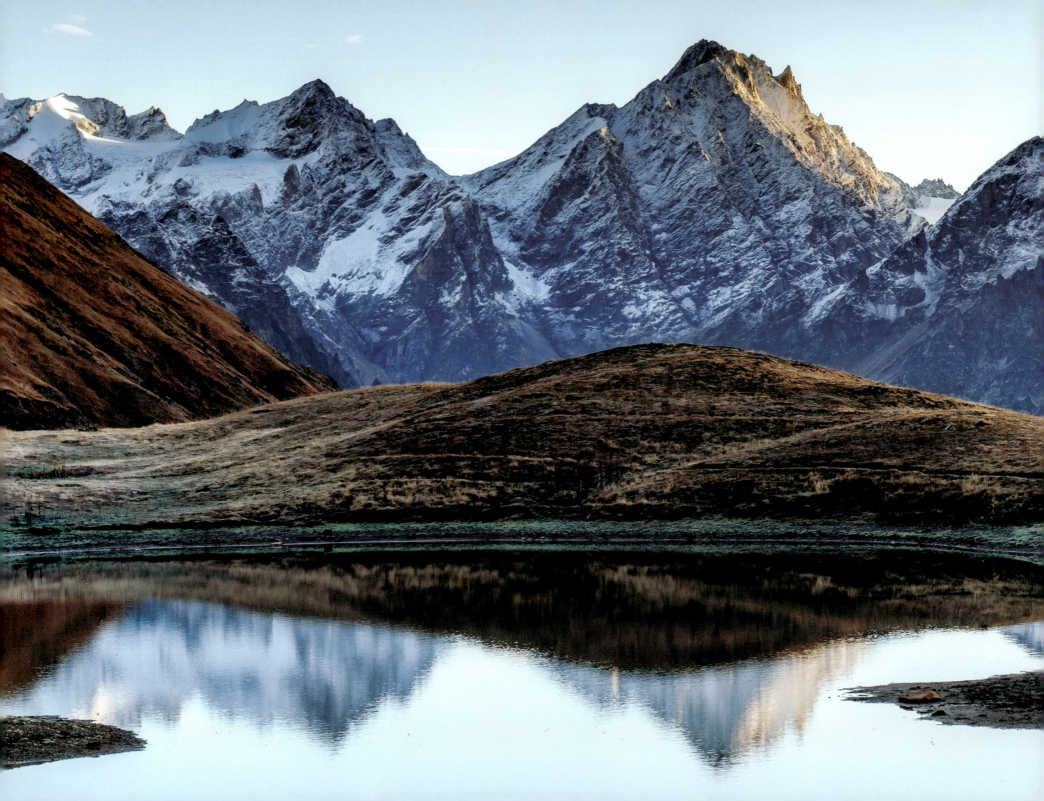

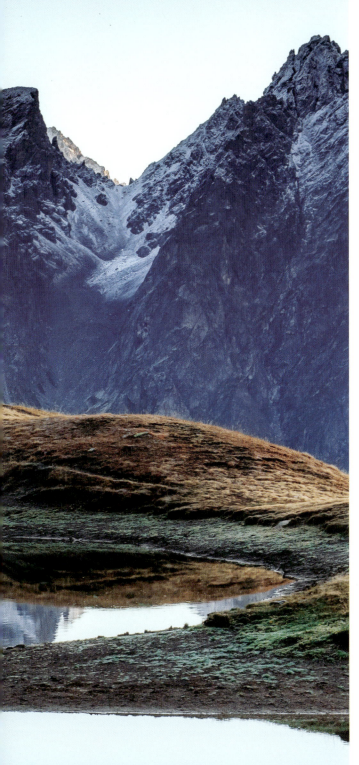

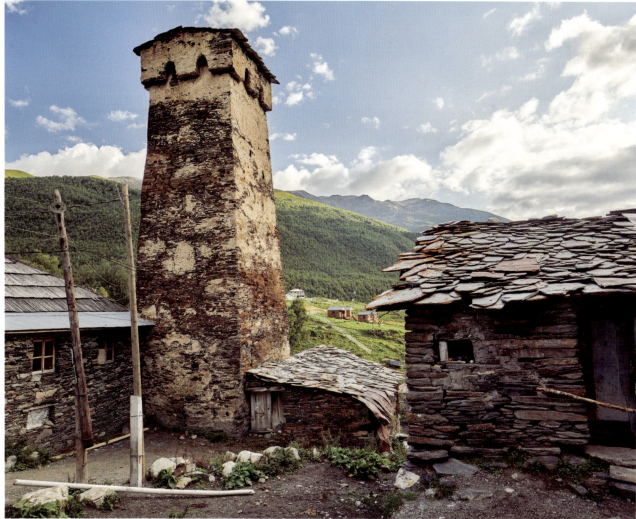

LEFT:
Koruldi Lakes, Svaneti, Georgia
The snowcapped peaks, deep gorges, and silent lakes of Svaneti make it one of Georgia's most breathtakingly beautiful regions. Located in the southern Greater Caucasus mountain range in the country's northwest and surrounded by 3000 to 5000m (9842 to 16404ft) peaks, Svaneti was isolated for centuries. Now it is a popular summer hiking destination.

ABOVE:
Svan tower, Svaneti, Georgia
The stone defensive towers of Svaneti are unique to the region. Built by the Svan people, a subgroup of ethnic Georgians who still today live primarily in the mountain-enclosed valleys of Svaneti, in the ninth to the twelfth centuries, the origins of the tower likely date back to prehistory.

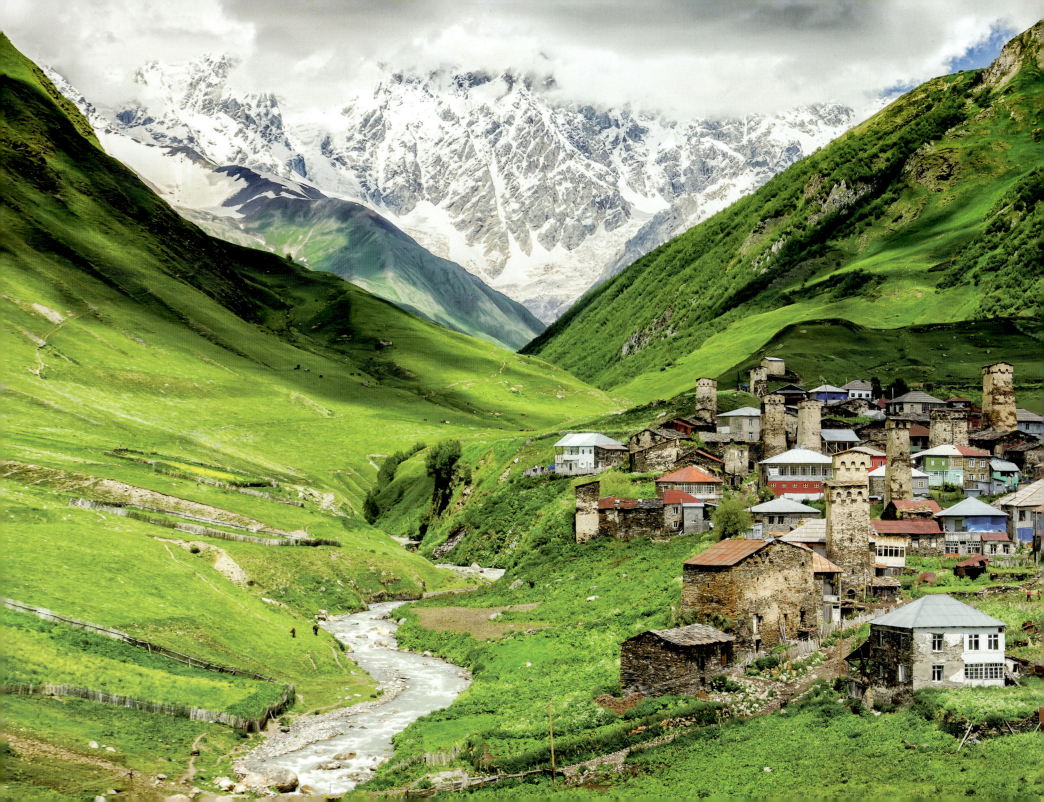

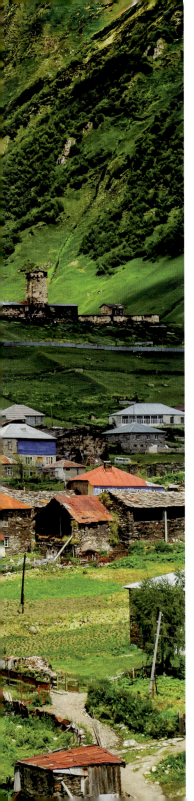
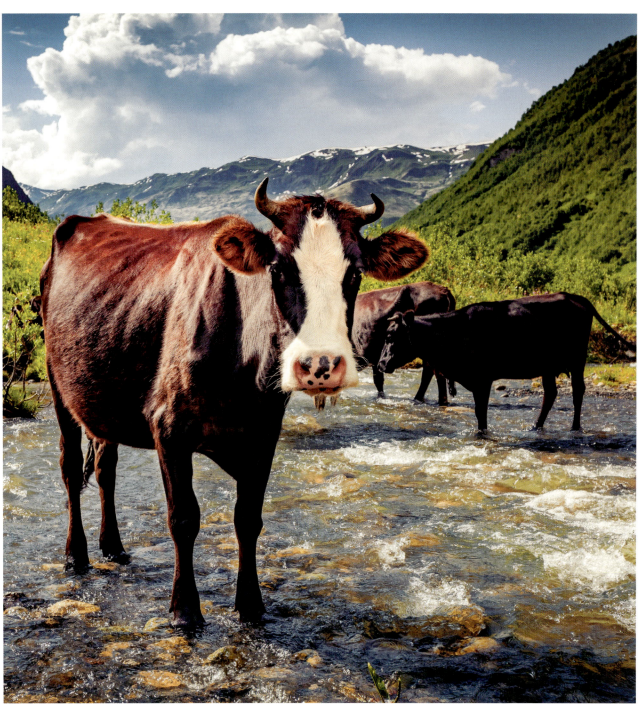

OPPOSITE:

Ushguli, Svaneti, Georgia
Ushguli, a community of five villages, is one of the highest permanently inhabited settlements in Europe. The inaccessibility of the location has ensured that the medieval character of the villages is well preserved, earning Ushguli, Mestia, and the surrounding region UNESCO World Heritage Site status.

LEFT:

Cattle, Upper Svaneti, Georgia
Life in the Upper Svaneti region continues as in centuries past. Livestock such as cows and horses range free in summer, grazing on lush grass in flower-speckled meadows. In winter, the valleys are thick with snow, and people and animals take shelter in the traditional stone dwellings.

RIGHT:
Selimiye Mosque, Edirne, Turkey
Ottoman architecture reaches its zenith in the Selimiye Mosque Complex, which dominates the skyline of Edirne in northwestern Turkey. The mosque was commissioned by Sultan Selim II and built by imperial architect Mimar Sinan between 1568 and 1575. The four elegant minarets measure 70.89m (232.5ft) and are some of the tallest Ottoman minarets ever built.

OPPOSITE:
Interior of Selimiye Mosque, Edirne, Turkey
Innovations in structural design allowed architect Mimar Sinan to add many windows into the domes of Selimiye Mosque, letting light stream into the interior. The spectacular space, dominated by the huge central dome, is decorated with beautiful Iznik tiles, marble stonework, and painted elements.

OVERLEAF LEFT:
The Siq at Petra, Jordan
The narrow gorge known as the Siq ('the Shaft') is the main entrance into the spectacular and world-famous ruins at Petra. Running for about 1.2km (0.74 miles), and at places only 3m (9.8ft) wide, the Siq is a natural geological fault split apart by immense forces on the Earth's crust and worn smooth by water.

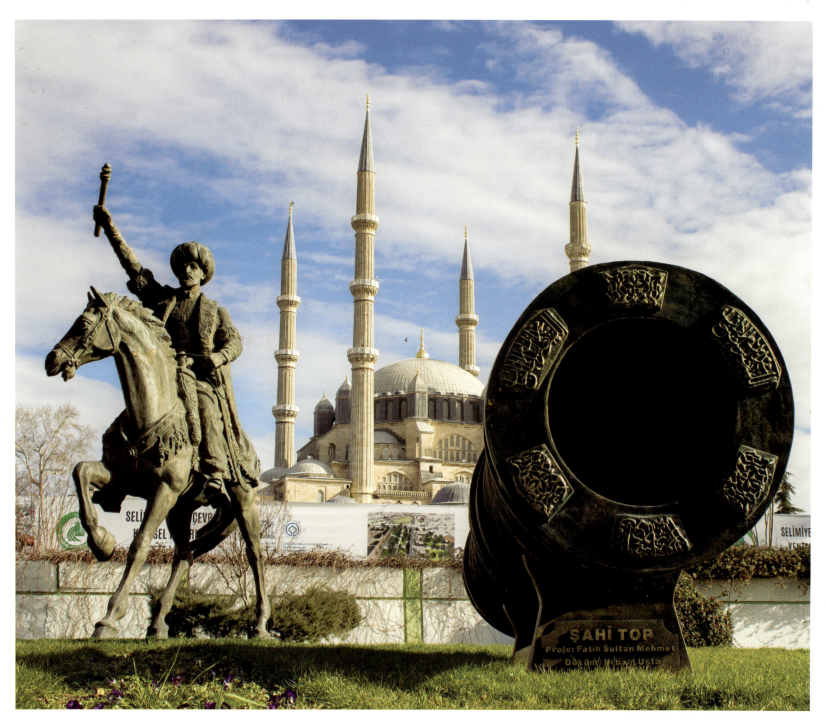

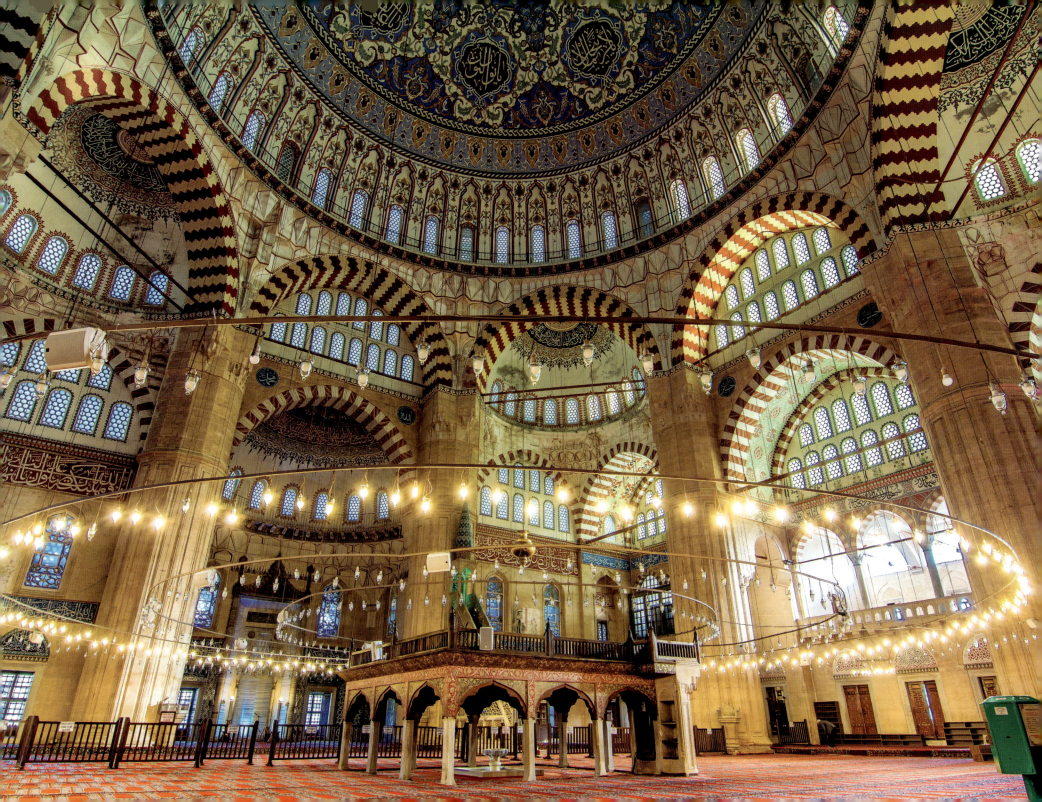

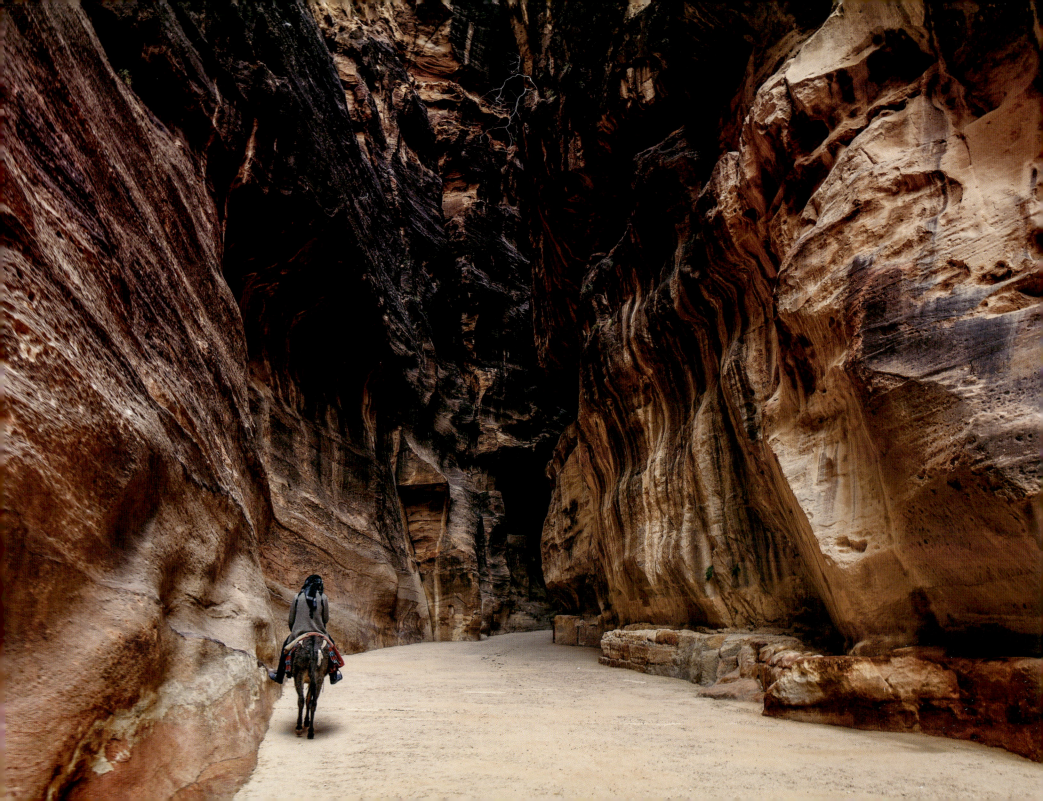

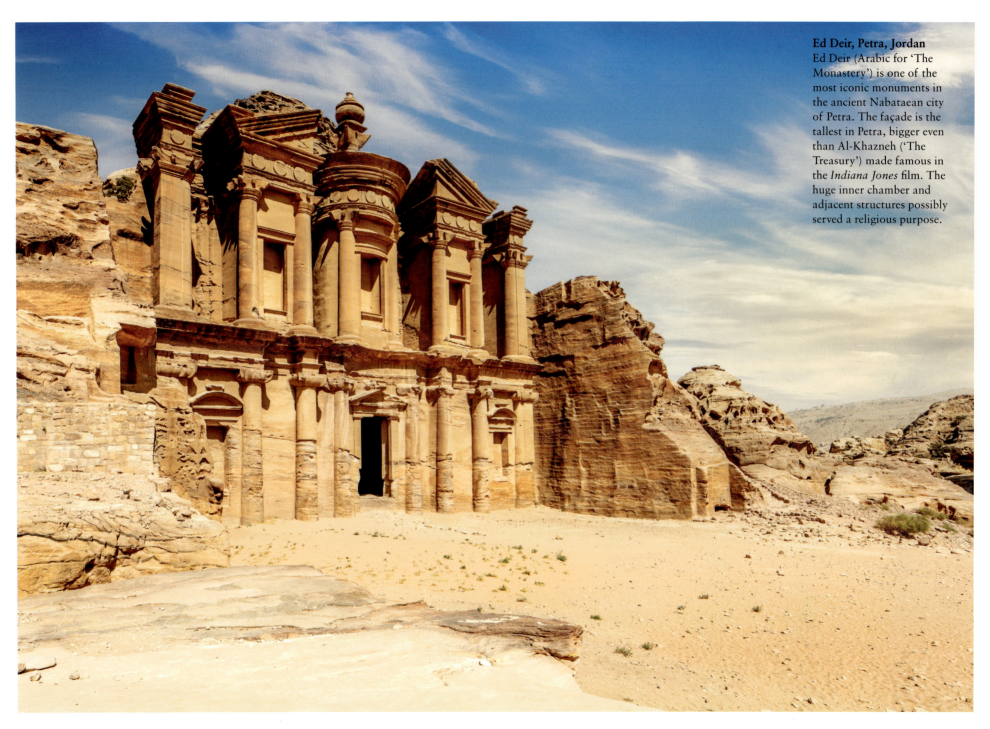

Ed Deir, Petra, Jordan
Ed Deir (Arabic for 'The Monastery') is one of the most iconic monuments in the ancient Nabataean city of Petra. The façade is the tallest in Petra, bigger even than Al-Khazneh ('The Treasury') made famous in the *Indiana Jones* film. The huge inner chamber and adjacent structures possibly served a religious purpose.

ALL PHOTOGRAPHS:
Temple Mount, Old City of Jerusalem, Israel
The sun sets over the Western Wall and the Dome of the Rock in the Temple Mount, the crossroads of the three great monotheistic religions of Christianity, Judaism, and Islam. The Western Wall, also known as the Wailing Wall, is the only remains of the original retaining wall surrounding the First and Second Temples of Jerusalem, and is uniquely holy and a place of prayer for Jews.

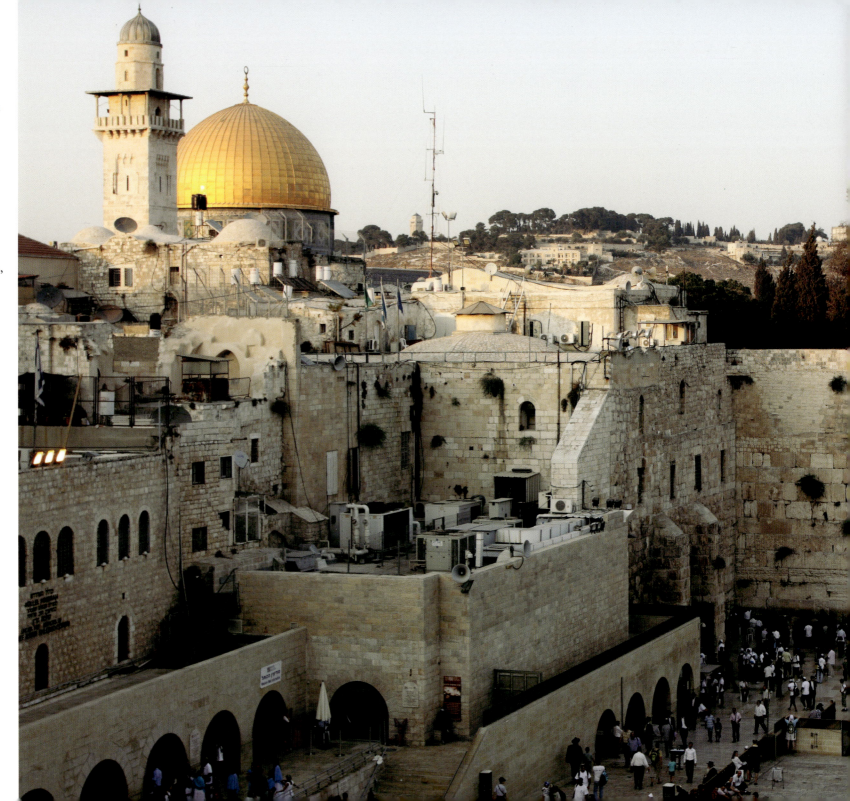

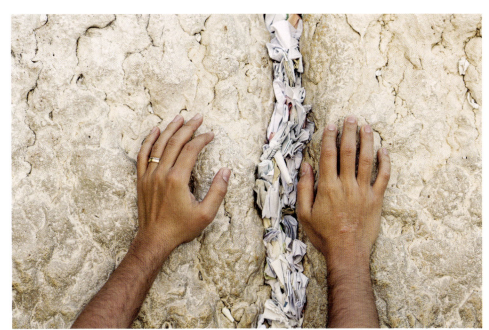
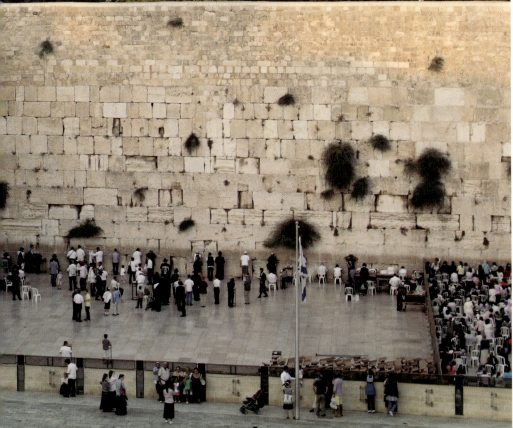
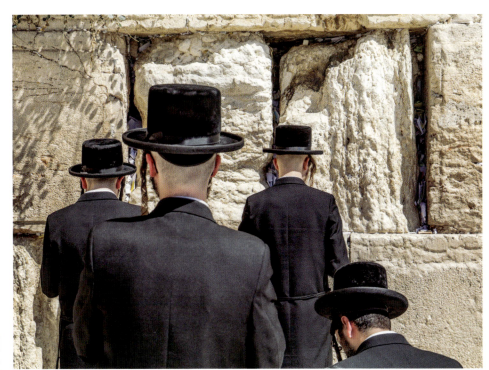

BOTH PHOTOGRAPHS:
Dome of the Rock, Old City of Jerusalem, Israel
The world's oldest surviving work of Islamic architecture, the Dome of the Rock is a shrine in the Al-Aqsa Mosque compound on Temple Mount. According to Islamic belief, the rock above which the dome is constructed is where the Prophet Muhammad was taken into heaven for an encounter with God. In the Early Ottoman period, bright Iznik-style tiles were applied to the exterior and the roof was plated in gold in 1959–1961 and again in 1993.

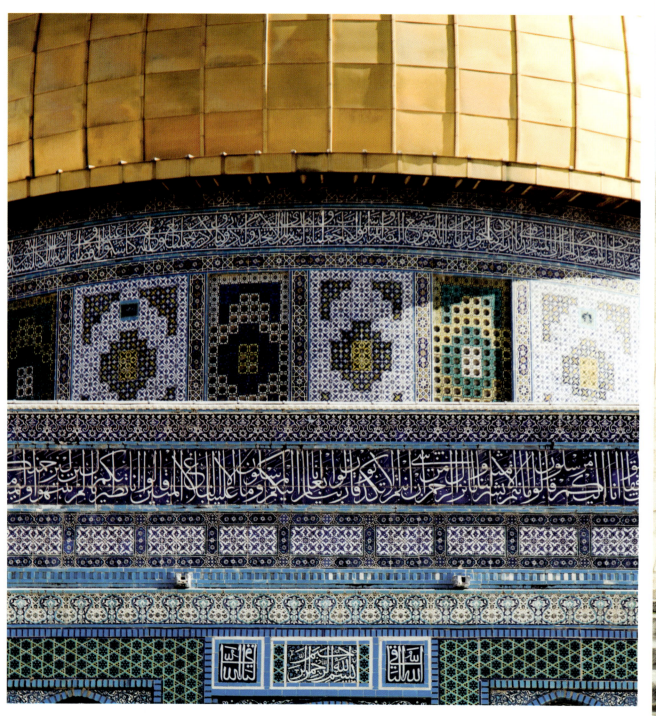

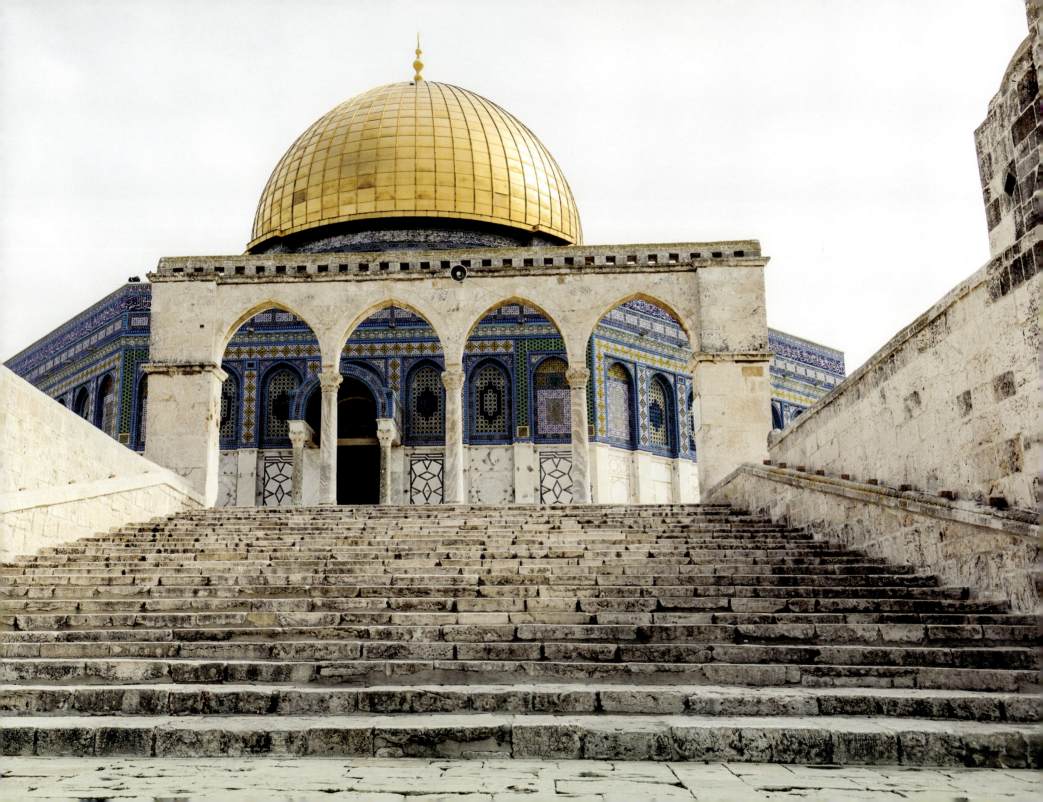

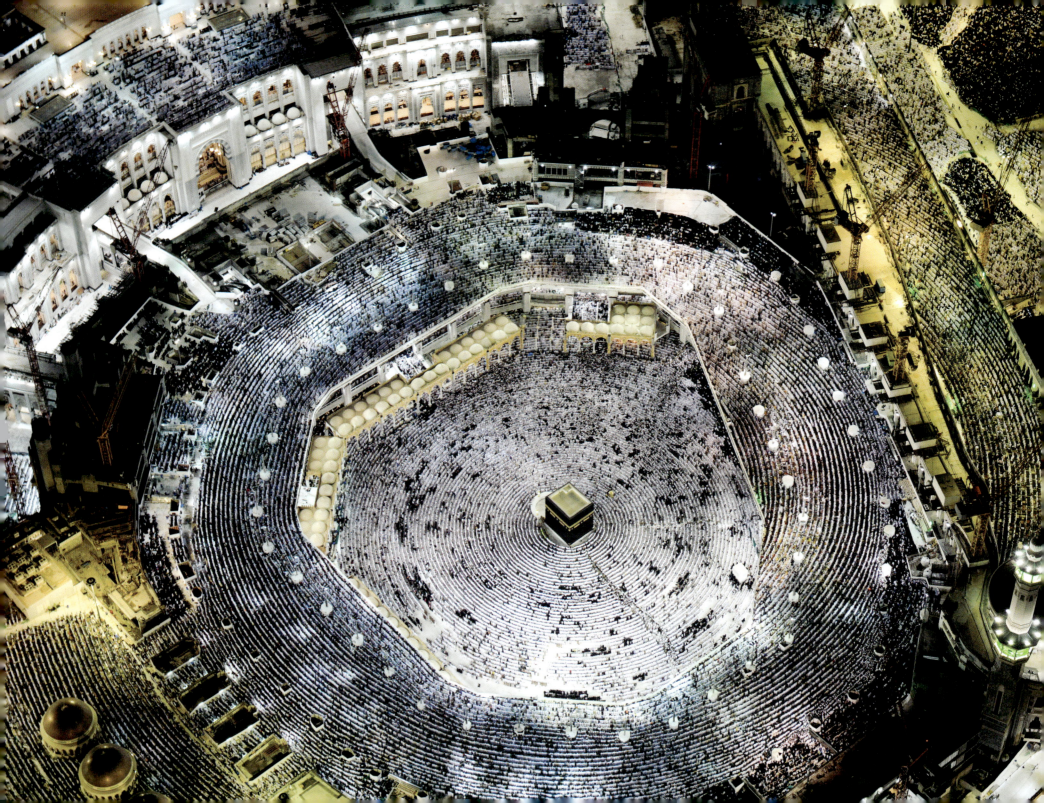

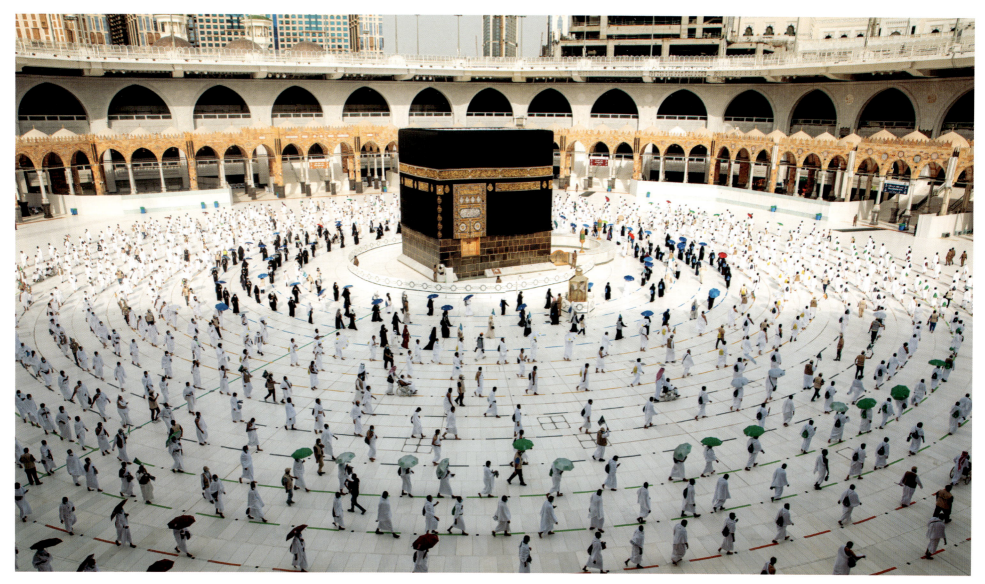

BOTH PHOTOGRAPHS:
Mataf at Makkah, Saudi Arabia
During Ramadan, millions make the sacred pilgrimage to Makkah, or Mecca, to perform tawaf – circumambulate anti-clockwise for seven circuits around the Kaaba, a stone building at the centre of Islam's most important mosque and holiest site, the Masjid Al-Haram. The mosque is the *qibla*, or direction of prayer for Muslims around the world.

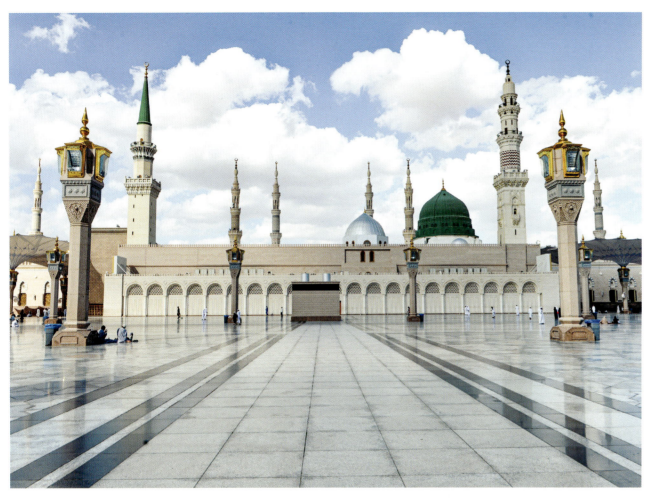

BOTH PHOTOGRAPHS:
Al-Masjid an-Nabawi, Madinah, Saudi Arabia
The vast Al-Masjid an-Nabawi ('Prophet's Mosque') in Madinah, or Medina, is one of the three holiest places of Islam. The mosque was established and built by the Islamic prophet Muhammad, and its eye-catching green dome rises over his tomb and those of early Islamic leaders Abu Bakr and Umar. The mosque is a major pilgrimage site for the faithful.

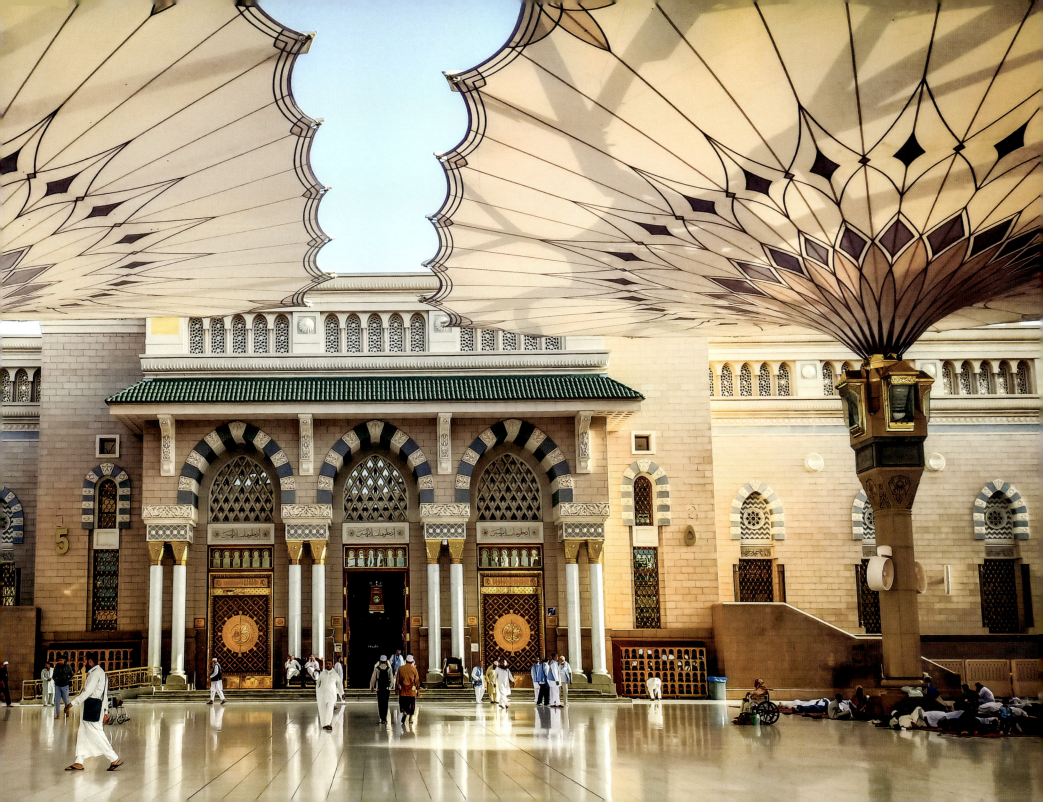

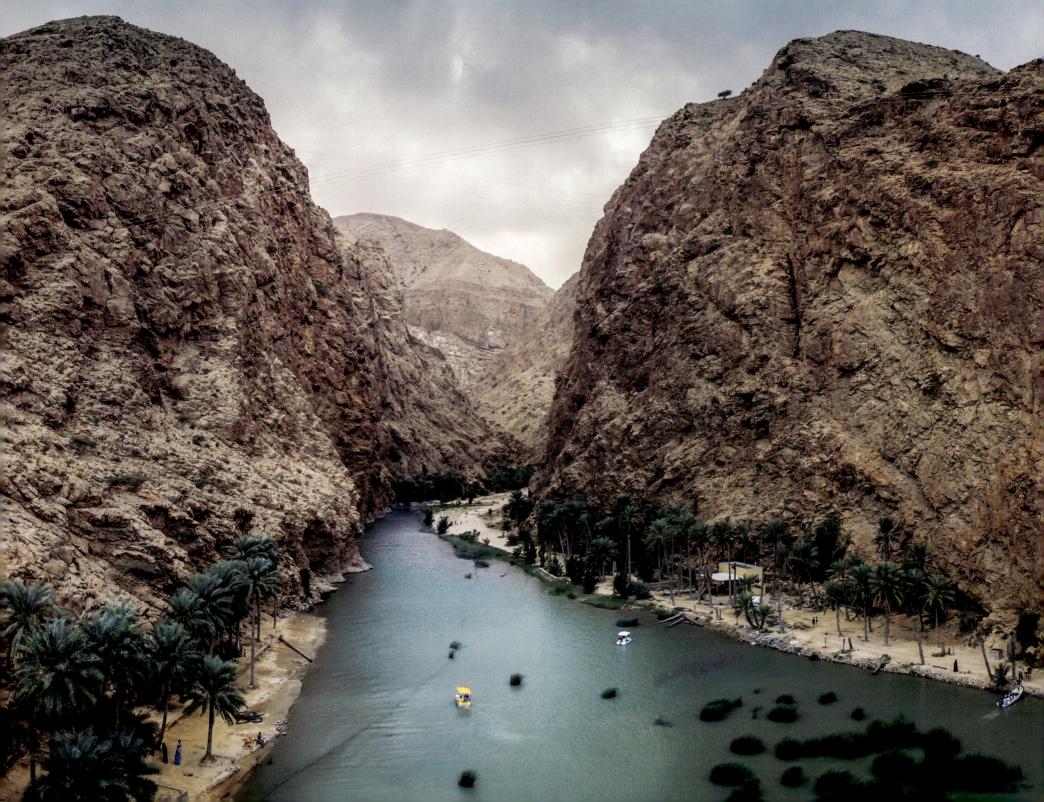

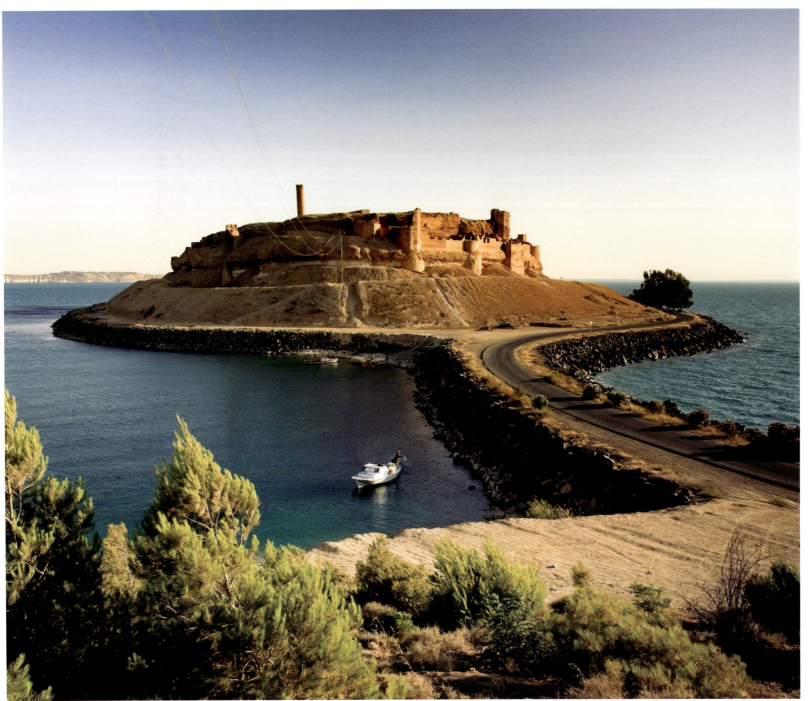

OPPOSITE:
Wadi Shab, Oman
A true oasis in the desert, Wadi Shab has the requisite palm trees, emerald pools, and walls of golden honeycombed rock that offer shade and shelter from the heat of the sun. Visitors can bathe in the crystal clear waters, and swim through a crack in the rocks into a cave with a waterfall inside.

LEFT:
Qal'at Ja'bar in Lake Al-Assad, Syria
Rising up out of the waters of the man-made Lake Assad, Qal'at Ja'bar is primarily the work of Turkoman ruler Nur ad-Din, who rebuilt the castle from 1168. Before the lake was built in 1974, the castle overlooked the Euphrates River, and the hilltop likely had fortifications for hundreds of years before the existing castle took shape.

LEFT:
Lake Qadisiyah, Iraq
Lake Qadisiyah is a man-made reservoir in the Euphrates, the longest river in Western Asia. The lake sits just north of Haditha Dam, which was built between 1977 and 1987 to provide hydro-electric power and irrigation water for surrounding fields, and to regulate the flow of the Euphrates. Lake Qadisiyah has 100km (62 miles) of shoreline.

OPPOSITE:
Dura-Europos, Syria
On the banks of the Euphrates in Syria, Dura-Europos was a Hellenistic, Parthian, and Roman border city. Its well-preserved ruins, including a shrine to the god Mithras, a synagogue with murals of biblical scenes, and an early Christian house church, made it an archaeological treasure. The site was mostly destroyed between 2011 and 2014 during the Syrian Civil War.

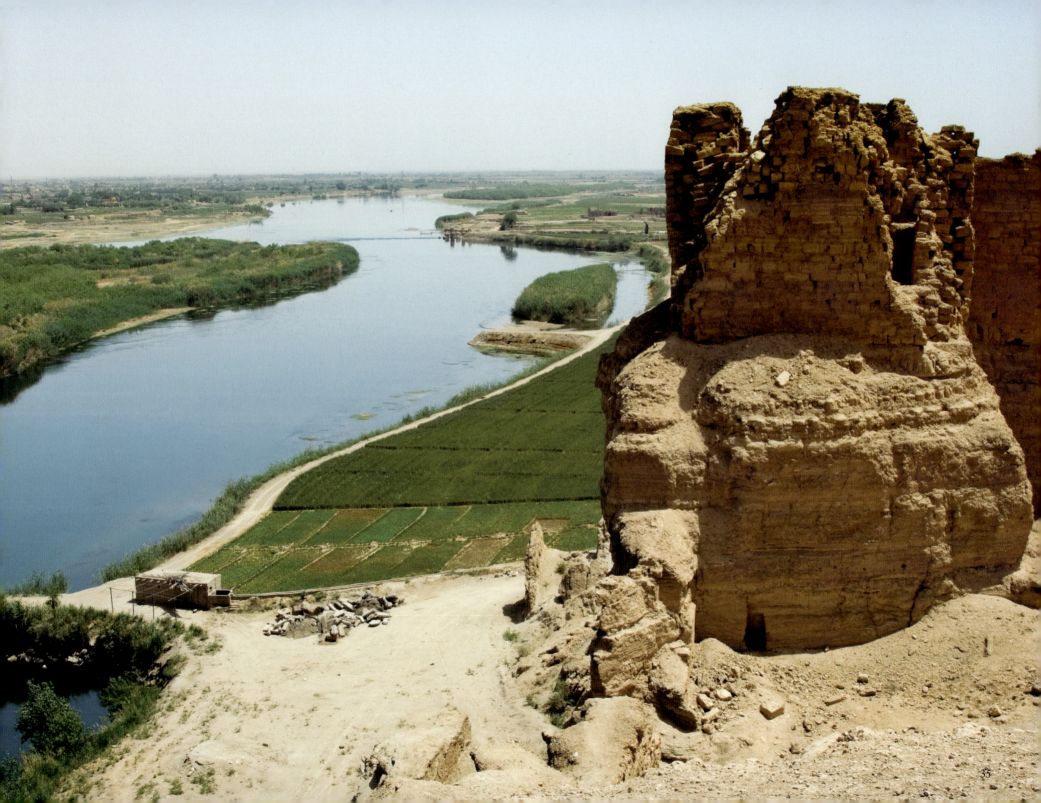

RIGHT:
Sunken mosque, Halfeti, Turkey
Most of the villages of Halfeti in Turkey's Şanliurfa Province were flooded in 1999 while damming the Euphrates river at Birecik. Some of the villages are only half submerged, leaving tantalizing glimpses of community life before the water, and attracting tourists who visit on boats and ferries.

FAR RIGHT:
Rumkale Castle, Gaziantep, Turkey
This ancient fortress on the Euphrates river is at least 1000 years old – but could be far older, although no remains of periods earlier than 1000CE have been identified at the site. It is now located on a peninsula created by the reservoir of Birecik Dam, which opened in 2000.

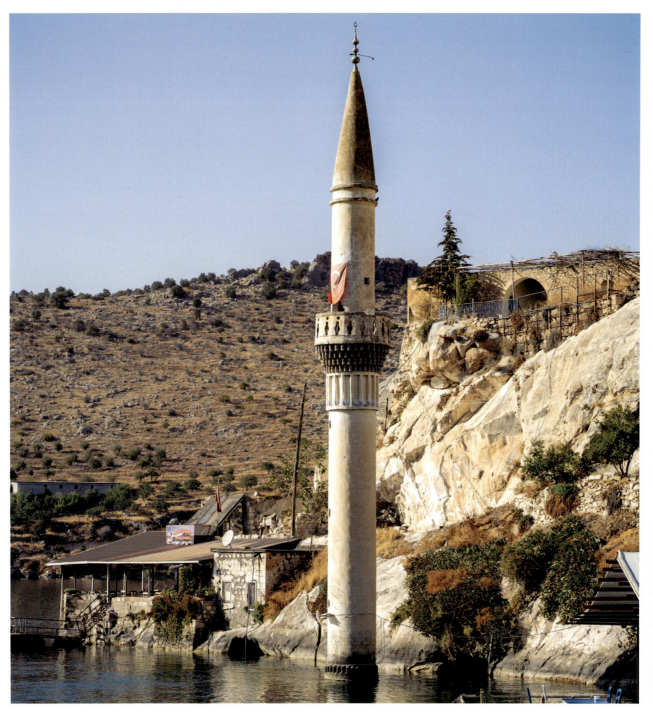

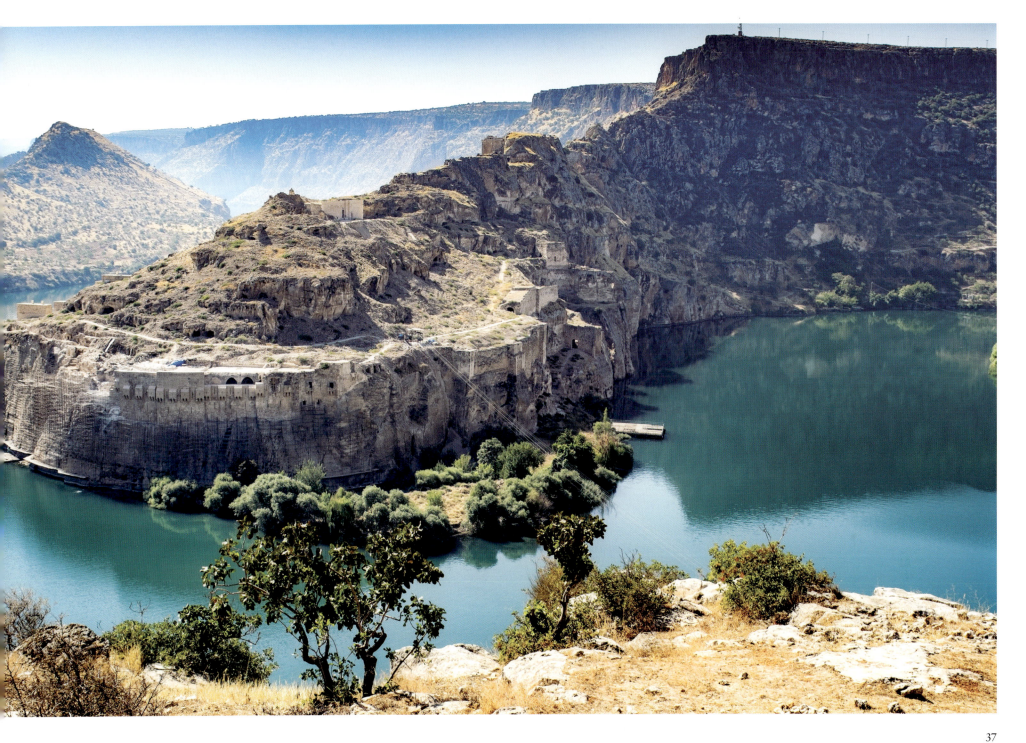

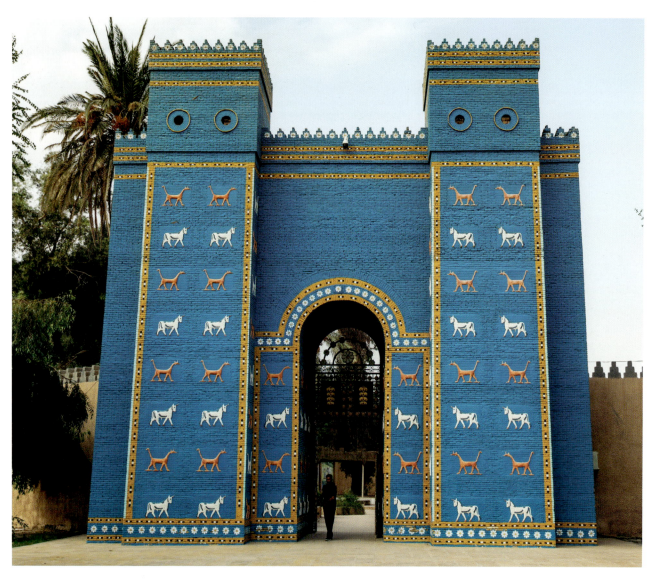

ABOVE:
Ishtar Blue Gate, Babylon, Iraq
The monumental Gate of Ishtar once marked an entrance to the ancient city of Babylon. Built in 575BC out of enamelled bricks in cobalt blues and sea greens and decorated with reliefs of hundreds of dragons and bulls, the gate captures all the splendour of the city that, at its peak, was the largest metropolis in the world.

RIGHT:
Malwiya minaret at the Great Mosque of Samarra, Iraq
The Malwiya minaret rises up 50m (164ft) out of the desert sand at the Great Mosque of Samarra. The ninth century spiralling tower of sun-dried and baked brick was modelled on ancient ziggurats and was built to symbolize the power of Islam during the Abbasid caliphate. It was listed as a UNESCO World Heritage Site in 2007.

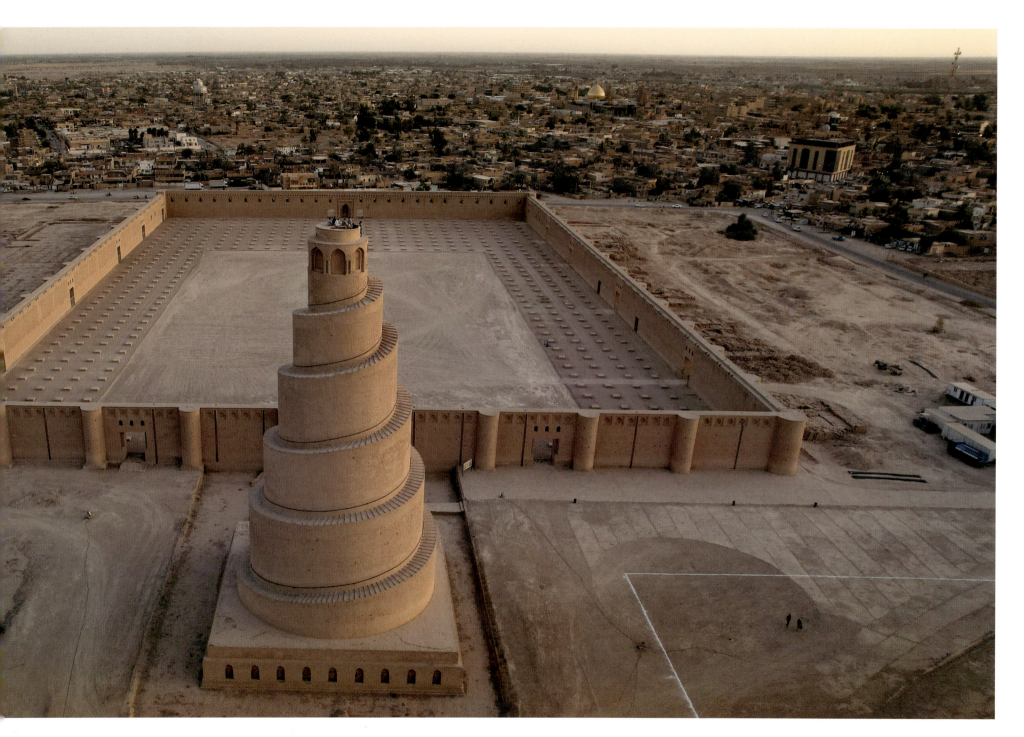

Caliphal Palace, Samarra, Iraq
The ancient city of Samarra, founded in 836CE, was capital of the Abbasid Empire, which extended from Tunisia to Central Asia for a century. The Dār Al-Khilāfa, or Caliphal Palace, is just one of the architectural marvels of the archaeological site that sprawls for more than 40km (24.8 miles) on both sides of the River Tigris.

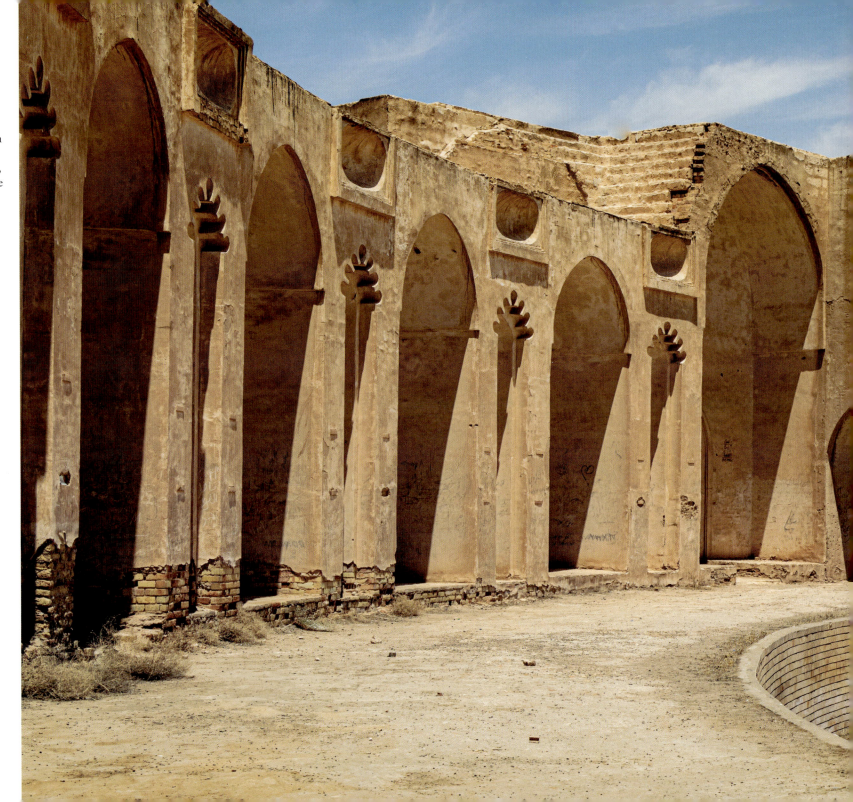

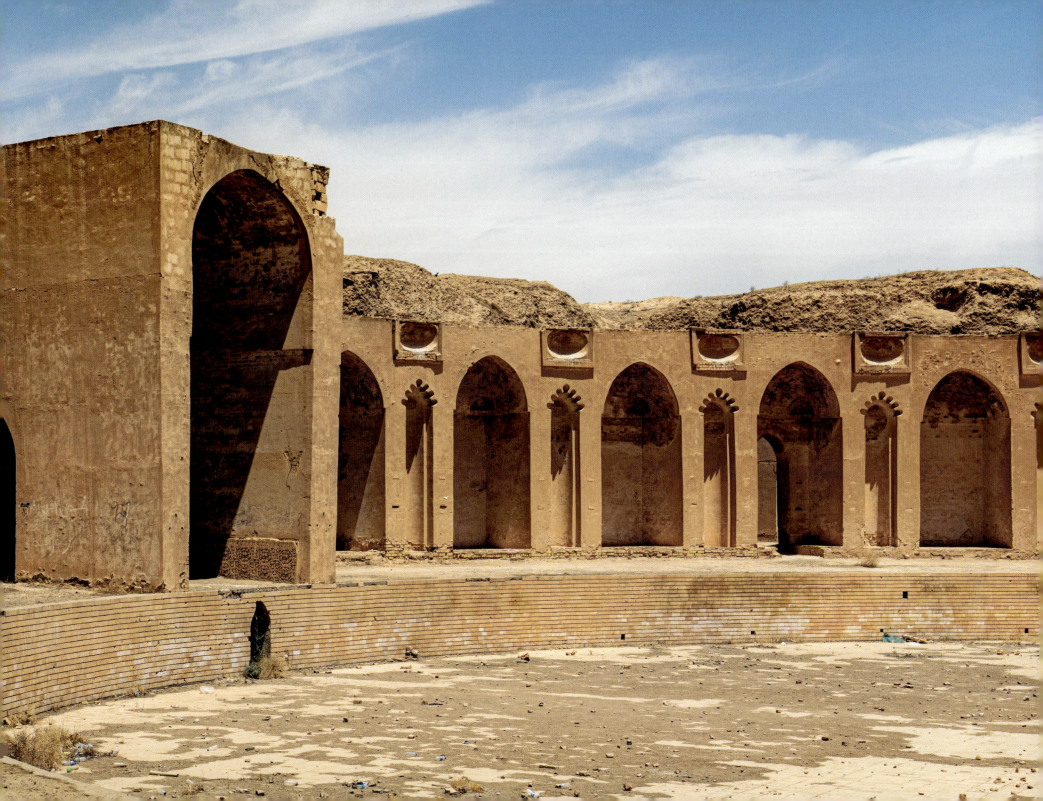

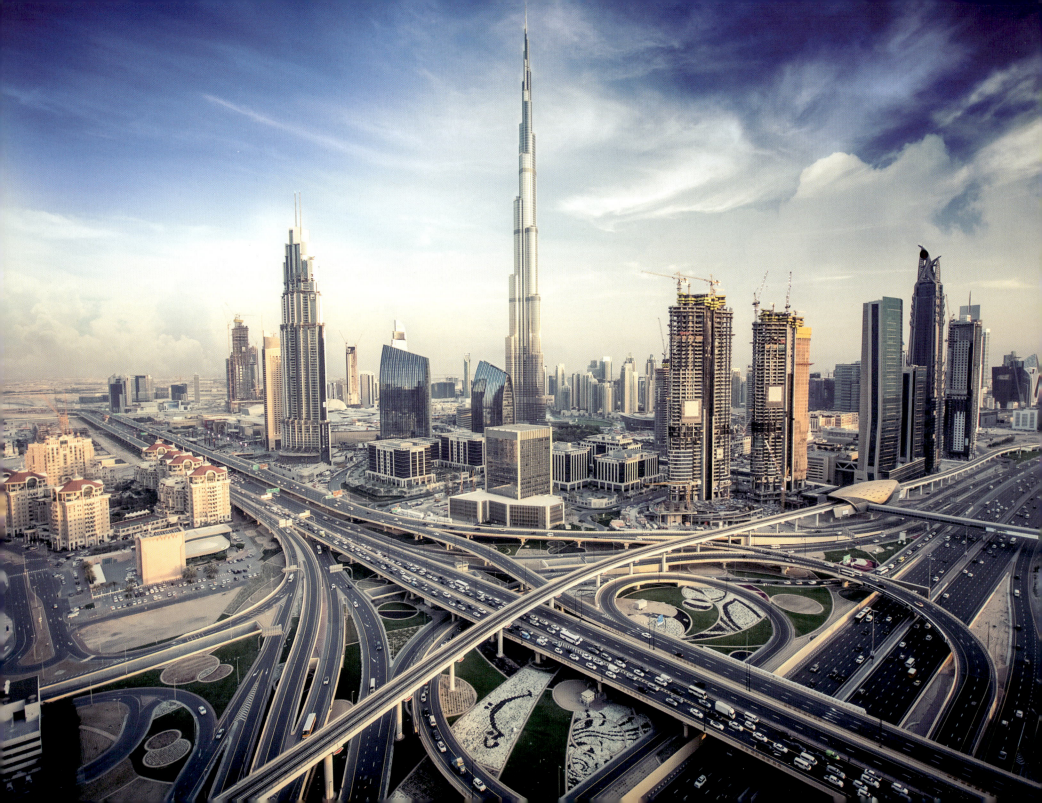

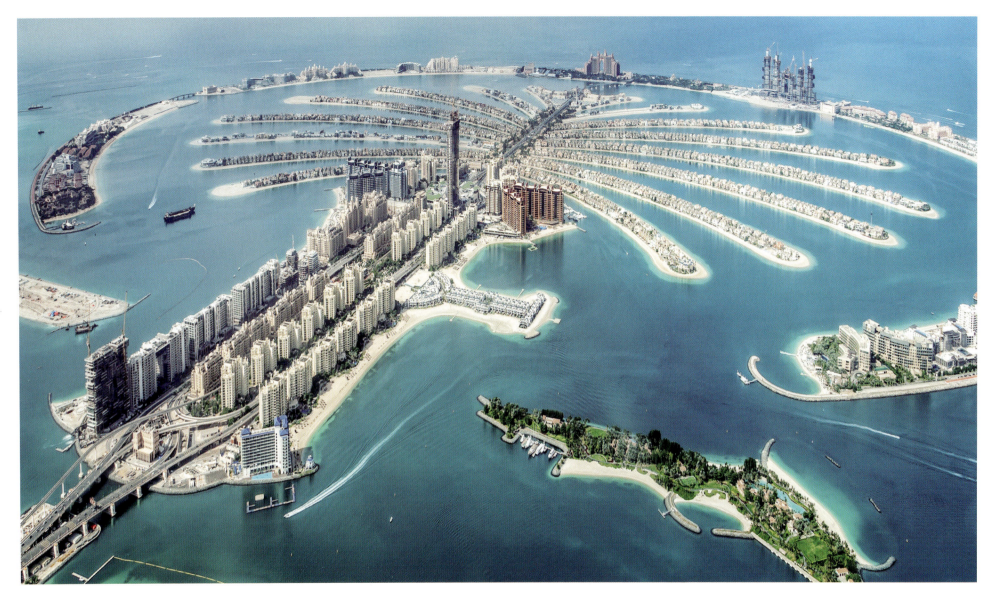

OPPOSITE:
Dubai, United Arab Emirates
From desert sands to city of skyscrapers, Dubai has transformed itself into a regional and international centre for trade, tourism, and luxury. Founded in the 1800s as a fishing village, Dubai now is a city of superlatives, including the iconic needle of the Burj Khalifa, the world's tallest structure, measuring 829.8m (2722.4ft).

ABOVE:
Palm Jumeirah, Dubai, United Arab Emirates
This archipelago of artificial islands shaped as a date palm tree and crowded with luxury residences, hotels, and retail and dining destinations is visible from space. The islands were created from land reclamation and are part of a larger series of developments known as the Palm Islands, which will increase Dubai's shoreline by 520km (323 miles).

RIGHT:
**Dubai Marina,
United Arab Emirates**
The 3km (1.8 mile) long Dubai Marina is a man-made canal lined with residential towers and villas, retail complexes, and hotels. With phases still under construction, the marina is set to be the world's biggest once complete. The waterway, connected to the Persian Gulf, provides mooring for yachts and boats, as well as space for watersports such as jet skiing.

OPPOSITE:
**Dubai Creek,
United Arab Emirates**
Among the gleaming skyscrapers, Dubai Creek offers a glimpse of life as it once was when the city was just a fishing village. Wooden dhow cargo boats loaded with merchandise ply the waters, which historically divided the city into two halves – Deira and Bur Dubai.

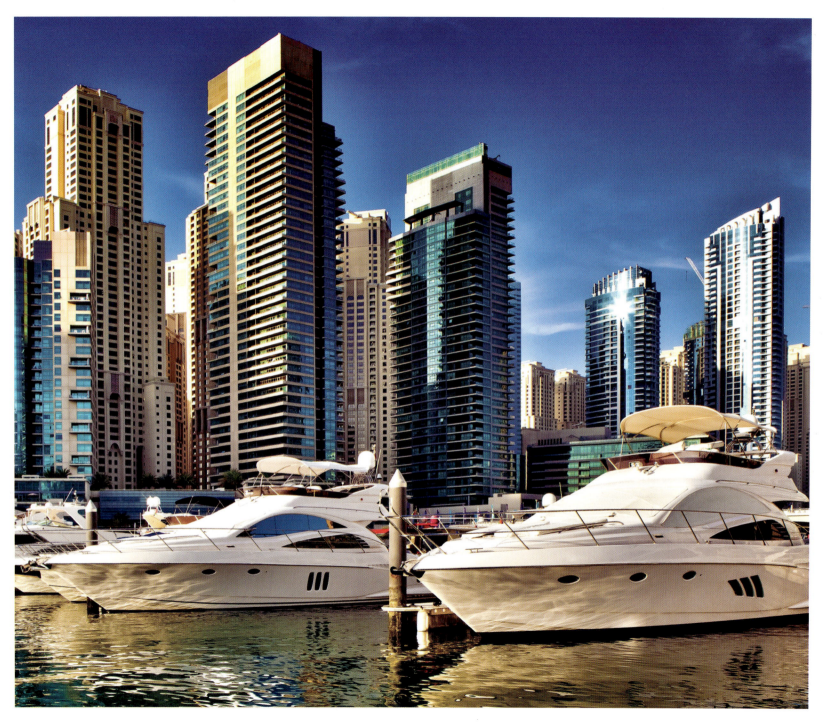

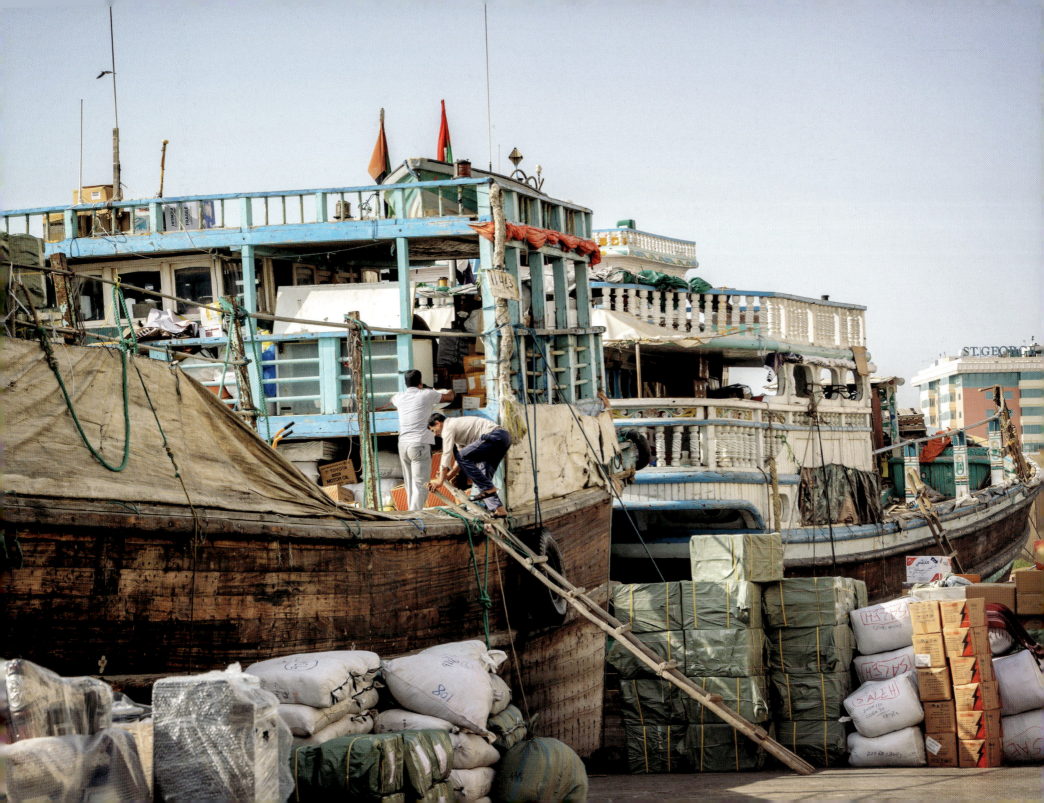

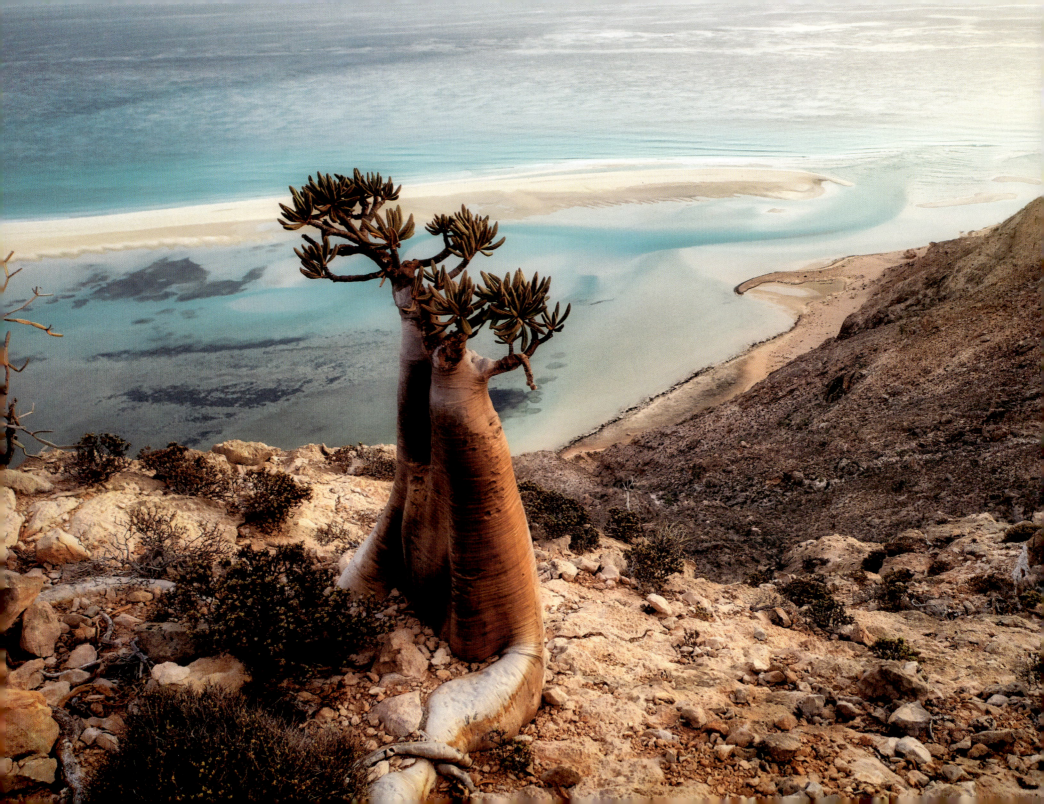

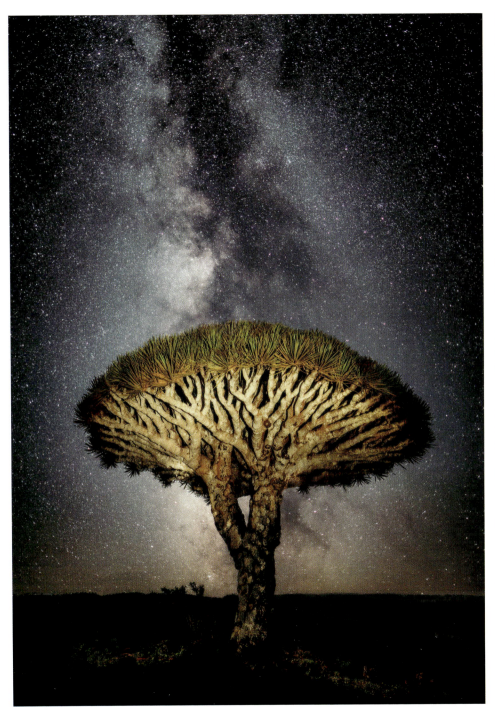

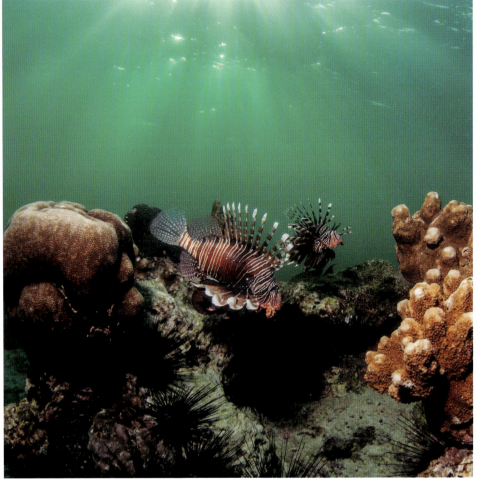

OPPOSITE:
Bottle tree, Socotra, Yemen
The unique flora and fauna of Socotra have earned it UNESCO World Heritage Site status. Of the 830 recorded plant species on the island, 322 are found nowhere else, including the bottle tree. Its strange swollen trunk and its ability to take root on vertical cliffs and high mountain plateaus ensure it is one of Socotra's most striking plants.

LEFT:
Dragon blood tree, Socotra
The most well-known of Socotra's endemic trees, and the national tree of Yemen, the peculiar *Dracaena cinnabari* 'bleeds' a dark red resin known as 'dragon's blood'. It is related to other dragon trees found in parts of Africa, Arabia, and southeast Asia, but the Socotri species is the only one known to form extensive woodland.

ABOVE:
Coral reef, Socotra, Yemen
The reefs in the Socotra archipelago are less degraded than most in the Indian Ocean, and marine life in the plankton-rich green waters is diverse. Around 730 species of coastal fish, including the eye-catching lionfish, make their homes among the 283 species of coral.

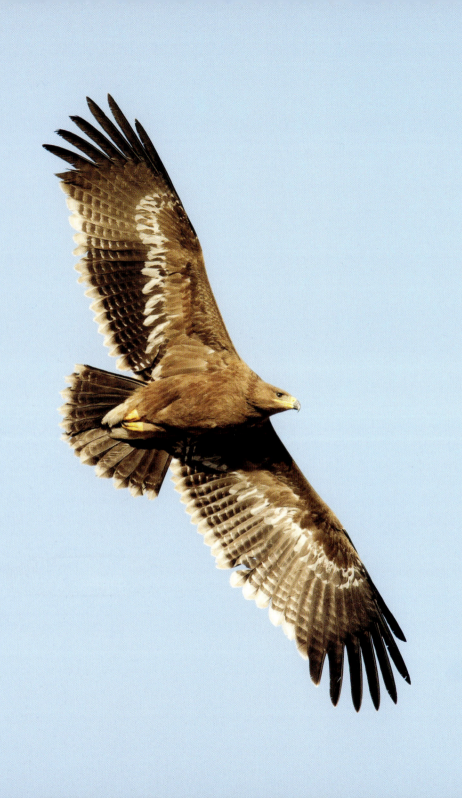

LEFT:
Steppe eagle, Zagros Mountains, Iran
The high peaks and vast valleys of the Zagros Mountains, which run along Iran's western border with Turkey and Iraq, provide a safe haven for wildlife, including for the majestic steppe eagle. The migratory eagle (*Aquila nipalensis*) is considered endangered.

RIGHT:
Monastery of Saint Thaddeus, West Azerbaijan, Iran
The conical Armenian roofs of the Monastery of Saint Thaddeus can be seen from miles away. Rising up from a flat plain in Iran's mountainous northwest, the monastery, believed to be one of the oldest church buildings in the world, has attracted pilgrims for centuries. The three-day pilgrimage to the monastery was in 2020 listed as a UNESCO Intangible Cultural Heritage.

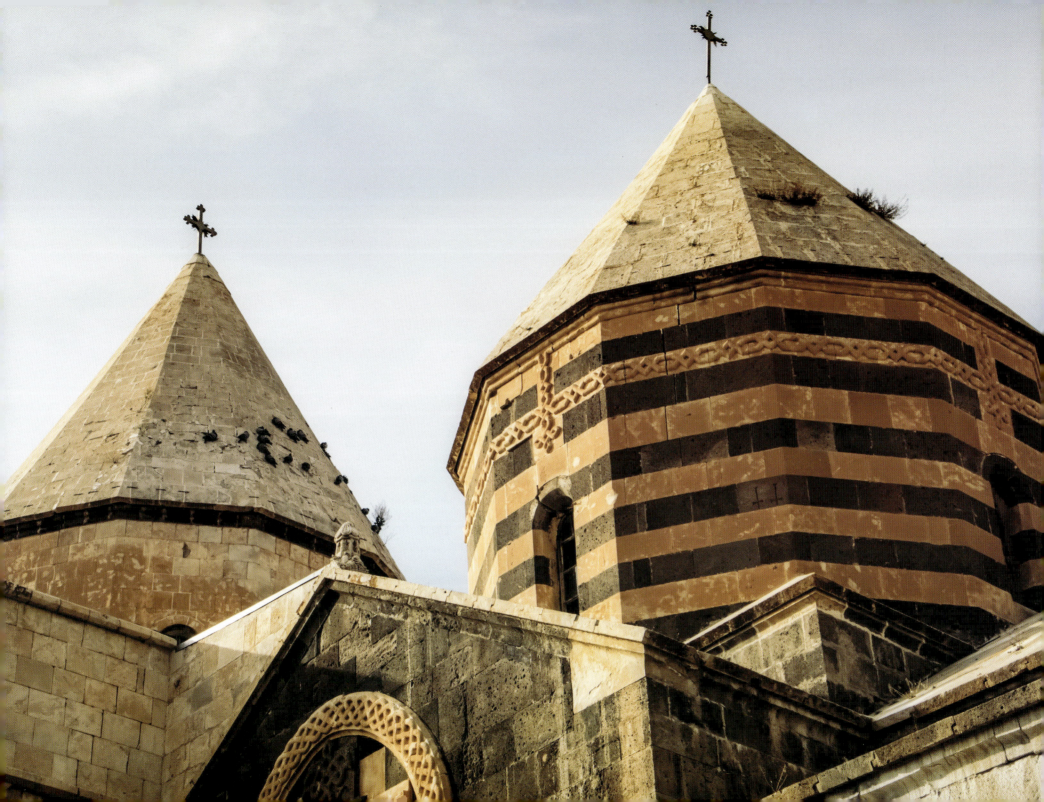

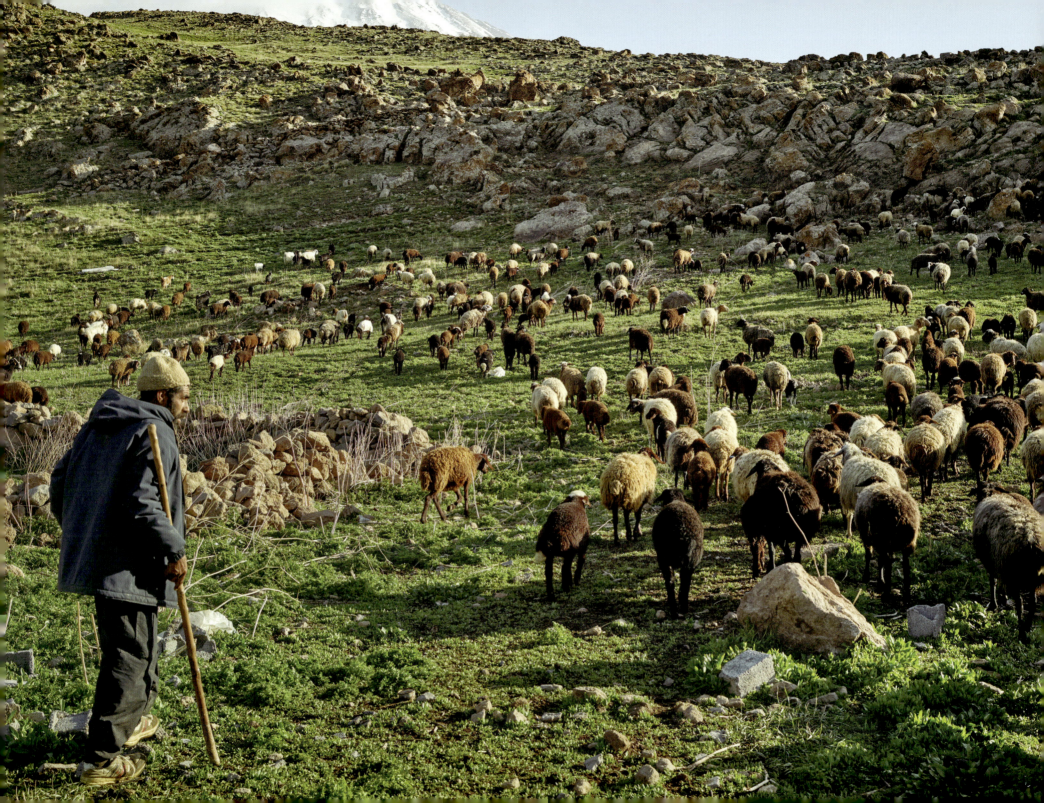

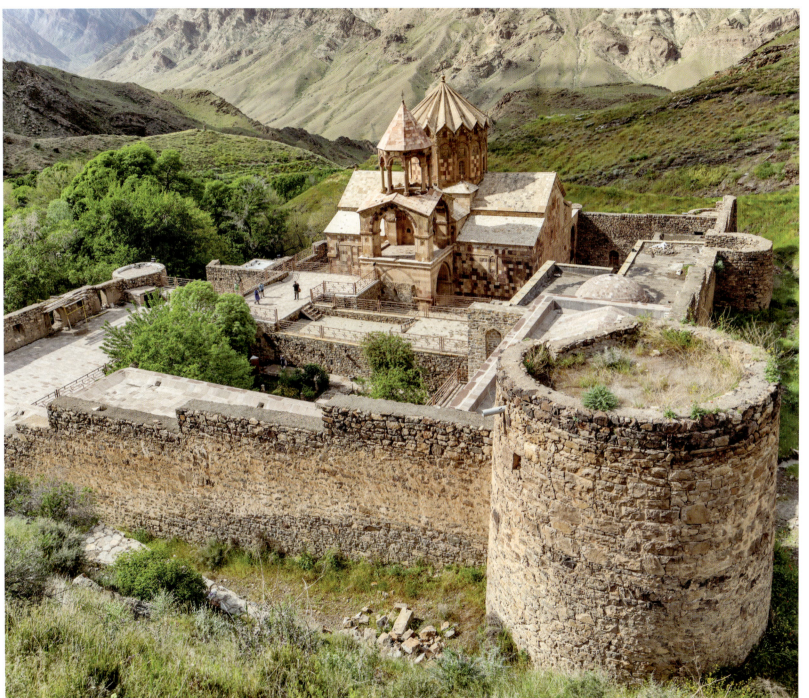

OPPOSITE:

Polour, Mazandaran, Iran
Afghan shepherds tend to their animals in meadows near the village of Polour, which rests at the foot of Mount Damavand, a dormant stratovolcano and at 5609m (18402ft) the highest mountain in Iran. While the mountain is increasingly attracting hikers and outdoor enthusiasts, life for local Polour inhabitants continues as in decades past.

LEFT:

Saint Stepanos Monastery, East Azerbaijan, Iran
Located in northwestern Iran, Saint Stepanos Monastery was built in the ninth century, but, after war and earthquakes took their toll, was rebuilt during the Safavid (1501–1736) era. The monastery has even older roots: it was built on the site of a church founded by Bartholomew the Apostle in around 62CE.

RIGHT:
Sheikh Safi Al-Din Shrine complex, Ardabil, Iran
The tomb complex of Sheikh Safi Al-din Ardabili, a mystic, poet, and Sufi teacher born in 1252, was built between the beginning of the sixteenth century and the end of the eighteenth century. The complex, a place of spiritual retreat in the Sufi tradition, also accommodates a library, mosque, hospital, school, bakery, and kitchens.

OPPOSITE:
Entrance to Sheikh Safi Al-Din Shrine complex, Ardabil, Iran
The richly ornamented facades and interiors of the Sheikh Safi Al-Din Shrine complex are well preserved and are a remarkable example of medieval Islamic architecture. The tilework, in dazzling turquoise and deep blue, and featuring Quranic calligraphy, is a vivid exhibition of Safavid artistry.

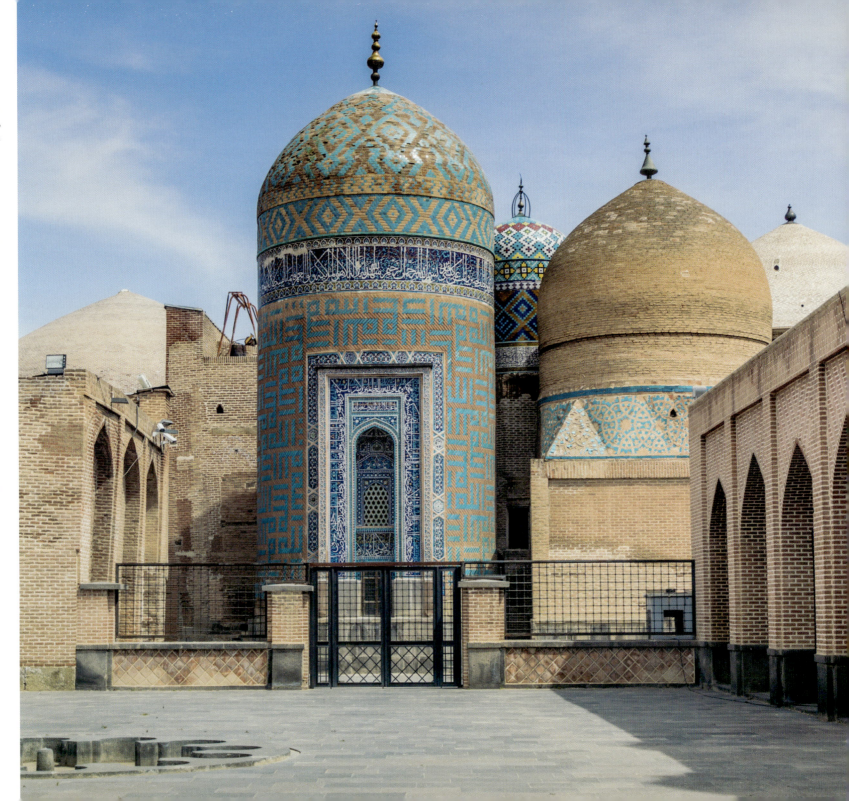

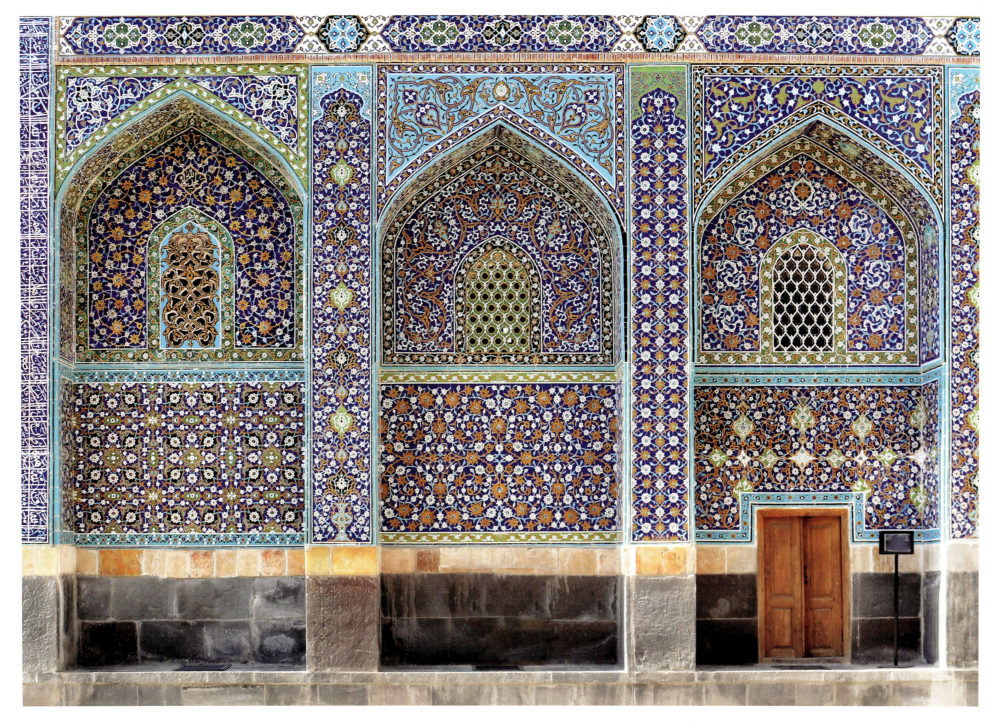

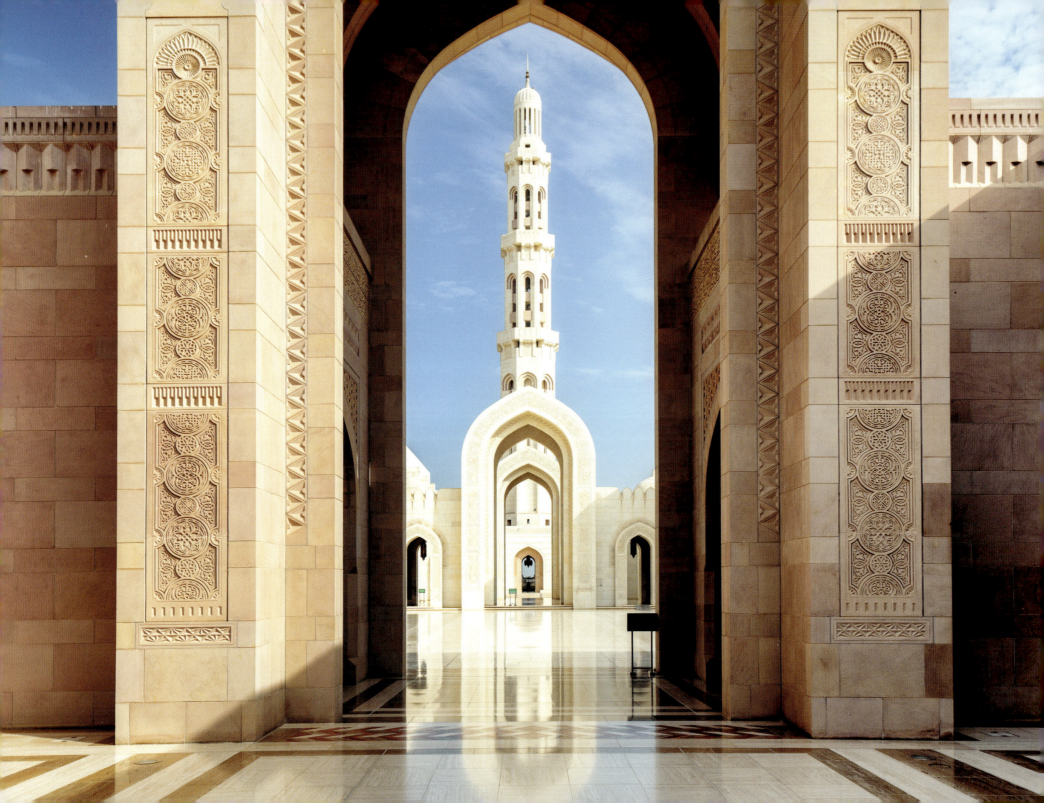

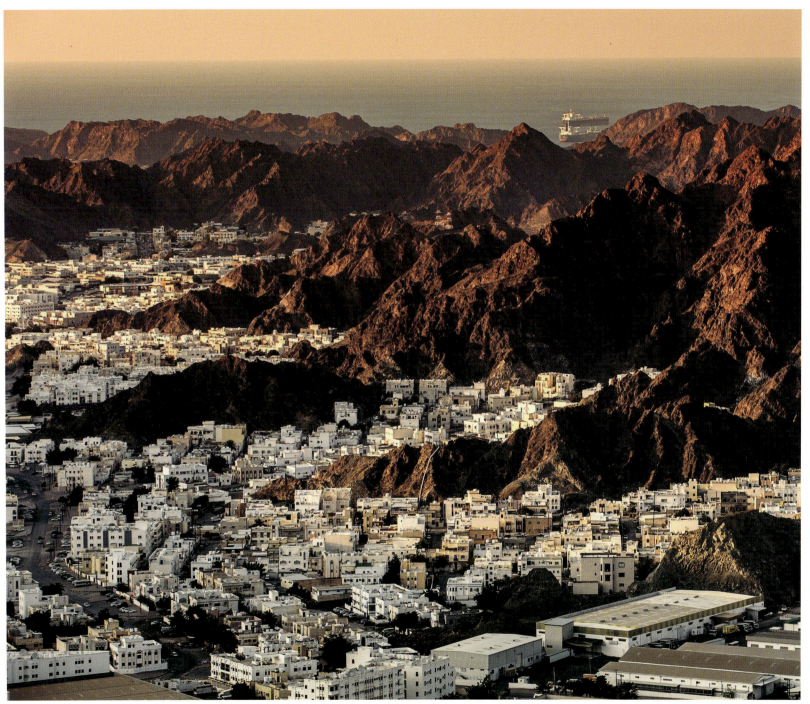

OPPOSITE:
Sultan Qaboos Grand Mosque, Muscat, Oman
Construction on Muscat's Grand Mosque began in 1994, after being commissioned by the then Sultan of Oman, Qaboos bin Said Al Said. It took around 300,000 tonnes (300,000,000 kg) of Indian sandstone to build the mosque. The five elegant minarets are focal points; the tallest rises up 90m (295ft) while other the four reach 45.5m (149ft).

LEFT:
Muscat, Oman
Lying on the Arabian Sea along the Gulf of Oman, and resting in the shadow of the spectacularly jagged Hajar Mountains, Muscat is an ancient settlement: fishermen burial sites unearthed near the present-day city suggest there has been communal activity in the area since the sixth millennium BCE. Today, Oman's capital is its most populous city, with 1.72 million residents.

Ziggurat at Ur, Iraq
Located in the ancient Mesopotamian city of Ur in southern Iraq, this ziggurat is one of around 25 pyramidal stepped temple towers built by the Sumerians, Babylonians, and Assyrians, and one of the best preserved. The earliest bricks at the site date to about 2100BCE.

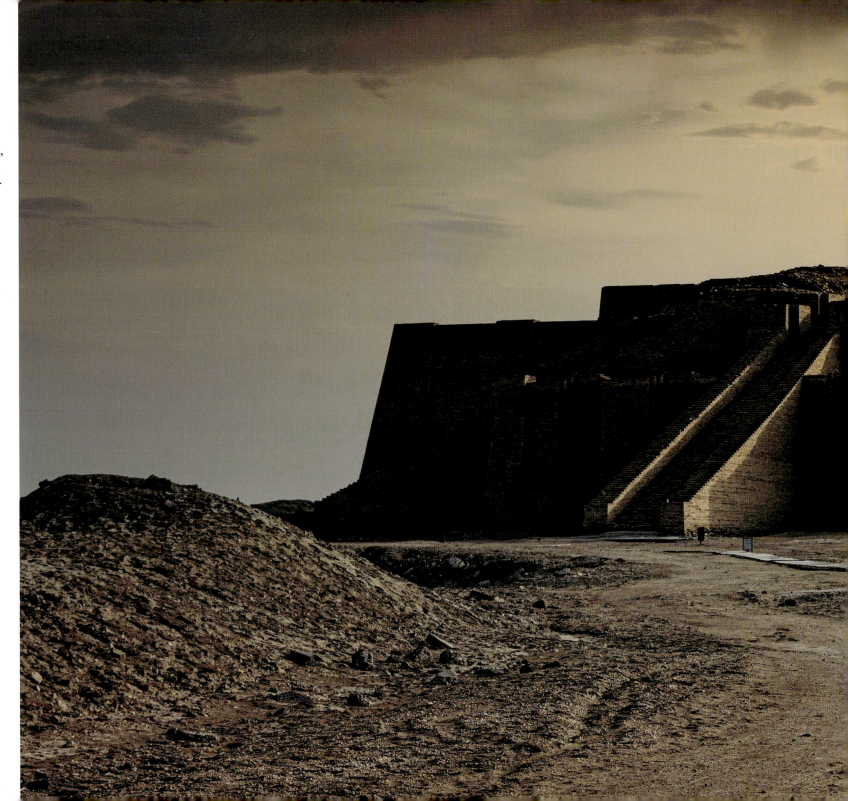

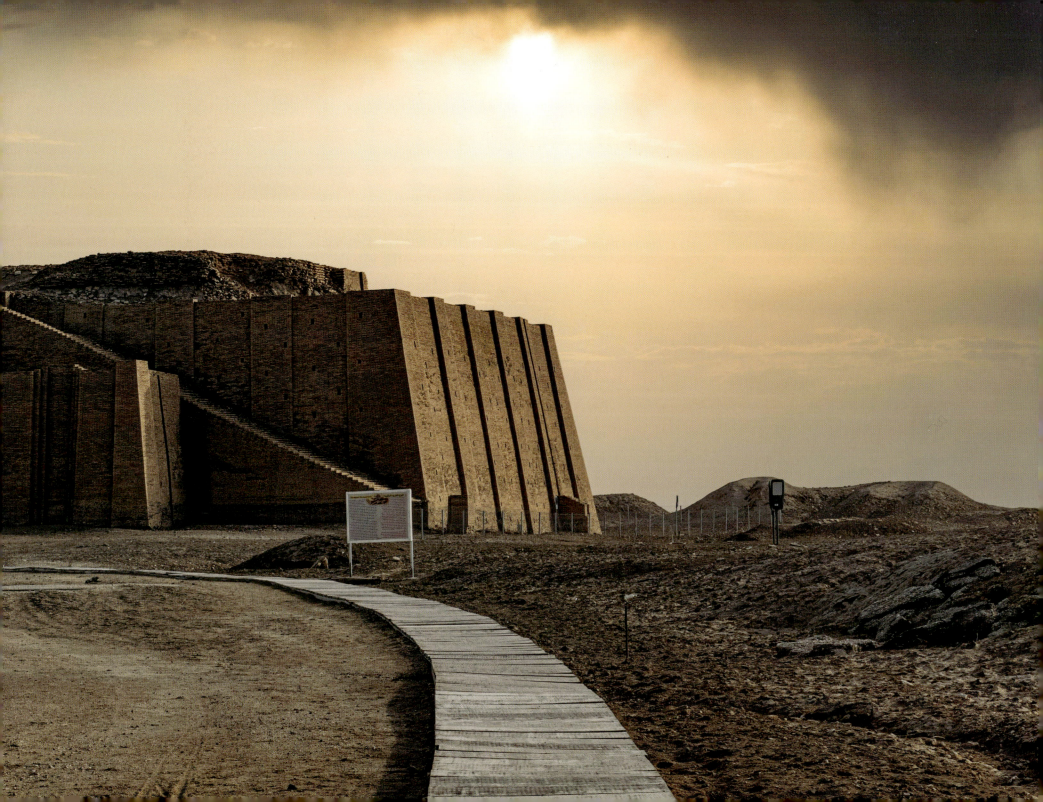

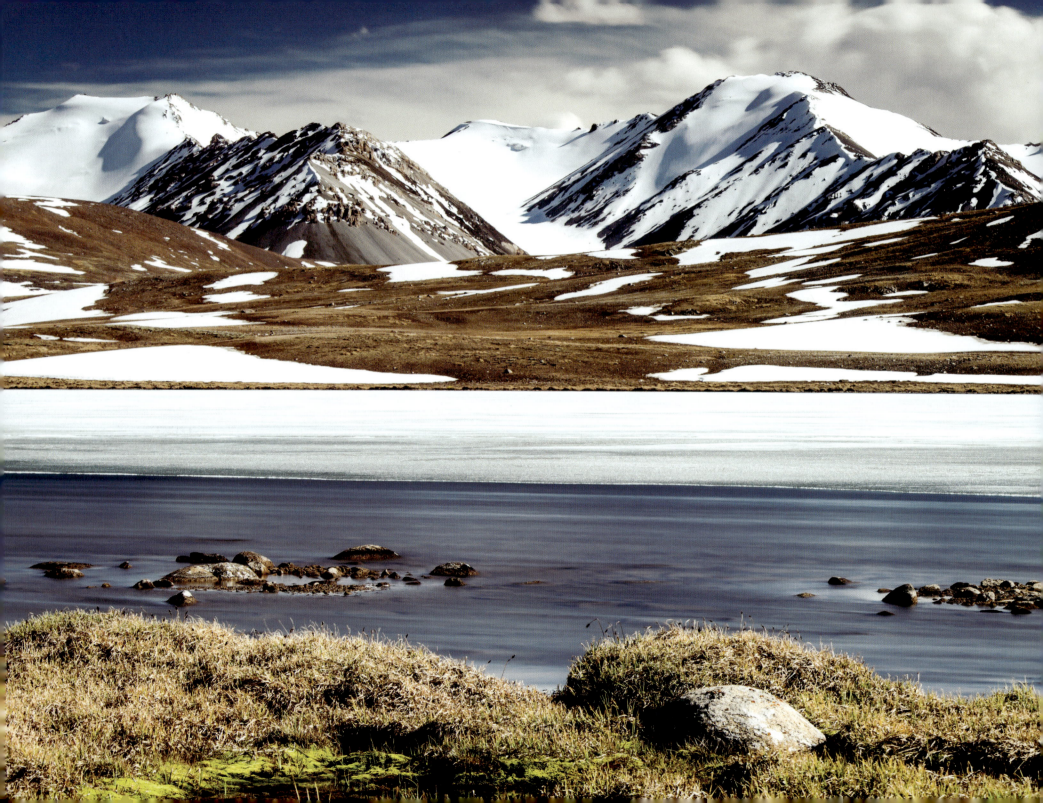

Central and Northern Asia

It is only in recent years that the countries at the heart of Asia – today's Kazakhstan, Kyrgyzstan, Tajikistan, Turkmenistan, and Uzbekistan – have begun to reveal their treasures to the world. With their rich tapestry of age-old cities, vibrant traditions, and stunning landscapes, what they offer is unique and unforgettable.

At the crossroads of East and West on the ancient Silk Road, this area was for centuries a centre of trade and a conduit for the exchange of ideas and technologies. Giant empires, stretching back to the Persian and Mongol periods, and to the modern era with the Soviet Union (1918–1991), have also shaped local culture, resulting in a mosaic of ethnicities, languages, and communities.

The region's Islamic heritage is rich, particularly in Uzbekistan's fabled cities of Samarkand and Bukhara, where intricate madrasas, mausoleums, and bustling bazaars echo with the region's storied past.

Away from the cities, the dramatic natural environment of the region has shaped the way of life of its peoples; while it has been, like everywhere, impacted by globalization, many of its indigenous traditions remain. Even today, the felt yurts of nomad families dot summer meadows, such as those surrounding Lake Song-Köl in Kyrgyzstan.

The remote areas, from the soaring peaks of the Tian Shan to the vast steppes and arid Karakum desert, are nothing short of spectacular and help to make the region one of the world's top emerging travel destinations.

OPPOSITE:
Barskoon Valley, Issyk-Kul region, Kyrgyzstan
The Issyk-Kul region in Kyrgyzstan's eastern corner is famed for its stunning high-altitude vistas, and Barskoon – a *syrt*, or high-mountain valley – offers plenty of these. The valley, an ancient Silk Road caravan route, is surrounded by the snowy peaks of the Tian Shan mountains, and dotted with waterfalls.

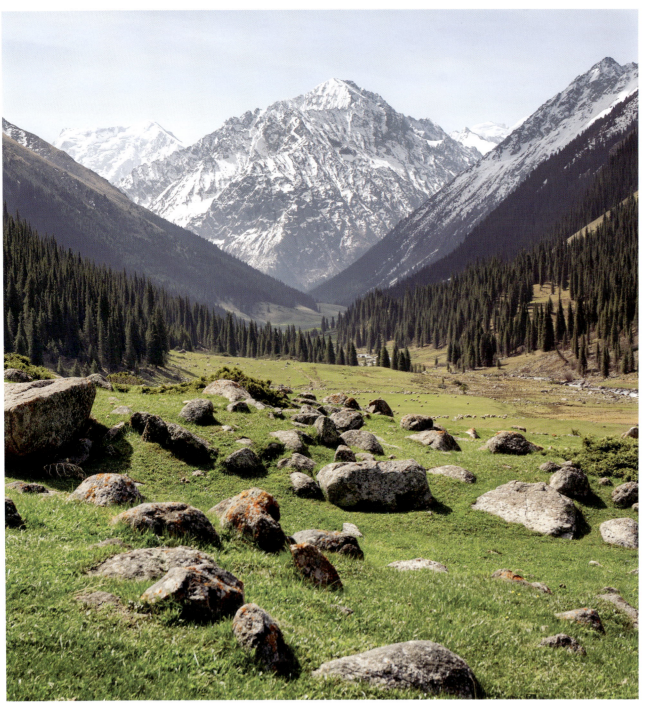

OPPOSITE:
Tian Shan, Kyrgyzstan
The Tian Shan mountains stretch east to west for 2500km (1553 miles) through Kyrgyzstan and northwestern China. They cradle the eye-shaped Issyk-Kul ('Warm Lake') which, despite the severe cold in winter and being at 1607m (5272ft) above sea level, rarely freezes over due to its high salinity.

LEFT AND ABOVE:
Summer in the Tian Shan, Kyrgyzstan
As the winter snows melt, valleys in the Tian Shan, such as the splendid Altyn Arashan, bloom with lush grass and wildflowers. The Kyrgyz people still today retain some of their earlier nomadic way of life, herding their flocks of sheep and goats to high summer pastures to graze.

Song-Köl, Tian Shan, Kyrgyzstan

Song-Köl (literally 'Following Lake') is a high-alpine lake that sits at 3016m (9895ft) above sea level in the Tian Shan mountains. It is surrounded by virgin pastures and the ridges of Sonköl Too and Moldo Too, and is a conservation area. It is the largest fresh-water lake in Kyrgzstan.

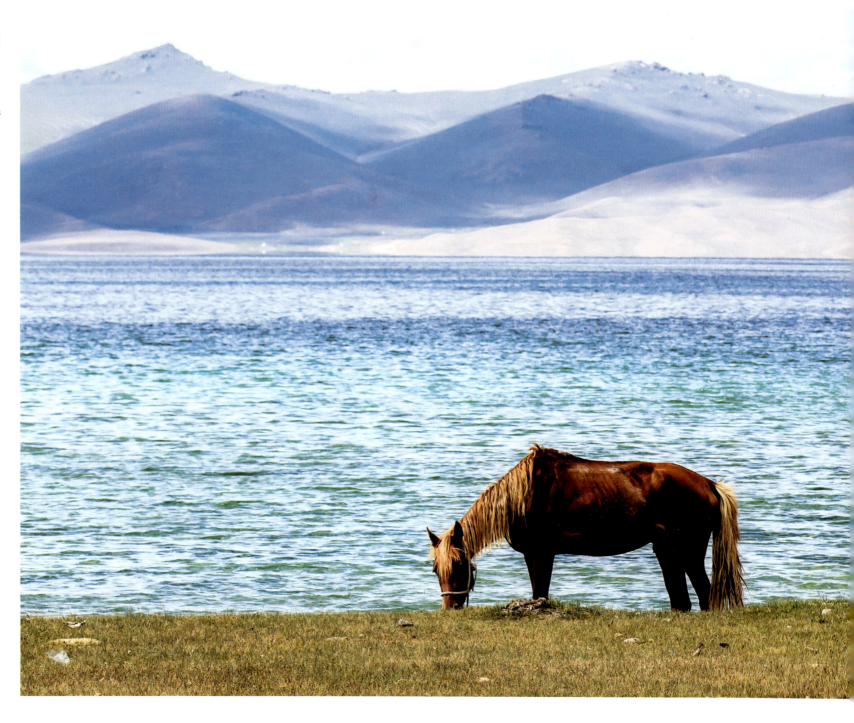

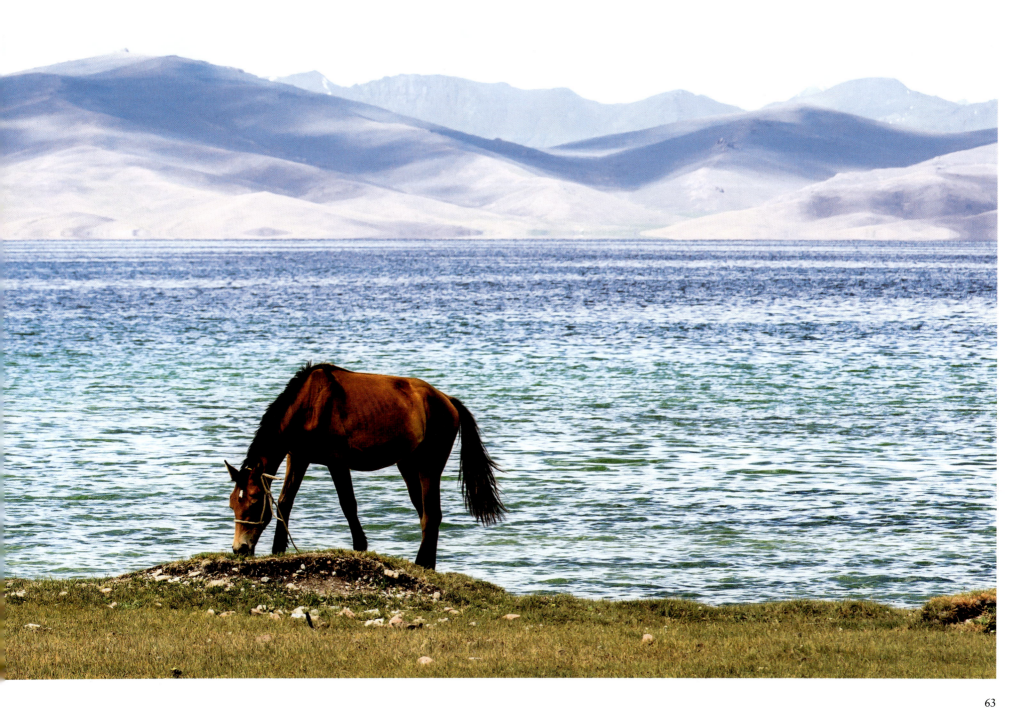

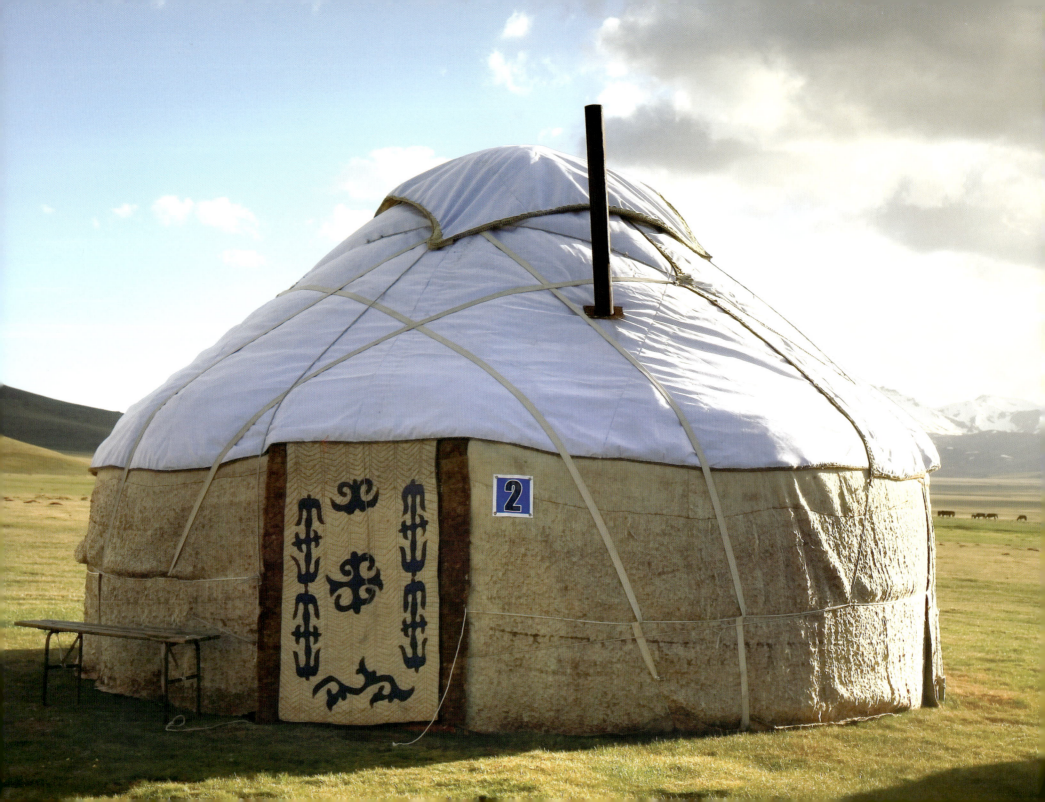

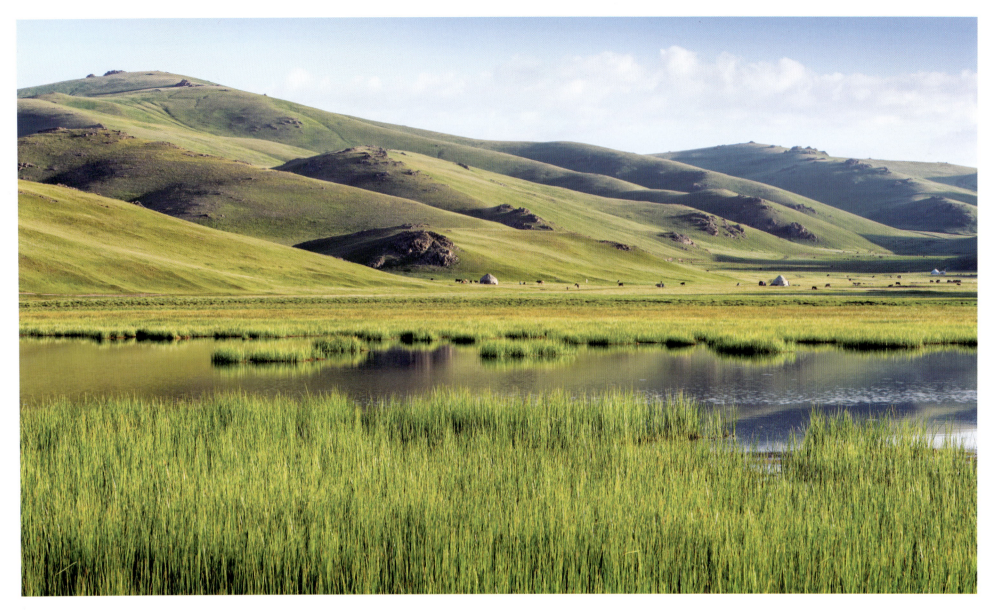

OPPOSITE:
Traditional yurt, Kyrgyzstan
Yurts have been used by the nomadic Kyrgyz for thousands of years. They are made by covering a frame of flexible branches or wooden poles with thick, waterproof sheep- or yak-wool felt. Today, many families open up their yurts as guesthouses for visitors.

ABOVE:
Nomadic camp, Song-Köl, Kyrgyzstan
The rolling green hills around Song-Köl have attracted the nomadic Kyrgyz people for centuries. Today, hundreds of traditional yurts dot the lush pastureland during the summer months, forming a temporary village that echoes life in generations past.

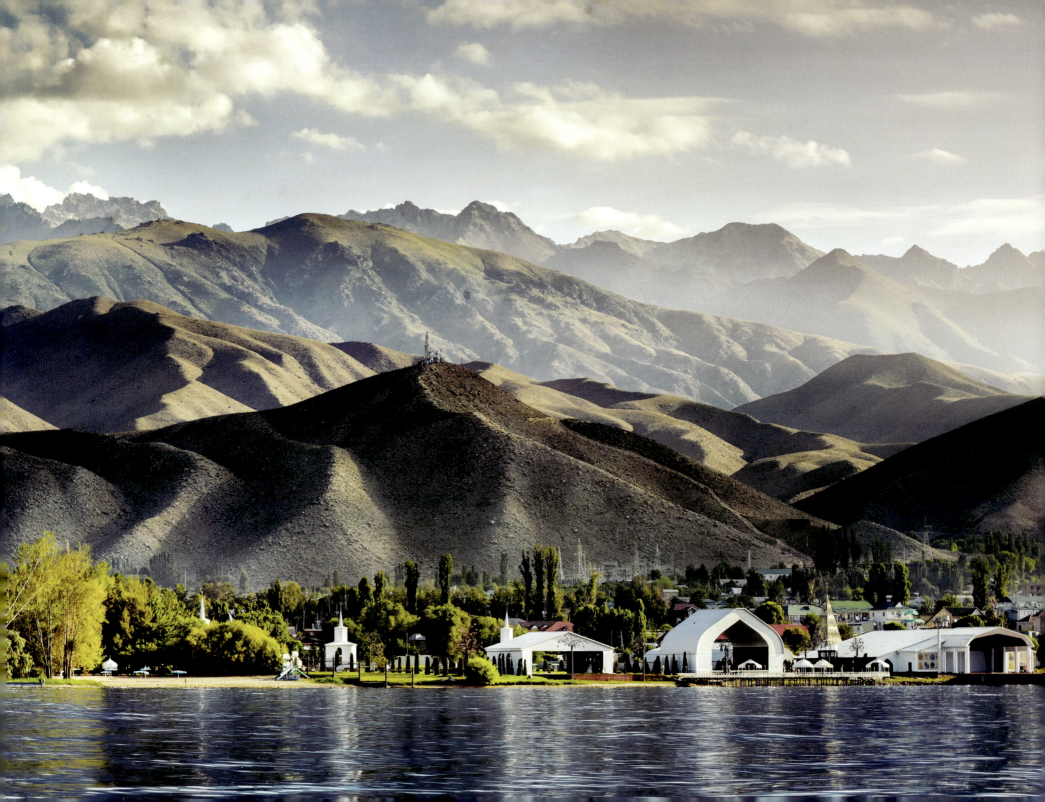

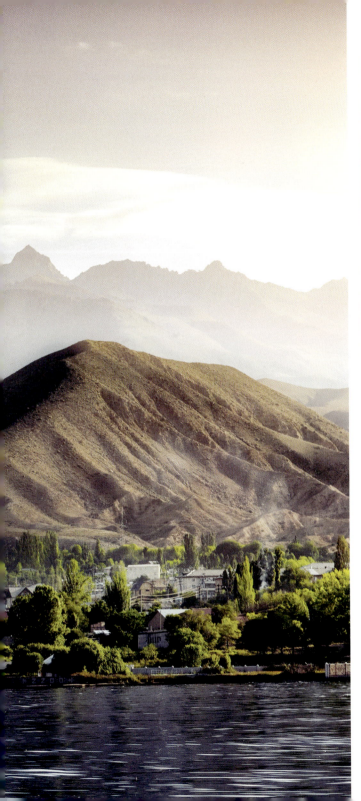

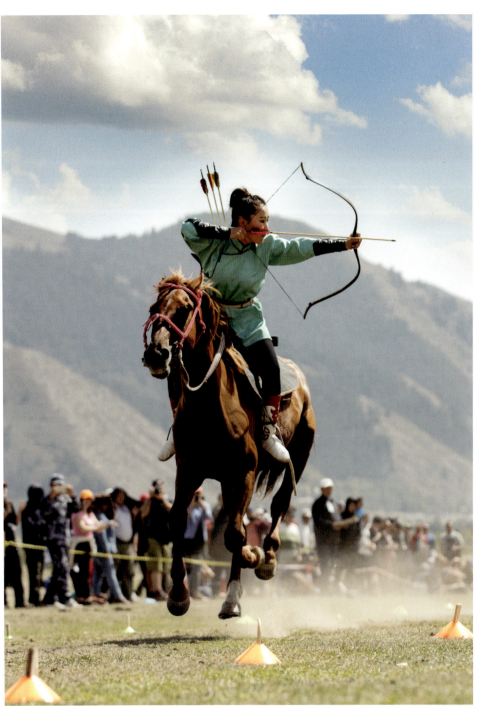

FAR LEFT:
Cholpon-Ata, Issyk-Kul Region, Kyrgyzstan
This resort town on the northern shore of Lake Issyk-Kul was founded in 1922 and became a popular spot for holidaymakers in the Soviet era. Today it has a population of around 15,000, and attracts local and foreign visitors.

LEFT:
World Nomad Games competitor, Cholpon-Ata, Kyrgyzstan
The first three World Nomad Games were held in Cholpon-Ata, in 2014, 2016, and 2018. The Games are dedicated to the ethnic sports practised in Central Asia, including horseback archery, hunting with falcons, and various folk wrestling styles.

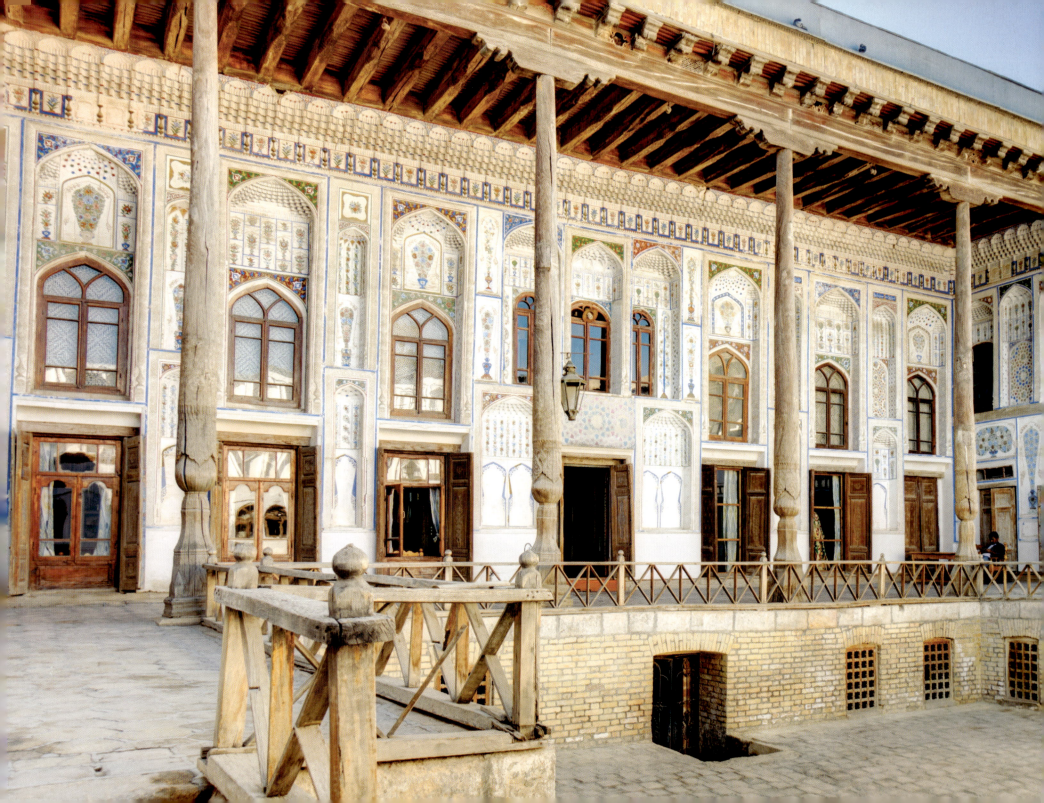

LEFT:

Fayzulla Khodzhaev House, Bukhara, Uzbekistan

This impressive house is the former family home of Fayzulla Khodzhaev, who plotted with the Bolsheviks to bring down the Emirate of Bukhara and became the first president of the Bukharan People's Soviet Republic. Covered in intricate frescoes and latticework, it is a glorious example of late nineteenth century Bukharan architecture.

RIGHT TOP:

Spices at the Central Bazaar, Bukhara, Uzbekistan

While travellers and traders in centuries past came by camel, today's visitors arrive by plane and train. But they still come to Bukhara's Silk Road markets for the same delights: gold and carpets, silver and silk. And, of course, spices – everything from cumin to cayenne and bay leaves to black pepper.

RIGHT BOTTOM:

Ceramic plates at a street market, Bukhara, Uzbekistan

Among the many crafts of Uzbekistan, pottery holds a special place in the nation's cultural heart. Artisans have made fine plates, bowls, teapots, cups, and vases for hundreds of years. Decoration is usually dazzlingly intricate, with different regions known for different colours, from azure to green and white.

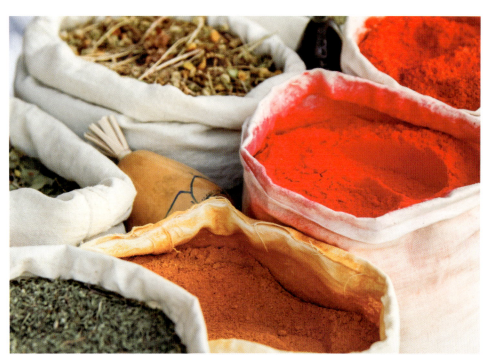

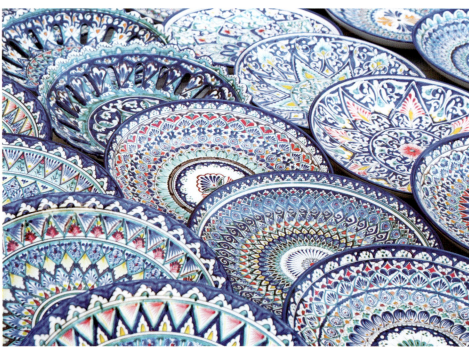

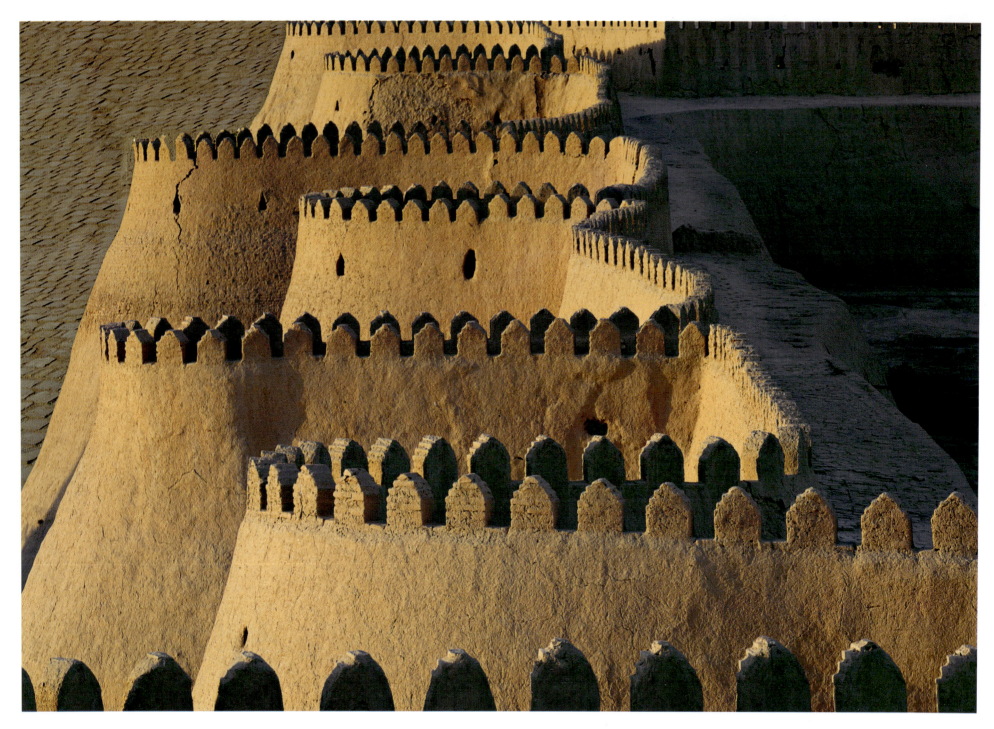

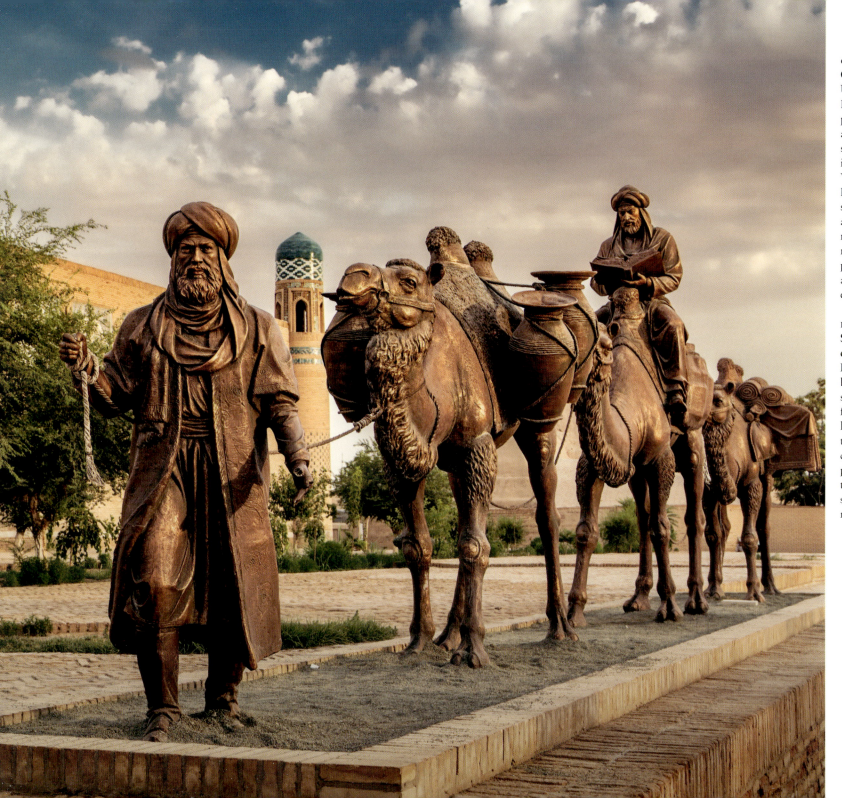

OPPOSITE:

City walls at Khiva, Uzbekistan
Khiva's old city walls, in places 10m (32ft) high and 5–6m (16–19ft) thick, surround the Itchan Kala, or inner fortress, a UNESCO World Heritage Site. Itchan Kala has a history that spans over two millennia, and although truly ancient ruins are scant, there are remarkable and well-preserved examples of Islamic architecture from the late eighteenth century.

LEFT:

Sculpture of an ancient caravan, Khiva, Uzbekistan
Bounded on the northeast by the Kyzylkum and the south by the Karakum deserts, for centuries Khiva was the last oasis before the crossing to Persia. Camel and mule caravans, as portrayed in this public sculpture outside the city walls of Khiva, stopped here to rest and replenish supplies.

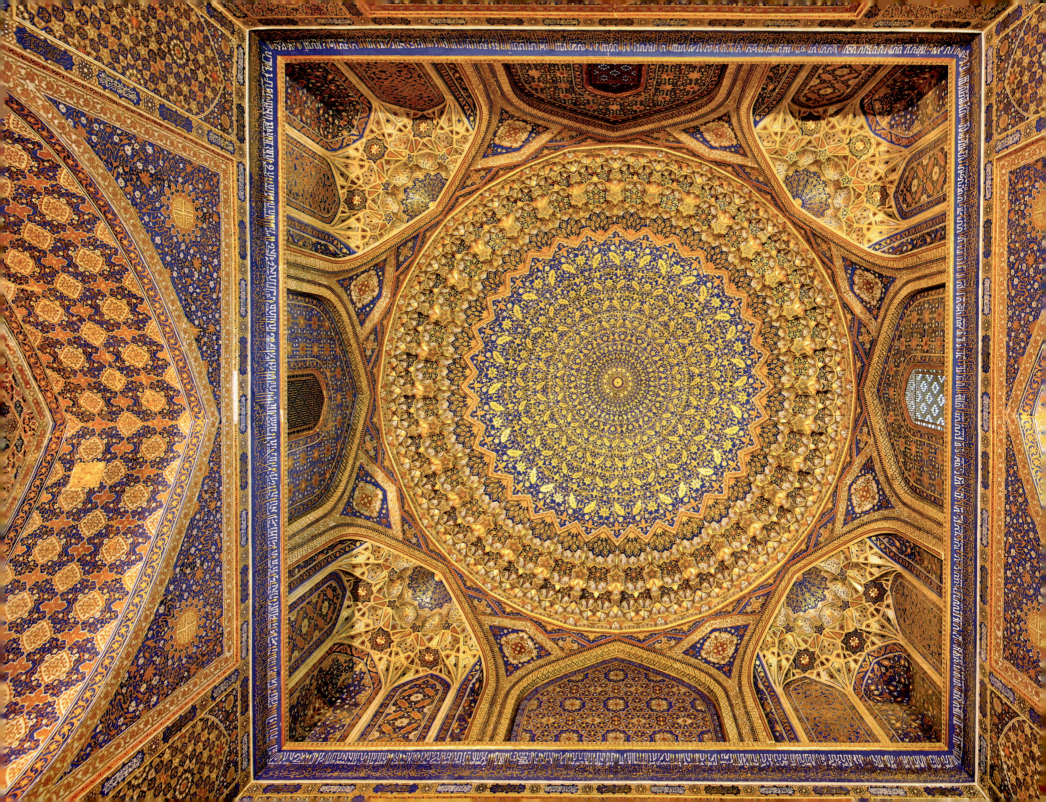

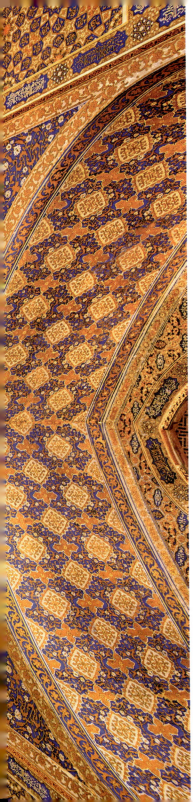

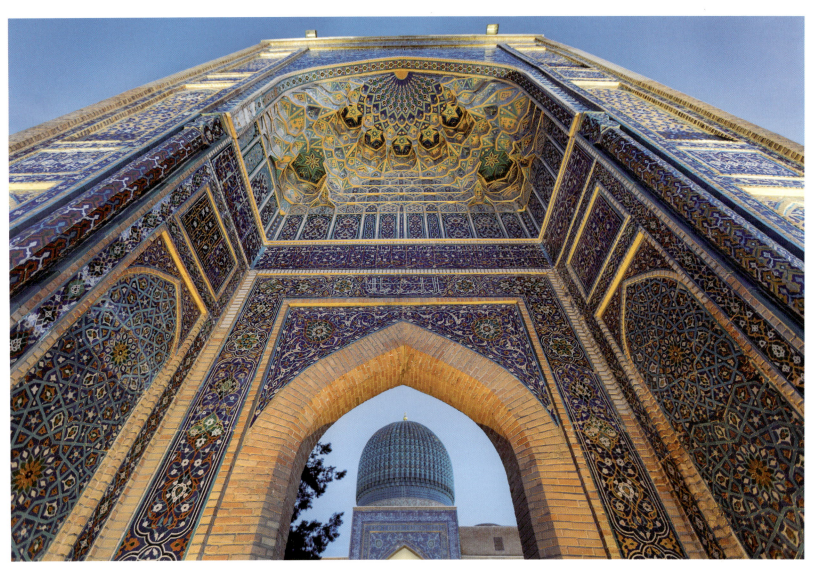

LEFT:
Bibi Khanym Mosque, Samarkand, Uzbekistan
In the fourteenth century, Samarkand was the capital of the Timurid Empire, and at the city's heart lay the Registan, its public square. Bibi Khanym Mosque, lying northeast of the square, was the jewel of the empire – one of the Islamic world's biggest mosques with domes that pushed architectural techniques at the time to the limit.

ABOVE:
Gur-e-Amir, Samarkand, Uzbekistan
The brick mausoleum known as Gur-e-Amir, meaning 'Tomb of the King' in Persian, is the resting place of the conqueror Timur, also known as Tamerlane. Dating to 1380, it is possibly Samarkand's oldest surviving monument and, with its azure fluted dome, is a precursor to later Mughal tombs such as the Taj Mahal in India.

RIGHT:
Public bus, Tashkent, Uzbekistan
Uzbekistan declared its independence from the Soviet Union in 1991, but reminders of its past remain. Soviet-era buses still ferry residents on the modern, multi-lane highways of the country's capital, Tashkent, and other major cities.

OPPOSITE:
Afrosiyob at the Samarkand railway station, Uzbekistan
The 600km (372 miles) high-speed rail connection from Tashkent to Bukhara, going via Samarkand, opened in 2011. Moving at 250km (155 miles) per hour, it more than halved the journey from its previous seven hours.

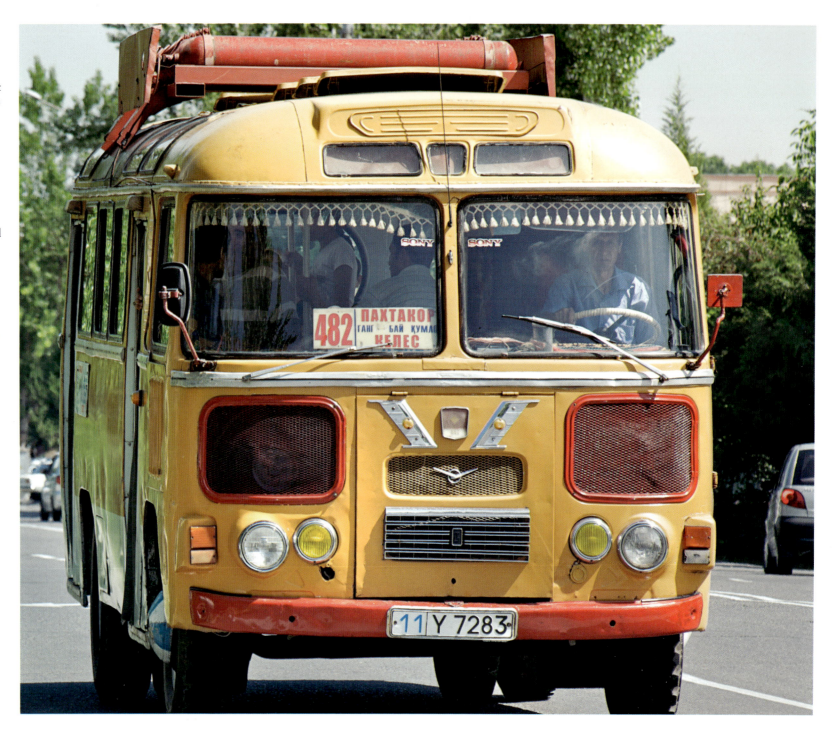

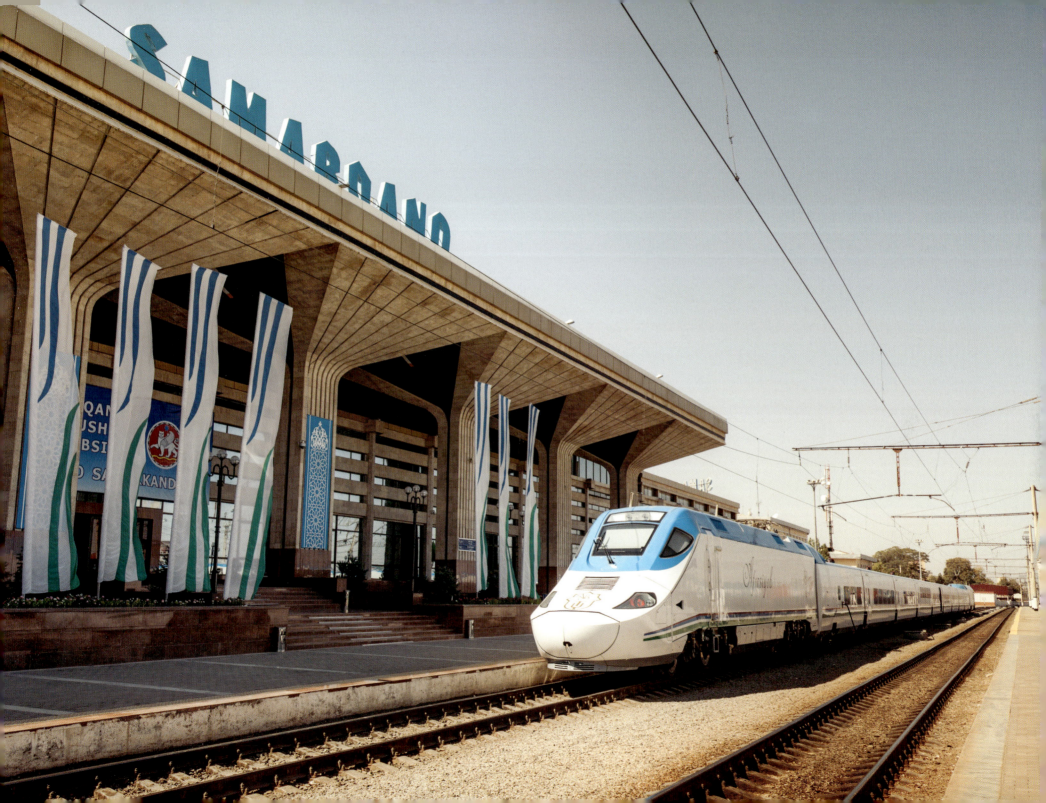

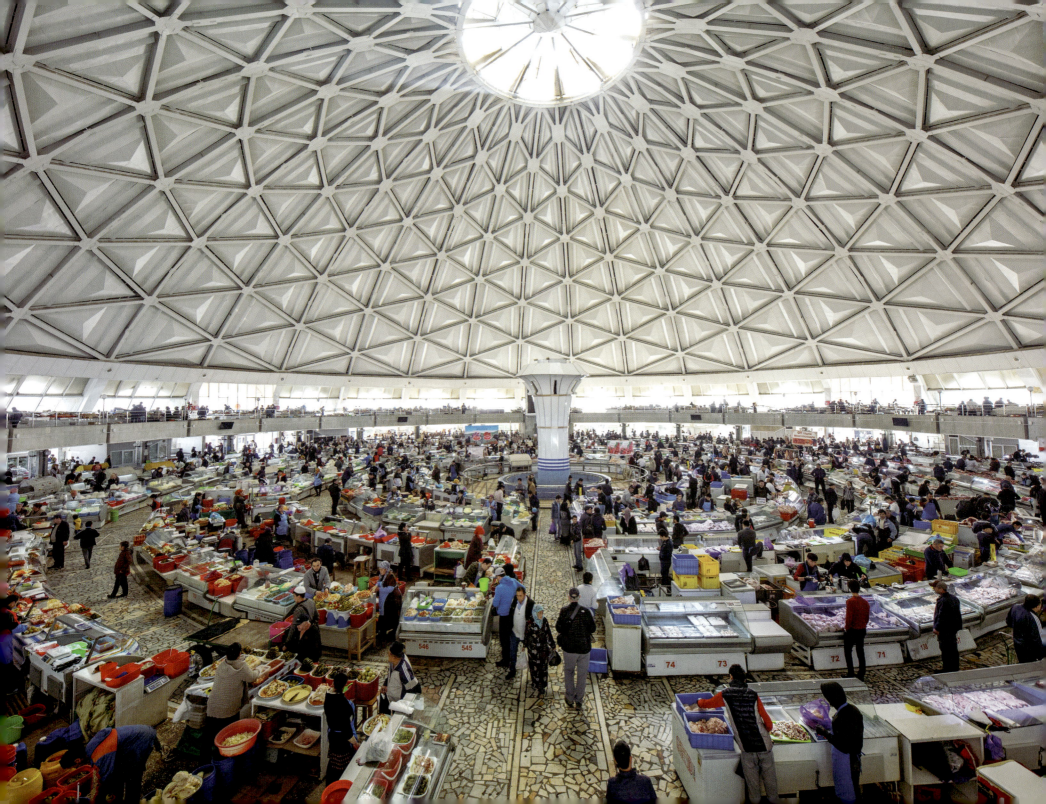

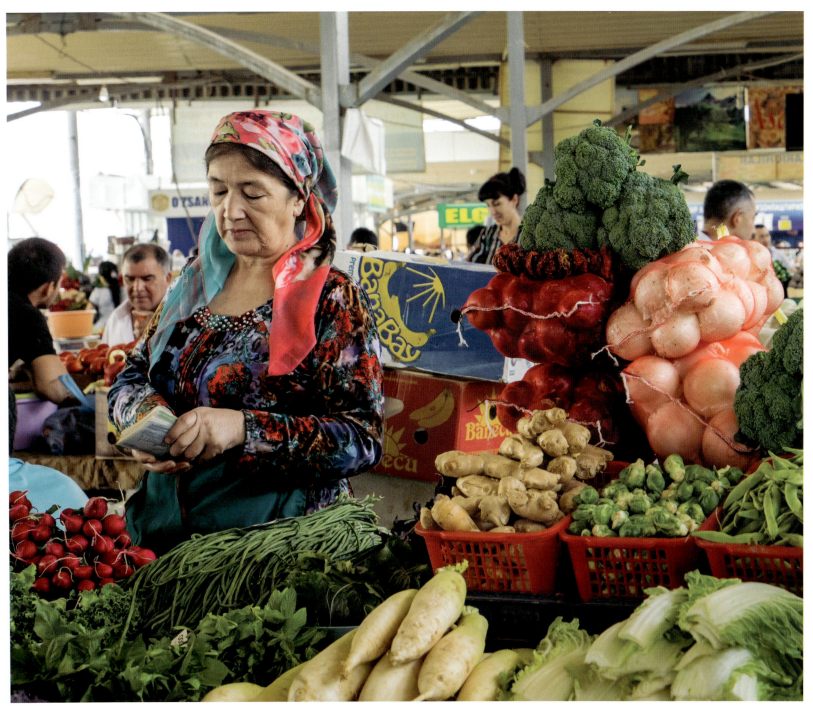

OPPOSITE:

Chorsu Bazaar, Tashkent, Uzbekistan
Located across the street from the Chorsu Metro station, this bazaar is Tashkent's most popular traditional market. Attracting locals and tourists alike, the bazaar offers hundreds of stalls selling everything from colourful *kurpacha* (sitting mattresses) to mountains of spices and sweets.

LEFT:

Vegetable seller, Chorsu Bazaar, Tashkent, Uzbekistan
Chorsu Bazaar is known for having the freshest bread, fruit, and vegetables in the city. Depending on the season, the market is overwhelmed with pomegranates and persimmons, onions and aubergines, along with, of course, Uzbekistan's famous melons.

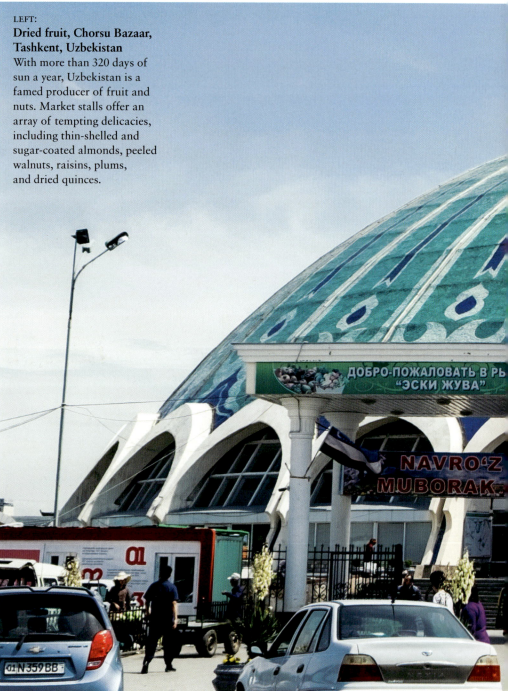

LEFT:

Dried fruit, Chorsu Bazaar, Tashkent, Uzbekistan
With more than 320 days of sun a year, Uzbekistan is a famed producer of fruit and nuts. Market stalls offer an array of tempting delicacies, including thin-shelled and sugar-coated almonds, peeled walnuts, raisins, plums, and dried quinces.

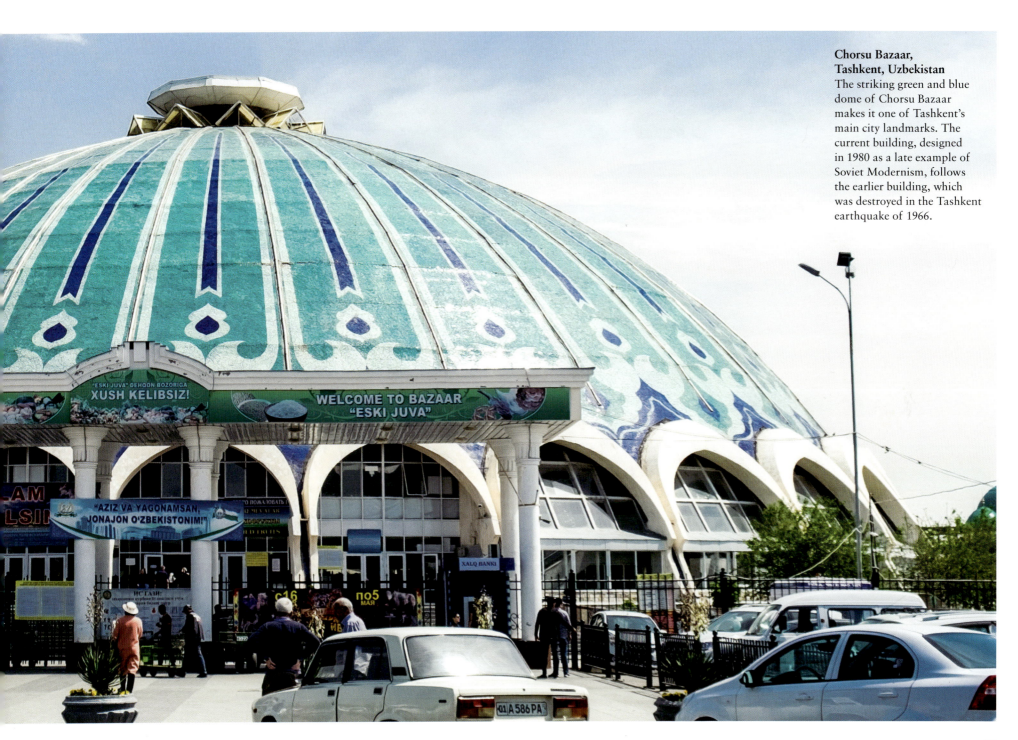

Chorsu Bazaar, Tashkent, Uzbekistan
The striking green and blue dome of Chorsu Bazaar makes it one of Tashkent's main city landmarks. The current building, designed in 1980 as a late example of Soviet Modernism, follows the earlier building, which was destroyed in the Tashkent earthquake of 1966.

Darvaza Gas Crater, Turkmenistan
Visible from miles away in the Karakum desert, this flaming crater known as 'The Door to Hell' is a collapsed natural gas field that was set alight in the 1980s to prevent poisonous gases from spreading. How the crater formed is still disputed, but it has become a major tourist site in Turkmenistan.

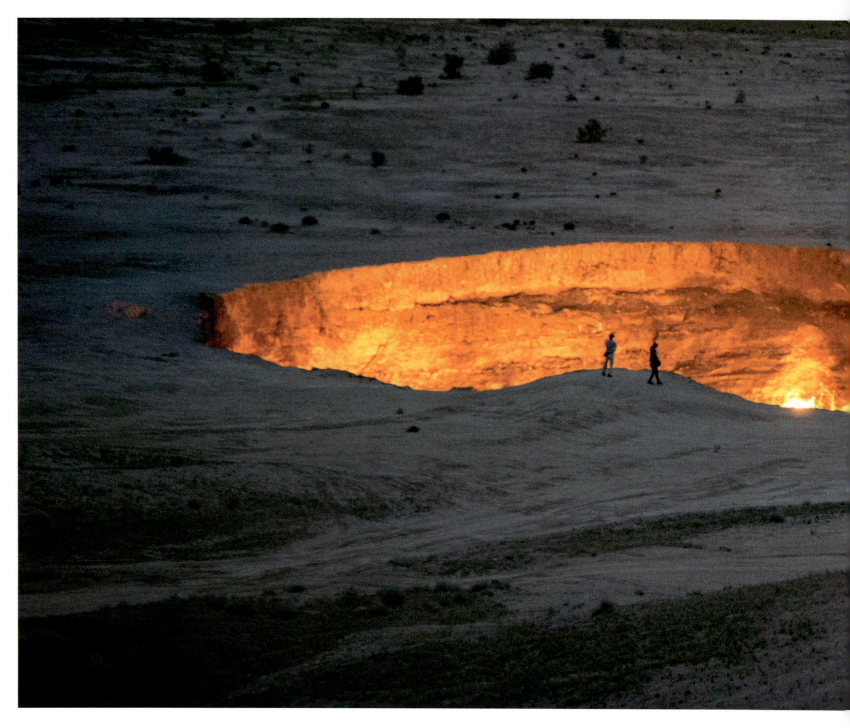

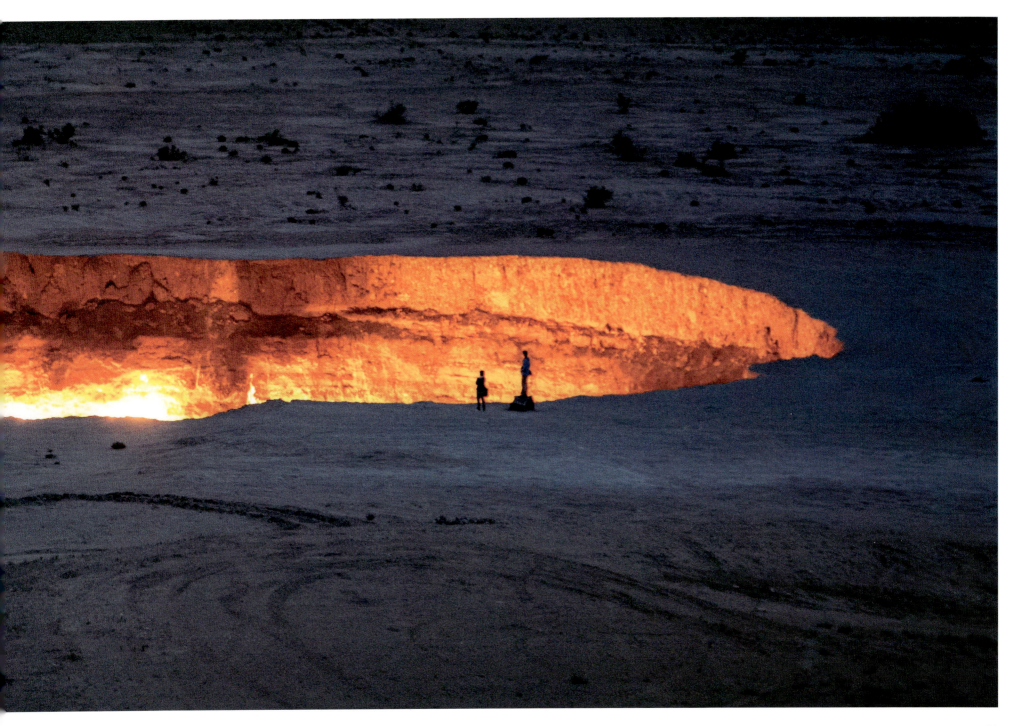

RIGHT:
Pamir Highway, Karakul, Tajikistan
Weaving through the Pamir Mountains of Afghanistan, Uzbekistan, Tajikistan, and Kyrgyzstan, the Pamir Highway, officially known as the M41, runs for more than 1200km (745 miles). In Tajikistan it passes by Karakul, a hypersaline lake located within an impact crater that is around 50km (31 miles) in diameter and at 4000m (13123ft) above sea level.

OPPOSITE:
Charyn Canyon, Kazakhstan
Kazakhstan's Grand Canyon, the 150–300m (492–984ft) deep split in the windswept steppe of southeastern Kazakhstan is a sight to behold. Over millions of years the Charyn River has worn the sedimentary red sandstone into fantastical shapes, leaving behind striped pillars of rock.

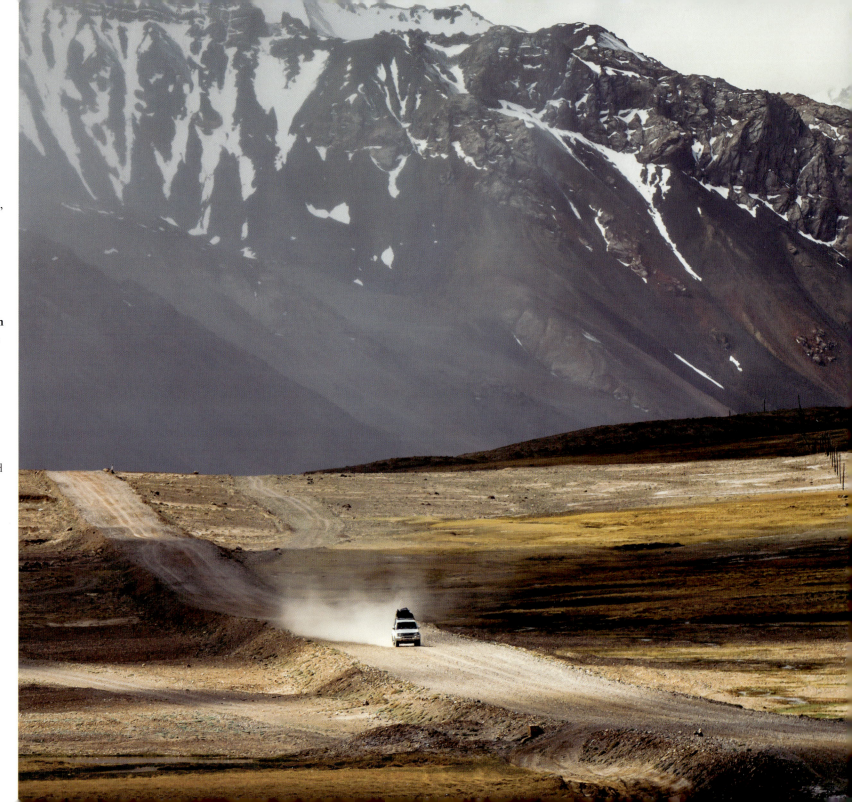

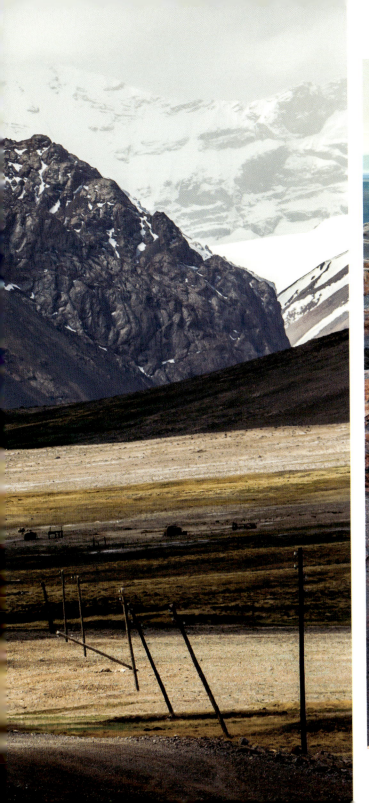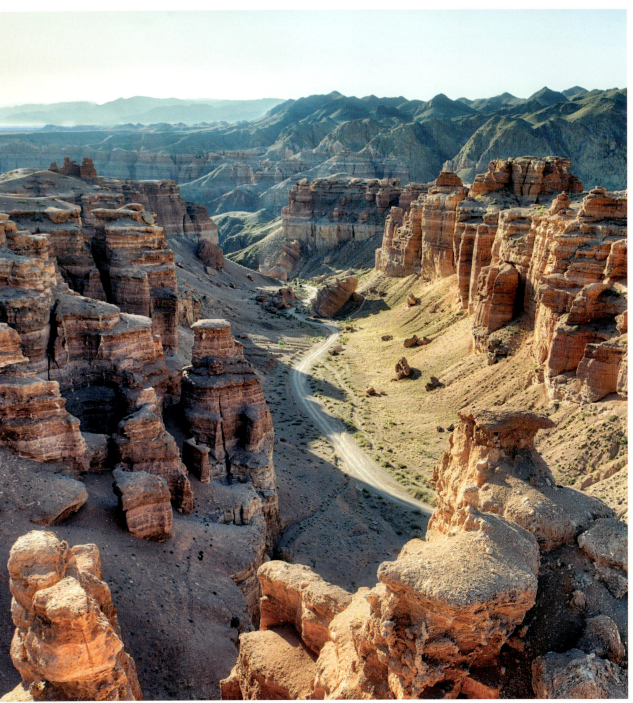

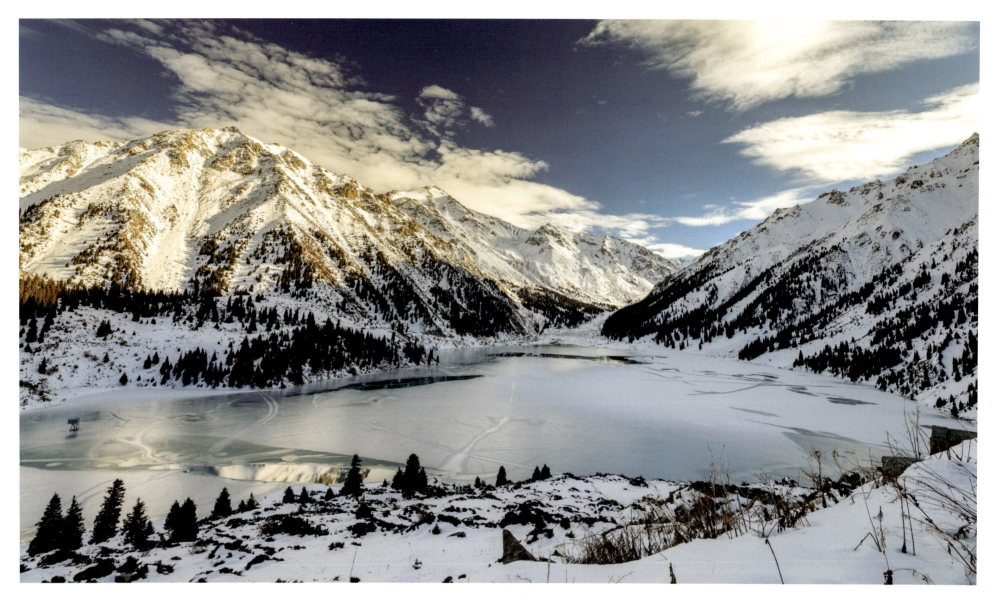

ABOVE:
Big Almaty Lake, Ile-Alatau National Park, Kazakhstan
Fed by melting glaciers, Big Almaty Lake is a natural alpine reserve that sits at 2511m (8238ft) above sea level in the Trans-Ili Alatau mountains of southern Kazakhstan. The lake, shaped like a chalice, is the major source of drinking water for Almaty, just 15km (9 miles) away.

OPPOSITE:
Shymbulak, Almaty, Kazakhstan
Just minutes' drive from Kazakhstan's largest city, Almaty, is Central Asia's biggest ski resort, Shymbulak. Located in the picturesque Trans-Ili Alatau mountains at an altitude of around 2200m (7217ft) above sea level, the ski resort offers 20km (12 miles) of skiing and snowboarding slopes.

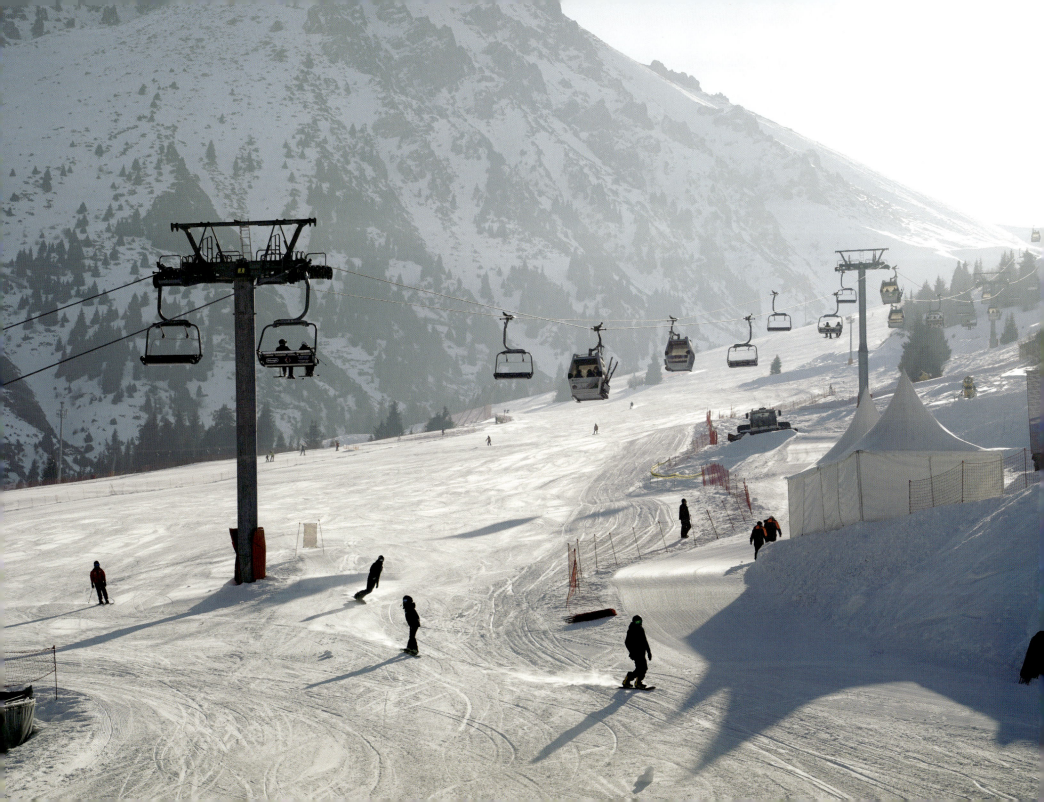

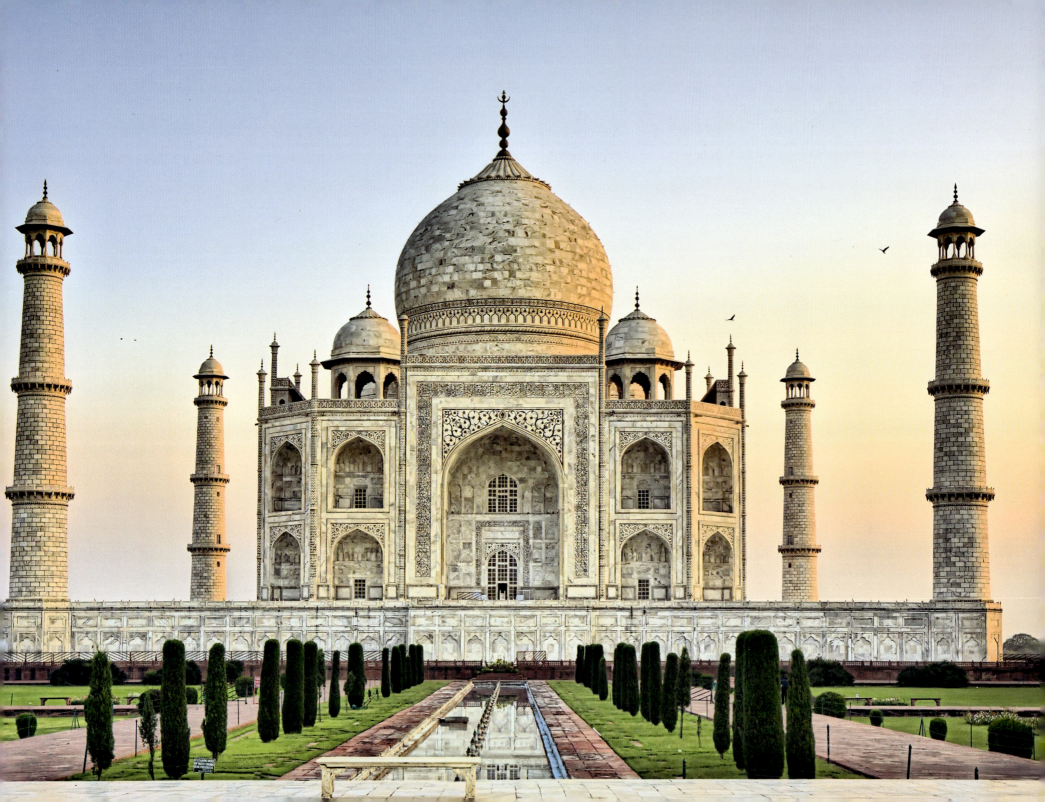

South Asia

An estimated 2 billion people now call South Asia home. The most densely populated region in the world also has within it the most densely populated country – India – along with a dizzying array of languages, cultures, religions and traditions that have evolved over millennia.

In the ebb and flow of history, including with South Asia's complex history of colonization, rulers have come and gone. But they have left behind some of South Asia's most captivating monuments, including that iconic symbol of India, the Taj Mahal, and the enchanting palace of Sigiriya, built on a granite column rising out of the forests of central Sri Lanka.

Religions continue to have a profound impact on the cultures of South Asia. Hinduism, Buddhism, Islam, Sikhism, Jainism, and Christianity have been practised for centuries, if not millennia, and sites such as the Tiger's Nest in Bhutan and Pashupatinath Temple in Nepal are testament to the deep spiritual devotion of many communities.

Geography here is equally diverse, ranging from the world's highest peak, Mount Everest, and the jaw-dropping splendour of the full Himalayan range to the fertile plains of the Ganges river, and the tropical coastlines of the Indian Ocean.

While the region has its challenges, including inequality, poverty, and environmental pressure, it also has some of the world's fastest-growing economies with a firm vision of uplifting its people. An exercise in contrasts, South Asia is a thrilling, at times baffling, kaleidoscope of colour and energy.

OPPOSITE:
Taj Mahal, Agra, India
The iconic Taj Mahal is perhaps the world's greatest monument to love. Commissioned by Shah Jahan in 1631 to be the final resting place of his beloved wife, Mumtaz Mahal, who had died in childbirth, it also houses the tomb of the Mughal emperor himself.

ALL PHOTOGRAPHS:
Taj Mahal, Agra, India
Considered a jewel of Islamic art and a symbol of India, the Taj Mahal combines the design traditions of Indo-Islamic and Mughal architecture. Considered one of the world's most beautiful buildings, it is made of white marble and inlaid with semi-precious gems including deep red carnelian, emerald green jade, and royal blue lapis lazuli.

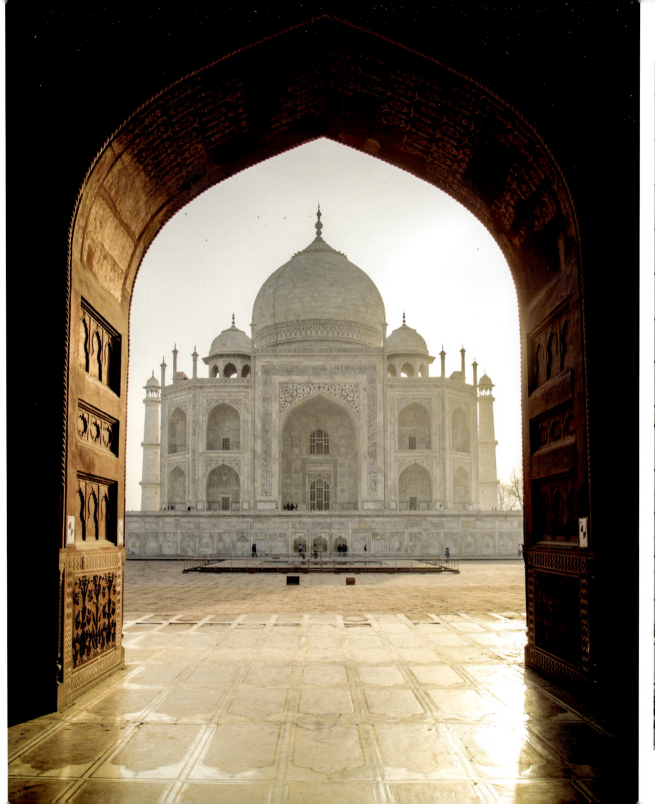

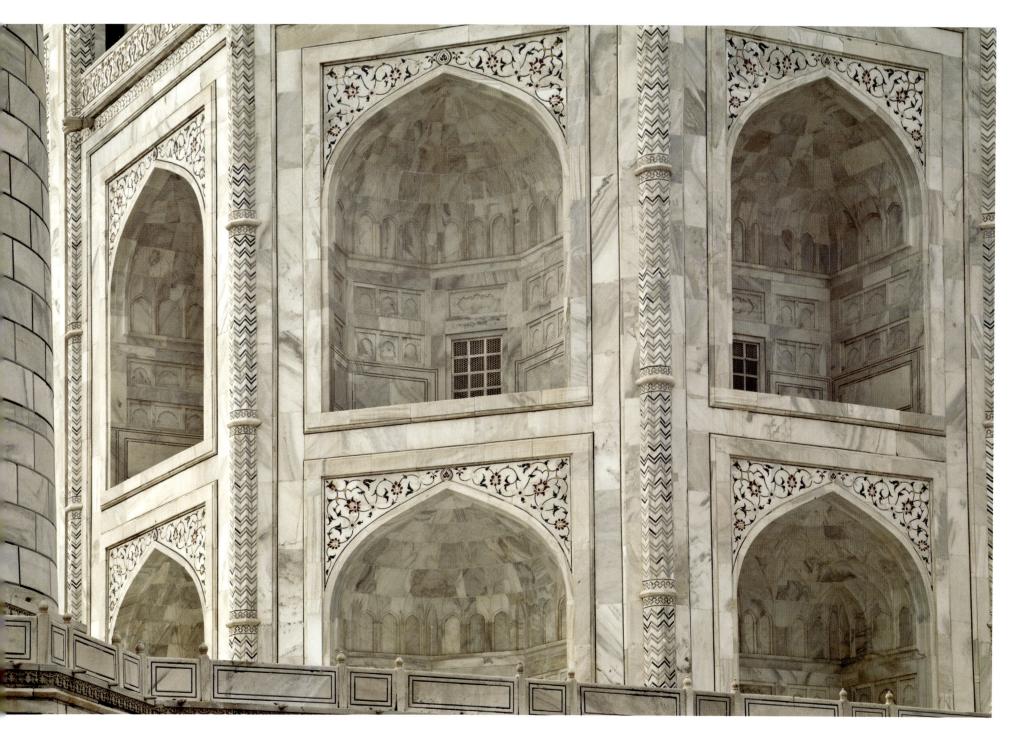

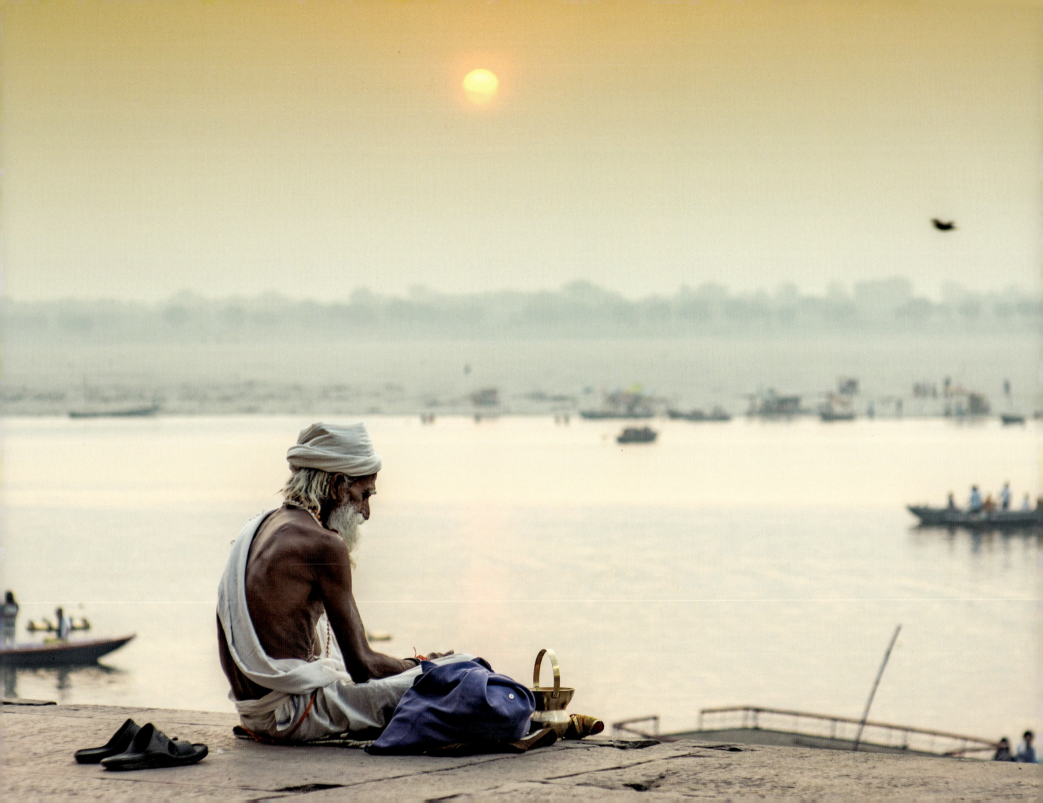

LEFT:
The Ganges, Varanasi, India
Worshipped as the goddess Ganga, the Ganges is the most sacred river to Hindus. The river gains further spiritual significance as it flows through the holy city of Varanasi, where it attracts religious devotees (sadhus), who have renounced earthly desires and who meditate and lead prayers on its banks.

RIGHT:
Life on the Ganges, Varanasi, India
Varanasi is one of the world's oldest continuously inhabited cities, and the waters of the Ganges that flows to the east of the settlement have supported life here for thousands of years. The city is known worldwide for its many *ghats*, steps leading down to the water, where pilgrims perform rituals.

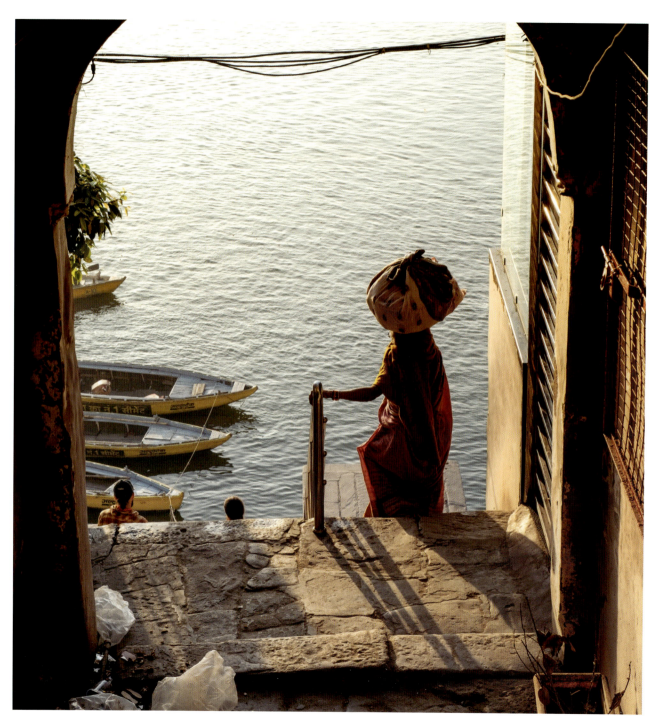

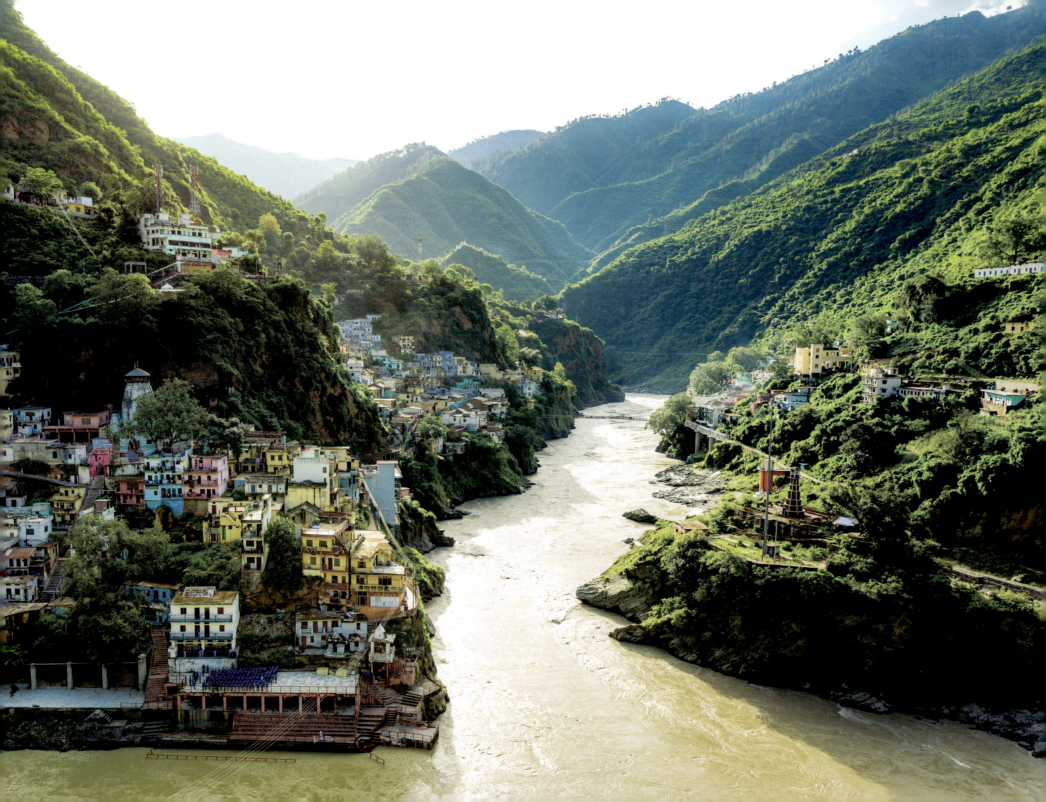

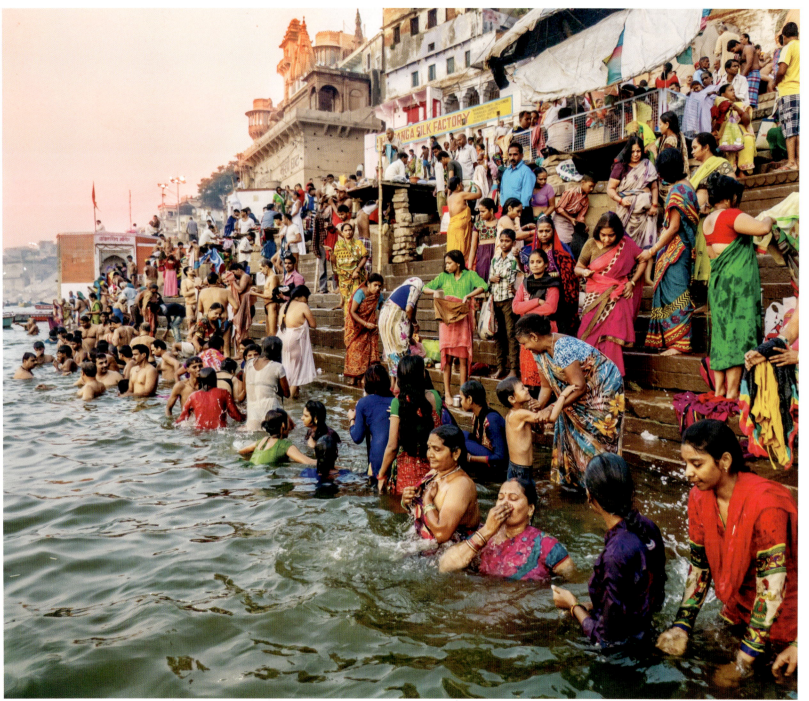

OPPOSITE:

Devprayag, Uttarakhand, India
The confluence of the Alaknanda and Bhagirathi rivers is considered the beginning of the main stem of the Ganges river. 'Devprayag' means 'Godly Confluence' in Sanskrit and the site is an important place of pilgrimage for devout Hindus.

LEFT:

Varanasi, India
Pilgrims come from all over India and beyond to wash away sins in the sacred waters of the Ganges. The city is also known for its cremation *ghats*, where ashes are scattered in the waters. To die in Varanasi, Hindus believe, means liberation from the cycle of rebirth.

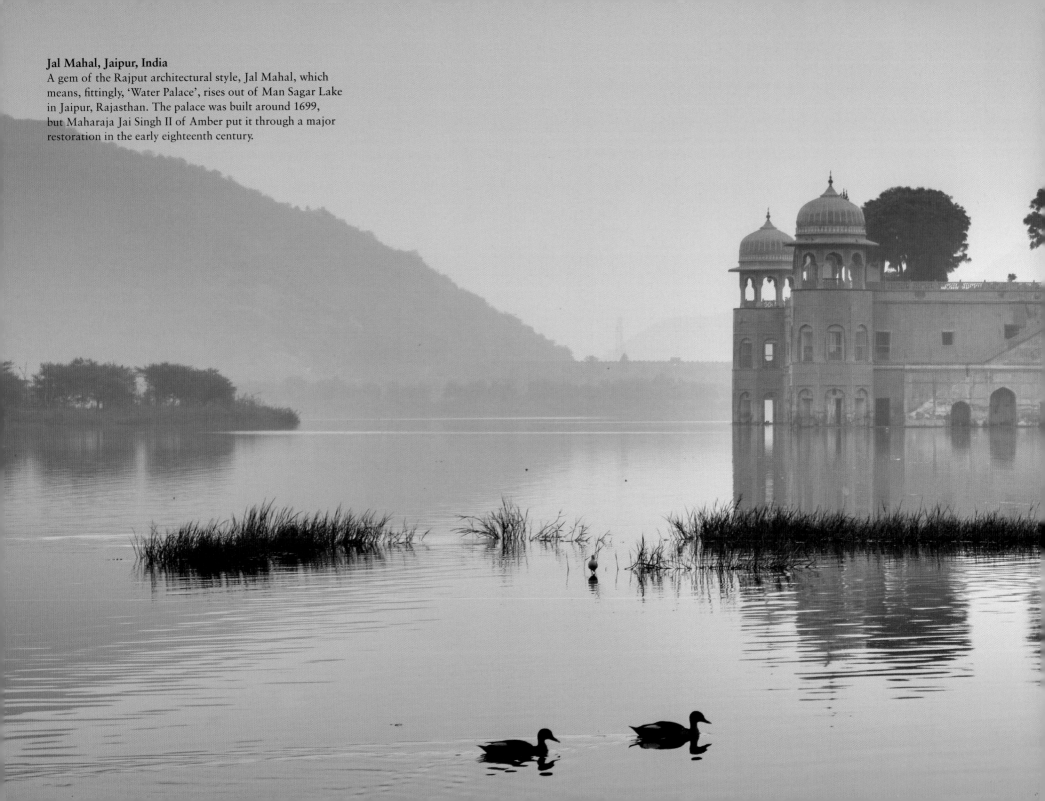

Jal Mahal, Jaipur, India
A gem of the Rajput architectural style, Jal Mahal, which means, fittingly, 'Water Palace', rises out of Man Sagar Lake in Jaipur, Rajasthan. The palace was built around 1699, but Maharaja Jai Singh II of Amber put it through a major restoration in the early eighteenth century.

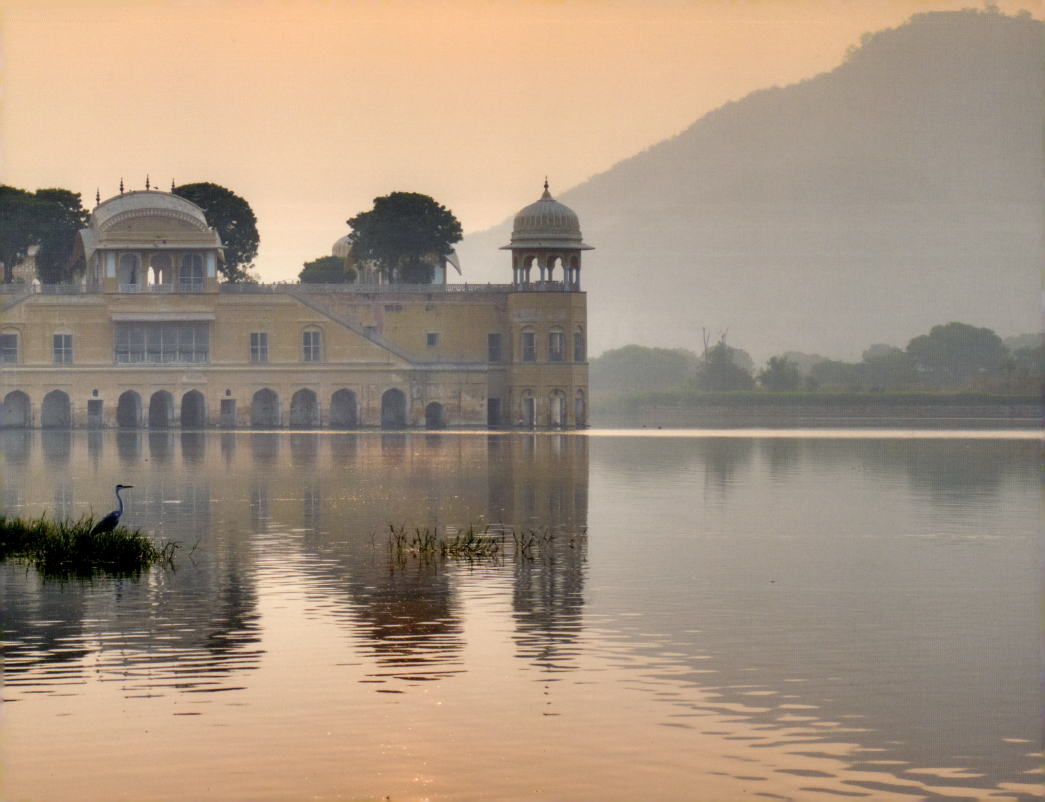

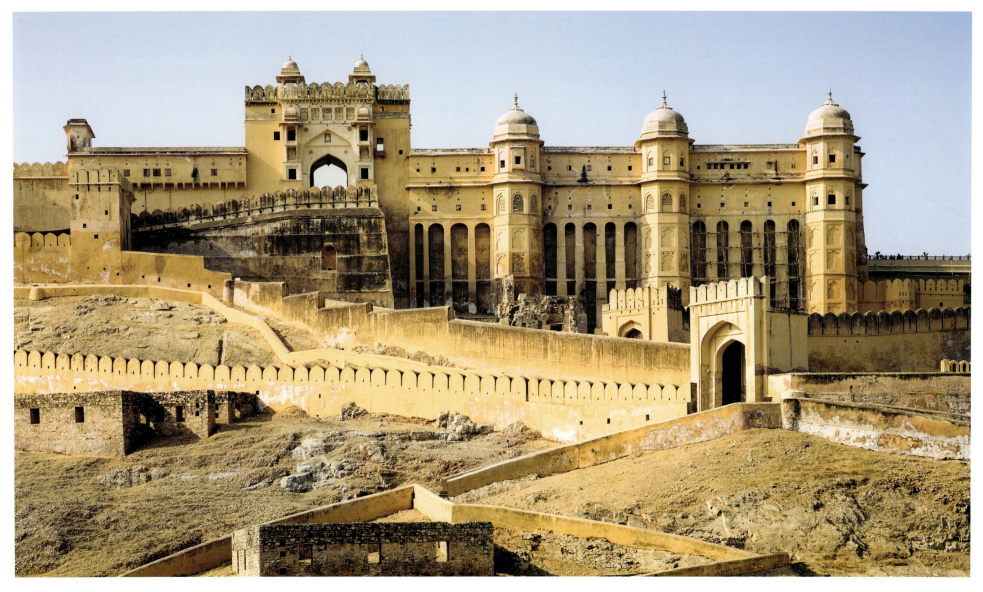

ABOVE:
Amer Fort, Jaipur, India
A must-see on any visit to Jaipur, the splendid Amer (or Amber) Fort, which dates back to 1592, is located on a hill about 10km (6.2 miles) from Rajasthan's capital. Walking its cobbled streets that wind through a series of imposing gates, one can almost hear whispers of the lives that once played out within the palace's imposing ramparts.

OPPOSITE:
Sheesh Mahal at Amer Fort, Jaipur, India
Almost every surface inside the Amer Fort is decorated with highly detailed designs, from stylised botanical engravings and reliefs to symmetrically patterned tilework. Sheesh Mahal ('Palace of Mirrors'), one of the four main courtyards in the fort, features an intricately patterned mirrorwork ceiling.

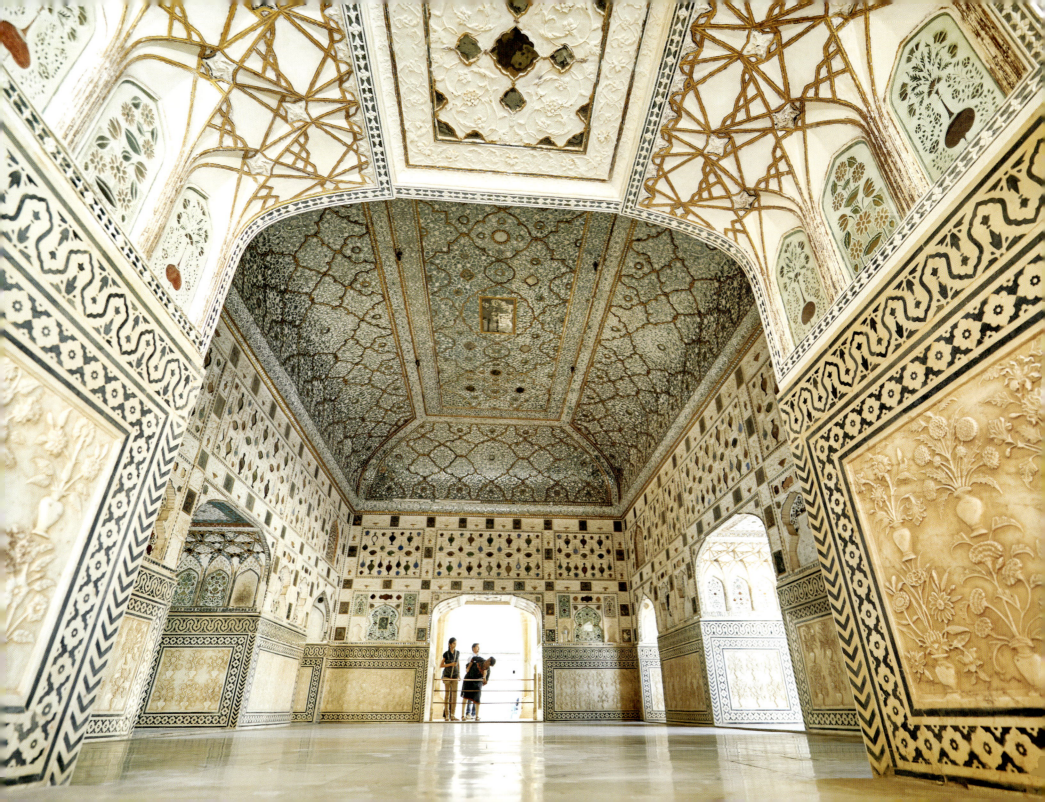

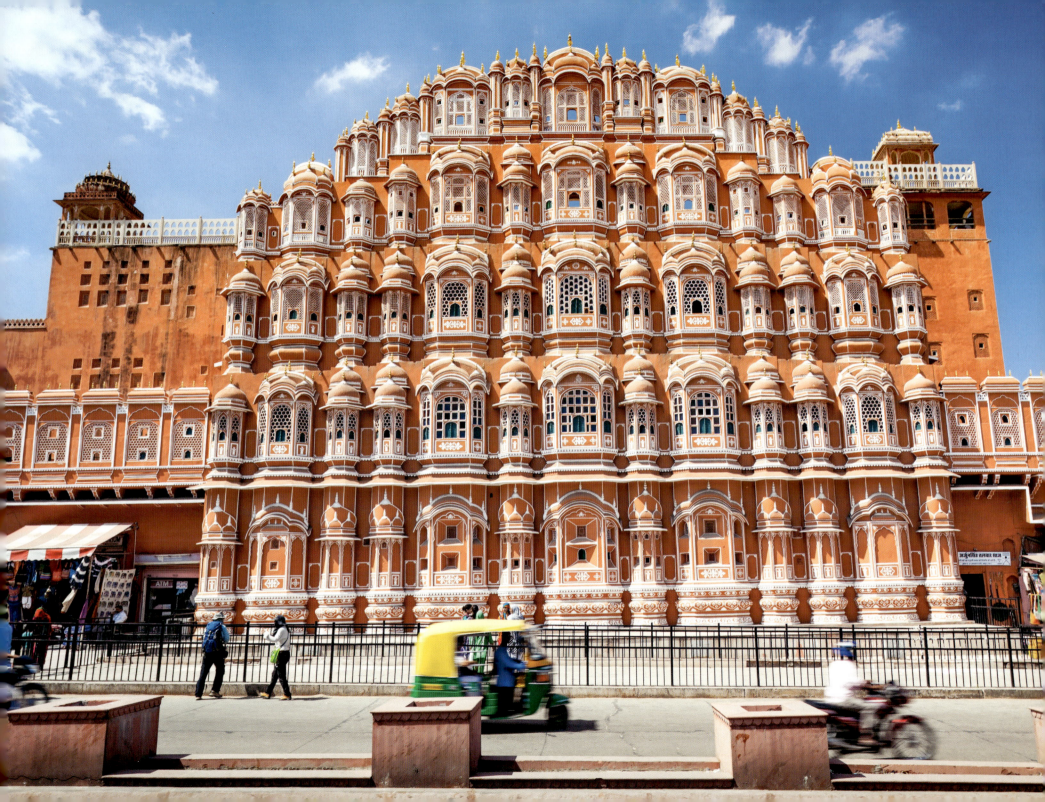

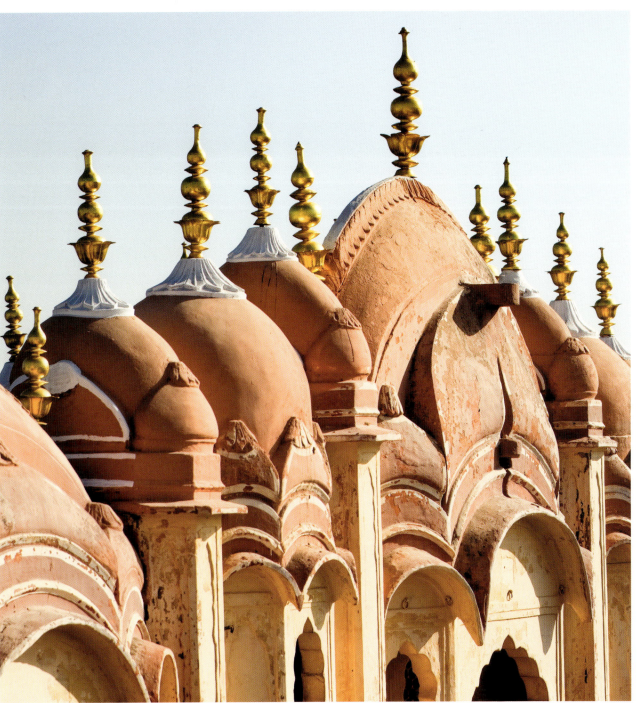

OPPOSITE AND LEFT:
Hawa Mahal, Jaipur, India
Famously known as the 'Palace of the Winds', Hawa Mahal was built by Maharaja Sawai Pratap Singh in 1799. The intricate latticework in the *jharokhas* (overhanging enclosed balconies) allowed the royal women, who lived in seclusion, to observe life on the street below without themselves being seen. This architectural feature also allowed cool air to flow through the palace during Rajasthan's hot summers.

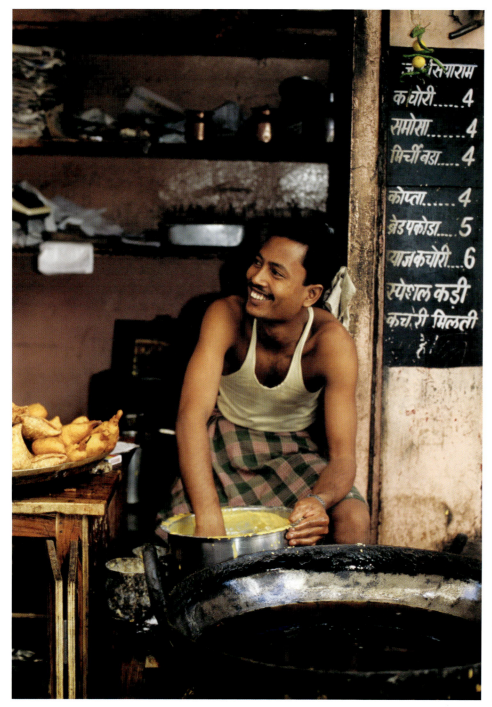
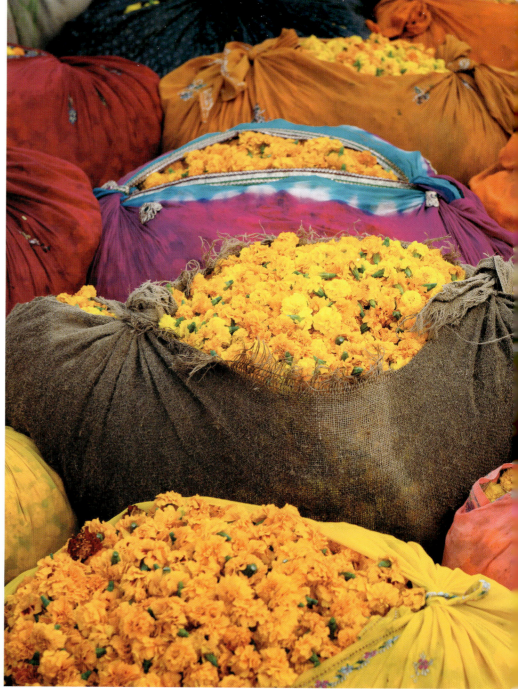

OPPOSITE:
Café in Jaipur, India
Jaipur, and Rajasthan more generally, is known for its street food snacks. Vegetable samosas and *pyaaz kachori* (pastry with spiced onion stuffing served with tamarind chutney) are particularly popular.

FAR LEFT:
Flowers at the Phool Mandi, Jaipur, India
Jaipur's wholesale flower market opens at dawn, when farmers from the surrounding villages bring their sacks bursting with roses and marigolds to sell. The flowers will end up strung into bright garlands used as offerings in temples, offices, and homes.

LEFT:
City Palace, Jaipur, India
Jaipur became known as 'The Pink City' after 1876, when Maharaja Ram Singh had most of the buildings painted pink, the traditional colour of hospitality, in advance of a visit by Queen Victoria's son, Albert Edward, then Prince of Wales. The terracotta-pink shade still dominates many buildings in the city.

Palolem Beach, Goa, India
One of the most picture-perfect beaches in Goa, Palolem is a wide curve of golden sand lined by rustic timber and bamboo beach restaurants and bars tucked among the coconut palms. The water is calm, so ideal for swimming but also sea kayaking, paddleboarding, and even scuba diving.

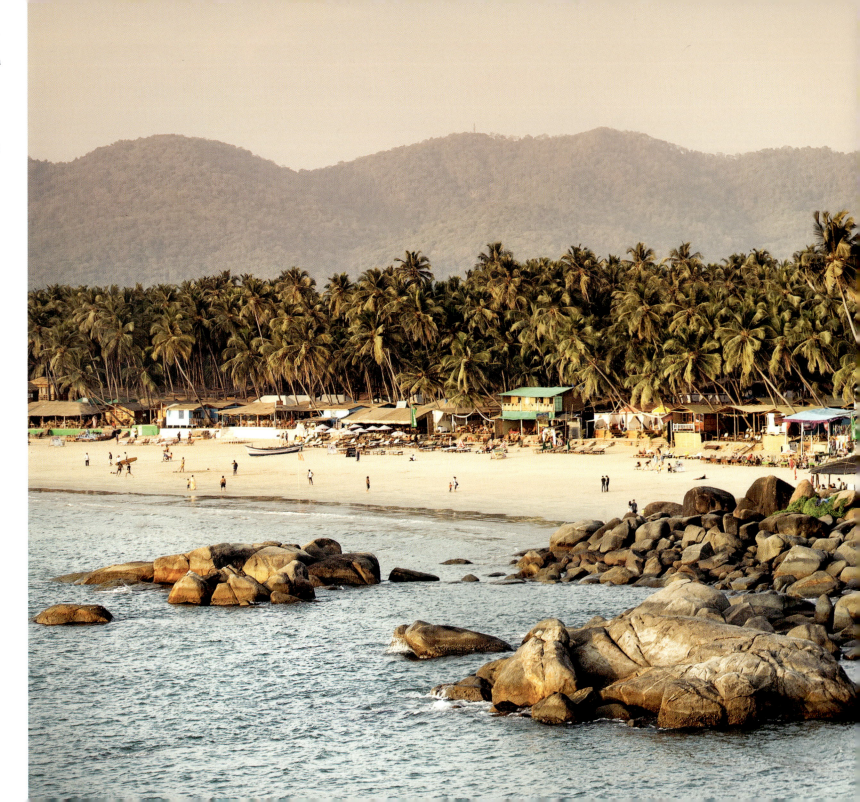

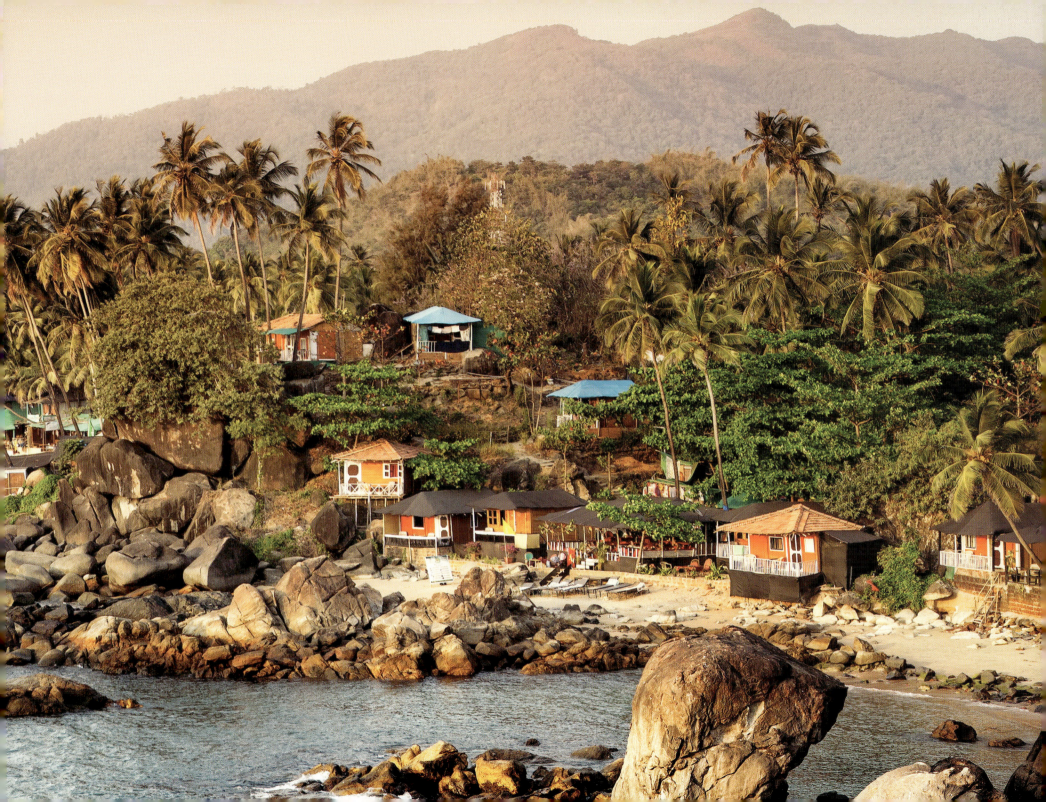

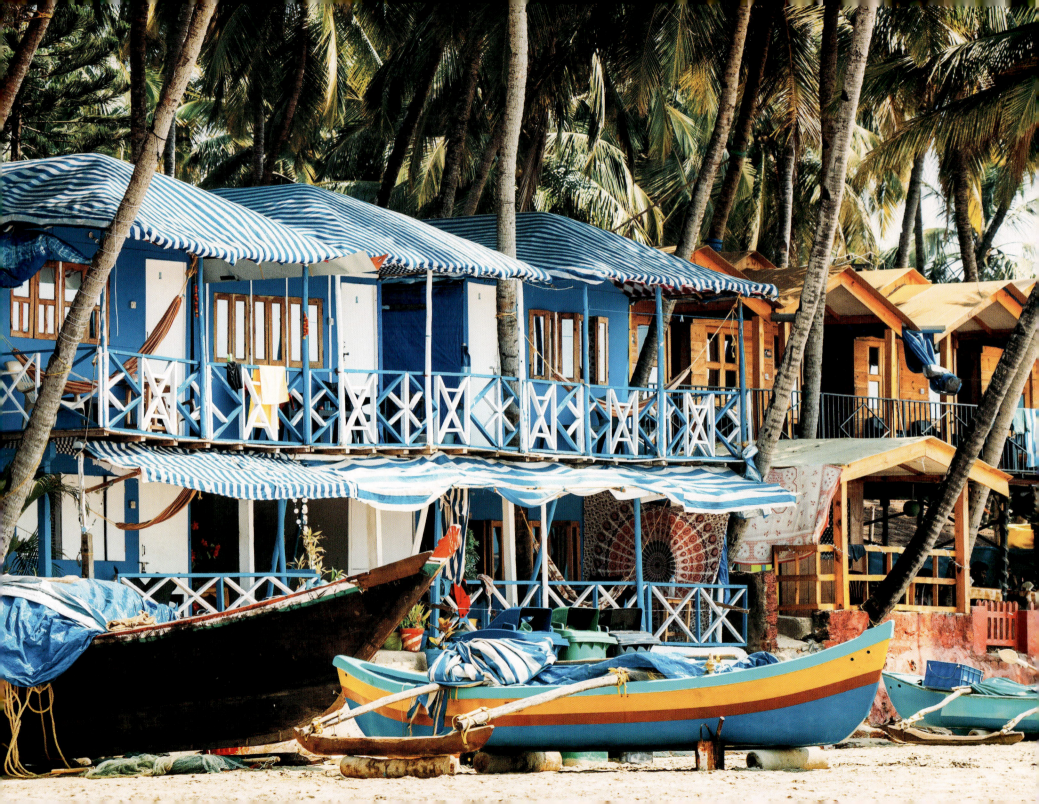

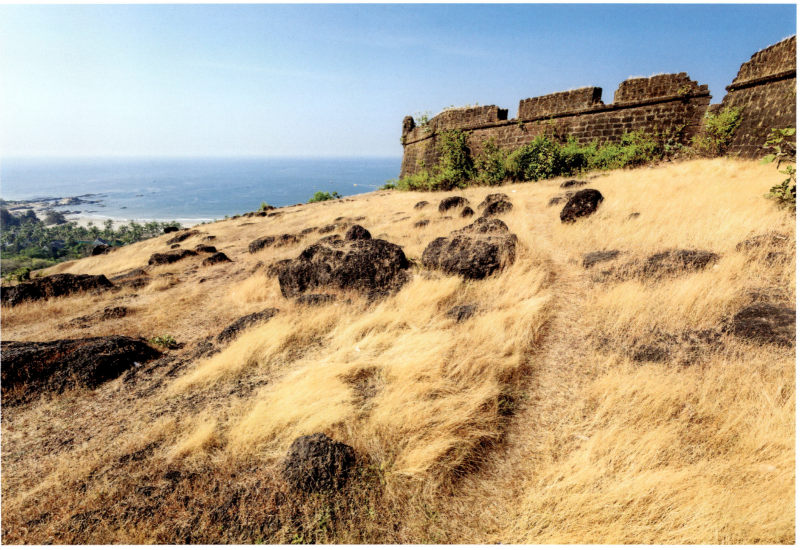

LEFT:
Guesthouses on Palolem Beach, Goa, India
Mainly during the winter season from November to March, Palolem attracts international visitors seeking a dose of sunshine who stay in the colourful guesthouses. The beach has retained its charm, with fishermen continuing their traditions as in decades past, and is largely unspoiled.

ABOVE:
Chapora Fort, Goa, India
The red laterite bastion was built in 1617 by the Portuguese as a border watchpost. Constructed on the site of an earlier Muslim structure, it once contained a church dedicated to Saint Anthony, although no traces today remain. After falling to Hindu raiders in the seventeenth century, it was deserted by the Portuguese in 1892.

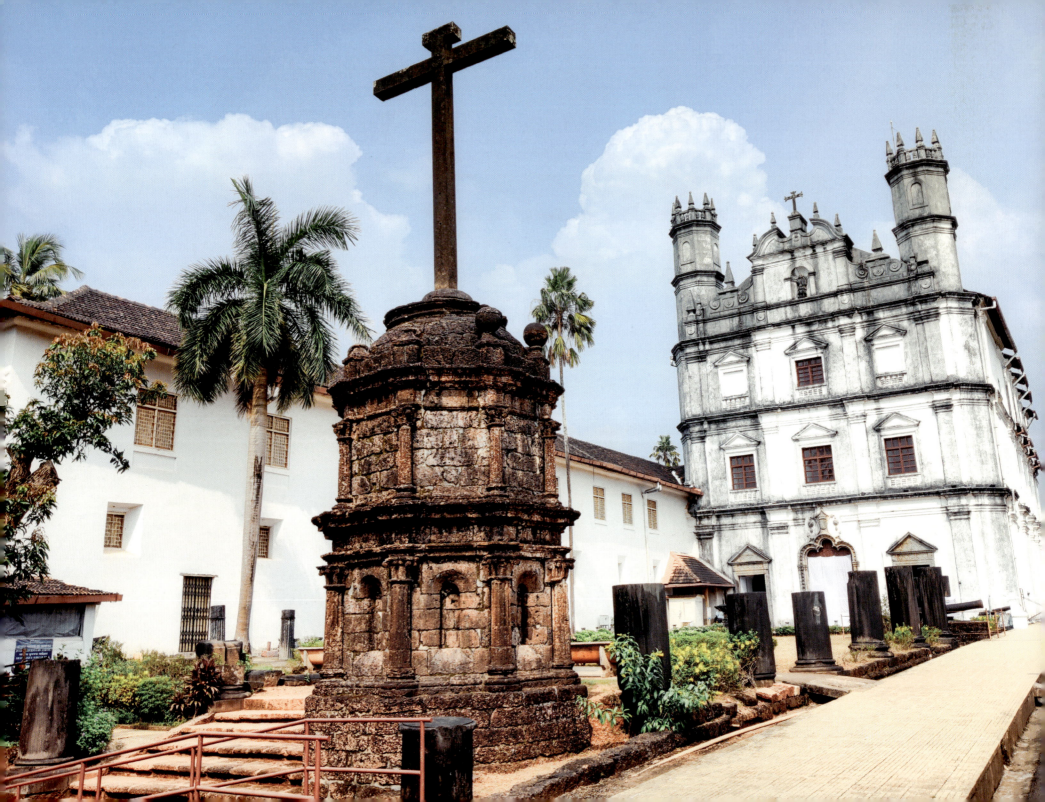

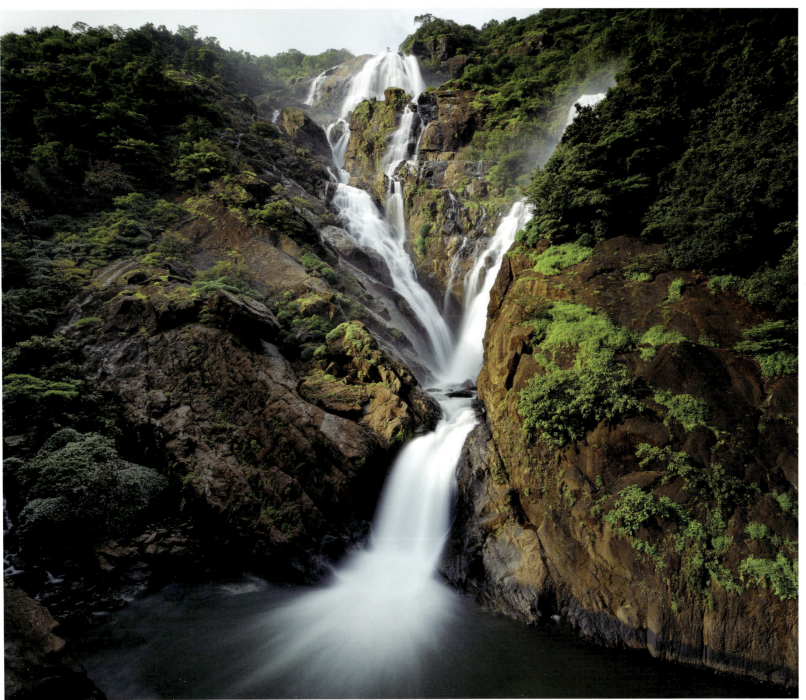

OPPOSITE:
Church of Saint Francis of Assisi, Goa, India
This Roman Catholic church located in the main square of Old Goa was established by eight Portuguese Franciscan friars who landed in Goa in 1517. At first just a small chapel, it was consecrated as a church in 1602. The present building was constructed in 1661.

LEFT:
Dudhsagar Waterfall, Goa, India
It is during the monsoon season when the rains are heaviest that this waterfall in the Western Ghats lives up to its name: Dudhsagar, which means 'Sea of Milk'. Then the falls are at their fullest and form torrents of white water tumbling down the 600m (1968ft) drop.

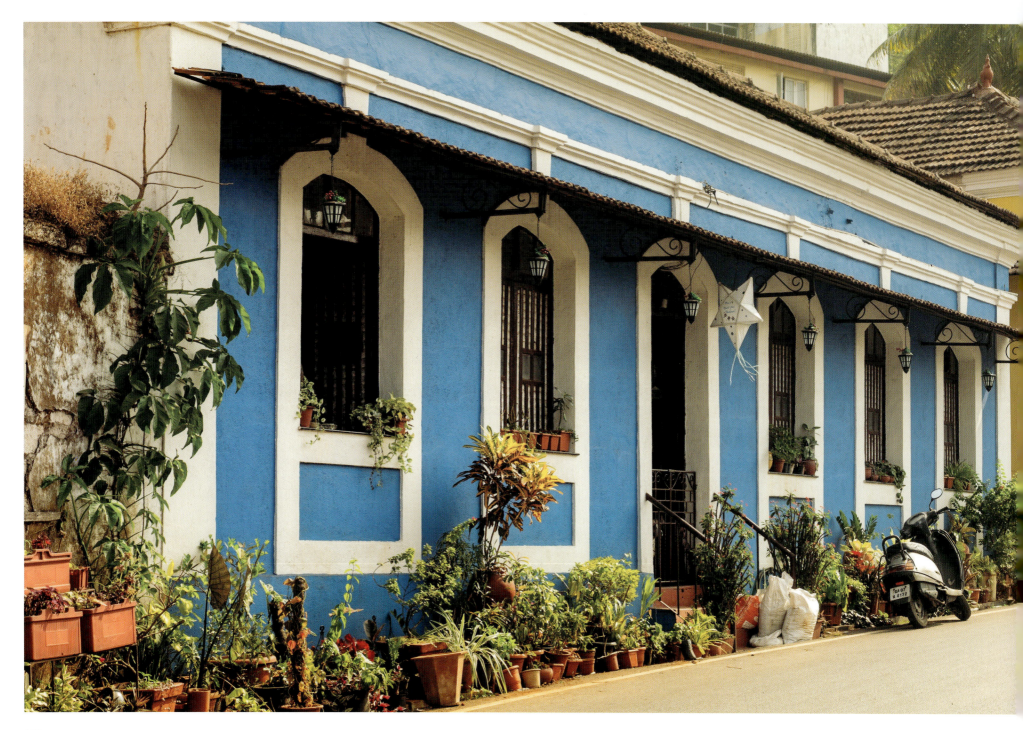

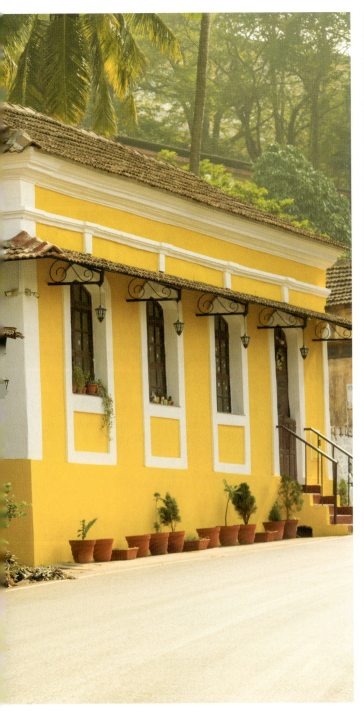

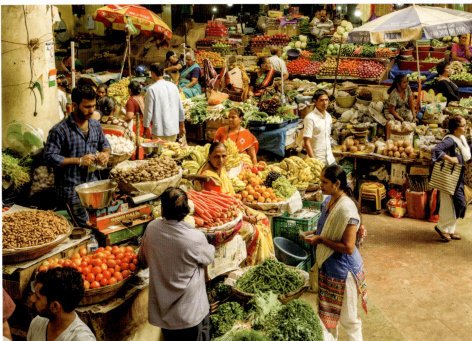

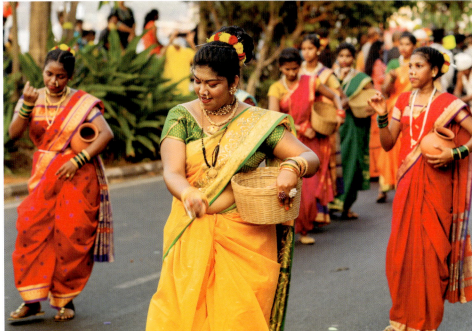

FAR LEFT:

Fontainhas, Panaji, Goa, India

The Old Latin Quarter of Panaji (also known as Panjim), which is the capital city of the state of Goa, retains its traditional European heritage in its beautiful Portuguese Baroque style buildings and enchanting, often brightly painted old villas, which line picturesque winding streets.

LEFT TOP:

Fresh produce market, Panaji, Goa, India

Tightly crammed with everything from fresh fruits and vegetables to street food stalls and traditional Goan handicrafts, Panjim Market offers a glimpse into the daily life and culture of Goa. Locals and tourists alike come here for the affordable prices and lively atmosphere.

LEFT BOTTOM:

Carnival celebrations in Panaji, Goa, India

It may be much smaller than the world-famous Rio Carnival or the Portuguese Carnival of Madeira, but Goa's Carnival is easily as colourful. It is also the largest in India, and one of the few traditional celebrations of the Western Christian holiday to be found in Asia.

RIGHT:
Statue of Sir Pherozeshah Mehta, Mumbai, India
Known as 'The Lion of Bombay', Sir Pherozeshah Mehta was an Indian lawyer and politician during the time of the British Empire who advocated for social and political reform. His statue was erected in 1923 in front of Mumbai's famed railway station, Chhatrapati Shivaji Maharaj Terminus, a UNESCO World Heritage Site.

OPPOSITE:
Gateway of India, Mumbai, India
The foundation stone for this iconic arch-monument on the Mumbai waterfront was laid in 1911 to commemorate the landing of King George V and Queen Mary on their visit to India the same year. Designed in Indo-Saracenic style and made of basalt, it was completed in 1924.

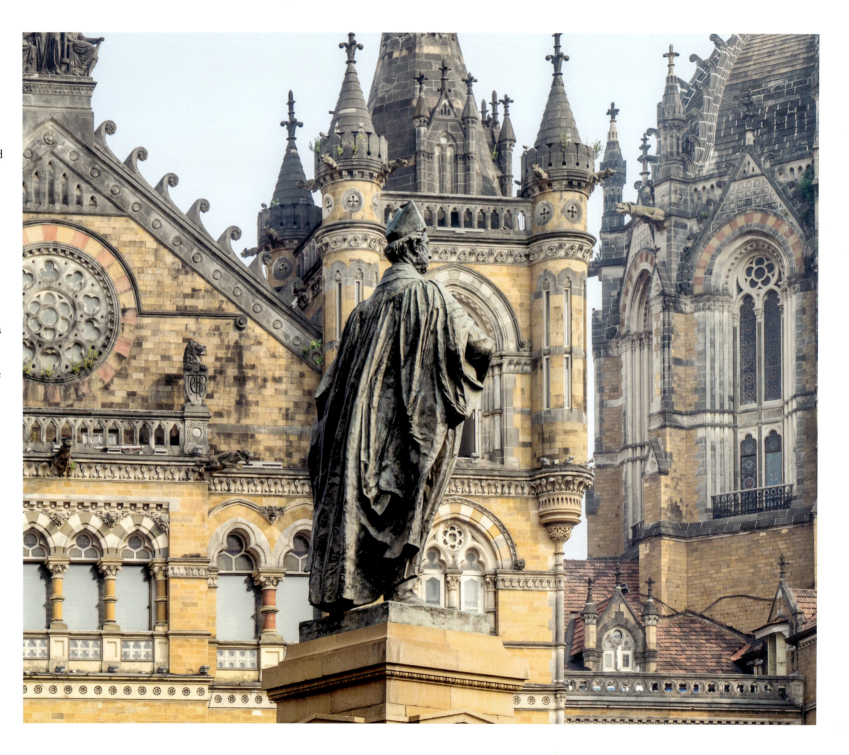

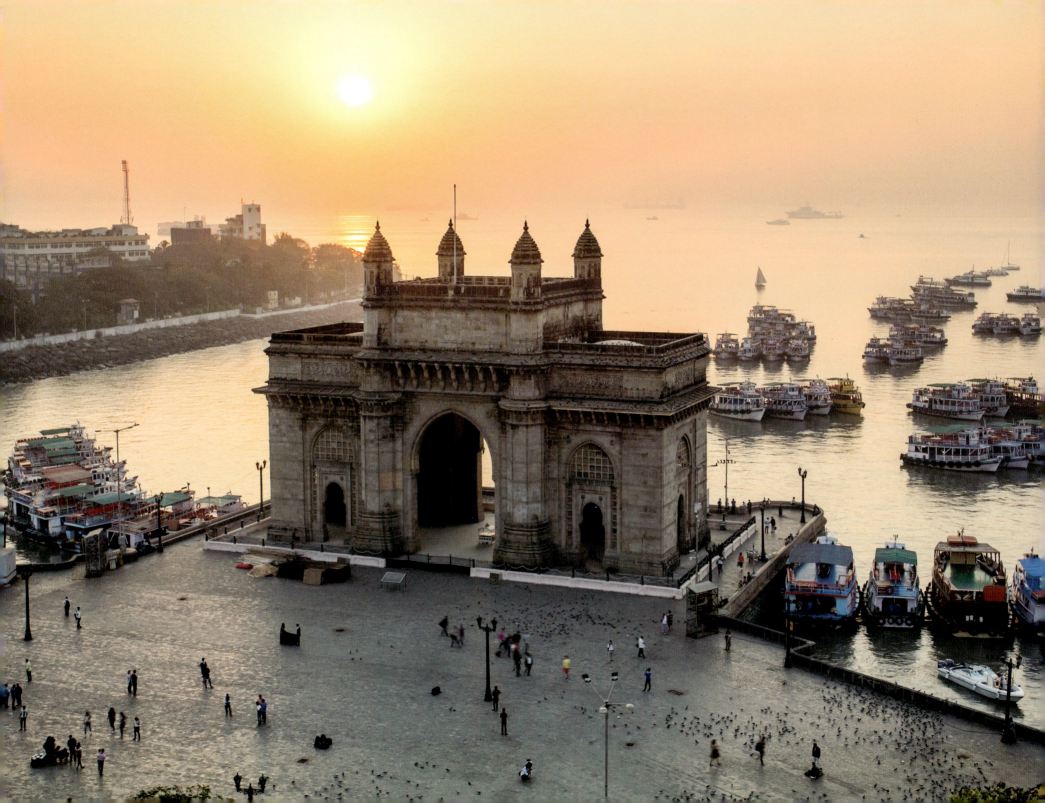

RIGHT AND OPPOSITE:
Global Vipassana Pagoda, Mumbai, India
Built to honour the Buddha and spread the philosophy of vipassana, this almost-100m (328ft) tall pagoda in acres of lush greenery north of Mumbai was inaugurated in 2009. Under the 85m (278ft) diameter dome is a meditation hall that can seat 8000. The pagoda houses original bone relics of the Buddha, which were donated by the Sri Lankan government and the Mahabodhi Society of India. The gold paint on the pagoda was donated by Thailand, while Myanmar donated the marble flooring and the umbrella on top of the pagoda. The construction was mainly funded through donations from devotees.

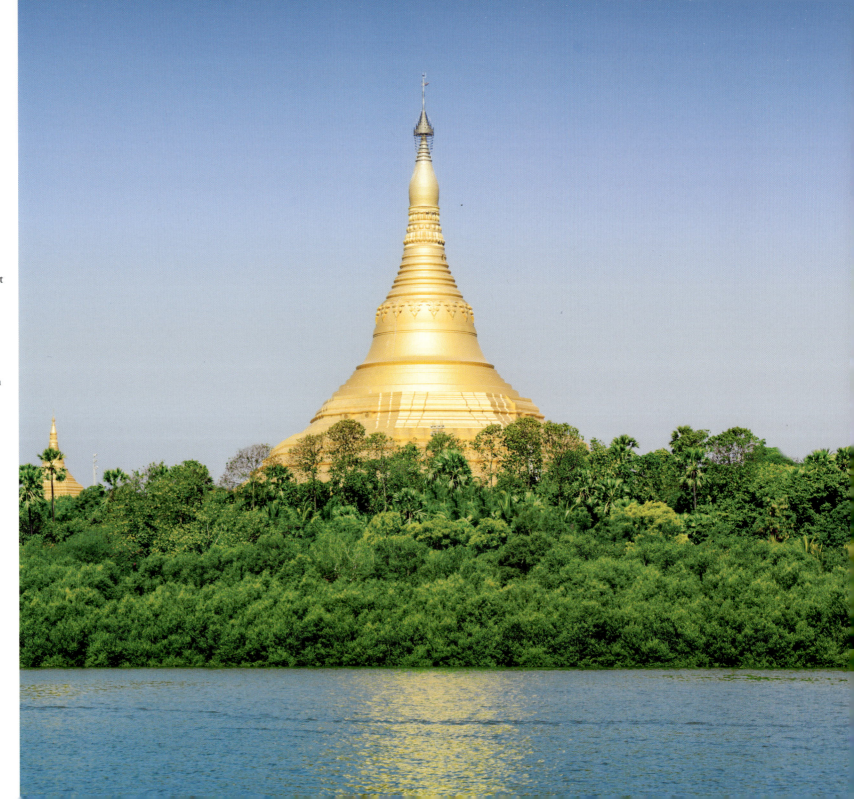

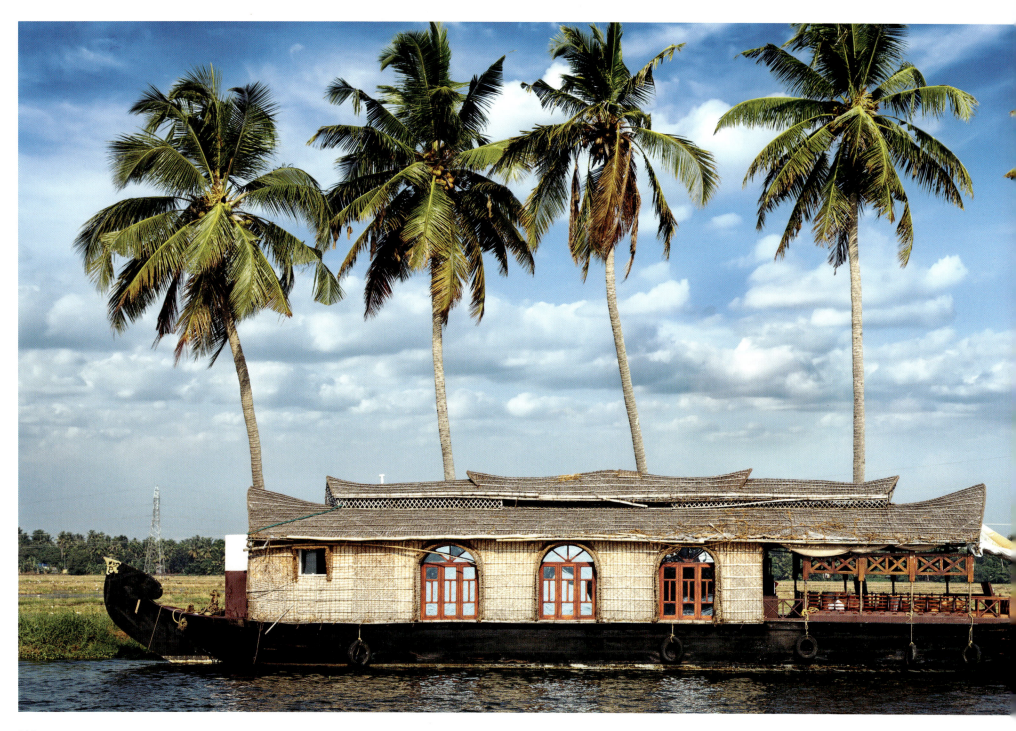

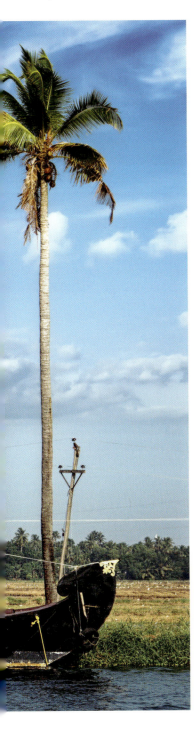

LEFT:
Houseboat on the backwaters of Kerala, India
Cruising the backwaters of Kerala on a modified *kettuvallam*, a boat made of jackfruit wood traditionally held together by rope, is an unhurried way to experience the quieter side of India. The boats cruise through narrow waterways and still lagoons past homes, schools, and orchards tucked among coconut palms, offering glimpses into the daily life of Keralans.

RIGHT:
Paravur Lake, Kerala, India
Fishermen have made their living from the serene backwaters in Kerala for centuries. The shallow waters teem with an abundant variety of fish. Alongside traditional fishing activities, Paravur Lake is becoming a tourist destination, attracting visitors with its natural beauty, its mangroves, and bird life.

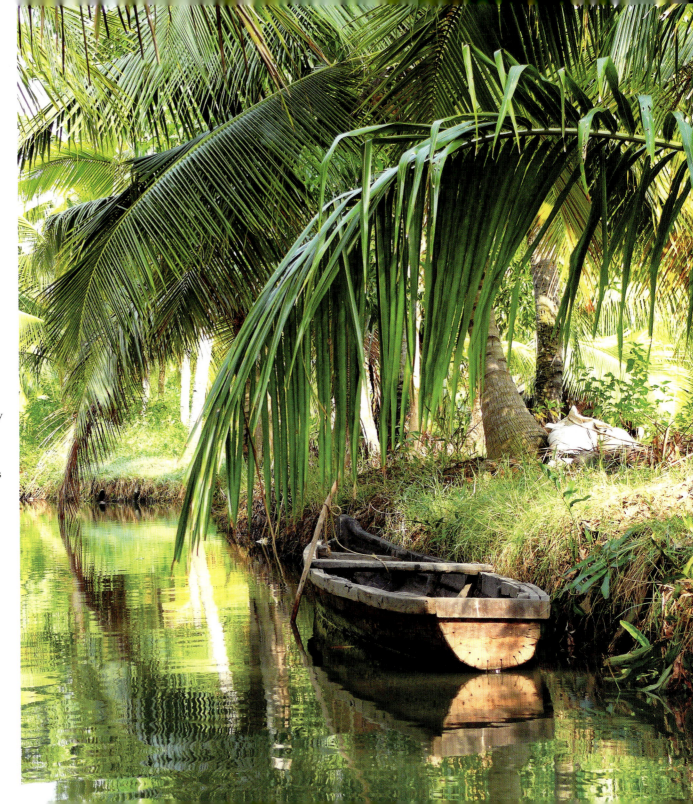

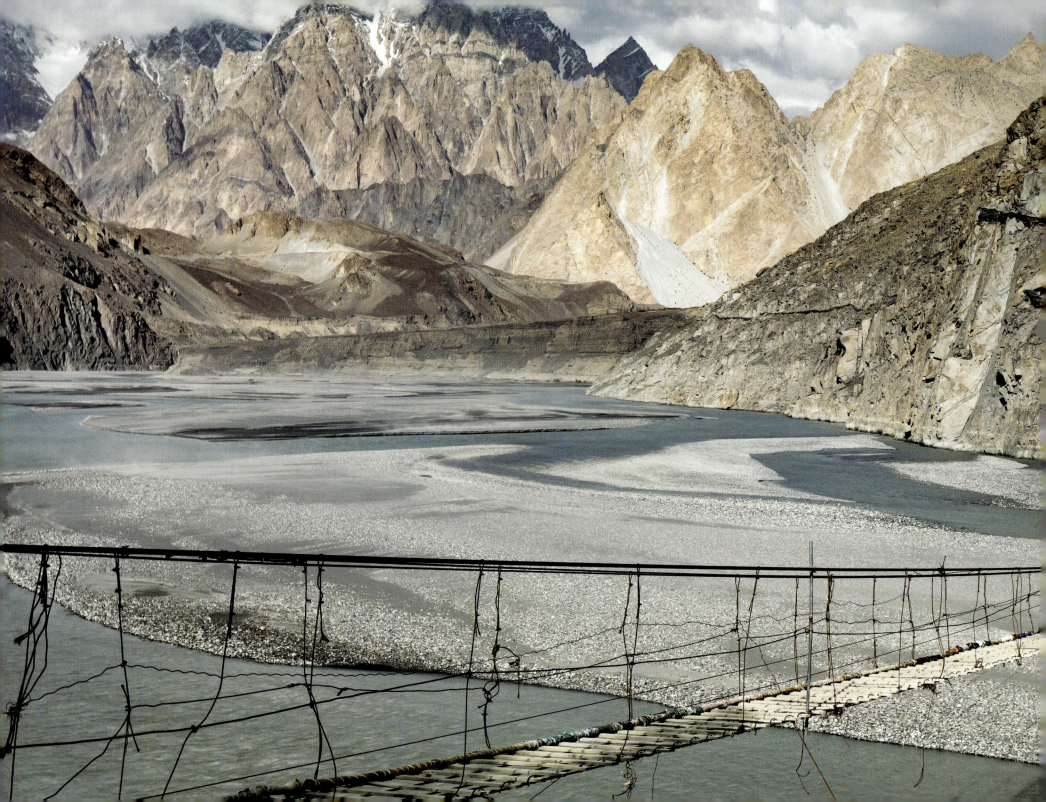

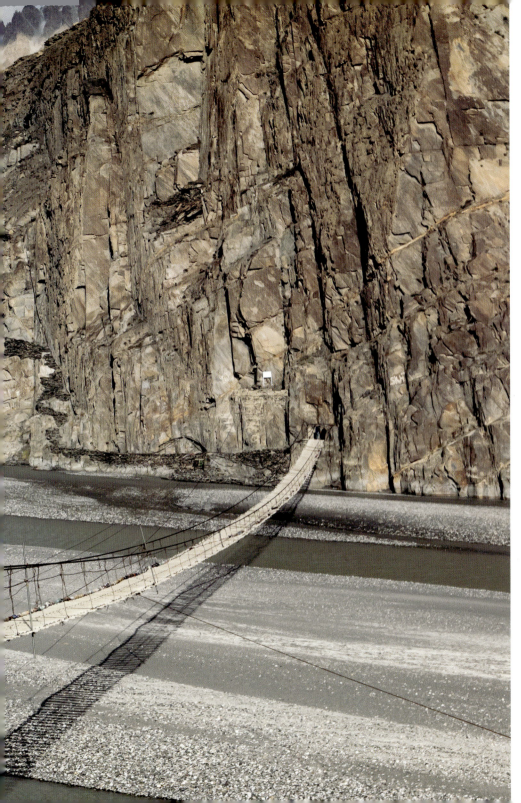
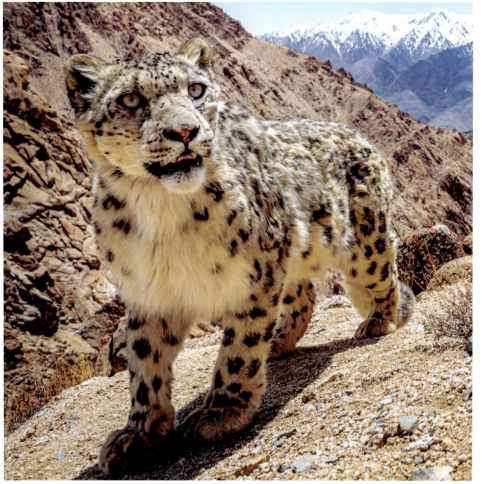

LEFT:
Hussaini Suspension Bridge, Gilgit-Baltistan, Pakistan
Once one of the most dangerous bridges in the world, this hanging bridge crossing Borit Lake is long and shaken by strong winds. After it was washed away in 2011, its ropes and weather-worn planks have been replaced with steel cables and solid wood, making it safer but still daunting to cross.

ABOVE:
Snow leopard, Ladakh, India
Up on the vast high-altitude plateau of Ladakh is considered one of the best places to see snow leopards, with more than 450 counted in India's latest population assessment. These elusive felines can stand extreme cold and high altitudes, so the stunningly rugged and remote regions of the Tibetan Plateau are its kingdom.

RIGHT:
Diskit Monastery, Ladakh, India
Founded in the fourteenth century, this Tibetan Buddhist temple rests at 3150m (10334ft) above sea level on a hill above the flood plains of the Shyok River in Nubra Valley. The 35m (114ft) statue of Maitreya Buddha at the monastery was consecrated by the Dalai Lama in 2010.

OPPOSITE BOTH:
Young girls dressed in traditional clothes, Ladakh, India
Traditional clothing plays an important role in the cultural identity of Ladakhis, and young and old wear traditional clothing, especially at the various Buddhist festivals that take place through the year. Those of the Drokpa (or Brokpa) tribe are known for their headdress called *tepi*, which is garlanded with fresh or dry mountain flowers. Others wear the *tipi* or *tibi* (top hat with upturned corners) for special events.

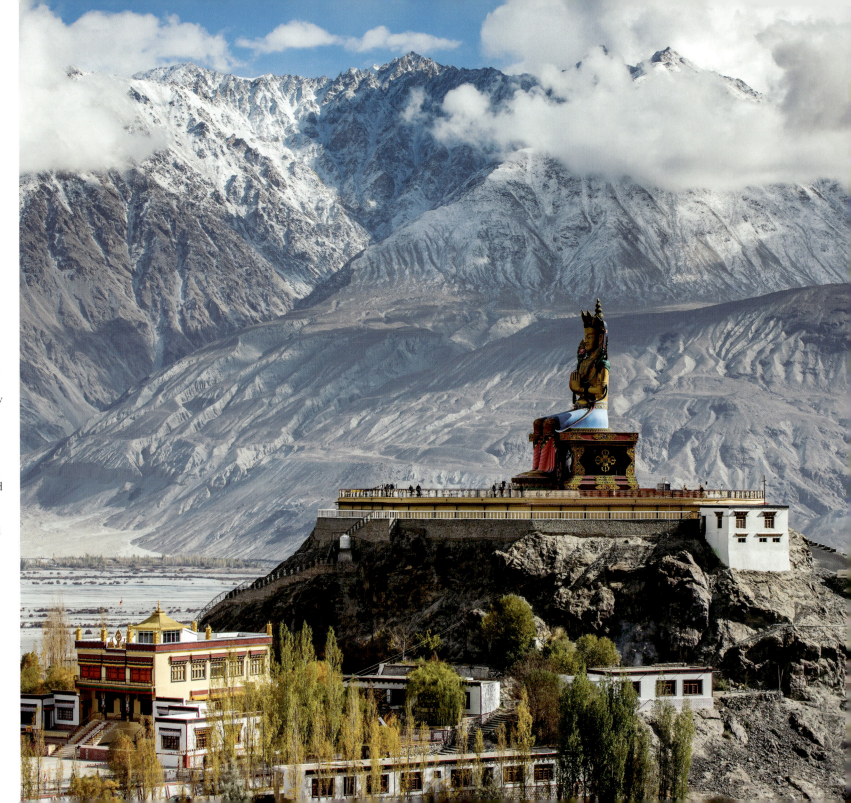

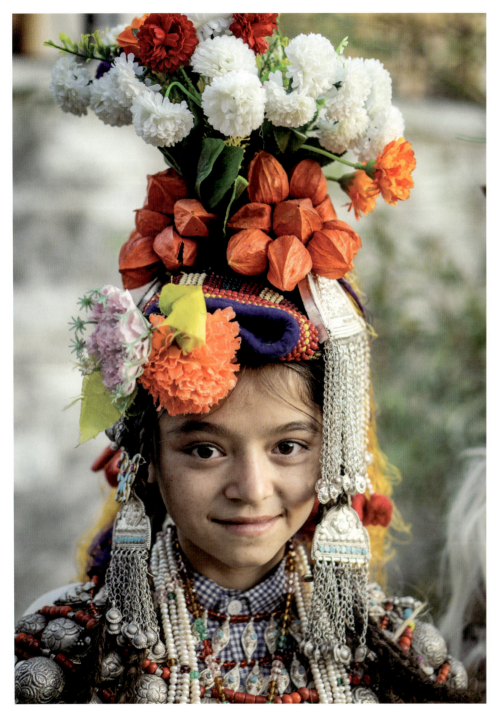
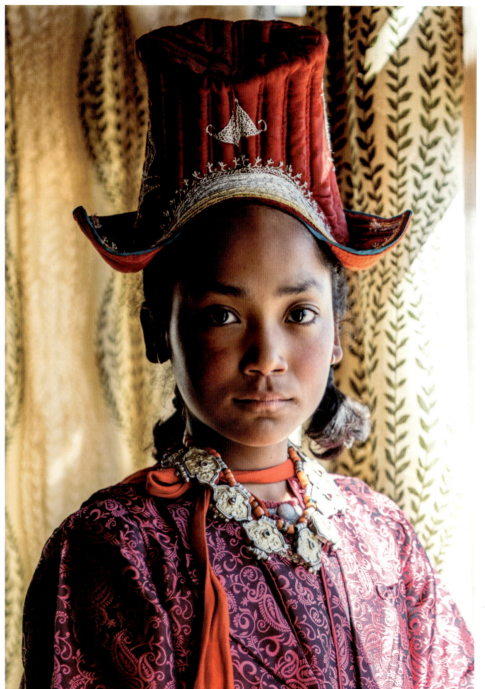

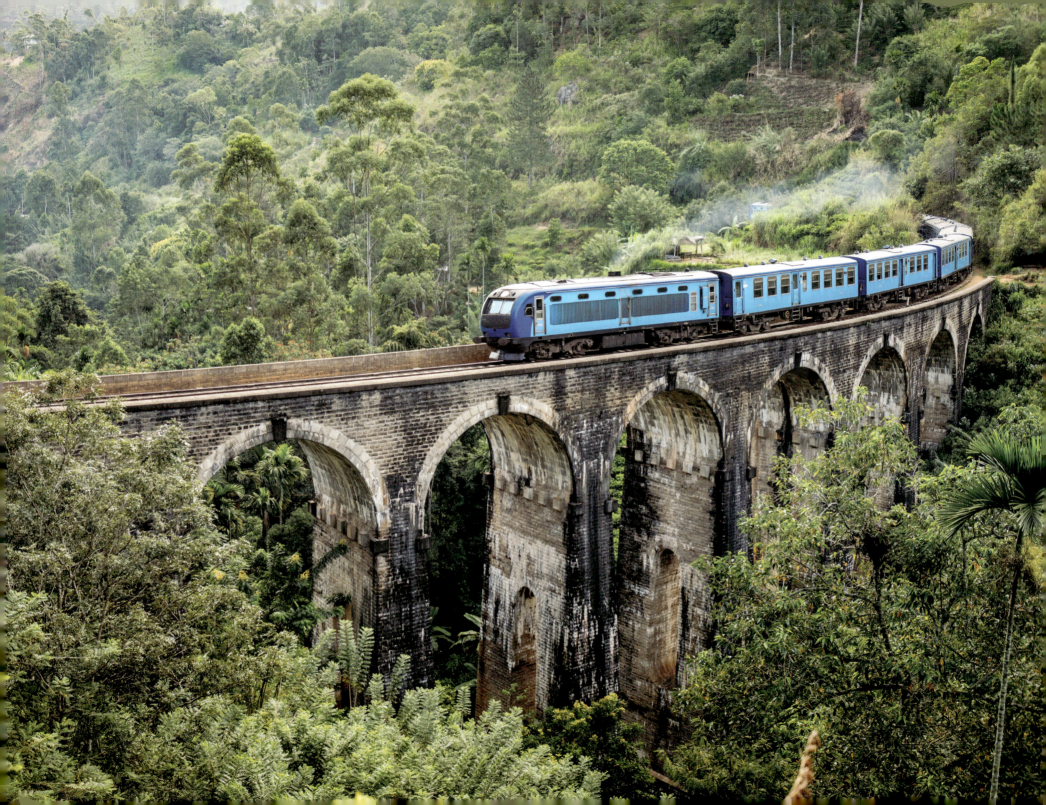

OPPOSITE:
Nine Arch Bridge, Ella, Sri Lanka

Known as the 'Bridge in the Sky', this viaduct bridge between Ella and Demodara railway stations is a shining example of colonial-era railway construction. Building the bridge was no easy feat, with its challenging nine-degree curve and steep gradient. Construction, using local labour under British supervision, was completed in 1919.

RIGHT:
Sigiriya, Central Province, Sri Lanka

According to an ancient chronicle, King Kashyapa built his palace atop this almost-200m (656ft) high column of granite in the late fifth century. About halfway up the side, he built a gate in the shape of a giant lion, giving this UNESCO World Heritage site its other name: Siṃhagiri, or 'Lion Rock'.

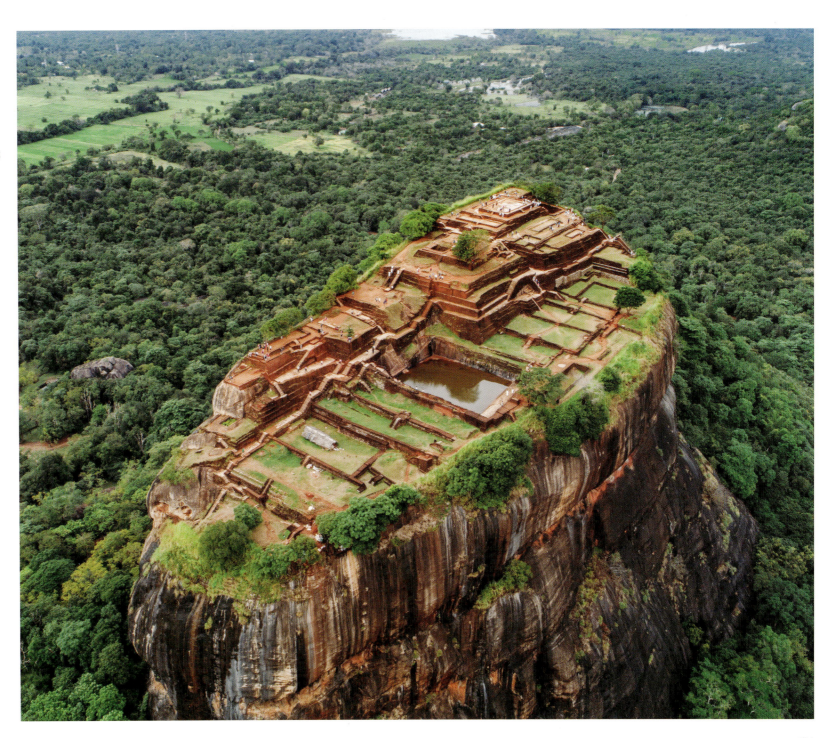

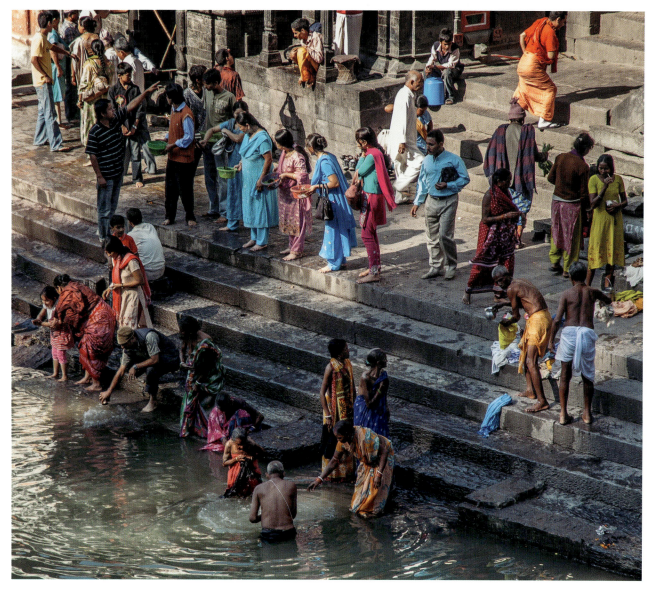

ABOVE:
Bathers at Pashupatinath Temple, Kathmandu, Nepal
Hindus from across South Asia and beyond come to the most sacred temple in Nepal to take a holy bath in the sacred Bagmati River. Pashupatinath is believed to be truly ancient, stretching back to pre-Vedic times (before about 1500BCE) and is dedicated to Pashupati, a form of Shiva.

RIGHT:
Pashupatinath Temple, Kathmandu, Nepal
Pashupatinath is a collection of temples, ashrams, images, and inscriptions that have been added over the centuries and that cover 246 hectares (2.46km^2) of the banks of the Bagmati. The temple precinct includes 518 mini-temples and a main pagoda house. It was designated a UNESCO World Heritage Site in 1979.

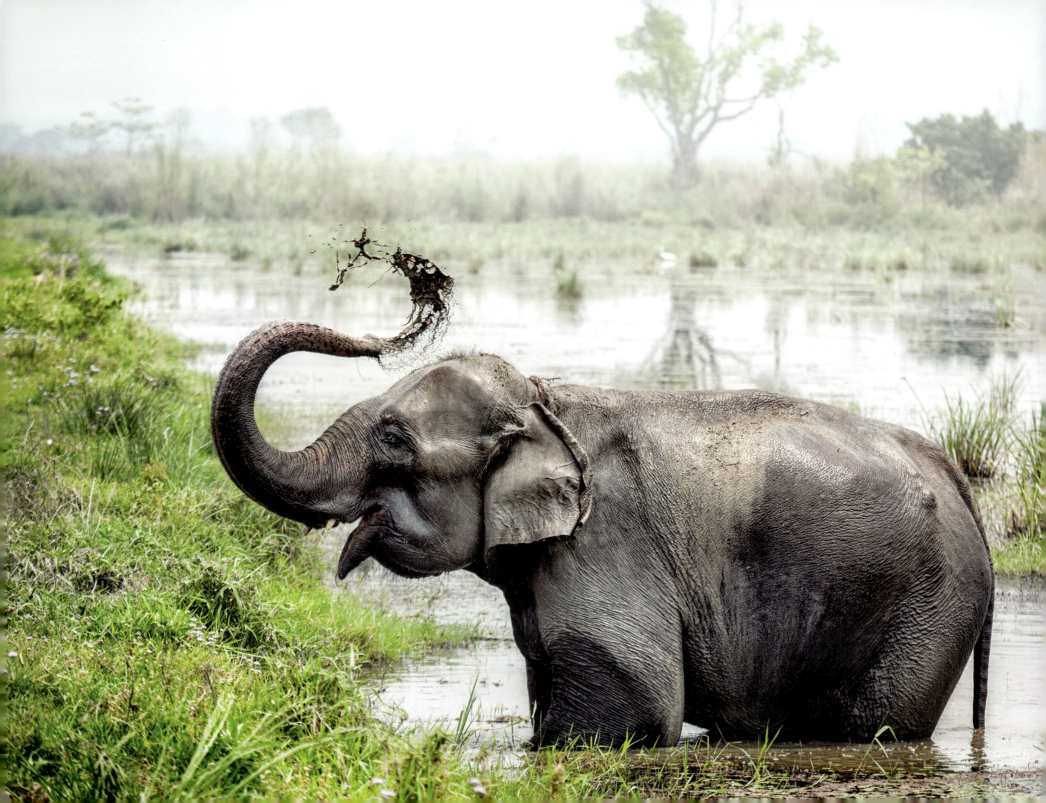

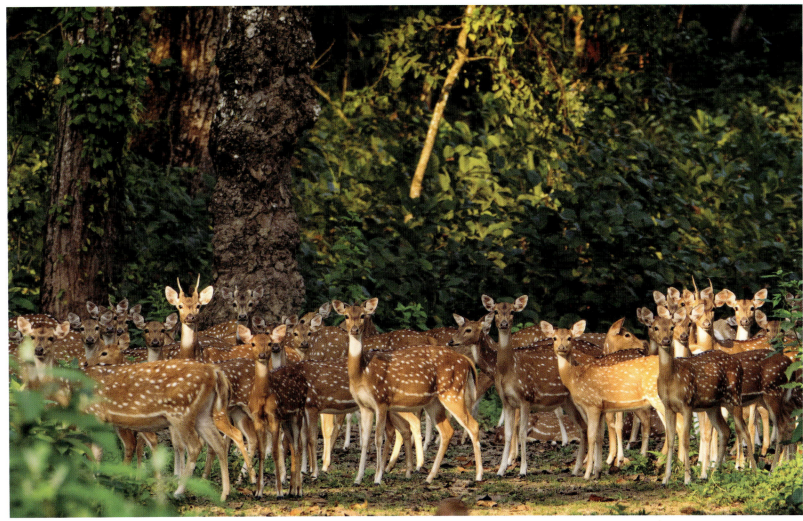

BOTH PHOTOGRAPHS:
Chitwan National Park, Nepal
Nepal's first national park, Chitwan was established in 1973 covering almost 100km² (38.6 miles²) of waterways, grasslands, and forests of *sal* trees. More than 700 species of wildlife make their homes here, including the rare Bengal tiger and Indian leopard, sloth bears, striped hyaenas, crocodiles, and pythons, along with elephants and spotted deer.

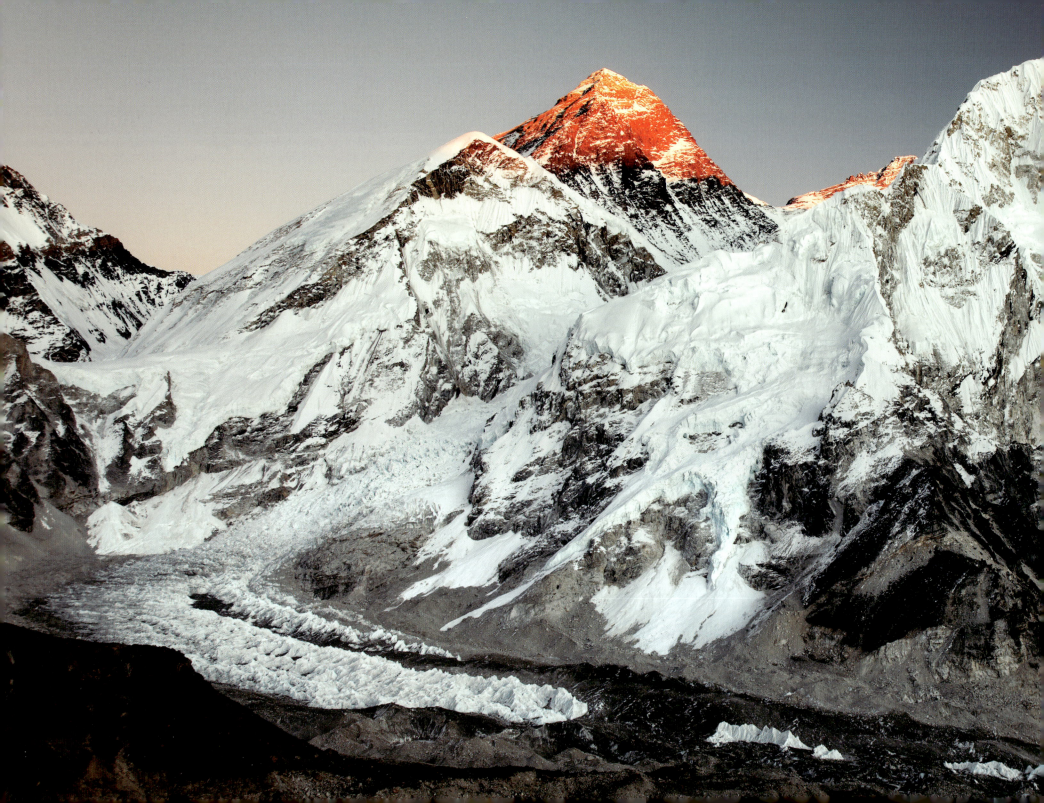

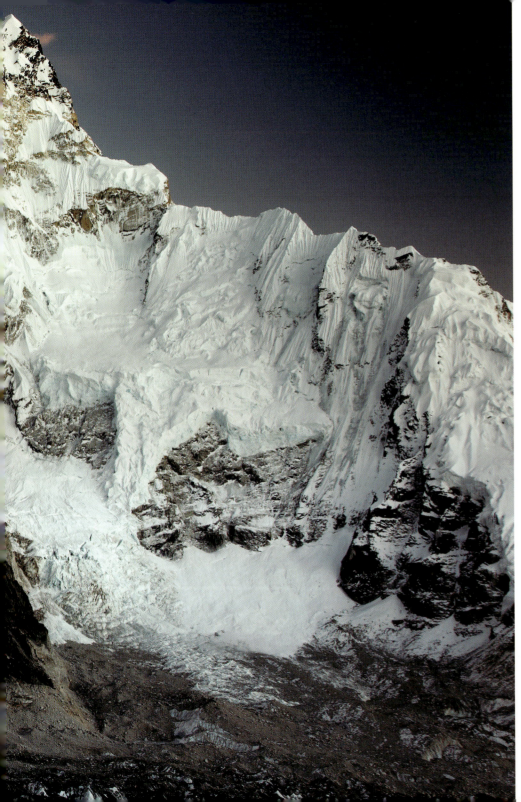
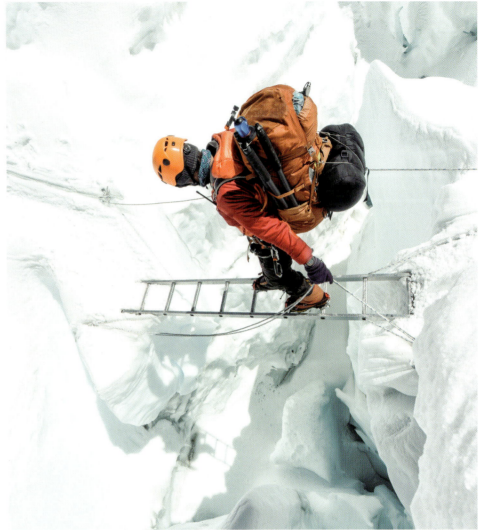

BOTH PHOTOGRAPHS:
Mount Everest, Himalayas, Nepal
Earth's highest mountain above sea level, the mighty Mount Everest (known as Chomolungma in Tibet and Sagarmatha, 'Goddess of the Sky', in Nepal) reaches 8848.86m (29031.69ft). The lure of reaching the top is strong, with around 800 people each year aiming to ascend the mountain.

RIGHT:
**Tiger's Nest,
Paro Valley, Bhutan**
Clinging to a cliff at an altitude of 3120m (10236ft), Paro Taktsang, or Tiger's Nest, is a Buddhist temple complex dating from 1692. It was built around a cave in which Guru Rinpoche (also known as Padmasambhava) taught Vajrayana Buddhism in the eighth century, introducing this form of Tantric Buddhism to Bhutan.

OPPOSITE AND OVERLEAF:
**Punakha Dzong,
Punakha, Bhutan**
At the confluence of the Pho ('Father') and Mo ('Mother') rivers, the winter capital of Bhutan, the 'Palace of Bliss', was built in 1637–1638. It is the second oldest and second largest (after Trongsa) *dzong*, or fortress-monastery. The magnificence of its architecture is matched by the splendour of the interior, which showcases exquisite golden sculptures, detailed woodwork, and intricate religious wall paintings and murals.

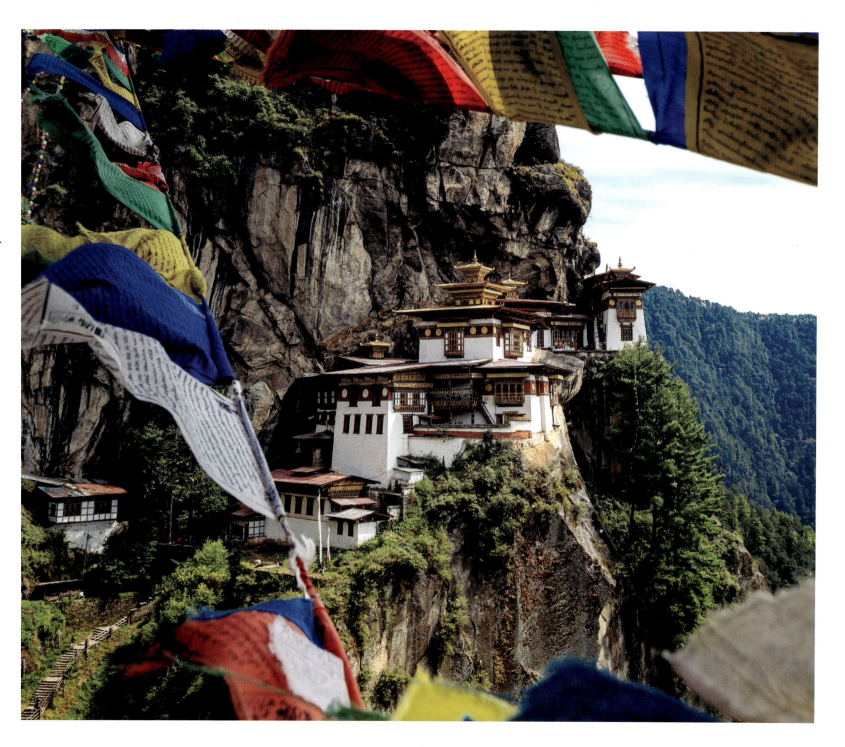

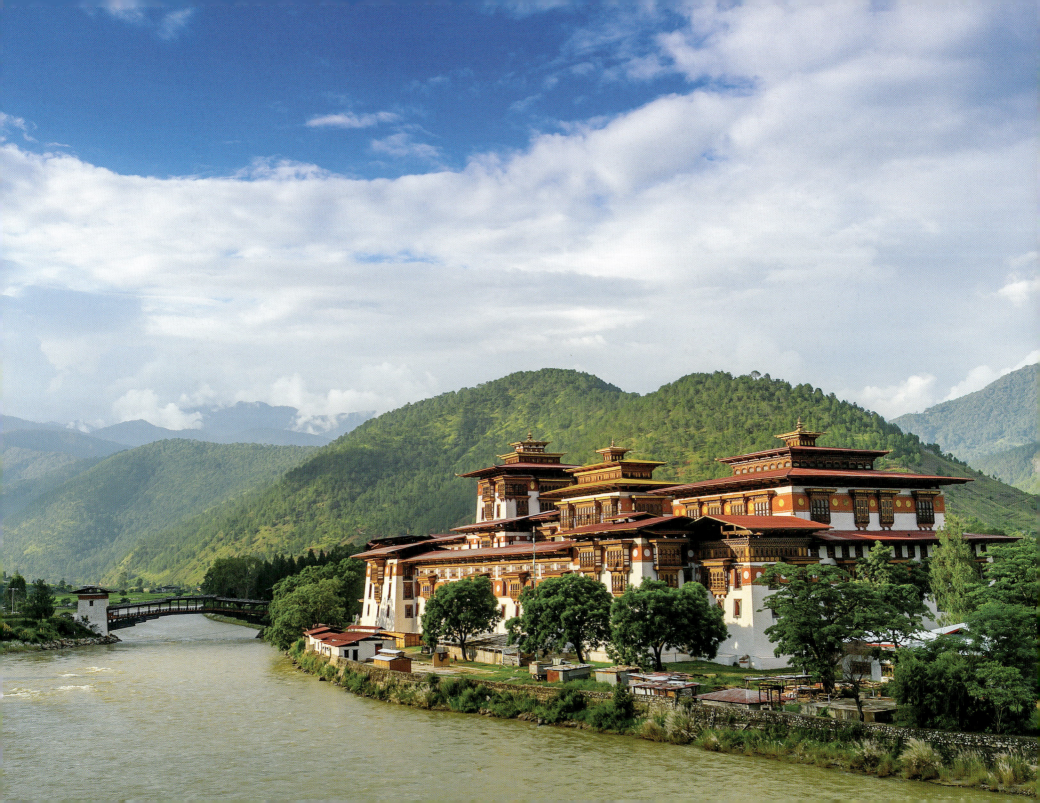

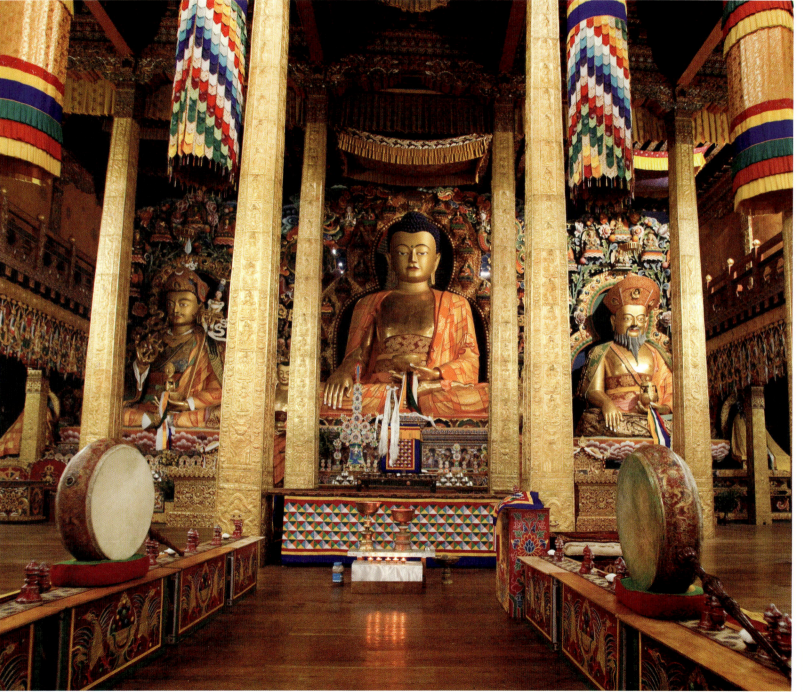

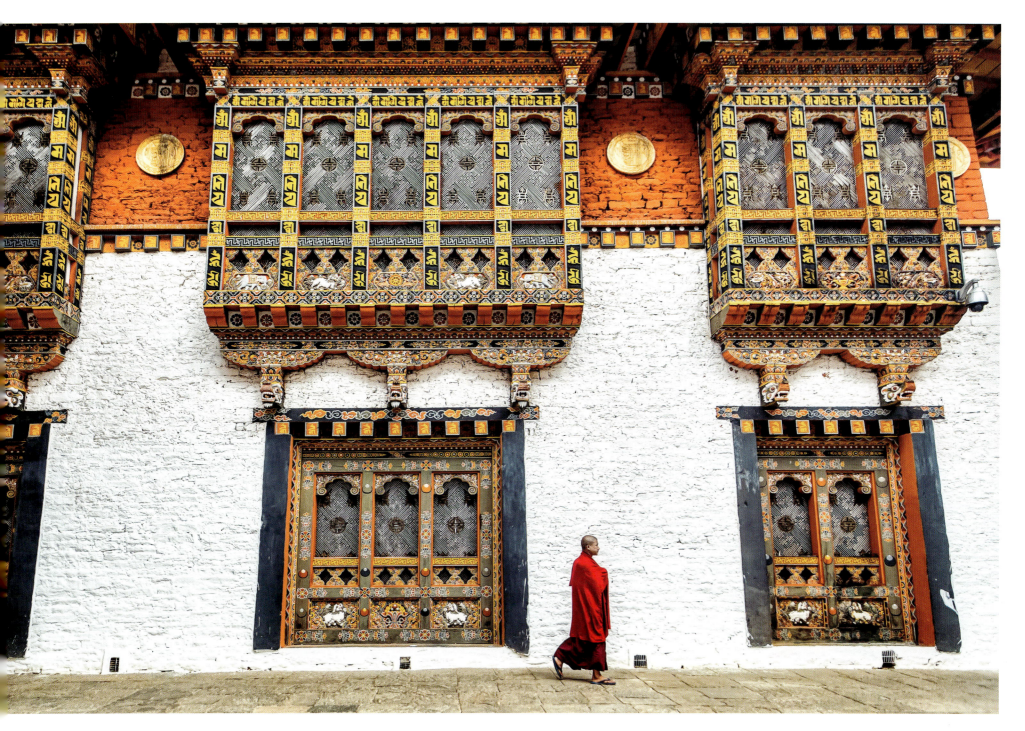

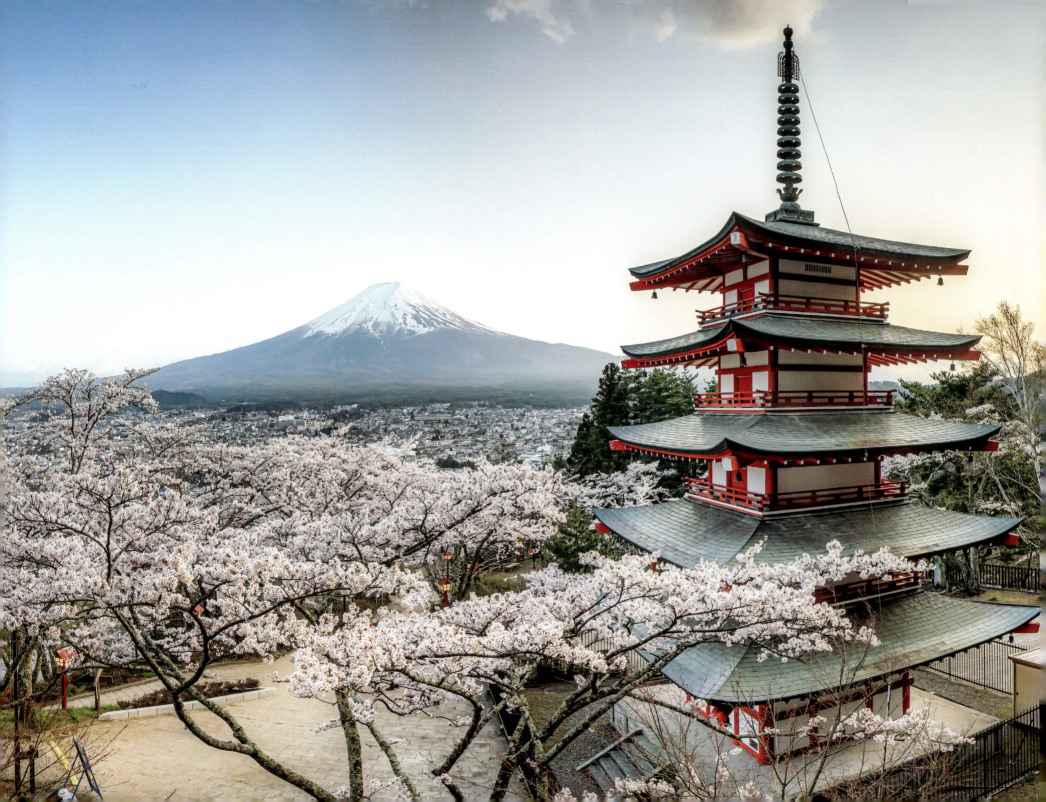

East Asia

From the burning yellow sands of the Taklamakan Desert to the delicate pink cherry blossoms of Japan in spring, and from the vast scrubby grasslands of the Gobi to the dense futurescape of the Hong Kong skyline, East Asia is a multifaceted and fascinating part of the world.

At the core of East Asian civilization is China – the first area to be settled, and from which other civilizations emerged. Throughout history, imperial China influenced its neighbours culturally, politically, and economically, particularly in Japan and on the Korean Peninsula.

Buddhism, Confucianism, and Taoism spread from China into the rest of East Asia and are still practiced widely across the region, alongside native religions such as Shinto in Japan and Tengrism in Mongolia. Glorious old temples, shrines, and palaces, from Seoul's Joseon-dynasty palaces to the Tōdai-ji Temple in Nara, Japan, show Chinese influence in their curving, hip-and-gable roofs.

Within China, the country's major tourist sites, from the ancient terracotta warriors at Xian to Beijing's Tiananmen Square with its tumultuous modern history, tell a millennia-old story of this complex land.

Today, East Asia is a global powerhouse, with China, Japan, and South Korea in particular driving global trade and innovation and shaping world culture and geopolitics. The region continues to have political sensitivities, security concerns, and environmental stresses but the rich cultural heritage, diverse attractions, and stunning natural landscapes make it an exciting destination for travellers seeking adventure and cultural immersion.

OPPOSITE:
Chureito Pagoda and Mount Fuji in spring, Fujiyoshida, Japan
Built as a peace memorial in 1963, the five-tiered Chureito Pagoda above the Arakura Sengen Shrine offers spectacular views of Mount Fuji. In spring, cherry blossoms coat the trees in delicate pinks.

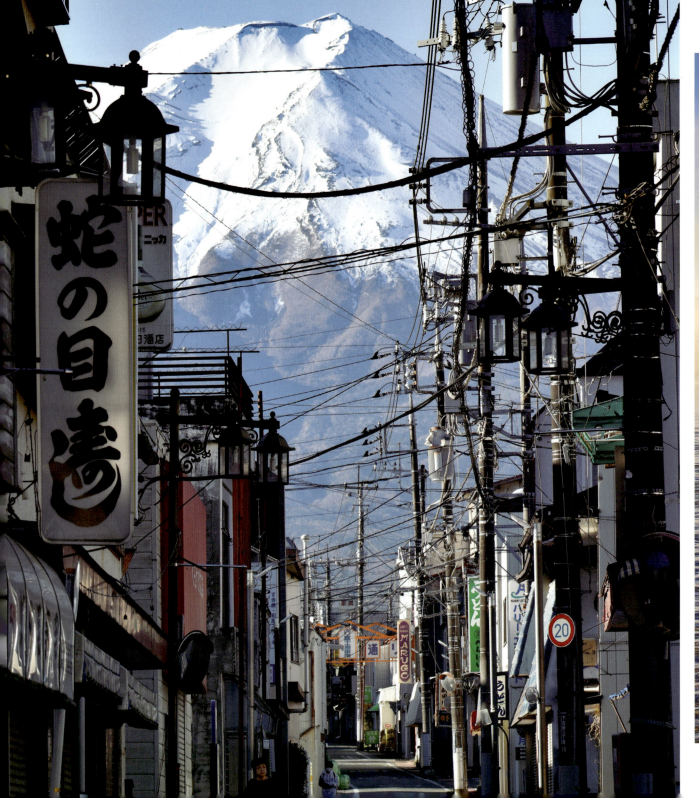

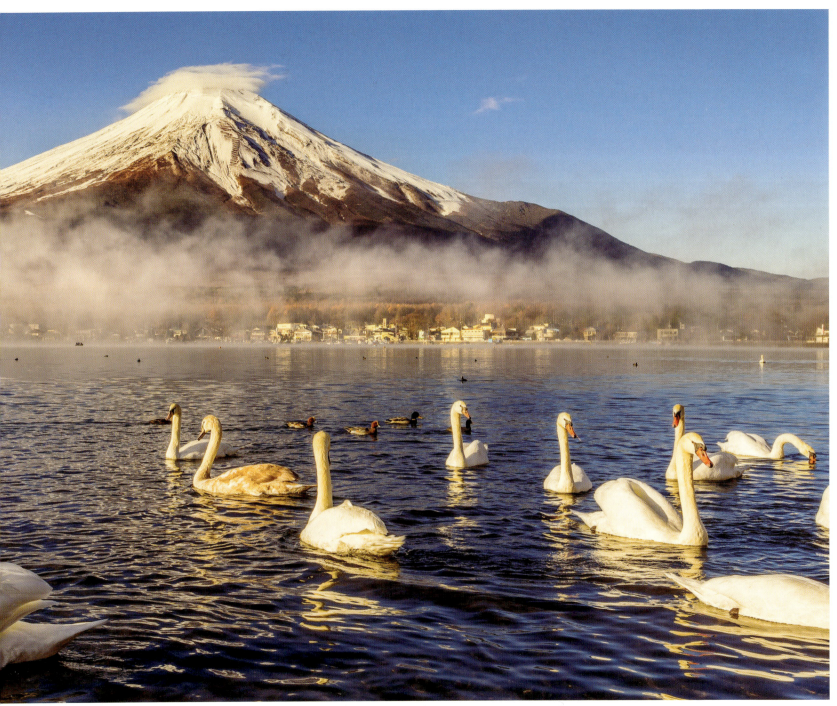

OPPOSITE:
Mount Fuji, Fujiyoshida, Japan
At 3776m (12388ft), Mount Fuji is the tallest peak in Japan and one of the country's sacred mountains. It is still considered an active volcano, although the last time it erupted was in 1707 and its last signs of volcanic activity were recorded in the 1960s.

LEFT:
Lake Yamanaka, Yamanashi Prefecture, Japan
Listed as a UNESCO World Heritage Site as part of the Fujisan Cultural Site, the picturesque Lake Yamanaka is the biggest of the Fuji Five Lakes. The lake's proximity to Mount Fuji attracts visitors wanting to photograph the mountain's reflection on the water, as well as indulge in some boating, fishing, or windsurfing.

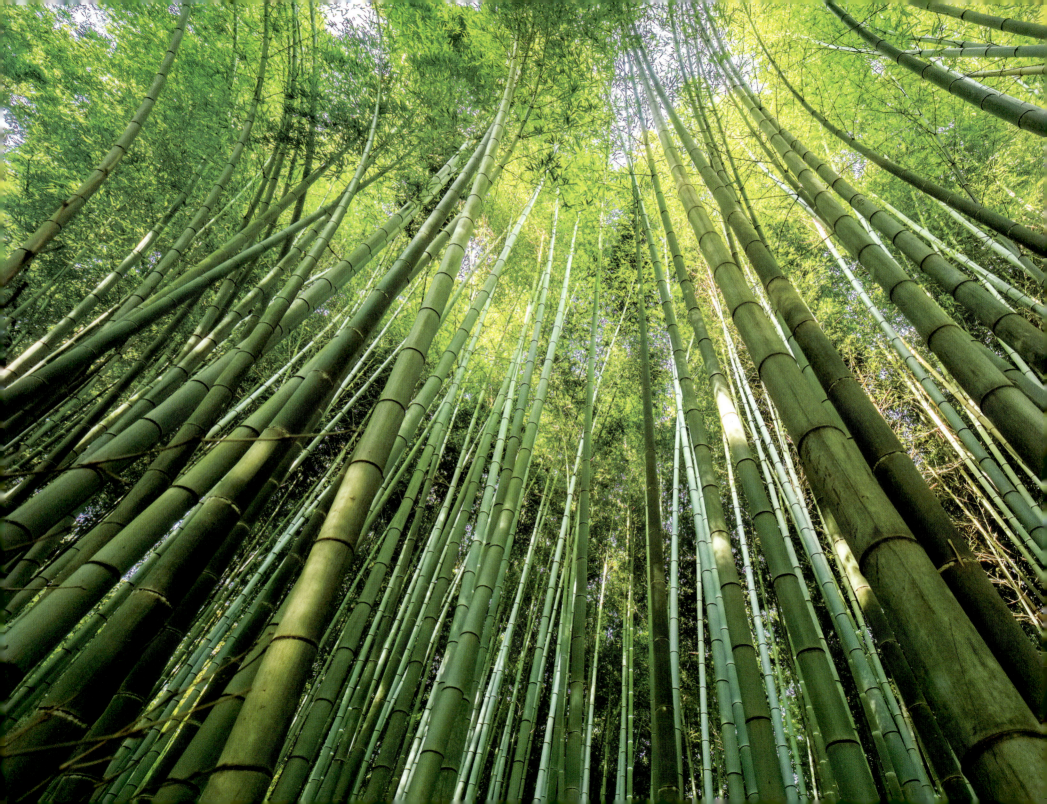

LEFT:
Arashiyama Bamboo Grove, Kyoto, Japan
The 16km² (6 miles²) bamboo forest is famed not only for the beauty of the towering culms but also for how they sound: the knocking of the hollow stems and the rustling whisper of the leaves in wind has been designated one of the top 100 soundscapes (noises representative of the country) of Japan.

RIGHT AND OVERLEAF LEFT:
Fushimi Inari-taisha, Kyoto, Japan
There are some 10,000 vermillion *torii*, or gates, straddling the trails at this serene Shinto shrine nestled at the foot of Inari mountain near Kyoto. This ancient and important shrine is dedicated to Inari, the *kami* (deity) for rice, tea, sake, agriculture, fertility, business, and overall prosperity, as well as foxes – thought to be Inari's messengers.

OVERLEAF RIGHT:
Tōdai-ji Temple, Nara, Japan
Founded in 738CE, this Buddhist temple is one of Japan's most famous and historically significant temples. It was built in the style of Chinese temples of the Tang Dynasty. The temple is the centre of the Kegon sect of Japanese Buddhism.

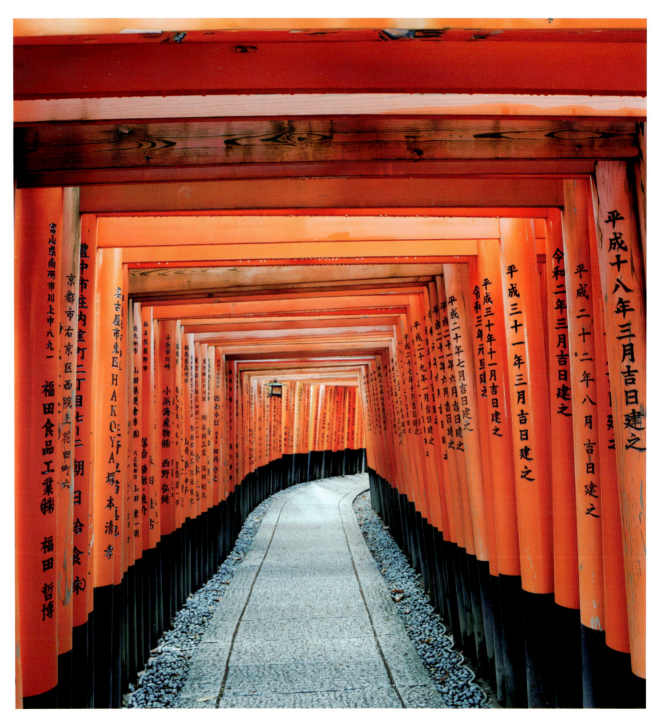

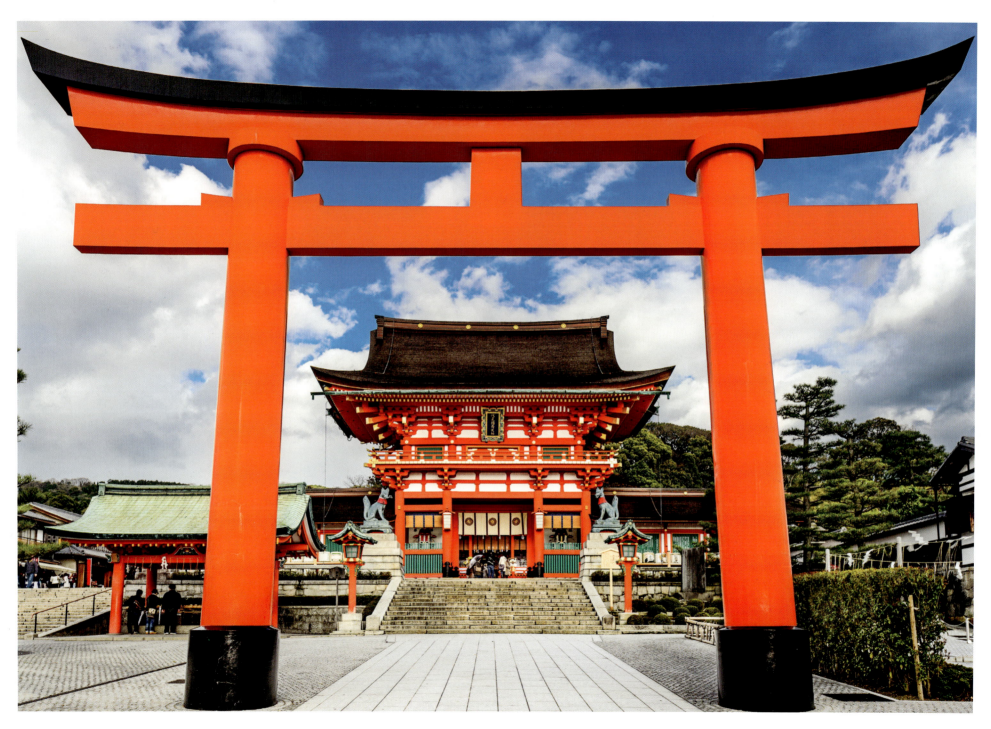

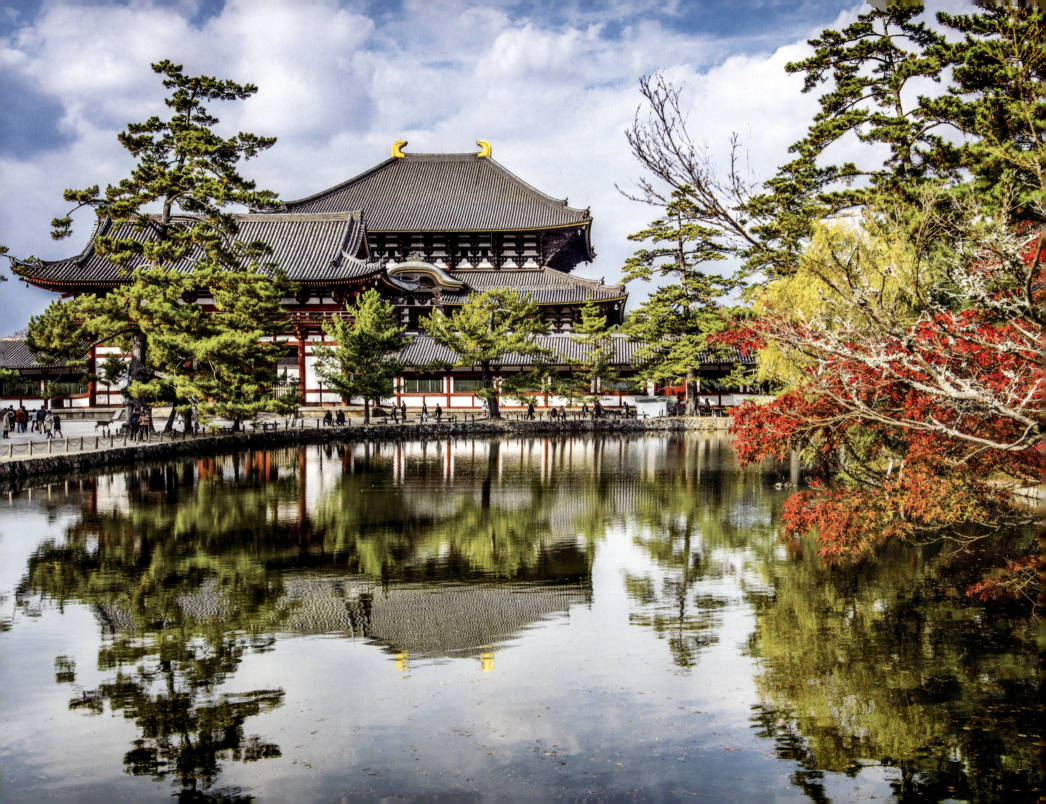

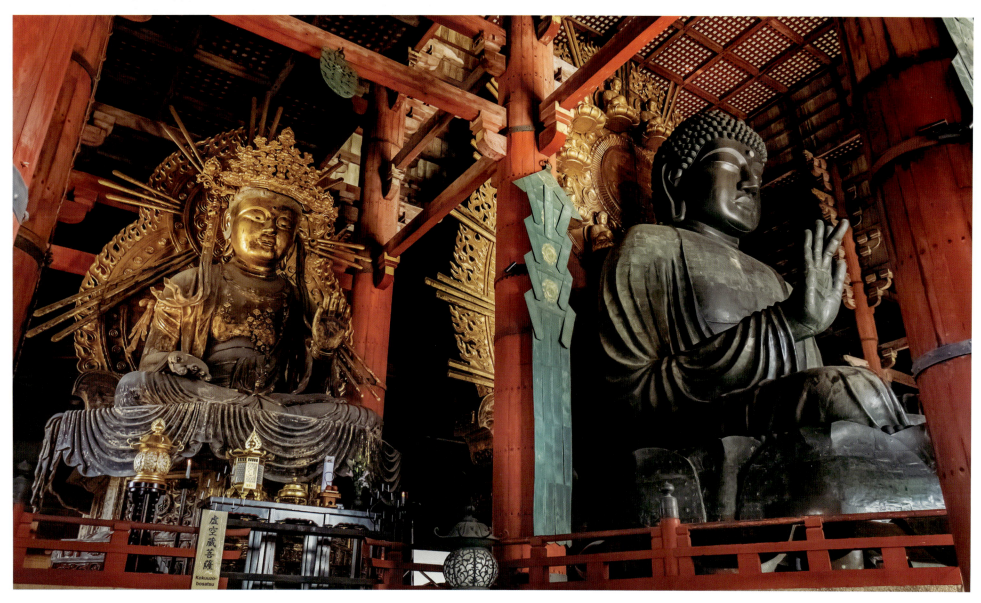

ABOVE:
Great Buddha Hall at Tōdai-ji Temple, Nara, Japan
The Daibutsu-den, or Great Buddha Hall, was constructed in 1709 to house the almost-15m (49ft) tall statue of Vairocana Buddha (regarded to be the supreme Buddha by Mahayana Buddhists), which was created in 752CE. It is the world's largest bronze statue of the Vairocana Buddha.

OPPOSITE:
Osaka Castle, Osaka, Japan
One of Japan's most famous historical buildings, the impressive Osaka Castle was built in 1583 by the powerful feudal lord and warrior, Hideyoshi Toyotomi. The main keep of the castle covers around 1km² and is supported by sheer walls of cut rock and protected by a series of moats and fortifications.

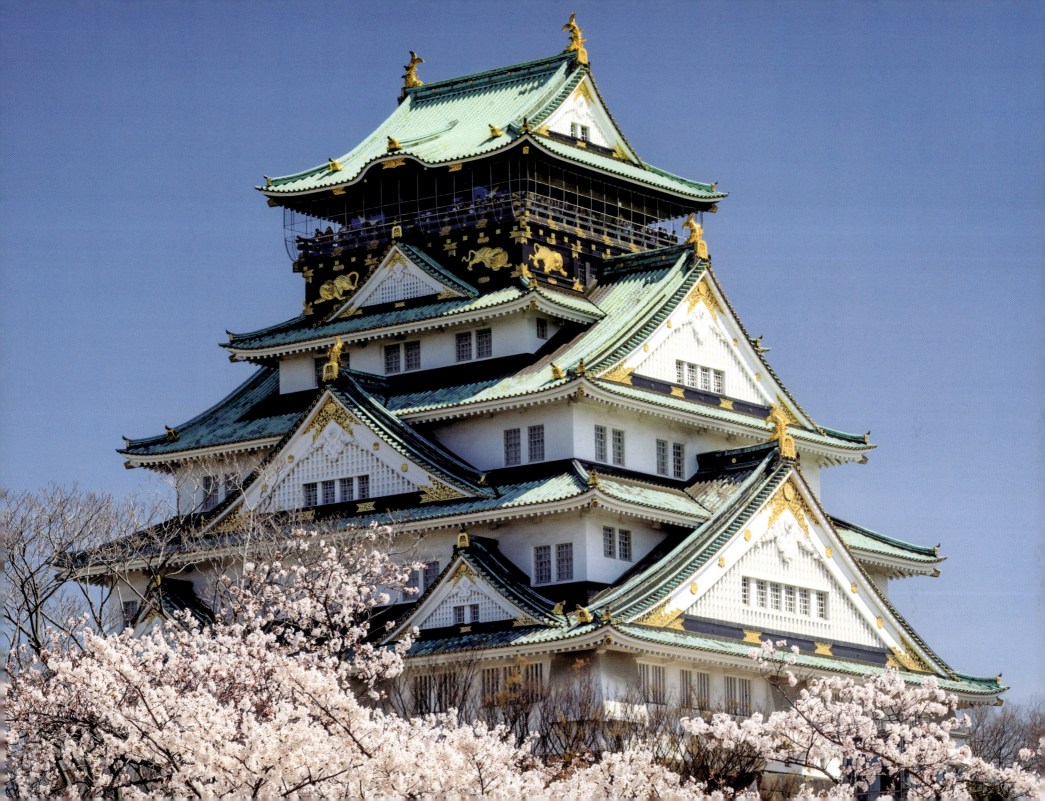

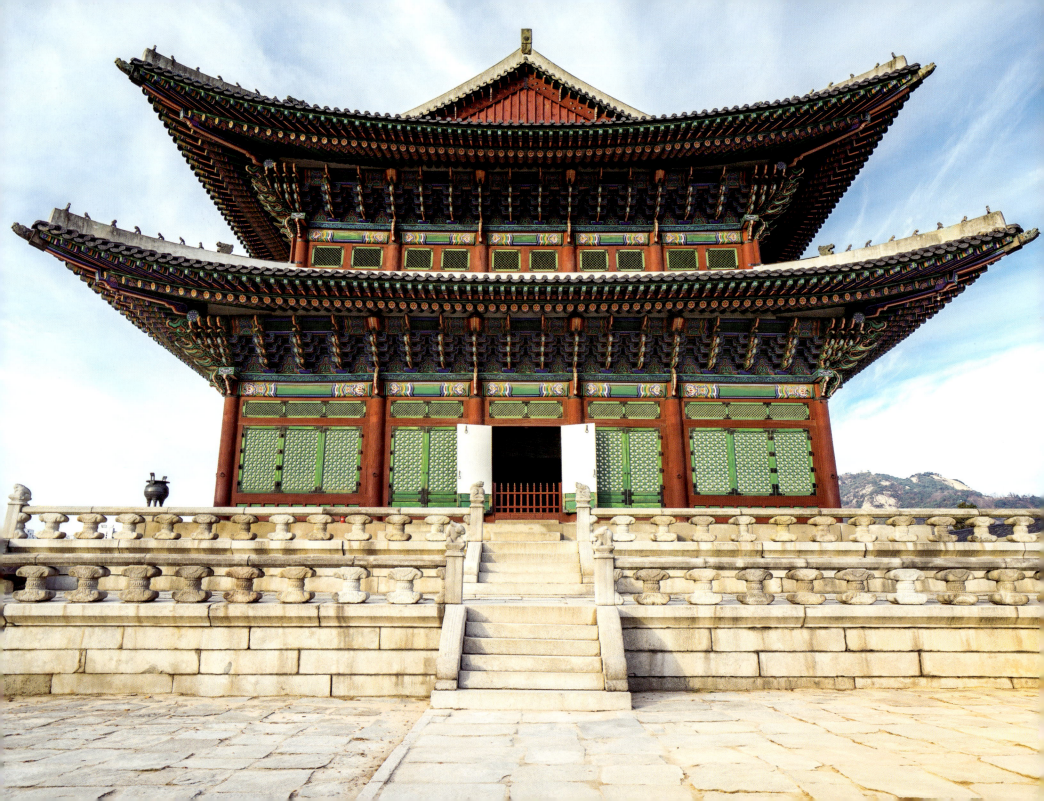

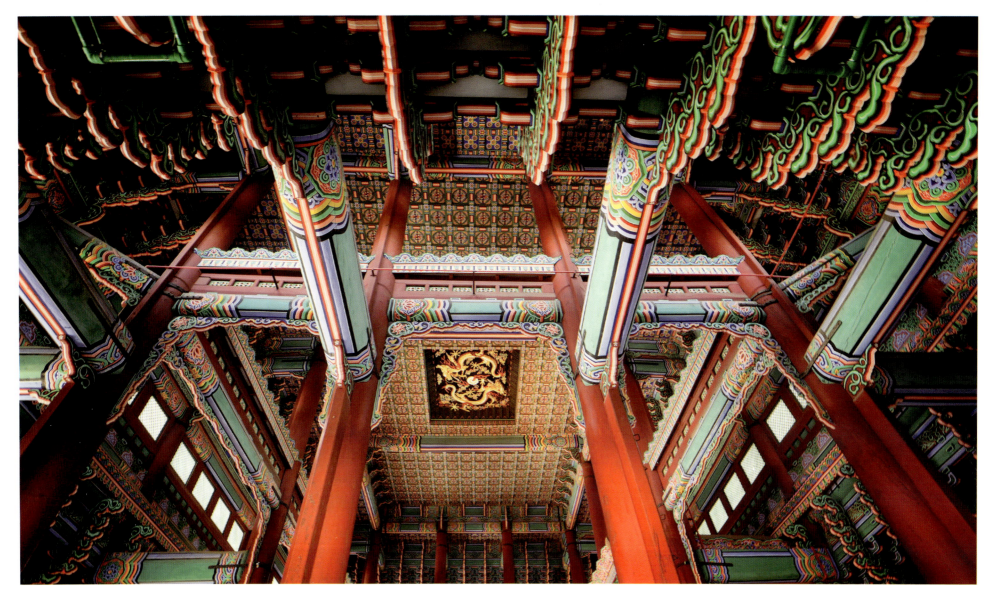

OPPOSITE:
Gyeongbokgung Palace, Seoul, South Korea
Built in 1395 as the official palace of the Joseon dynasty, Gyeongbokgung ('Palace Greatly Blessed by Heaven') is commonly referred to as the Northern Palace due to its location north of the city. It is the largest of all five royal palaces in Seoul.

ABOVE:
Interior of Gyeongbokgung Palace, Seoul, South Korea
Conservation and restoration of Gyeongbokgung Palace and its exquisitely painted and carved interiors continues today. The palace also houses two museums, the National Folk Museum of Korea and the National Palace Museum of Korea.

Great Wall of China, Jinshanling, China

From as early as the seventh century BCE, walls were built along the northern borders of Chinese states to defend against nomadic groups from the Eurasian Steppe. Over two millennia, successive dynasties added to the fortifications. The Jinshanling section of what is now known as the Great Wall of China was built during the Ming Dynasty, from 1570CE.

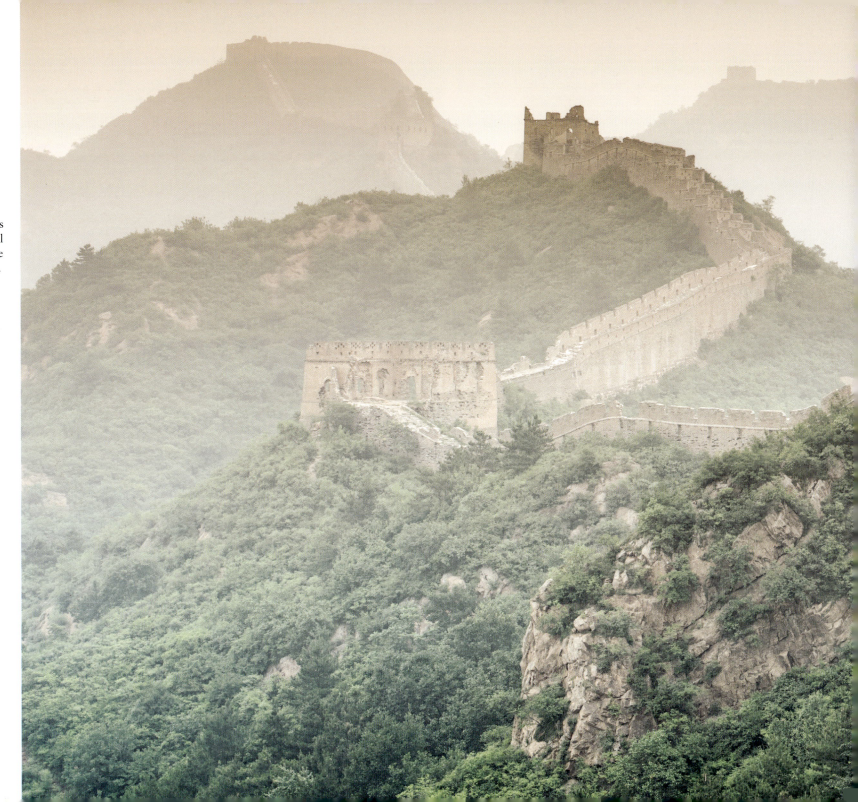

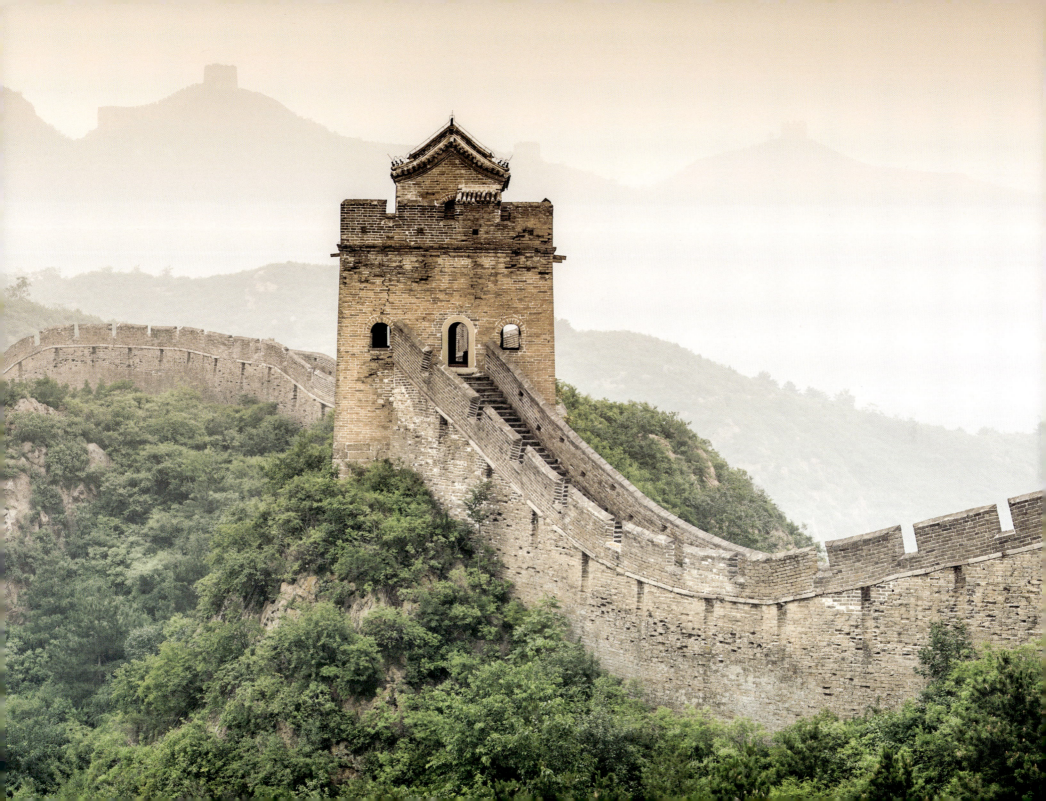

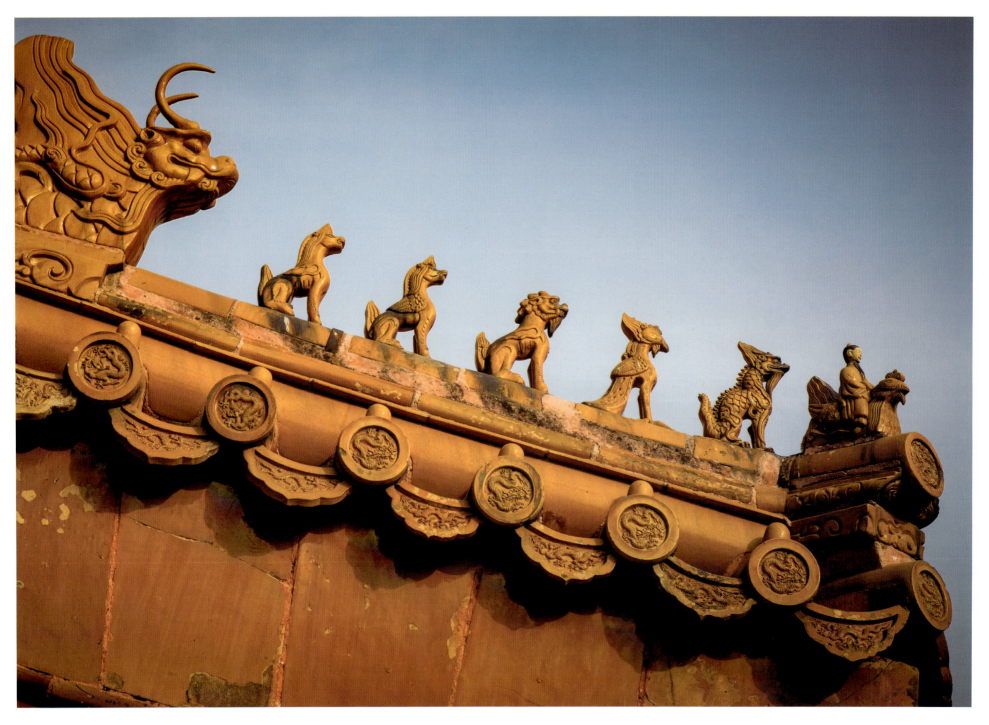

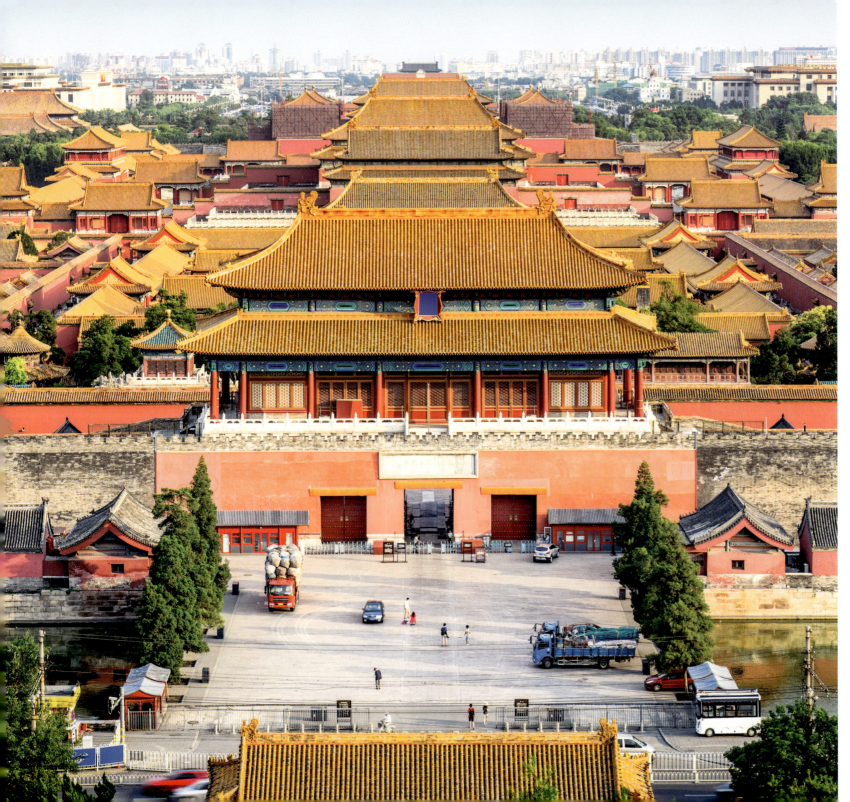

LEFT:
Forbidden City, Beijing, China
The Forbidden City – so named as only the Emperor, Imperial family, and eunuchs were allowed inside and unauthorized entry would result in immediate execution – was constructed from 1406 to 1420. The 72-hectare (0.72km²) compound was the centre of political power in China for more than 500 years.

OPPOSITE:
Roof tiles and figurines, Forbidden City, Beijing, China
In ancient China, the colour yellow was reserved for the exclusive use of the emperor. Yellow glaze roof tiles, favoured particularly by the Ming Dynasty, feature prominently throughout the Forbidden City. Animal figurines (*wenshou*) on roofs were both decorative and symbolic: lions, for example, are symbols of royalty, wisdom, and pride.

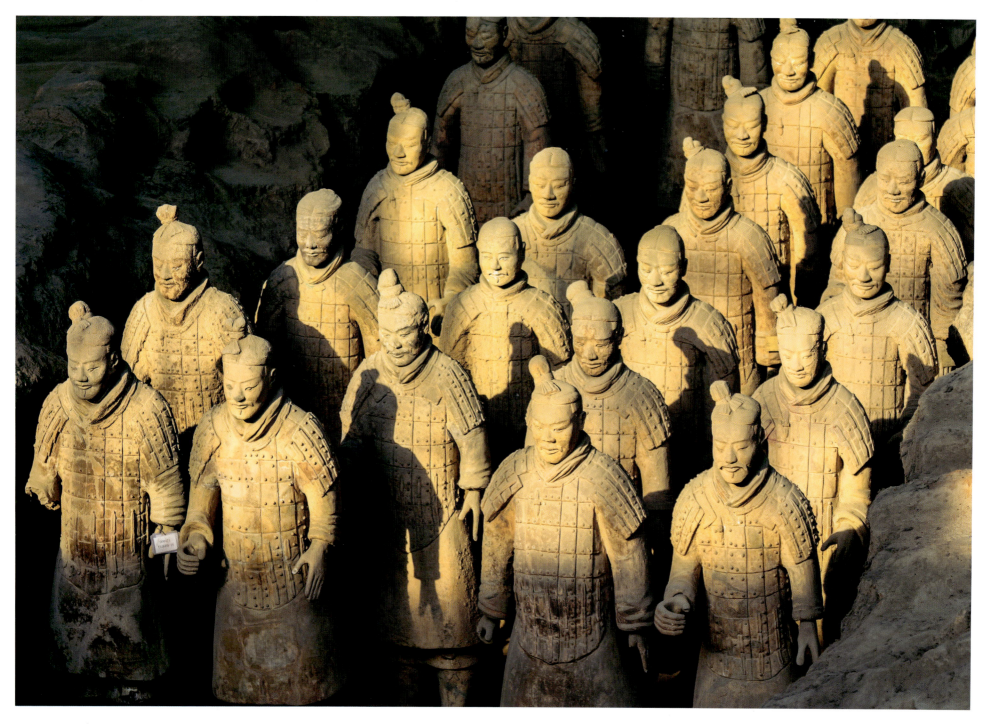

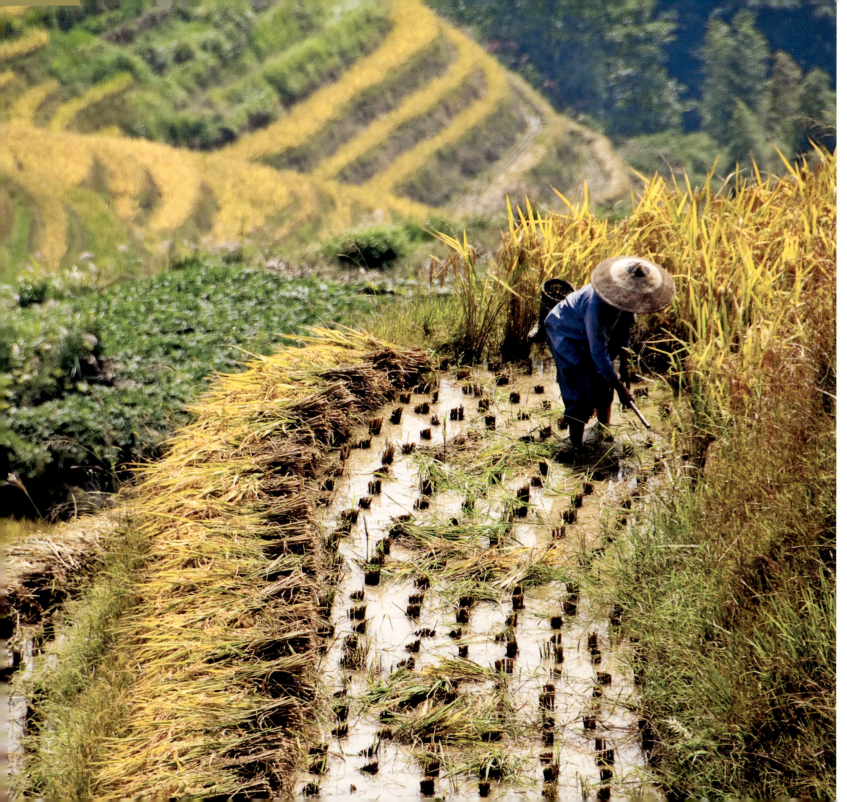

OPPOSITE:
Terracotta Army, Xian, China
The mausoleum of Qin Shi Huang, who proclaimed himself China's first emperor in 221BCE, included an entire army of life-size terracotta soldiers and horses. The site, at the ancient capital of Xianyang, lay lost and buried for 2000 years until peasants digging a well unearthed fragments of a figurine in 1974.

LEFT:
Farmer working a terraced rice field, Guangxi, China
The Longji ('Dragon's Backbone') rice terraces in Guangxi are incredible feats of farm engineering. The paddies, some rising up 1000m (3280ft), are often hundreds of years old and have been farmed by hand by the local minority communities who live in the mountains for generations.

RIGHT:
Boat on the Yangtze River, Chongqing, China
The Yangtze, the longest river in Eurasia, flows 6300km (3914 miles) from the Tibetan Plateau down to the East China Sea. The river has been a crucial part of the historical, cultural, and economic development of China, and continues today to be used today for water, irrigation, sanitation, transportation, and industry.

OPPOSITE:
Great Bend of Jinsha River, Yunnan, China
The Jinsha, or Lu, River is a major headstream of the Yangtze River which flows through the provinces of Qinghai, Sichuan, and Yunnan in western China. Hemmed in by mountains, at Shigu in Yunnan the river takes a sharp turn to run northeast, making a photogenic, moon-shaped loop.

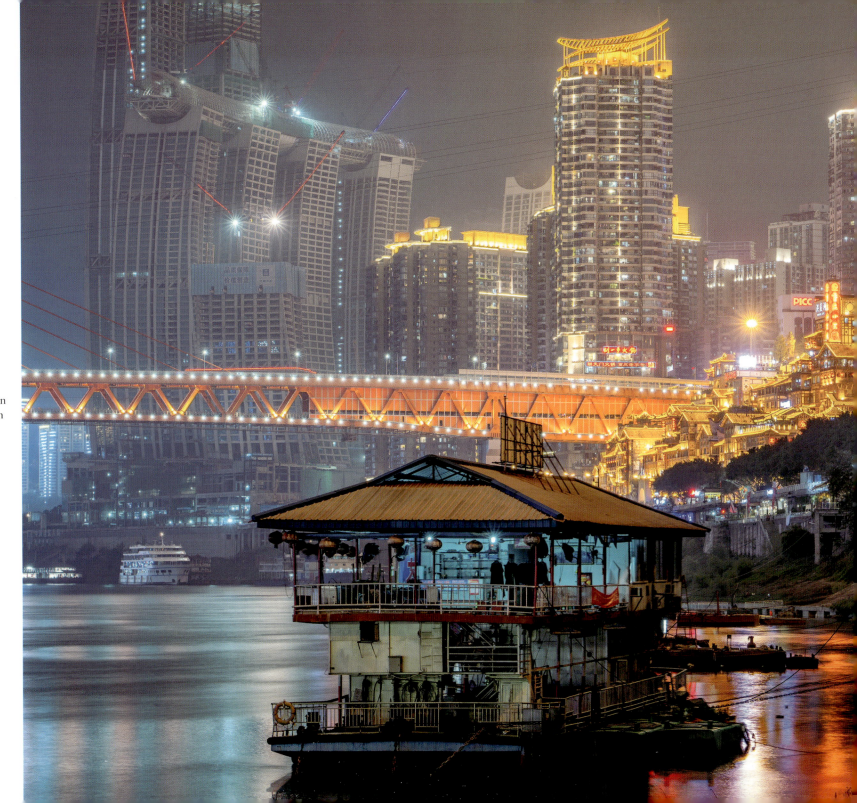

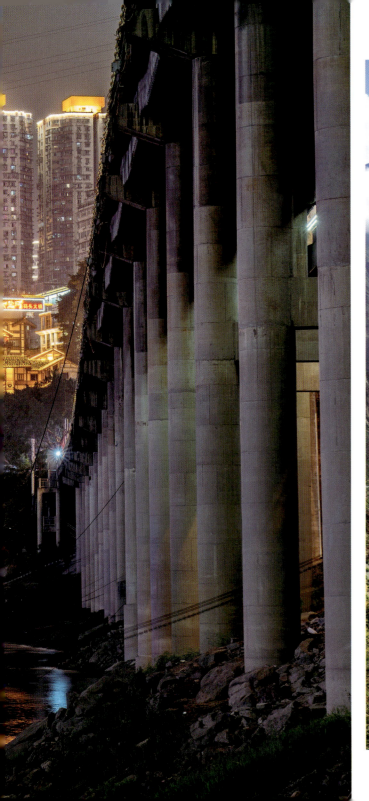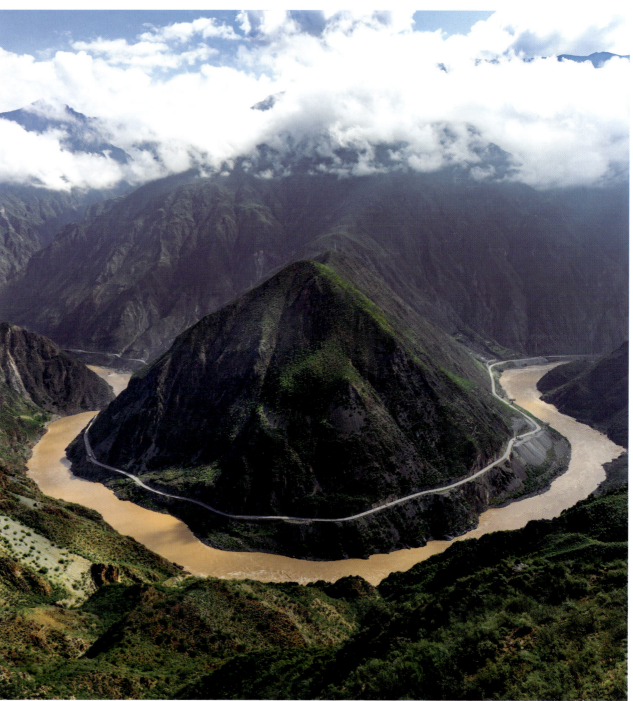

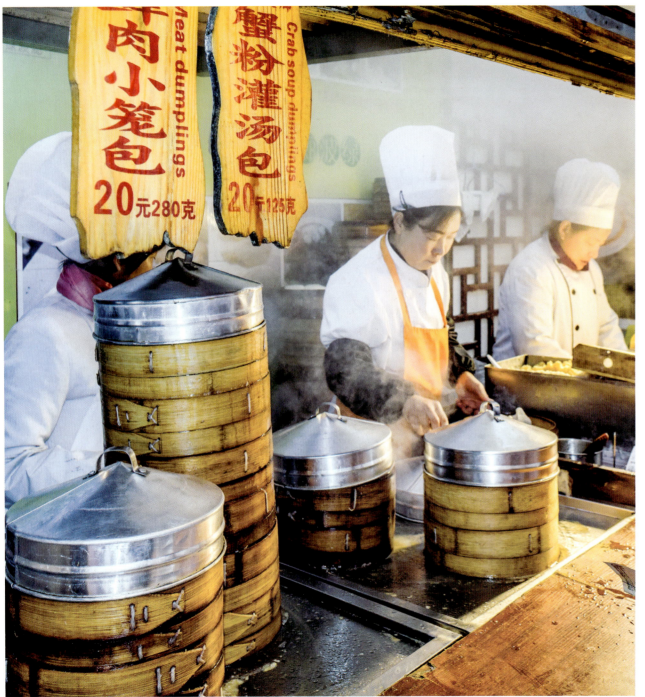

LEFT:
Preparing dumplings, Shanghai, China
Shanghai is known for its excellent food and is particularly famous for its dumplings. *Xiaolongbao*, the small, steamed buns typically filled with minced pork or crab meat and a delicious savoury broth, are available on streets across the city, usually prepared traditionally in bamboo steamers.

RIGHT:
Tiananmen Square, Beijing, China
Tiananmen Square is a symbol of Chinese national pride and identity. Built in 1651 in front of the earlier Ming Dynasty Tiananmen ('Gate of Heavenly Peace') in the Imperial City wall, the square was where Mao Zedong proclaimed the founding of the People's Republic of China in 1949. It is also the site of the Tiananmen Massacre of 1989.

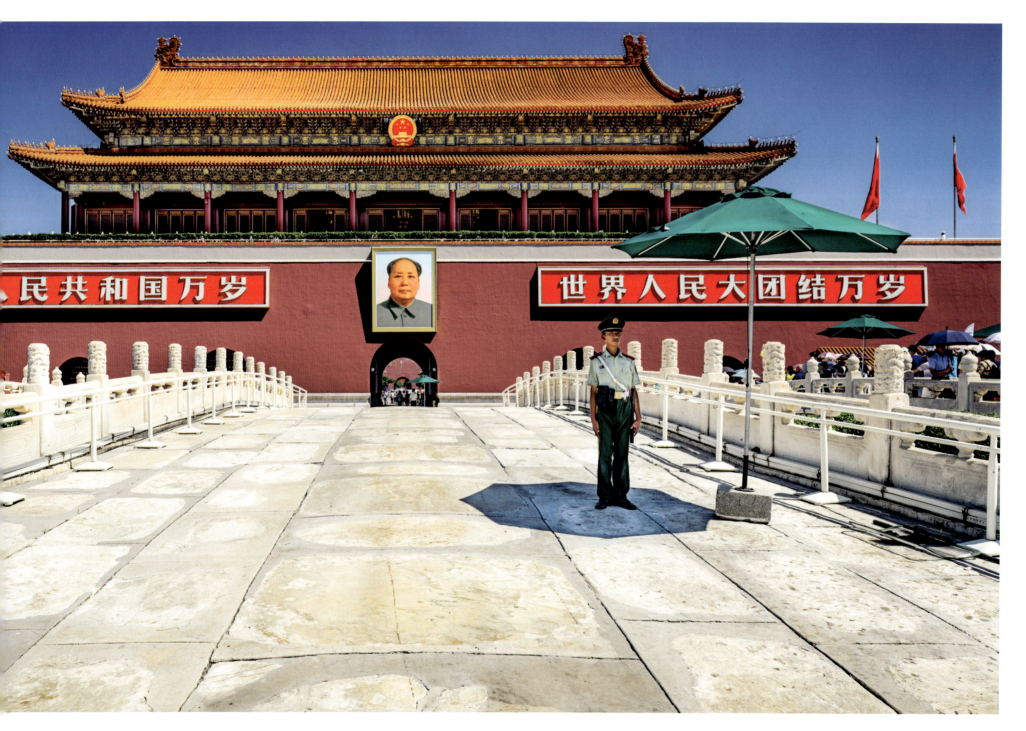

RIGHT AND OPPOSITE:
Huangshan, Anhui province, China
Literally meaning 'Yellow Mountain(s)', Huangshan is famous for its magnificent scenery with towering granite peaks rising up out of a sea of clouds and Huangshan pine trees, which are endemic to the mountains of eastern China, clinging to improbable ledges. The mountain range has inspired Chinese poets since the Tang Dynasty (eighth century CE).

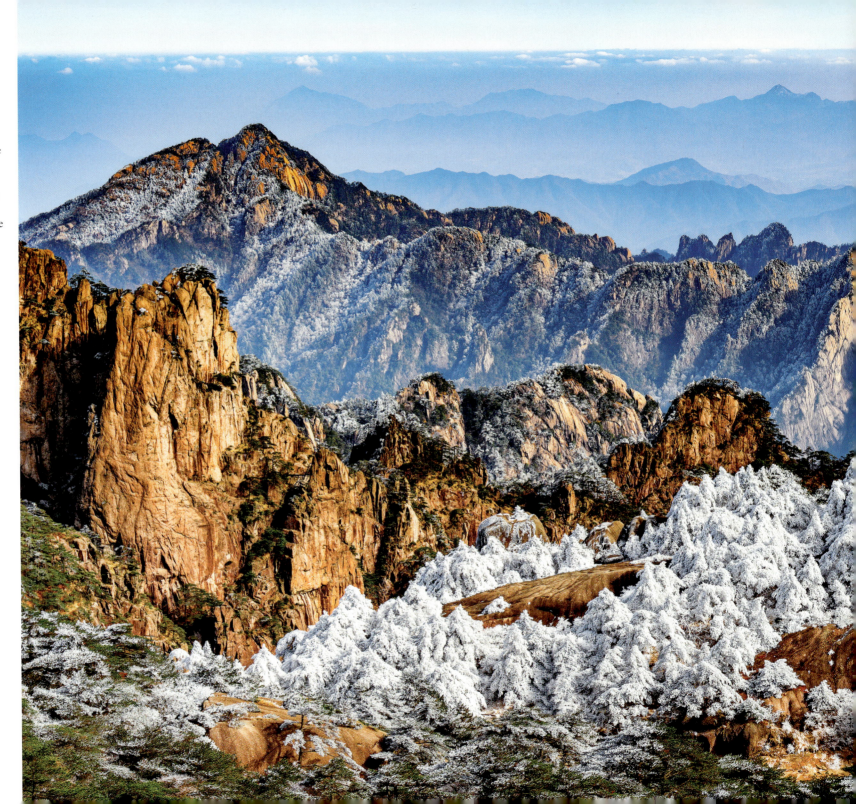

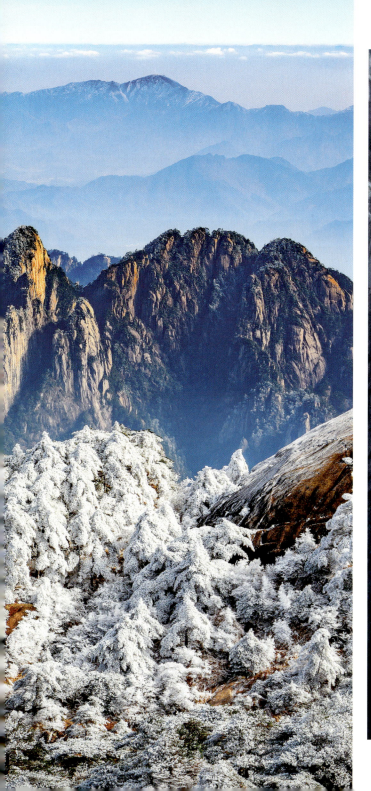
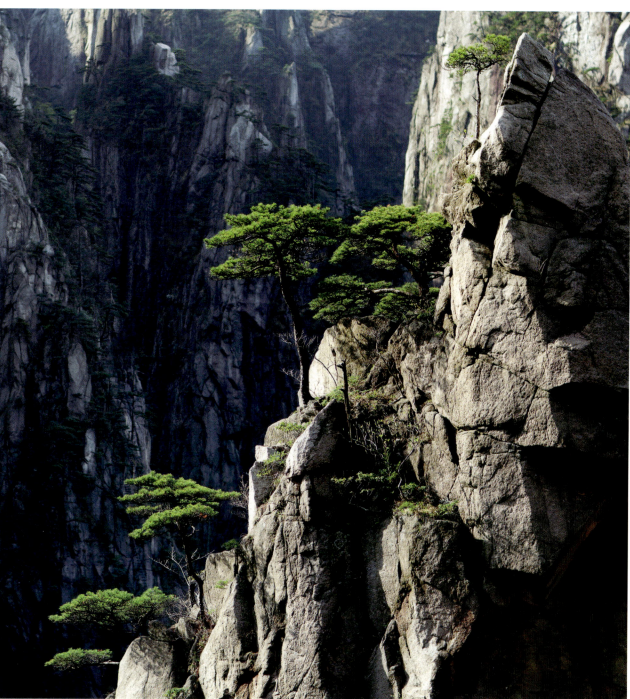

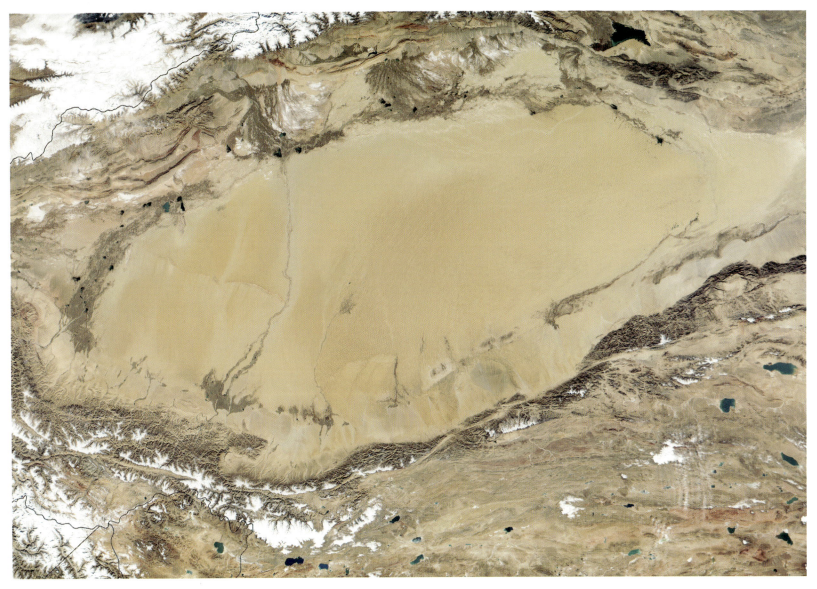

BOTH PHOTOGRAPHS:
Taklamakan Desert, Xinjiang province, China
The shifting sands of the Taklamakan Desert are stunningly beautiful but treacherously dry. Two branches of the ancient Silk Road bypassed the arid wasteland by following its northern and southern edges. Mummies, some 4000 years old, have been unearthed in sand-buried ruins in the desert.

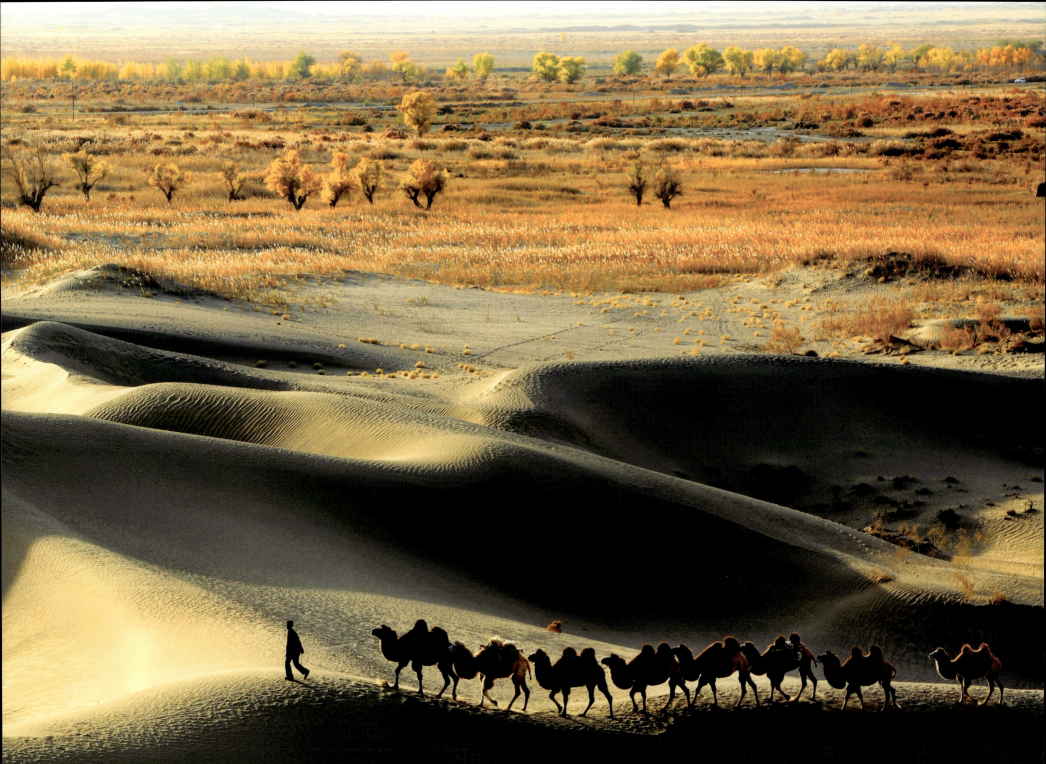

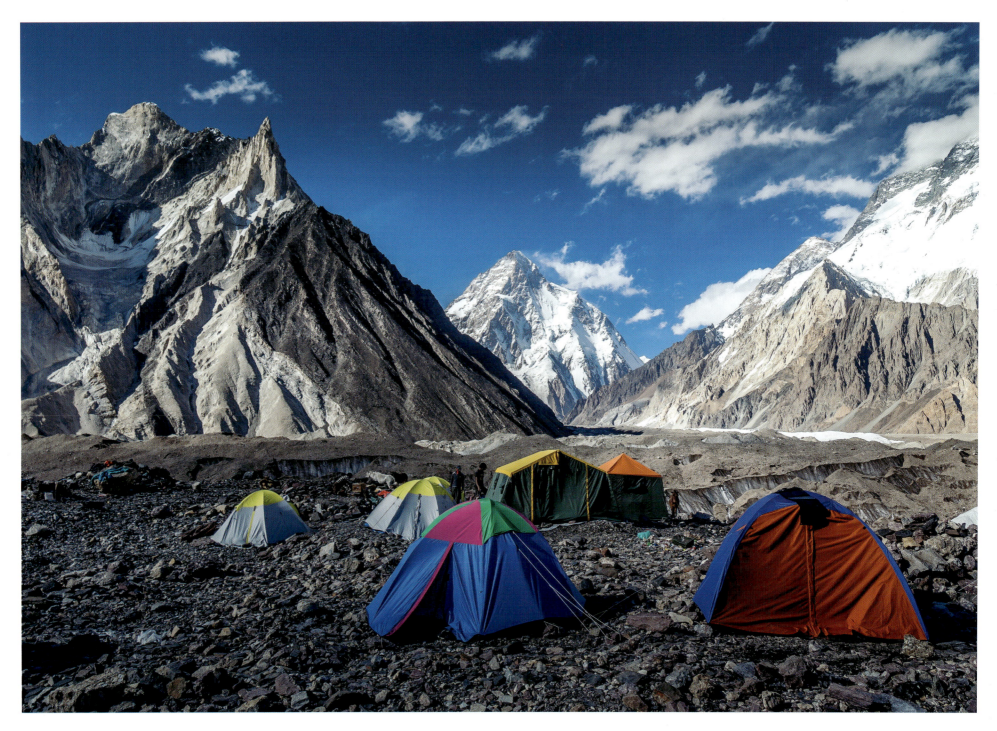

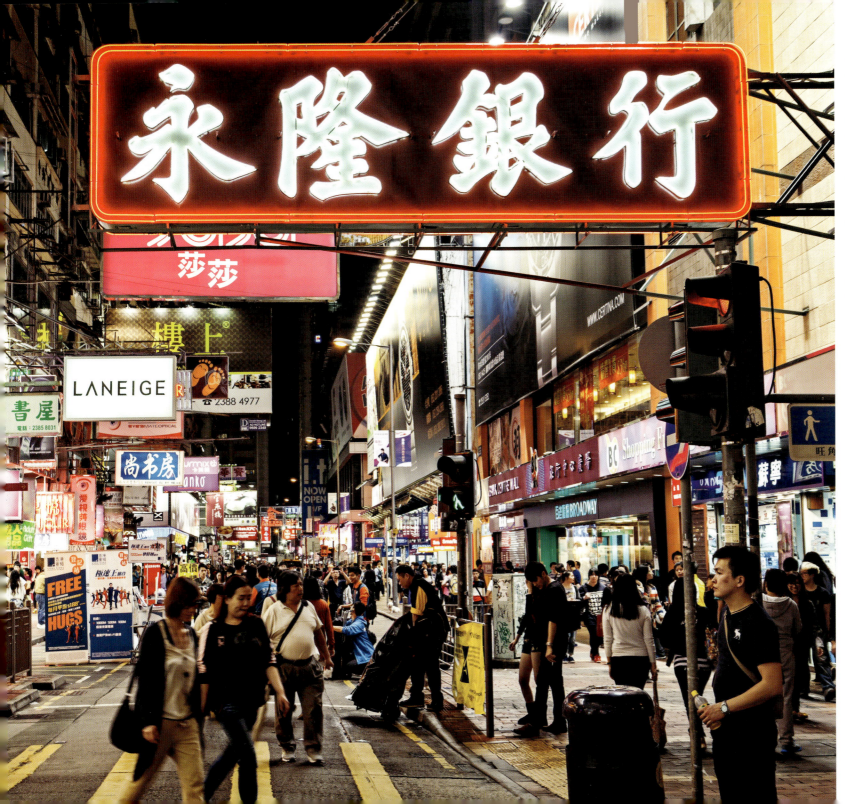

OPPOSITE:
K2, Xinjiang, China
K2 (8611m or 28251ft above sea level) in the Karakoram mountains lies partly in the Gilgit-Baltistan region of Pakistan-administered Kashmir and partly in the China-administered Trans-Karakoram Tract in Xinjiang. It is the second-highest mountain on Earth, but the deadliest of the highest five, with more than 10% of attempted ascents resulting in death. The mountain was first conquered in 1954.

LEFT:
Mong Kok, Kowloon, Hong Kong
Busy and buzzing, Mong Kok's streets are an endless opportunity for retail therapy: in the ground floor shops, but also tucked away on the upper floors of buildings. Droves of locals and tourists also come for the markets, including the Ladies Market, Fa Yuen Street, Goldfish Market, Sneaker Street, and Flower Market Road.

RIGHT:

Big Buddha, Lantau Island, Hong Kong

Almost 300 steps lead up to the 34m (111ft) tall, bronze Tian Tan Buddha, which was built by the nearby Po Lin Monastery in 1993. In a hall beneath the statue are relics of Gautama Buddha, said to be some of his cremated remains.

OPPOSITE:

Peak Tram, Victoria Peak, Hong Kong

Taking a ride on the Peak Tram is a must-do on any visit to Hong Kong. Built in 1888, it is one of the world's oldest and most famous funicular railways. Climbing a steep slope to 396m (1299ft) above sea level, the tram delivers passengers to the top of The Peak, which offers jaw-dropping vistas of Victoria Harbour and the Kowloon peninsula.

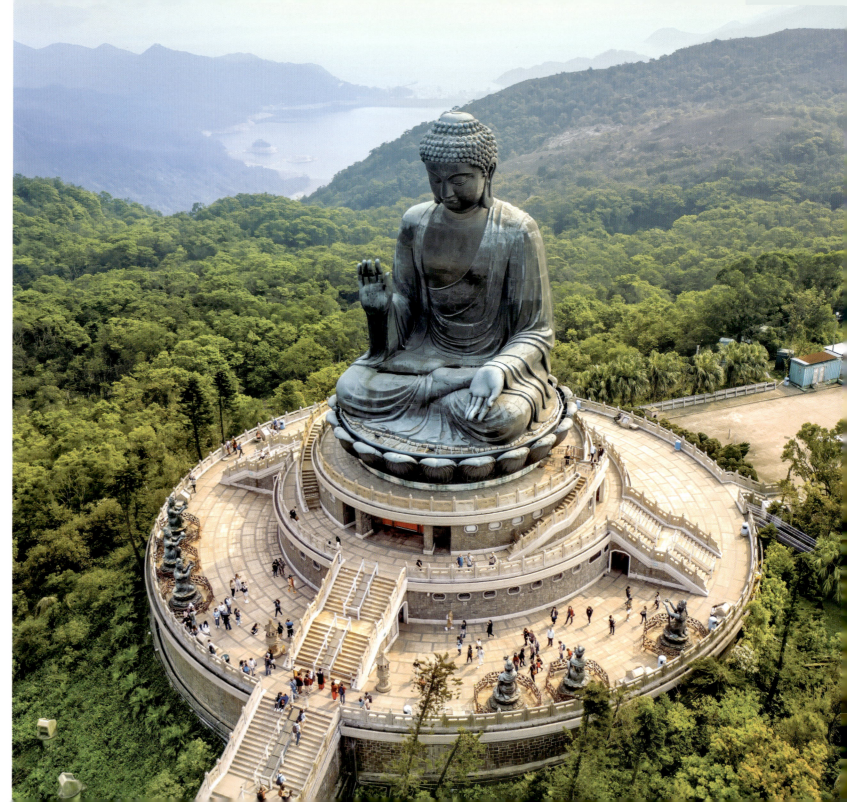

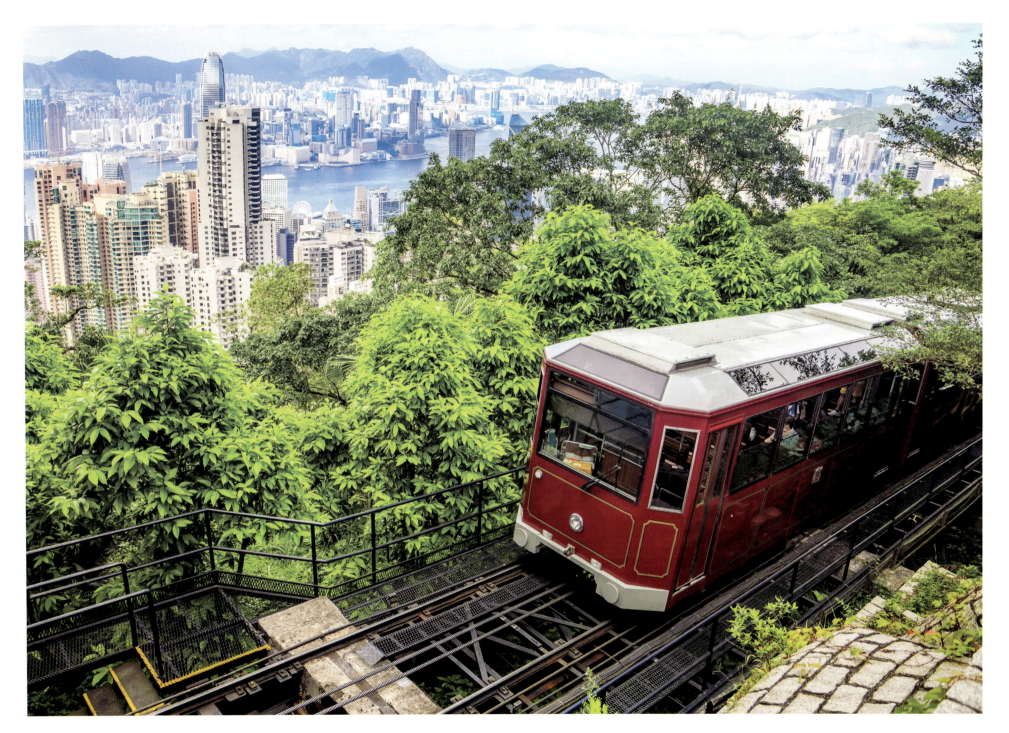

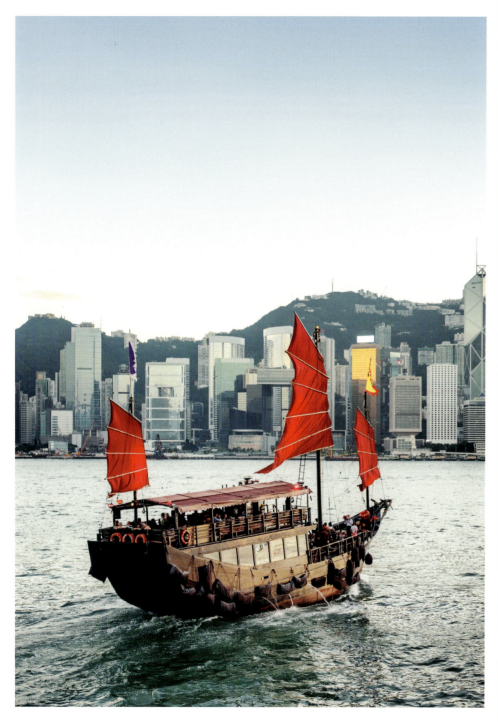
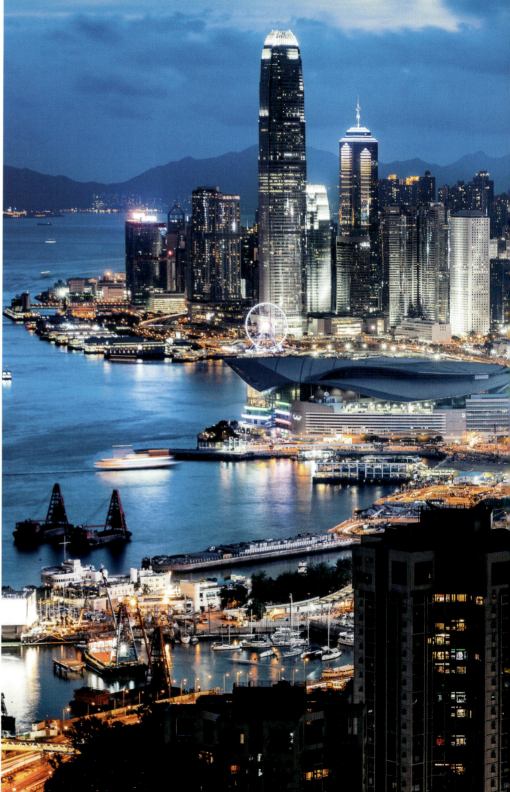

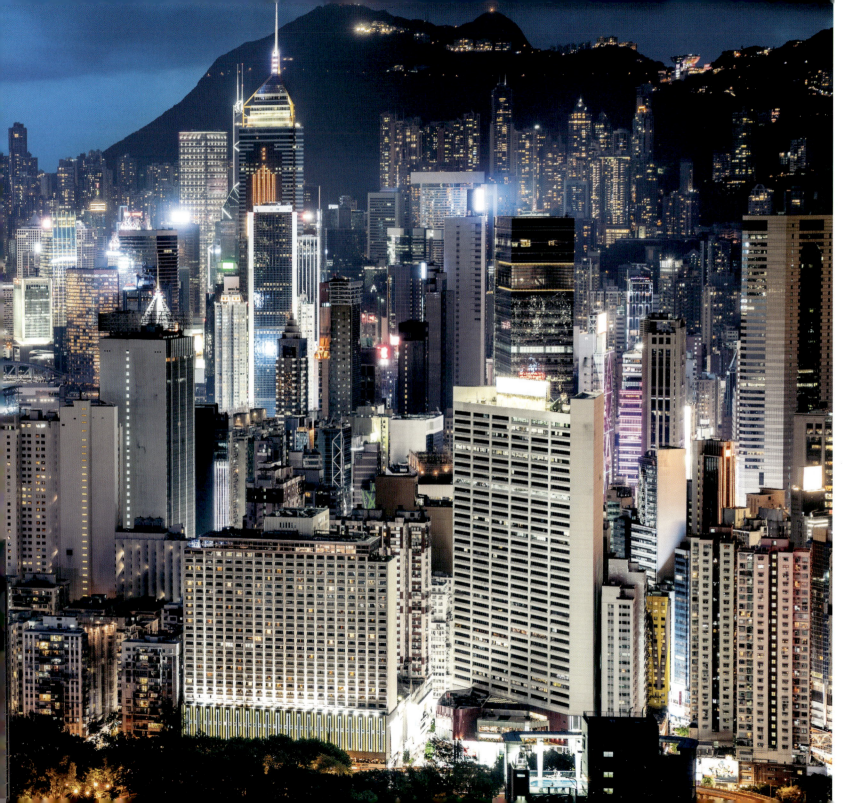

OPPOSITE:
Junk sailing across Victoria Harbour, Hong Kong
Traditional Chinese wooden sailing ships with red sails, known as junks, were once ubiquitous throughout the Pearl River Delta, including in Hong Kong. Today tourists can take a ride on a restored junk, or replica boats, that ply the waters of Victoria Harbour.

LEFT:
Victoria Harbour waterfront, Hong Kong Island, Hong Kong
Once a collection of traditional villages of indigenous Tanka fishermen, Hong Kong is now a city of lights and skyscrapers. The Hong Kong Island waterfront, stretching from Central to North Point, is one of the world's most stunning urban landscapes.

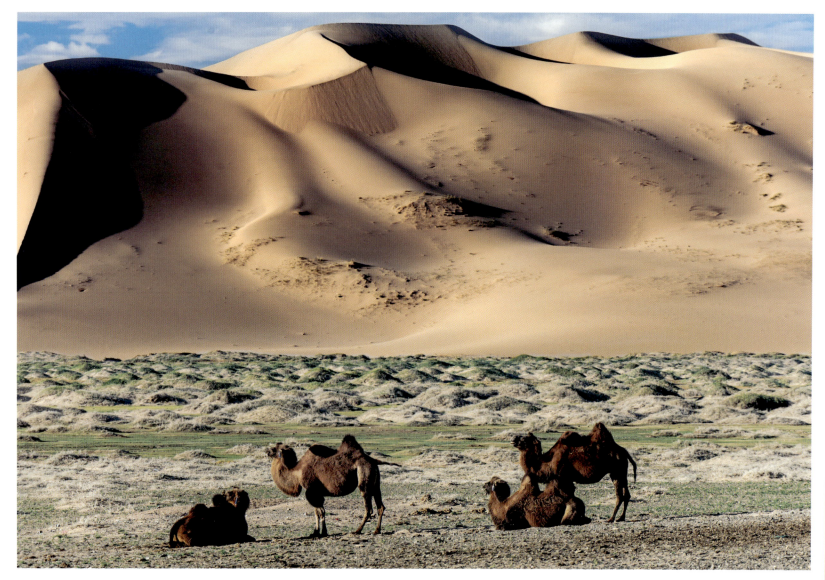

ABOVE:
Camels in the Gobi desert, Mongolia
Annual rainfall in the Gobi ('waterless place') is only about 40mm (1.5 inches), and temperatures range from 45°C in summer to minus 40 in winter. Bactrian camels in the Gobi can survive weeks without water while tolerating a water loss equal to 30 per cent of their body weight.

RIGHT:
Tsagaan Suvarga, Gobi Desert, Mongolia
Tsagaan Suvarga is a 400m (1312ft) long, zigzagging white-sand cliff that reaches 60m (196ft) high in places. The rock is striped with sedimentary deposits coloured purple, red, and orange. Once an ancient ocean floor, the area is known for its marine fossils.

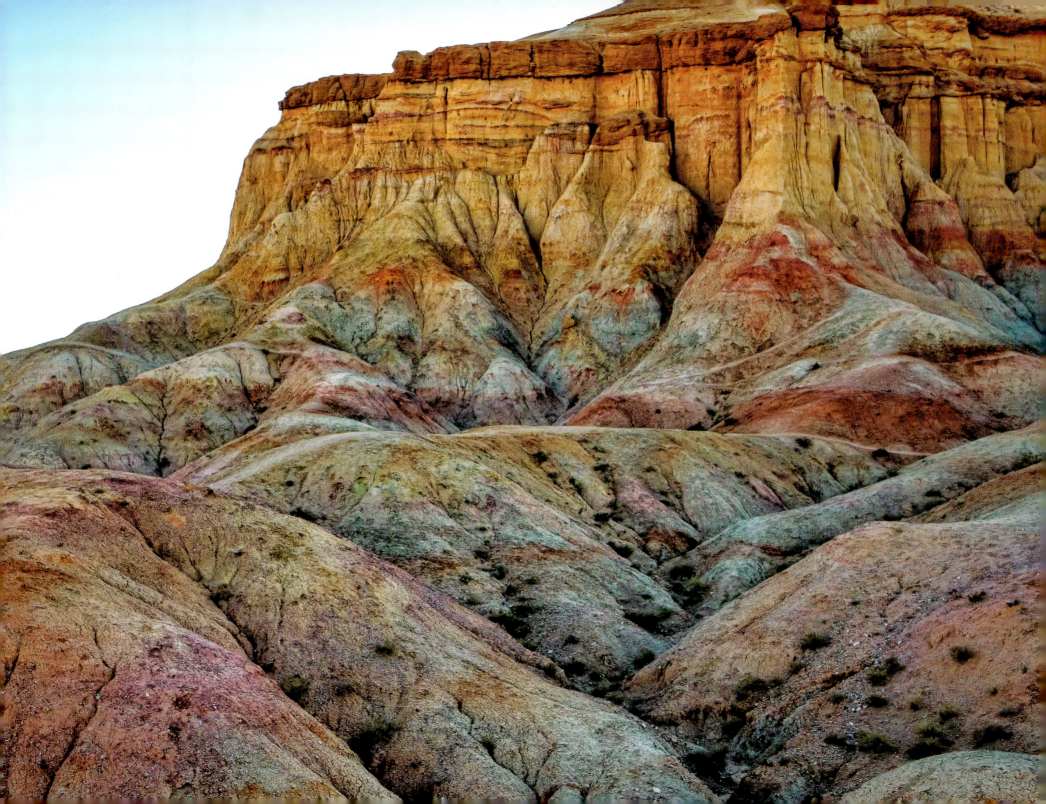

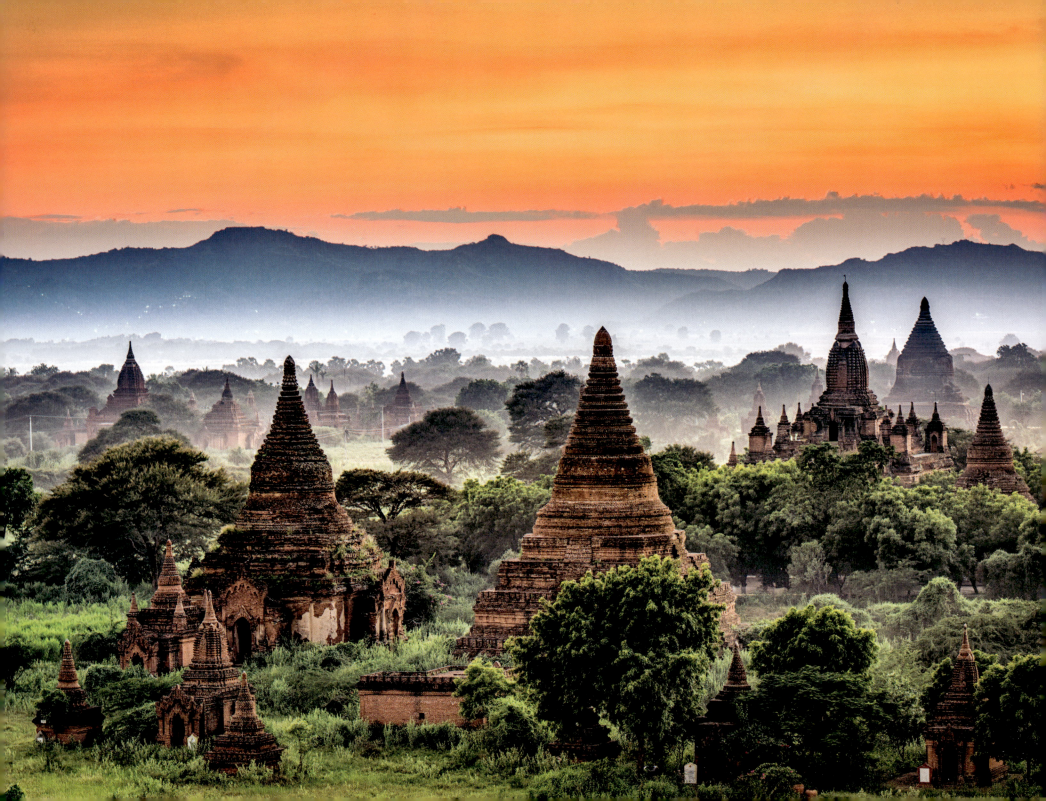

Southeast Asia

Fringed with white-sand beaches, crowned by volcanic peaks, blanketed in tropical rainforests, and dotted with glittering temples, Southeast Asia is a traveller's paradise.

For those interested in culture, the region has rich diversity, with millennia of influence from external powers shaping indigenous traditions and giving rise to new empires, from the Pagans of Burma to the Khmers of what is now Cambodia. The region has particularly strong ancient links to India and China, and these influences have shaped the region's art, architecture, and social structures.

Indian culture has profoundly impacted parts of Myanmar, Cambodia, Thailand, and the Indonesian archipelago, especially when it comes to religion: Theravada Buddhism spread here originally from India, while the island of Bali still today practises its own style of Hinduism in largely Islamic Indonesia.

Arab traders were largely responsible for introducing Islam to the region, while more recently European colonial powers made their mark. Southeast Asia's coveted spices, especially cloves, mace, and nutmeg from eastern Indonesia, attracted traders from across the world, whose own traditions merged with the local way of life.

Now, nations across mainland and maritime Southeast Asia are dynamic and developing rapidly. Vietnam, the Philippines and Indonesia are some of the world's fastest-growing economies. Many countries rely on tourism; while Southeast Asia today blends the old with the new, it has retained its age-old appeal as one of the world's most lively and diverse regions.

OPPOSITE:
Bagan, Mandalay Region, Myanmar
Between the eleventh and the thirteenth centuries, more than 10,000 Buddhist temples, monasteries, and pagodas stippled the expansive plains of Upper Burma on the bend of the Irrawaddy River. Here lay the ancient city of Bagan, the capital of the Pagan Kingdom, which united the regions that would go on to become today's Myanmar.

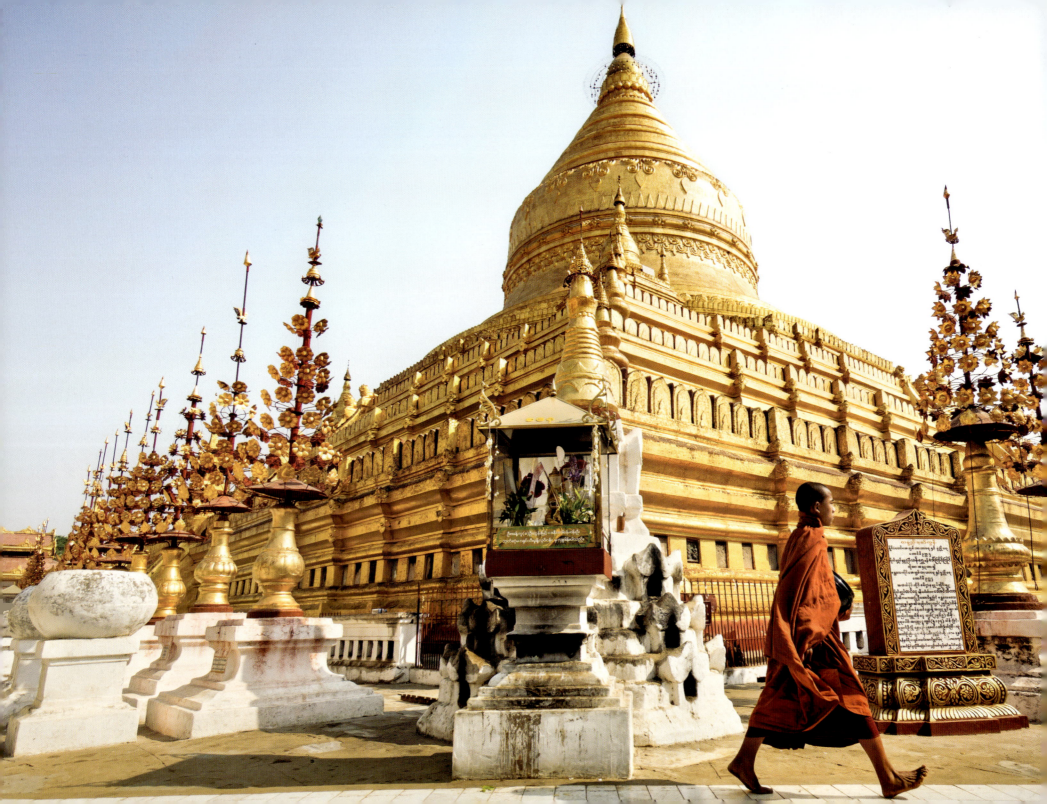

LEFT:
Shwezigon Pagoda, Bagan, Myanmar
This revered stupa was commissioned in 1059 by King Anawrahta, who founded the Pagan Empire, and was completed in 1102, during the reign of his son. It was designed in traditional Mon style, with a tall, richly ornamented spire atop a series of terraces.

RIGHT:
Young monks at study, Bagan, Myanmar
While some pagodas are solid, at Bagan many have interior spaces housing exquisite sculptures or religious relics – Shwezigon Pagoda is believed to have (or once have had) a tooth and bone of Gautama Buddha inside. These cool rooms are quiet places for prayer or study.

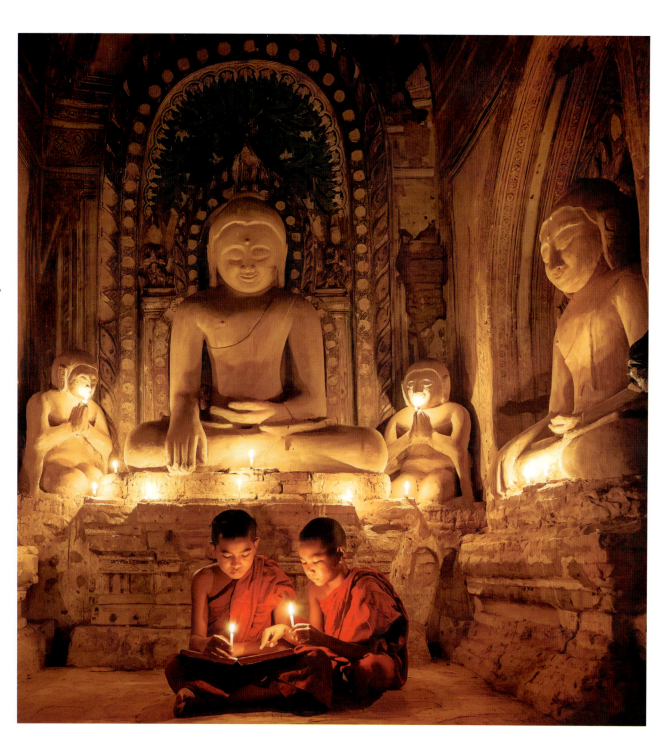

RIGHT:
Fishermen at Inle Lake, Shan State, Myanmar
The Intha people are known for their distinctive rowing style, with one leg on the stern and the other wrapped around the oar. Rowing standing up allows the fishermen to see and navigate around the many forests of reeds and floating plants that grow in the water.

OPPOSITE:
Stilted homes, Inle Lake, Myanmar
The Intha are devout Buddhists who live in simple homes of woven bamboo and wood perched on stilts above the lake. They are self-sufficient, fishing and growing vegetables in floating gardens that bob up and down on the nutrient-rich water. They also cultivate rice on the shores of the lake.

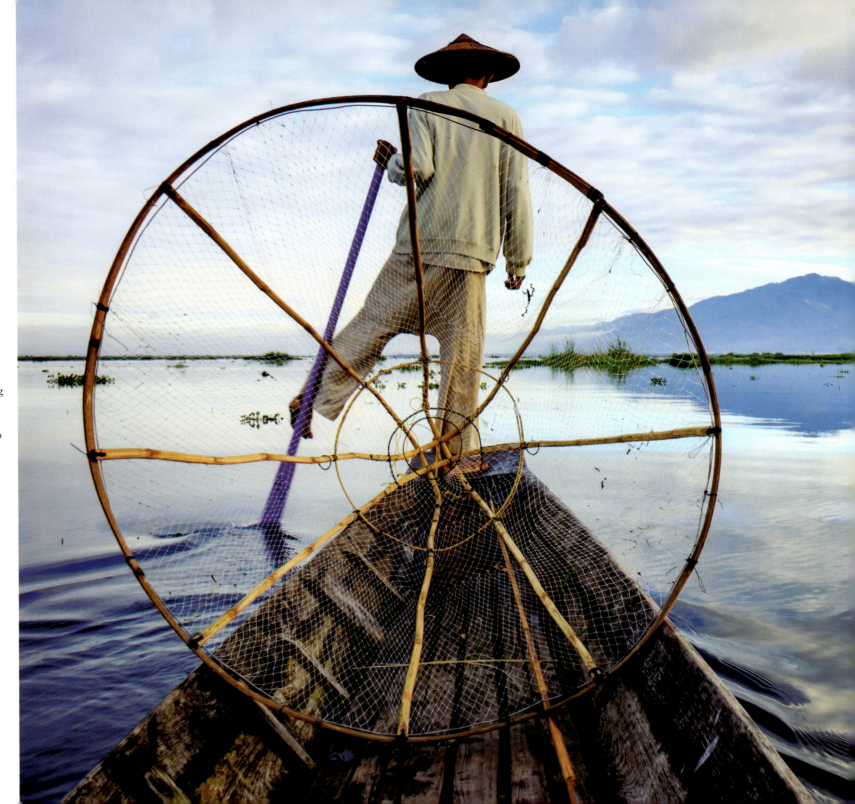

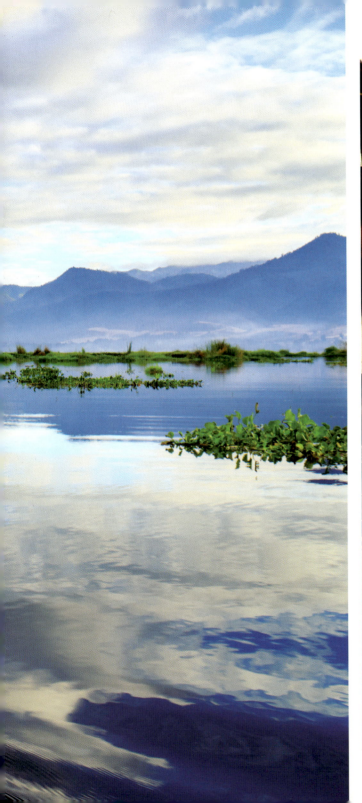
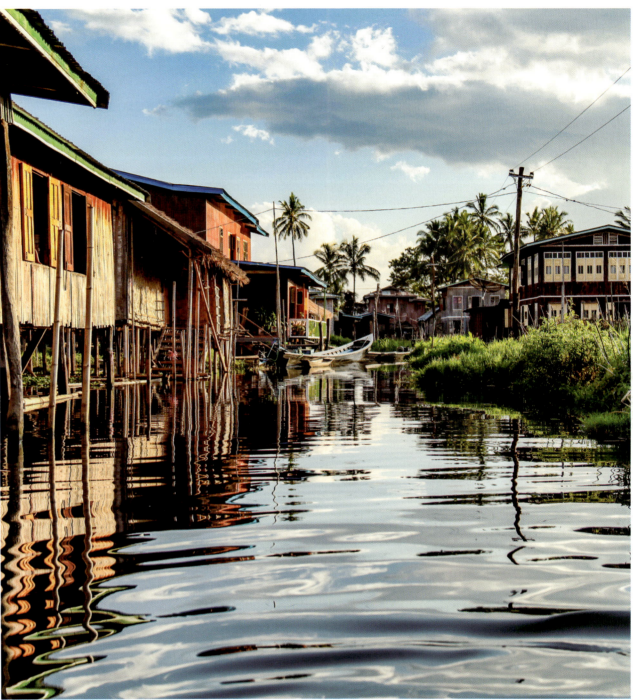

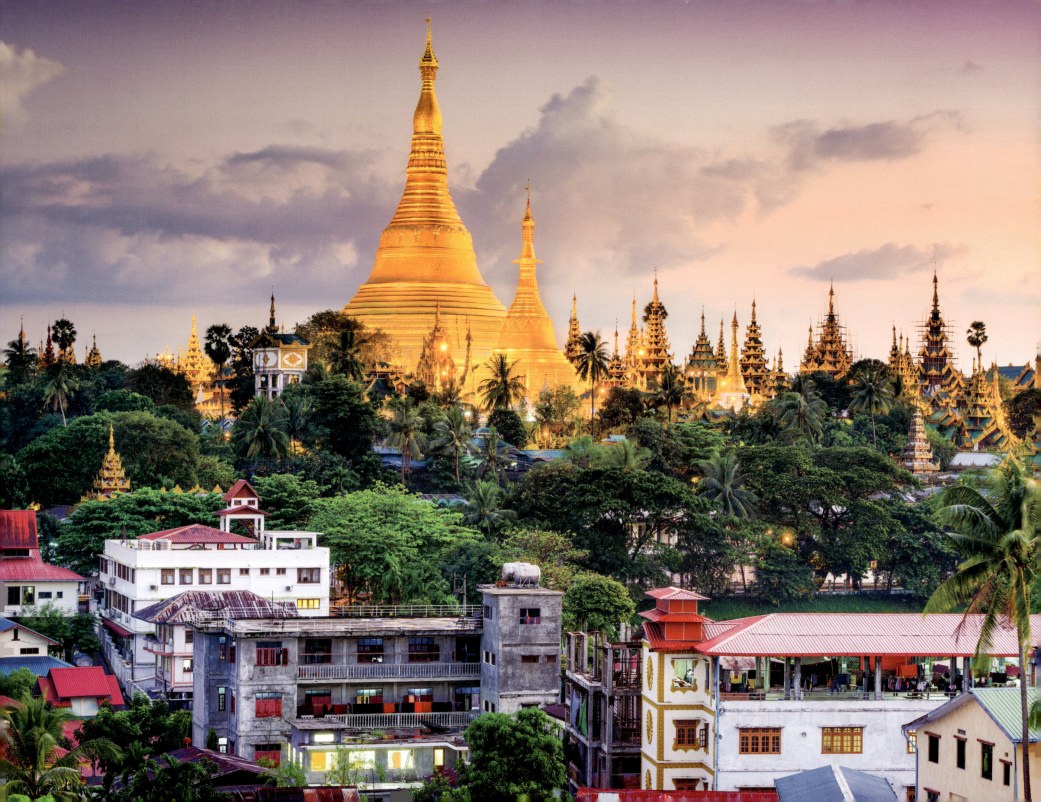

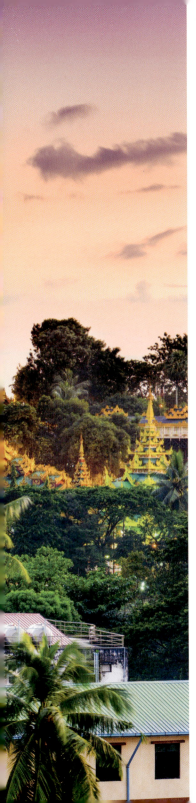
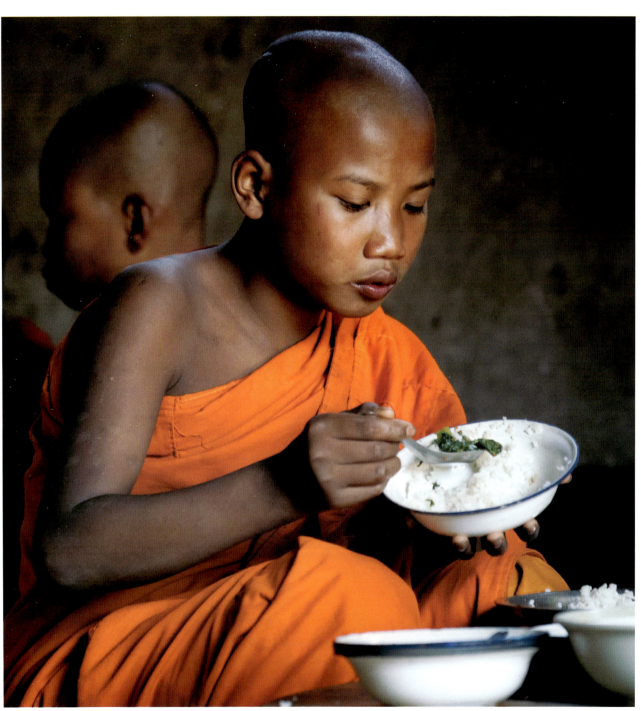

FAR LEFT:
Shwedagon Pagoda, Yangon, Myanmar
The most sacred Buddhist pagoda in Myanmar, Shwedagon Zedi Daw, as it is officially called, is said to contain the relics of four previous Buddhas, including eight strands of hair from the head of Gautama Buddha. Restrictions on the height of new buildings in Yangon ensure the pagoda remains prominent on its hill above the city.

LEFT:
Novice monk at Ko Yin Lay Monastery, Keng Tung, Myanmar
There are some half a million monks in Myanmar, and an estimated 75,000 nuns, in a population of 54 million. Around 90 per cent of the people in Myanmar are Buddhist, practising Theravada Buddhism overlapping with the worship of god-like spirits called *nats*.

Angkor Wat, Siem Reap, Cambodia

The largest religious monument on Earth, Angkor Wat is one of the great cultural wonders of the world. It was built by the Khmer King Suryavarman II in the first half of the twelfth century and marks the high point of Khmer architecture.

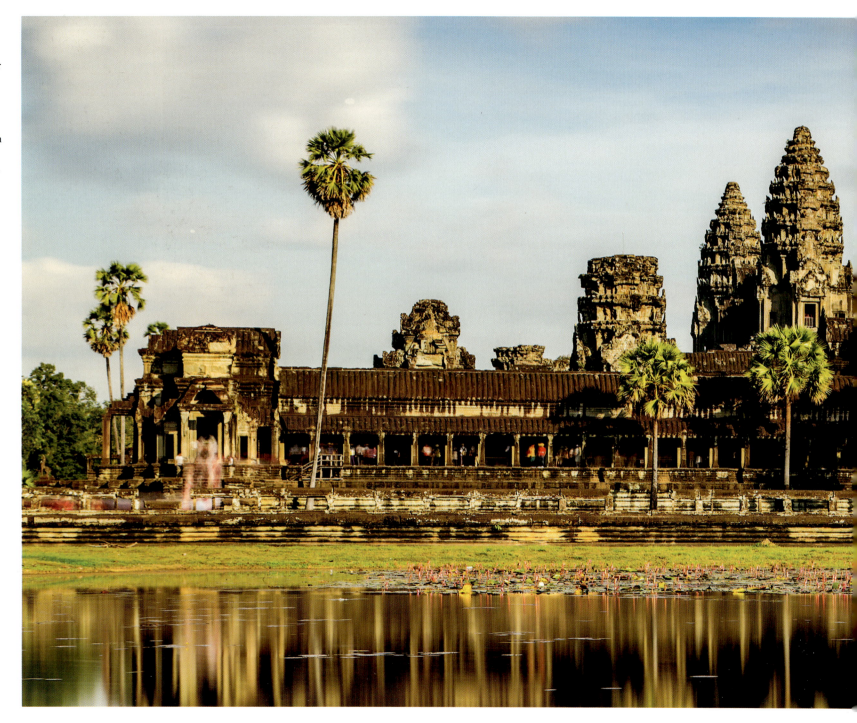

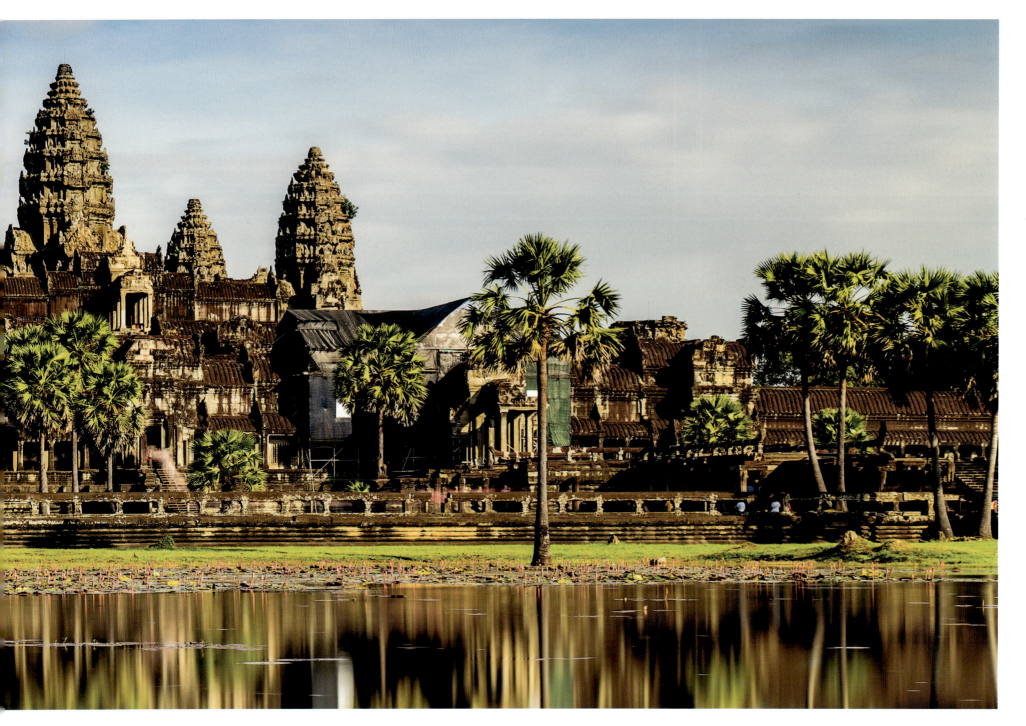

RIGHT:
Bayon, Angkor Thom, Cambodia
Angkor Thom was the last capital city of the Khmer Empire, established in the late twelfth century by Cambodia's most celebrated king, Jayavarman VII. At the city's heart was Bayon, the entrancing state temple with its 54 towers decorated with 216 enormous smiling faces of Avalokiteshvara.

OPPOSITE:
Ta Prohm, Siem Reap, Cambodia
Originally called Rajavihara ('Royal Monastery'), Ta Prohm was built by King Jayavarman VII in 1186. The temple was built without mortar and, after it was abandoned due to the fall of the Khmer Empire in the fifteenth century, jungle plants took root among the stones.

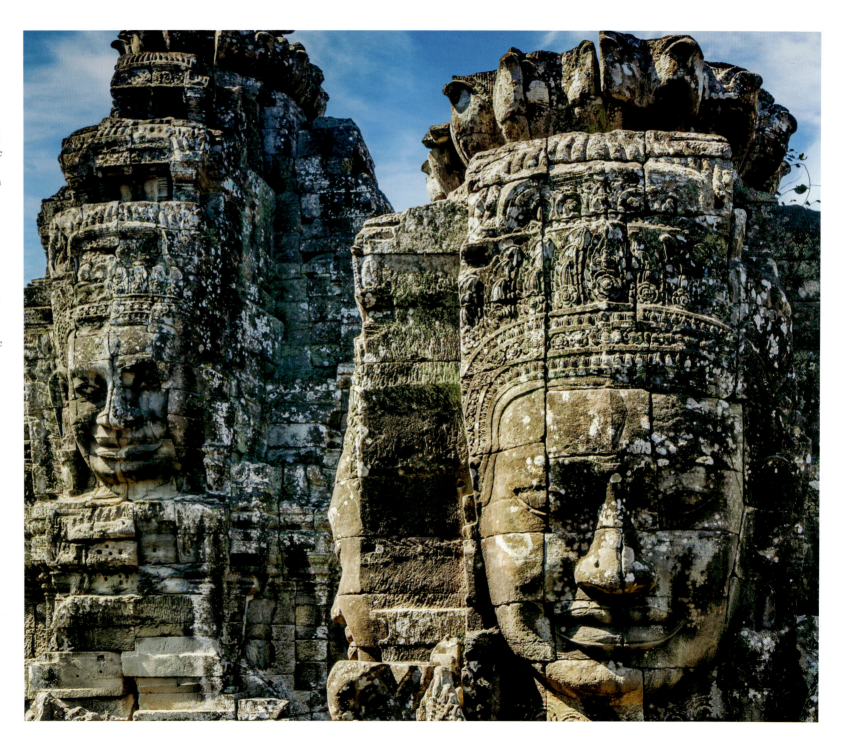

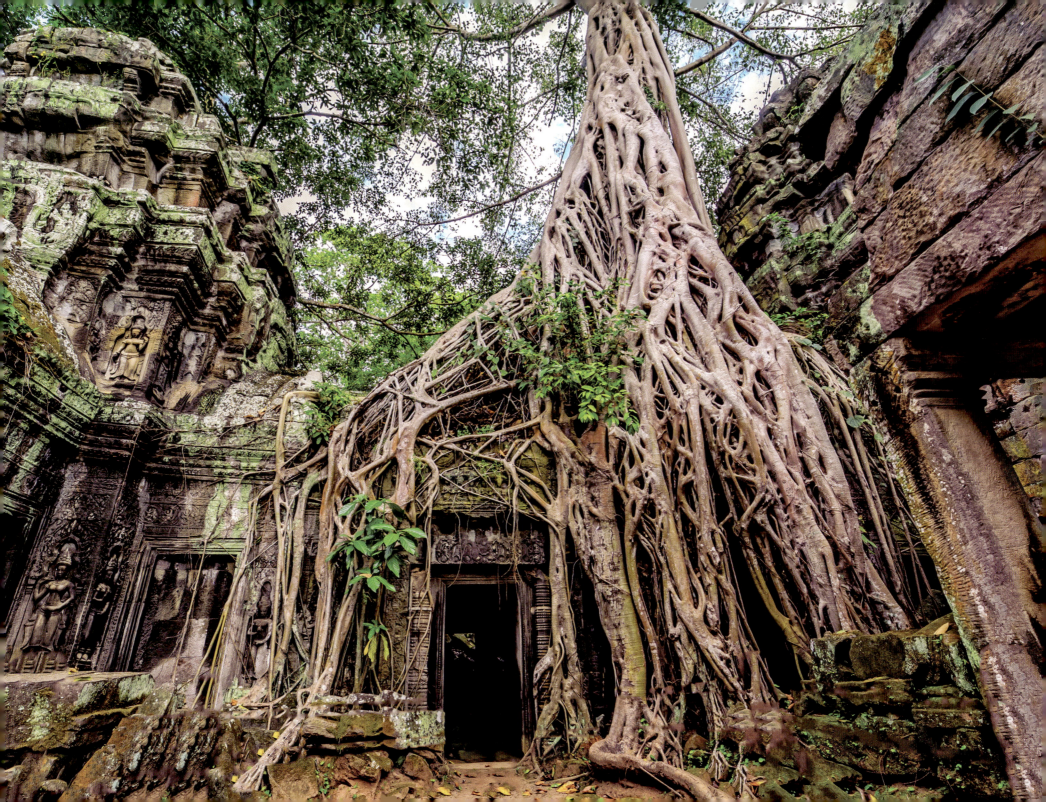

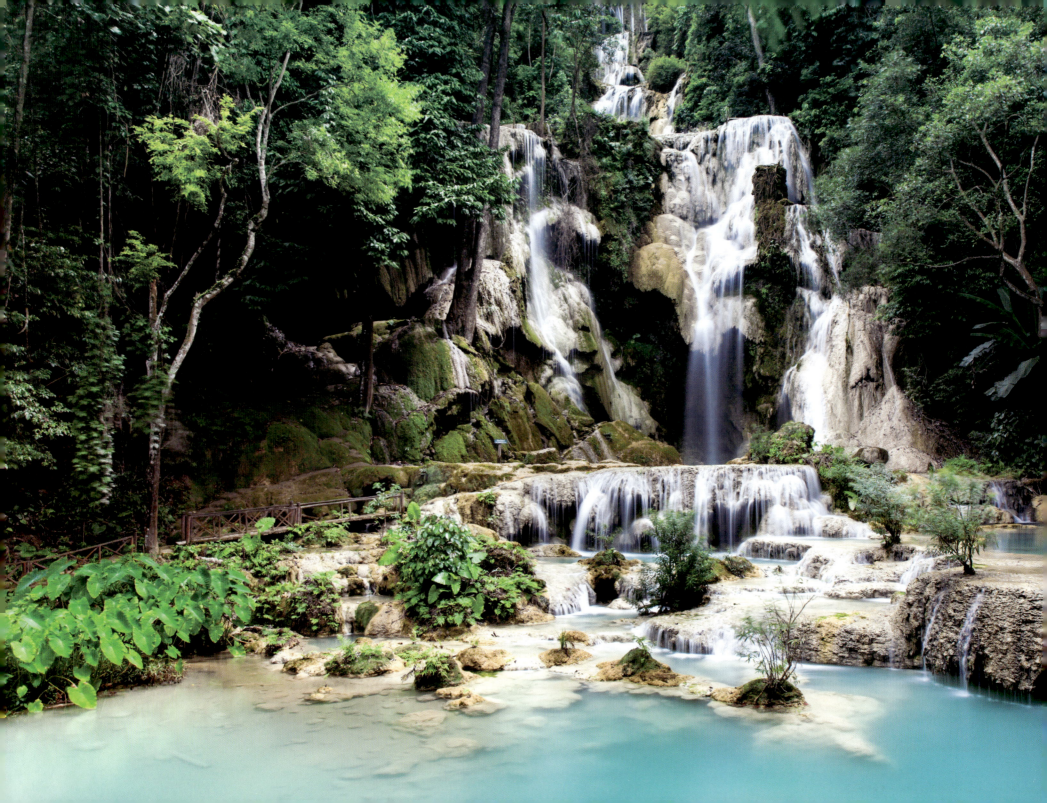

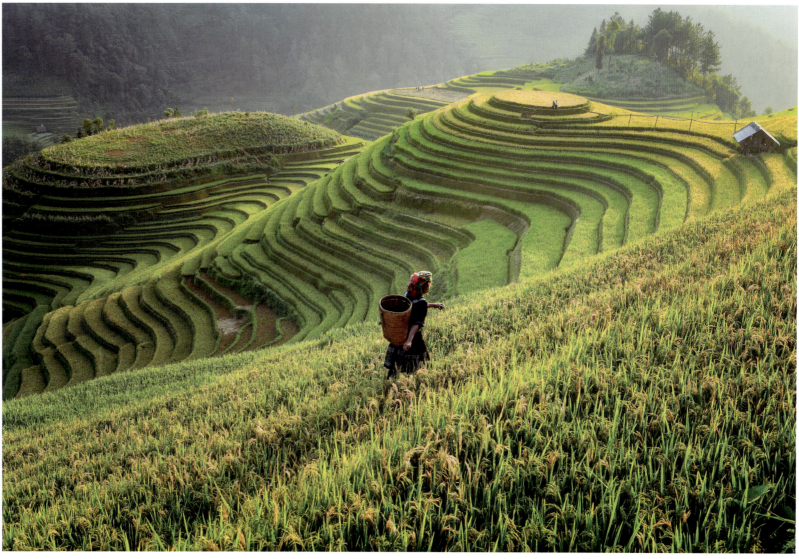

LEFT:
Kuang Si Falls, Luang Phrabang, Laos
Water from shallow pools on a steep hillside tumbles down more than 60m (196ft) at Kuang Si Falls, also known as Tat Kuang Si Waterfalls. The three tiers of the waterfall cascade into a turquoise blue pool before continuing downstream, disappearing into the jungle.

ABOVE:
Terraced rice field, Mu Cang Chai, Vietnam
North Vietnam's Mu Cang Chai region has some of Asia's most magnificent cultivated topography. Here, rice terraces that wrap around the sheer hillsides have been built and planted by hand, particularly by the Black Hmong people, for centuries.

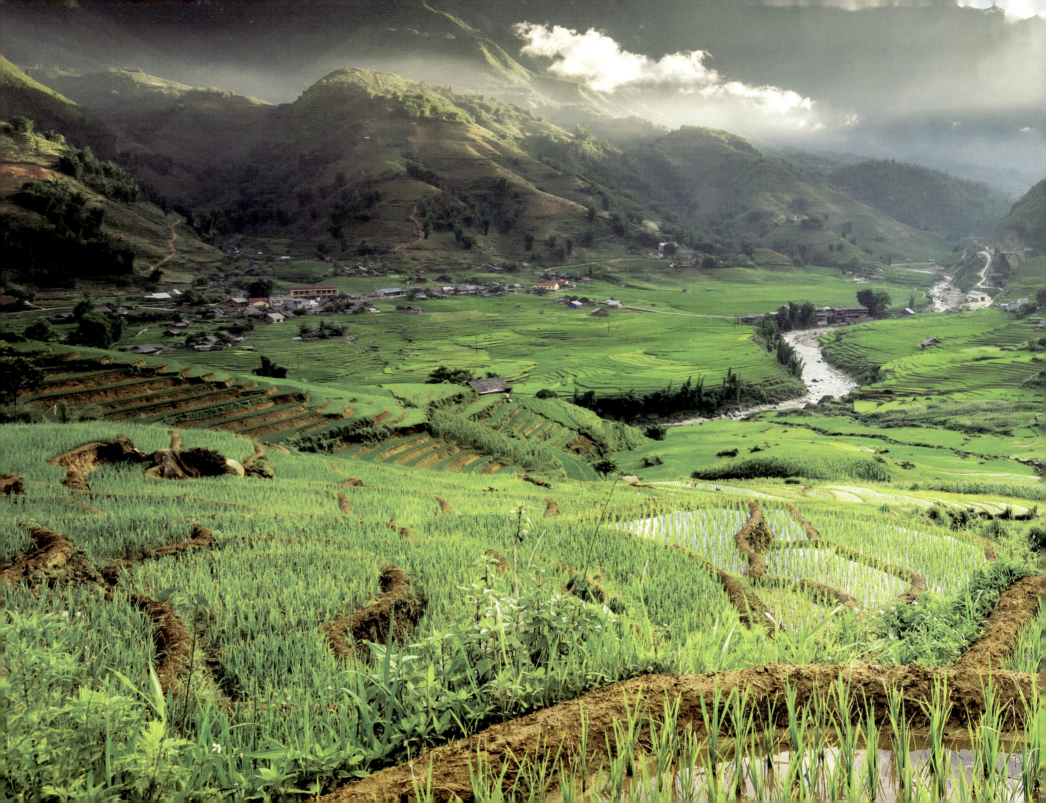

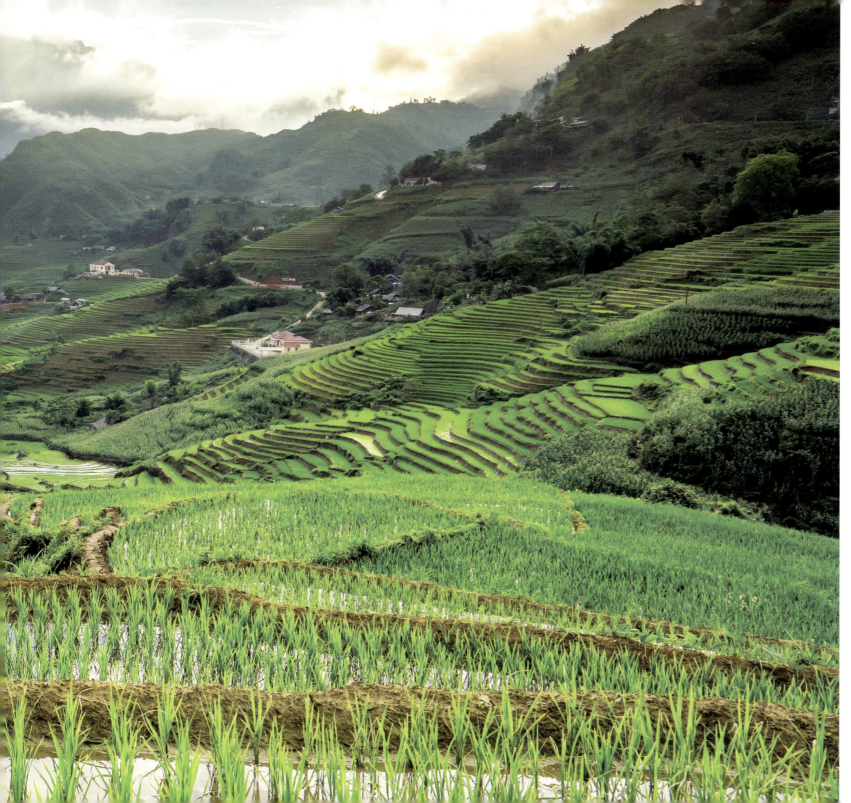

Rainy season rice terraces, Sapa, Vietnam
In summer, when the rains come, the rice that was planted in spring begins to ripen, blanketing the hills in vibrant green. When the rice turns yellow in autumn, it is ready to harvest. In winter, the terraces fill with water, turning into reflective pools lining the hillsides.

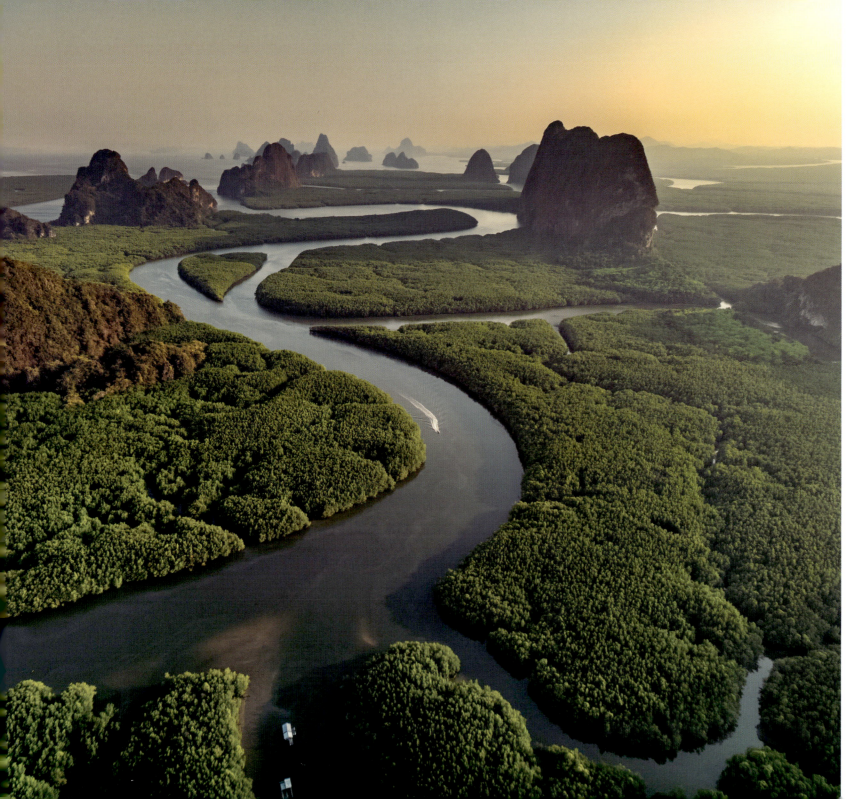

LEFT:

Phang Nga Bay, Phang Nga, Thailand
Limestone formations in extraordinary shapes rise up out of emerald-green mangrove forests in this bay in the Andaman Sea between Phuket island and the mainland of southern Thailand. Most of the bay's 400km² (40000 hectares) is protected as a national park.

RIGHT:

Ko Tapu, Phang Nga Bay, Thailand
Also known as James Bond Island, the limestone karst finger of Ko Tapu ('Crab's Eye Island'), along with Khao Phing Kan ('Hills Leaning Against Each Other') pictured to the right, were made famous in the 007 film *The Man with the Golden Gun* (1974).

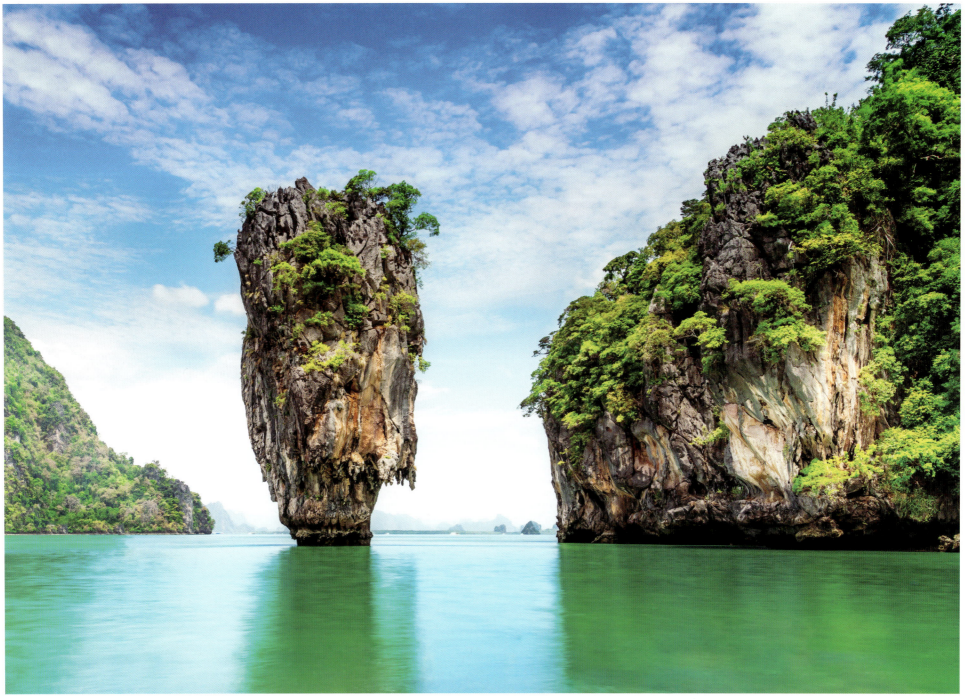

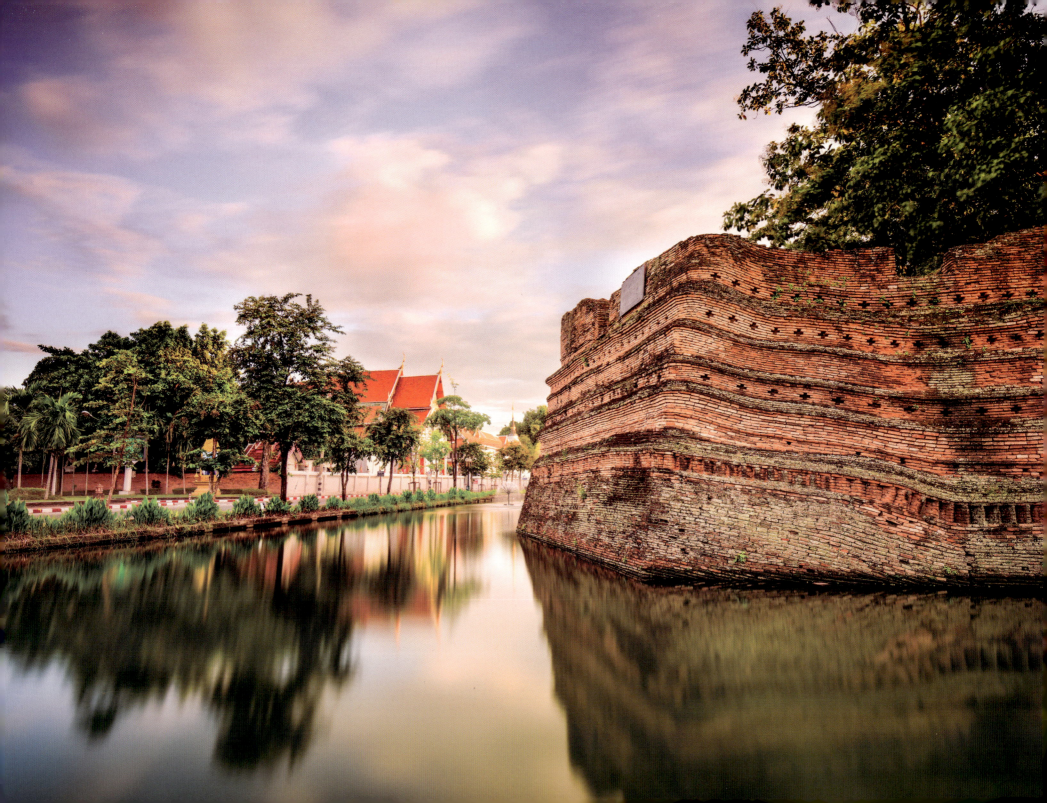

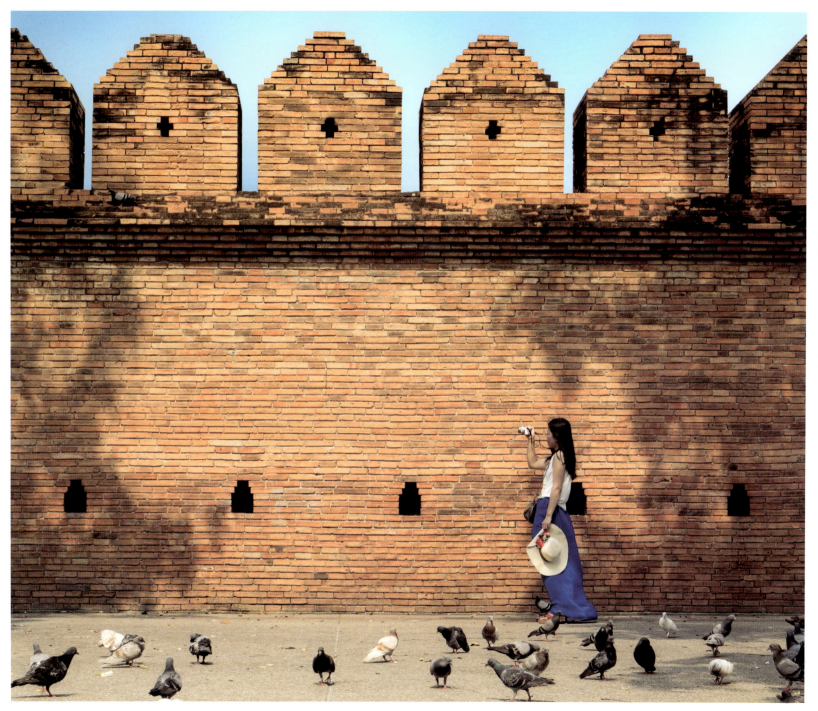

OPPOSITE:

Old city walls and moat, Chiang Mai, Thailand
King Mengrai founded Chiang Mai, the new capital of his Lanna kingdom, in 1296. The protected the city with defensive walls and a moat. While many old cities in Thailand had moats, Chiang Mai is almost the only one where it remains a significant part of the architecture.

LEFT:

Old city walls at Thapae Gate, Chiang Mai, Thailand
The square of medieval walls enclosing old Chiang Mai are punctuated by four gates, one on each side. On the eastern wall is Thapae Gate ('Tha' in Thai means 'Harbour'), which directly connected to the Mae Ping river. Two more gates were added in later years.

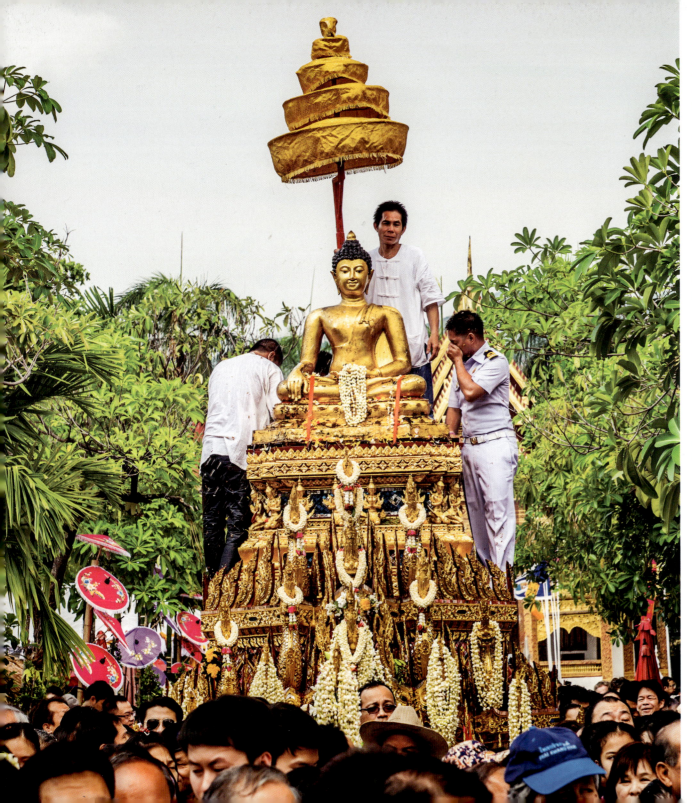

LEFT:

Songkran Festival, Chiang Mai, Thailand
Every Songkran, the Thai New Year celebrated annually on 13 April, spectators sprinkle water over the revered Buddha Phra Singh statue as it is taken from Phra Singh temple for a procession. Sprinkling water represents purification and good fortune in Thai Buddhist culture.

RIGHT:

Lantern festival, Chiang Mai, Thailand
Two festivals combine in Chiang Mai to create a celebration of lights. Based on the lunar calendar, but usually in November, the Northern Thai festival of Yi Peng sees the release of sky lanterns, while Loy Krathong, a countrywide Buddhist festival, inspires the release of floating lanterns on rivers or lakes.

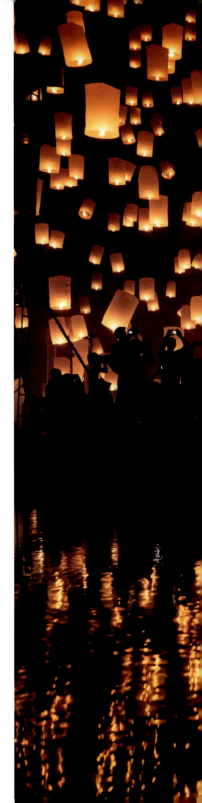

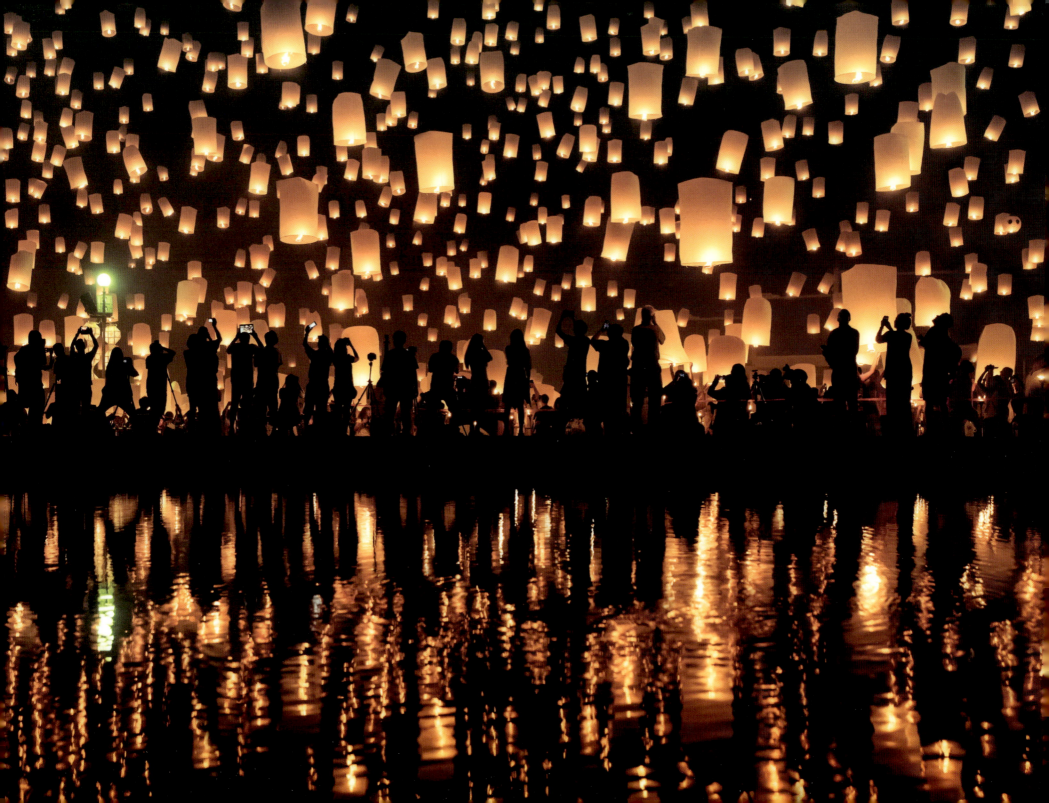

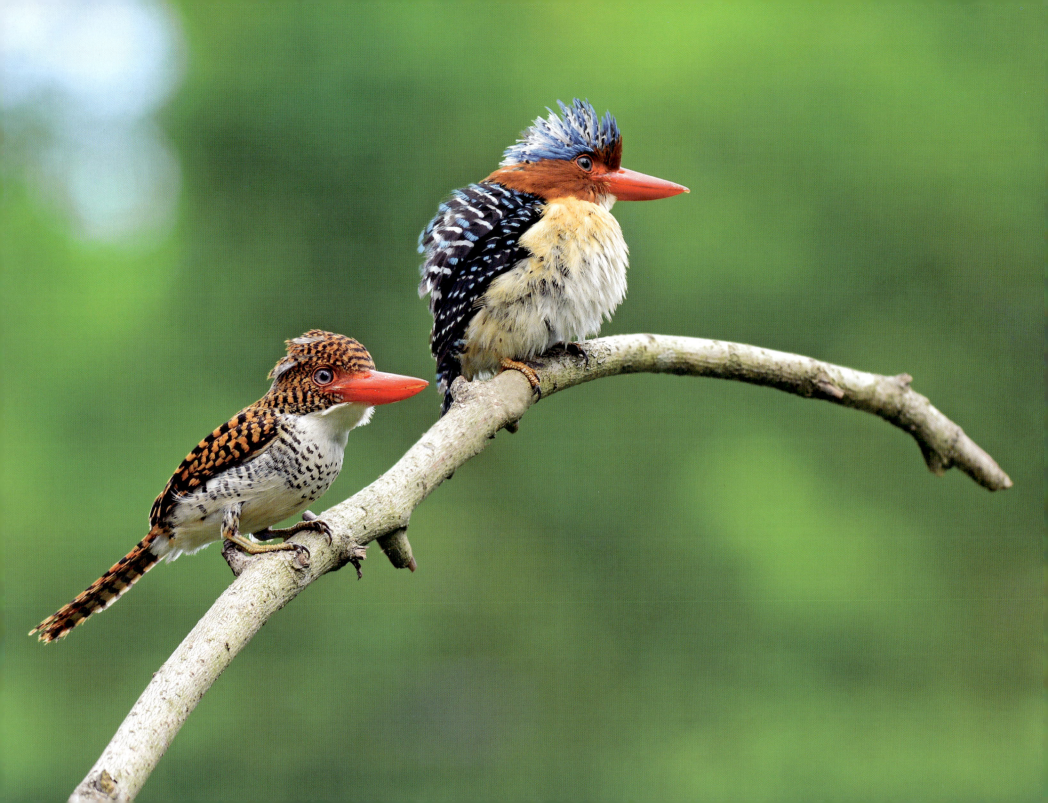

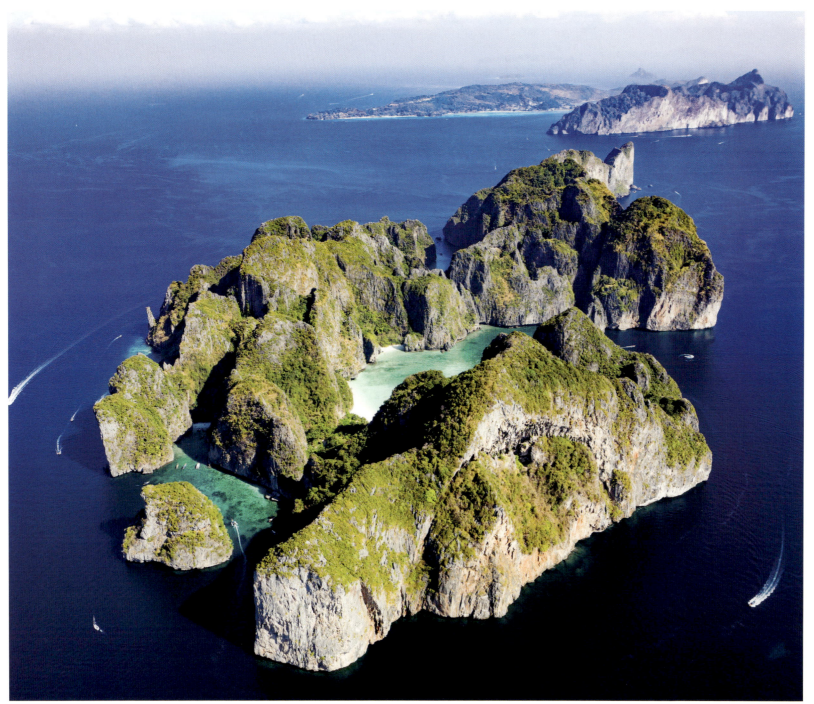

OPPOSITE:
Banded kingfishers
With its exceptionally high bird diversity, Thailand is a birdwatcher's paradise. The country is home to many colourful resident species, along with Palearctic and Himalayan migrants. The banded kingfisher (*Lacedo pulchella*) is a gorgeous forest inhabitant: the male has the bright blue crown while the female is rufous.

LEFT:
Koh Phi Phi, Krabi Province, Thailand
The six islands of Koh Phi Phi are known for their spectacular scenery, heavenly beaches, and vibrant marine life. Maya Beach on Koh Phi Phi Ley, made famous by the film *The Beach* starring Leonardo DiCaprio, is a popular day trip for visitors staying on the only island with accommodation, Phi Phi Don.

RIGHT:

Naga stairs at Wat Phra That Doi Suthep, Chiang Mai, Thailand

Built on Doi Suthep mountain and offering expansive views of Chiang Mai below, this revered temple is believed to house half of Gautama Buddha's shoulder bone. Visitors can climb 309 steps lined with *nagas* (semi-divine, human–cobra spirits), take a tram, or hike up on the Monk's Trail to reach the pagodas.

OPPOSITE:

Reclining Buddha statue, Wat Pho, Bangkok, Thailand

The Wat Pho temple complex houses the biggest collection of Buddha figurines in Thailand. Top of the must-see list here is the world-renowned, 46m (150ft) long, gold-plated reclining Buddha. The temple is also known as the earliest centre for public education in Thailand and the birthplace of traditional Thai massage.

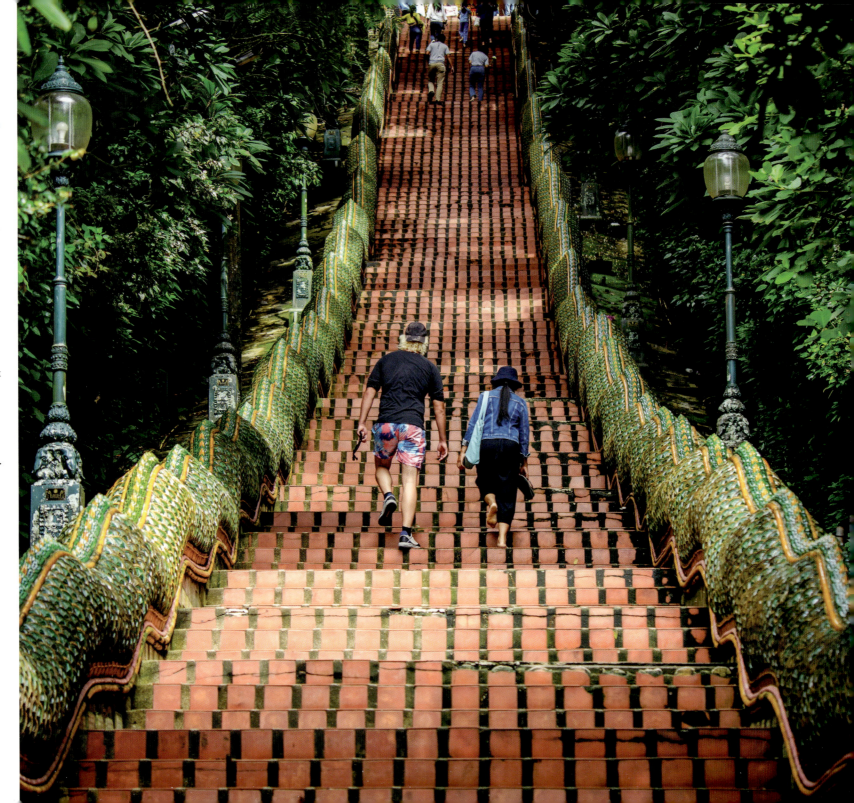

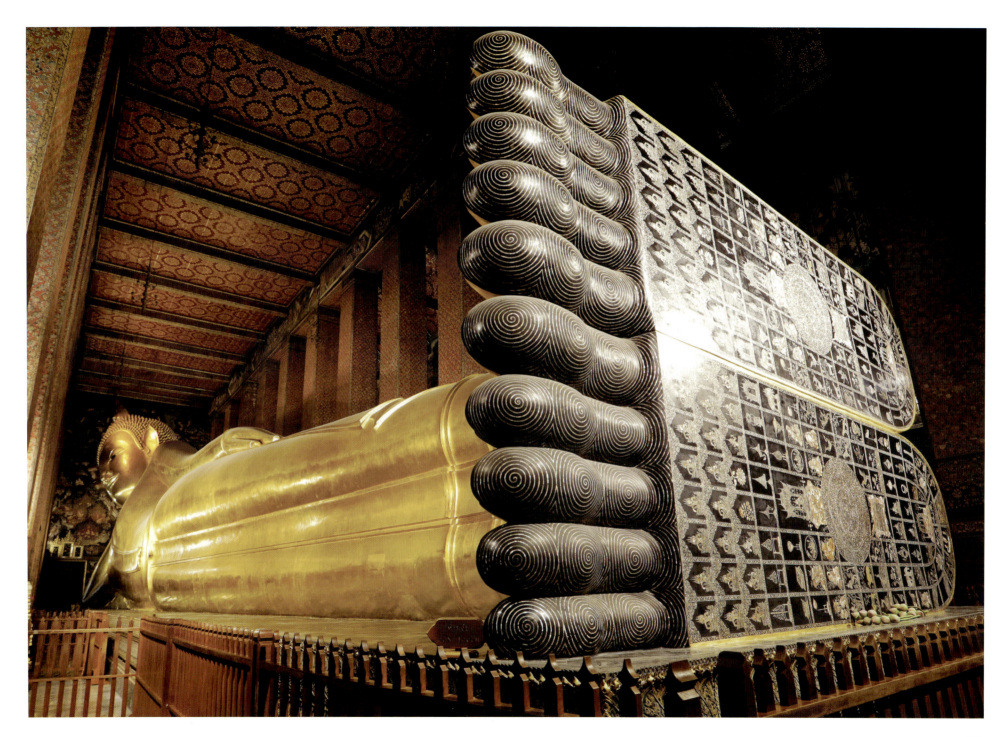

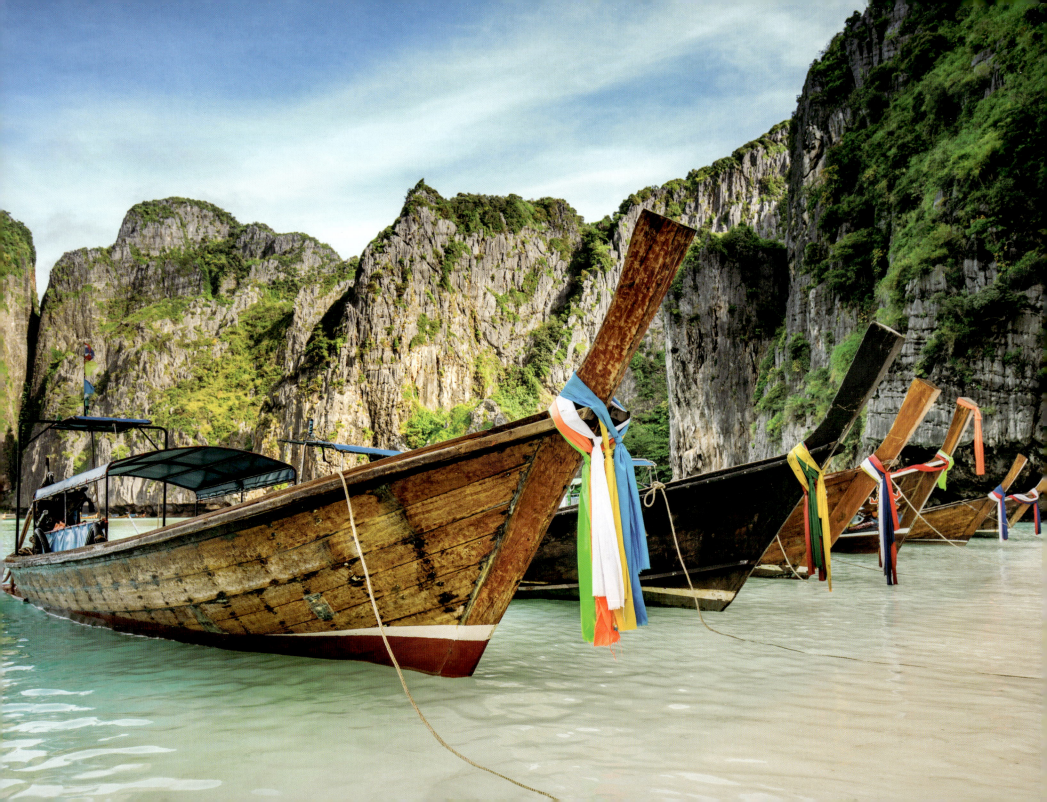

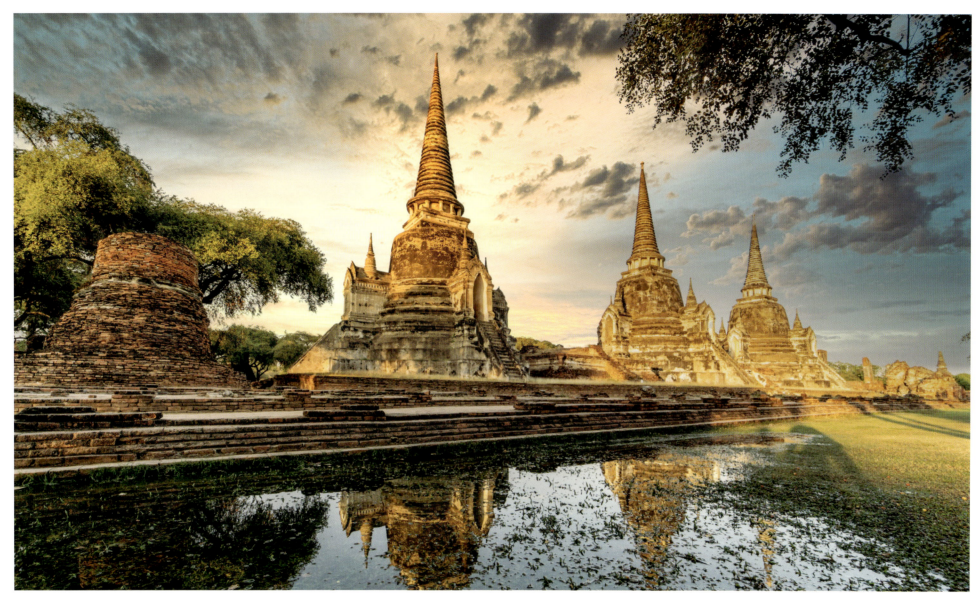

OPPOSITE:
Long-tail boats, Thailand
Long-tail boats originated in Thailand in the 1930s when a helmsman for the royal family mounted an engine on a rowing boat and extended the shaft to create a long propeller. Today, the long-tail boat is an iconic fishing boat and means of transportation for locals and tourists alike.

ABOVE AND ALL OVERLEAF:
Ayutthaya Historical Park, Phra Nakhon Si Ayutthaya Province, Thailand
Founded by King Ramathibodi I in 1351, although believed to be much older, Ayutthaya was one of the world's biggest cities by the 1700s, with an estimated population of 1 million. The city was destroyed in 1767 by the Burmese army.

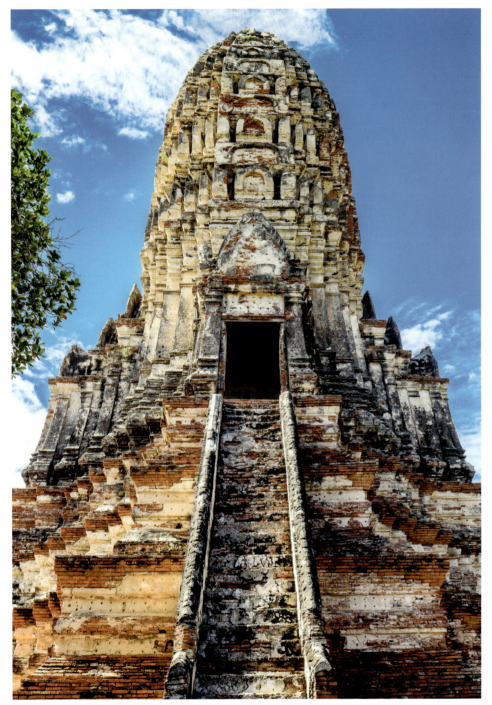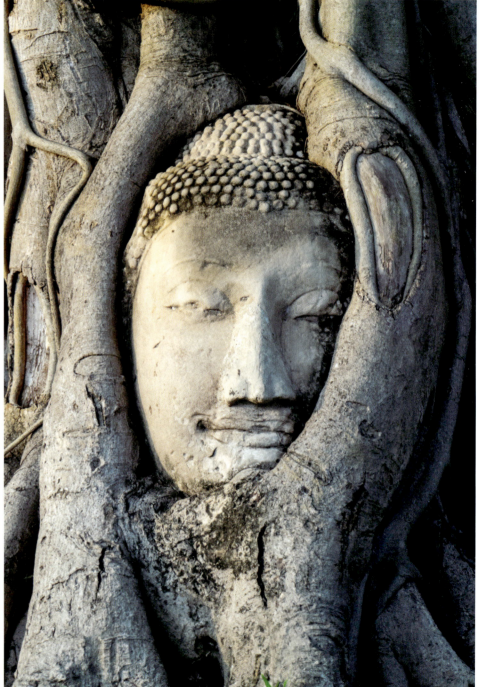

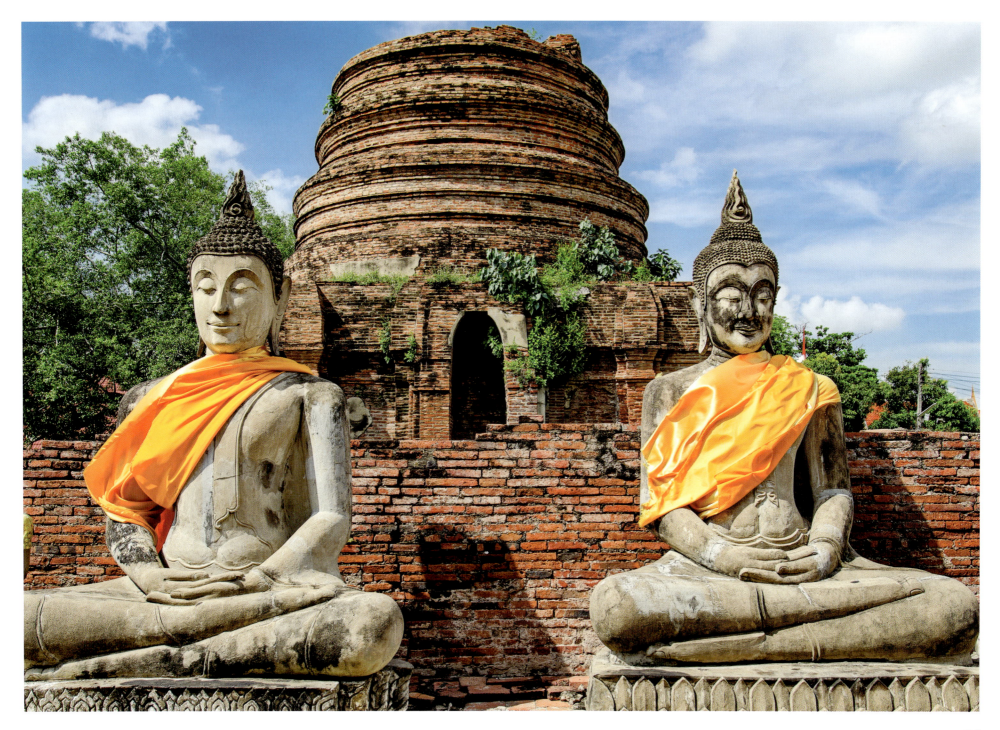

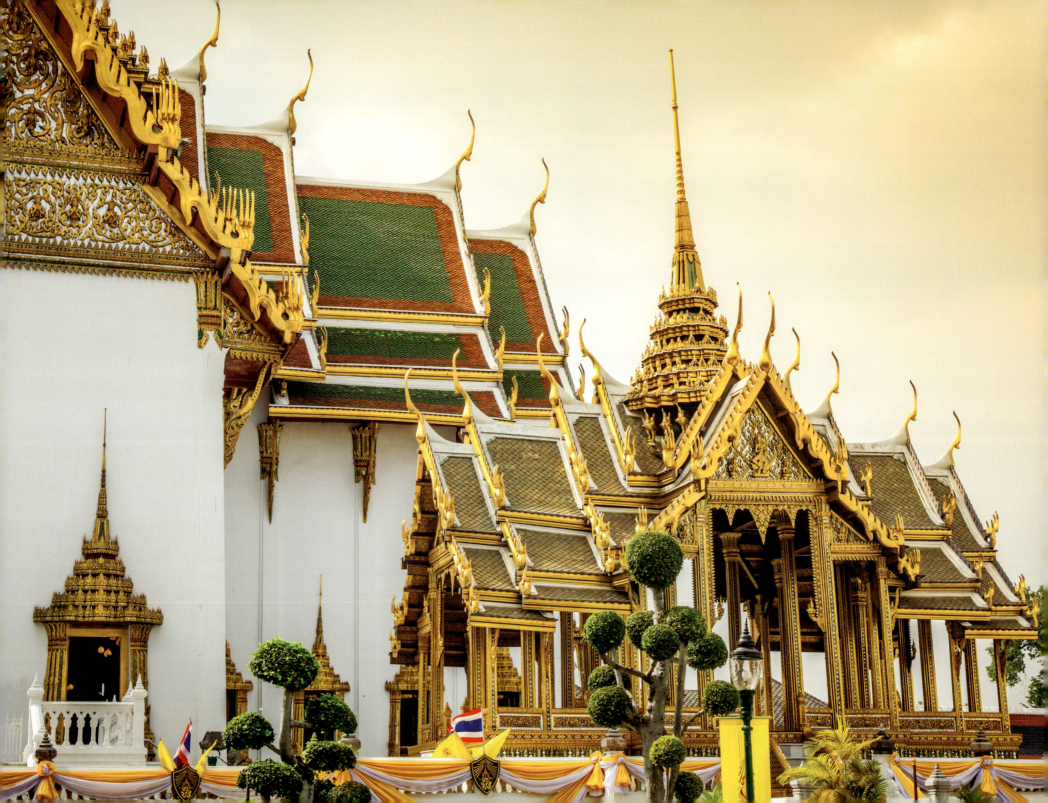

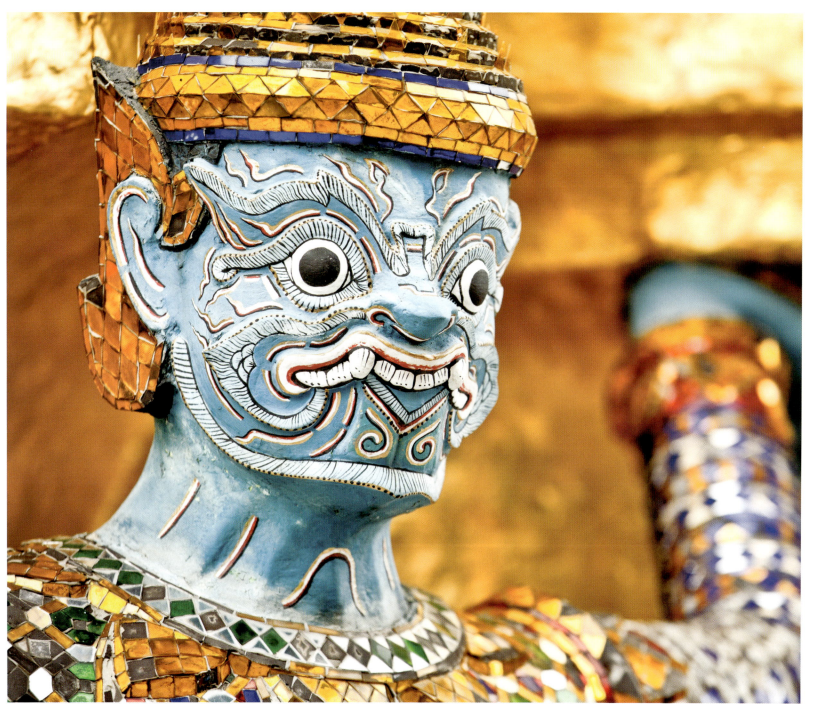

OPPOSITE:
Grand Palace, Bangkok, Thailand
This spectacular palace has been the official residence of the kings of Siam, and then Thailand, since 1782 when Rama I moved the capital to Bangkok from Thonburi. The complex includes Wat Phra Kaew, which contains the exquisite, 66cm (25 inch) tall emerald Buddha statue (actually made of jasper and clothed in gold), considered the palladium of Thailand.

LEFT:
Giant demon guardian, Grand Palace, Bangkok, Thailand
Several *yaksha*, or giant demons, stand guard at the Grand Palace. These spirits, usually sculpted with big bulging eyes and protruding fangs, appear as guardians of gates in Buddhist temples throughout Thailand. Their tradition goes back at least to the fourteenth century.

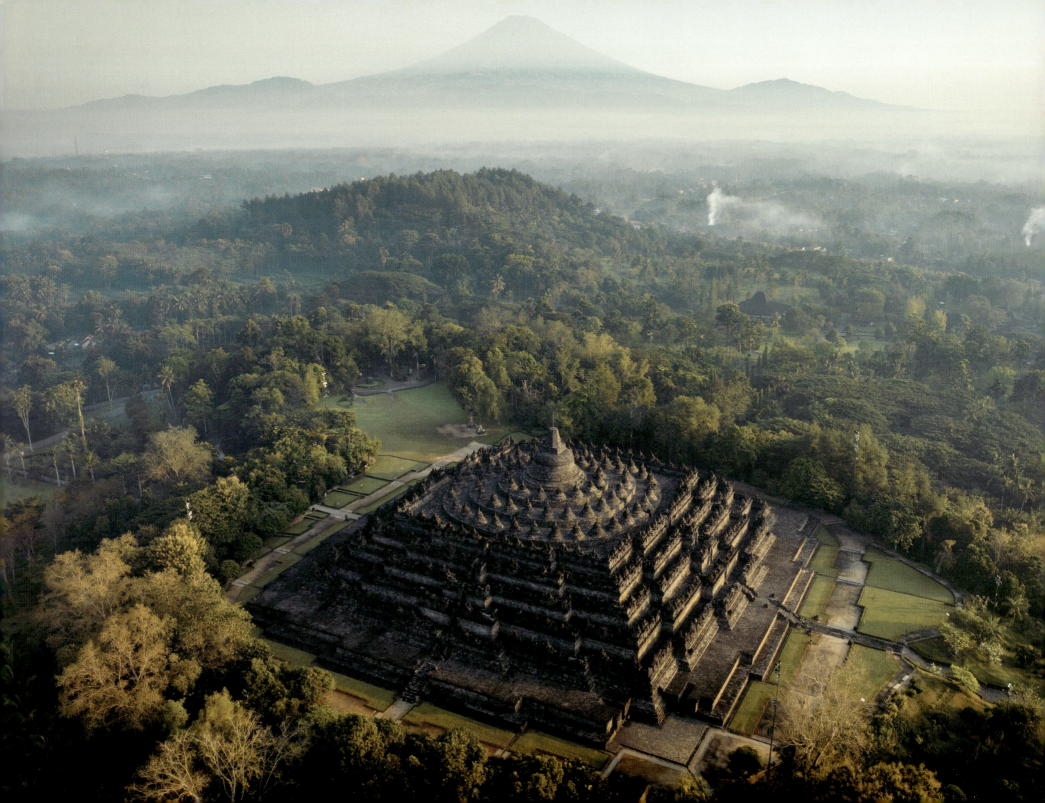

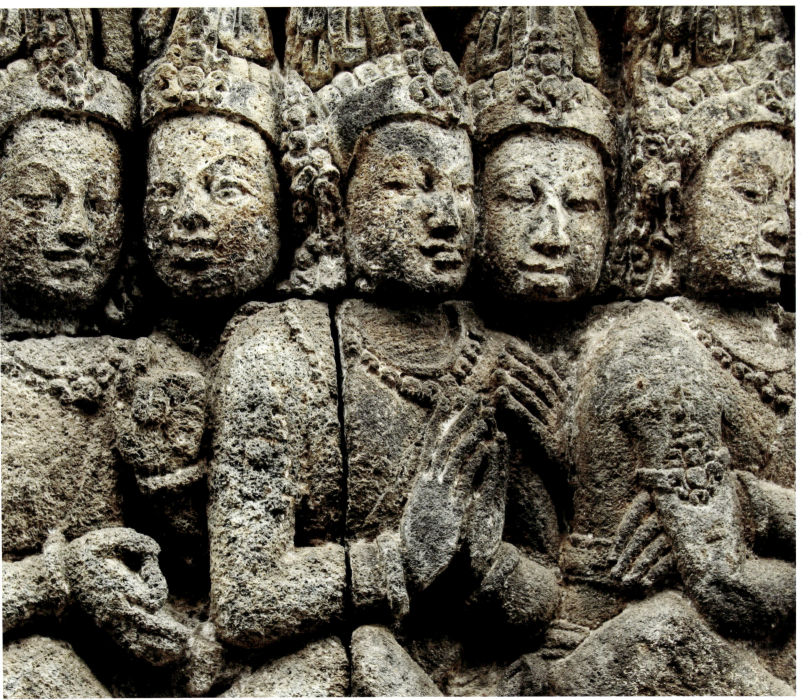

OPPOSITE:
Borobudur, Central Java, Indonesia
This captivating, ninth-century monument of grey volcanic rock is the largest Buddhist temple in the world, and, along with Angkor Wat of Cambodia and Bagan of Myanmar, is one of the great archaeological sites of Southeast Asia.

LEFT:
Relief carvings, Borobudur, Indonesia
A monument for pilgrimage rather than worship, Borobudur guides visitors though a system of stairways and corridors clad with 1460 narrative relief panels. The site has one of the world's most extensive collections of Buddhist reliefs.

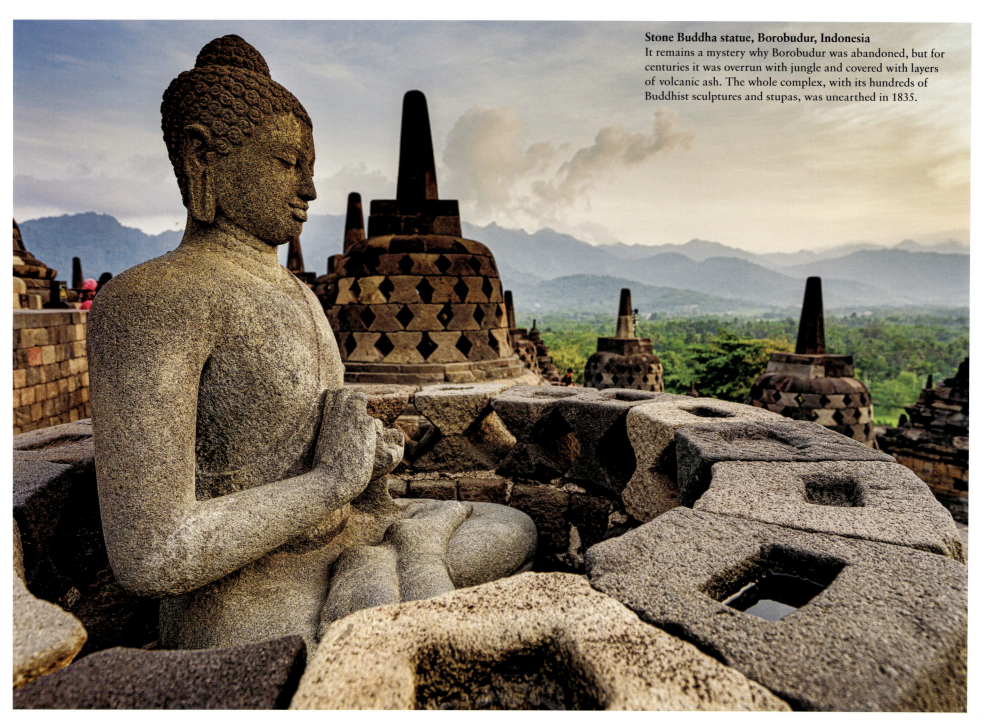

Stone Buddha statue, Borobudur, Indonesia
It remains a mystery why Borobudur was abandoned, but for centuries it was overrun with jungle and covered with layers of volcanic ash. The whole complex, with its hundreds of Buddhist sculptures and stupas, was unearthed in 1835.

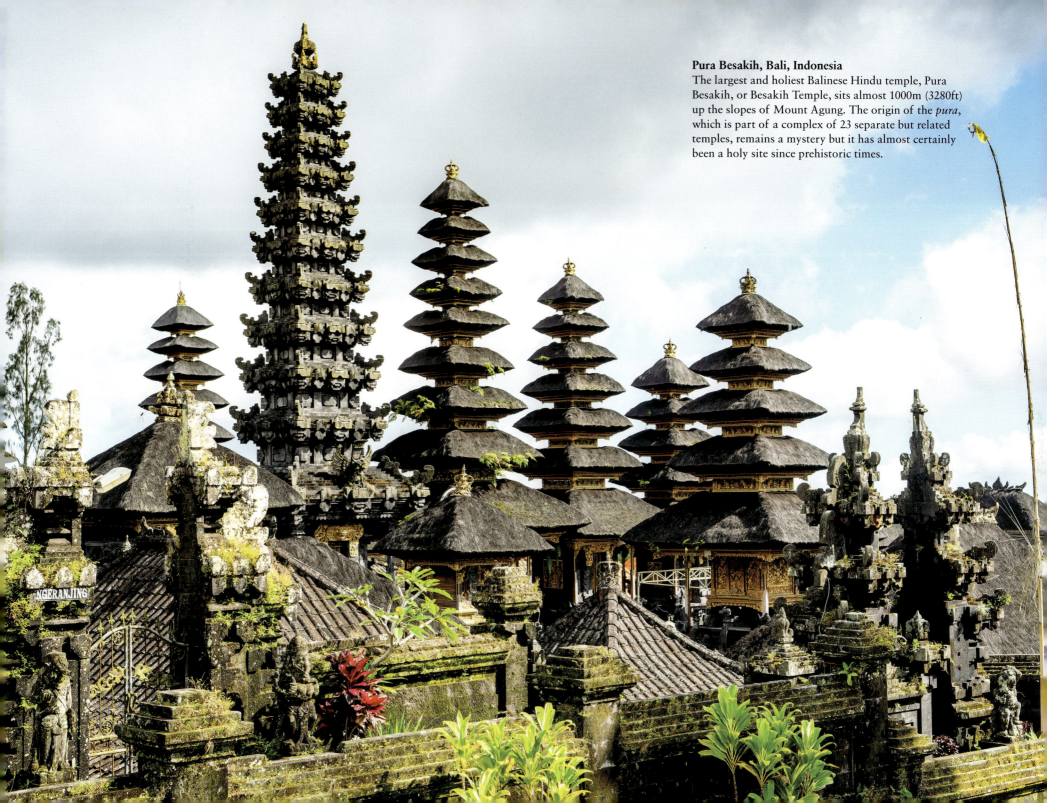

Pura Besakih, Bali, Indonesia
The largest and holiest Balinese Hindu temple, Pura Besakih, or Besakih Temple, sits almost 1000m (3280ft) up the slopes of Mount Agung. The origin of the *pura*, which is part of a complex of 23 separate but related temples, remains a mystery but it has almost certainly been a holy site since prehistoric times.

RIGHT:
Balinese Hindu shrine, summit of Mount Agung, Bali, Indonesia
Mount Agung, an active volcano, is believed to be home to Mahadewa, the supreme manifestation of Lord Shiva, who creates, protects, and transforms the universe. Brave devotees of Balinese Hinduism leave religious offerings, including flowers on banana leaves, at the very edge of the crater.

OPPOSITE:
Rice paddies under Mount Agung, Bali
Reaching 3142m (10308ft) above sea level, Mount Agung is Bali's highest point. The dominating stratovolcano, which last erupted in 2019, affects rainfall patterns, leaving the northern part of the island drier than the south. The volcanic soils are fertile, making the slopes of Mount Agung ideal for farming.

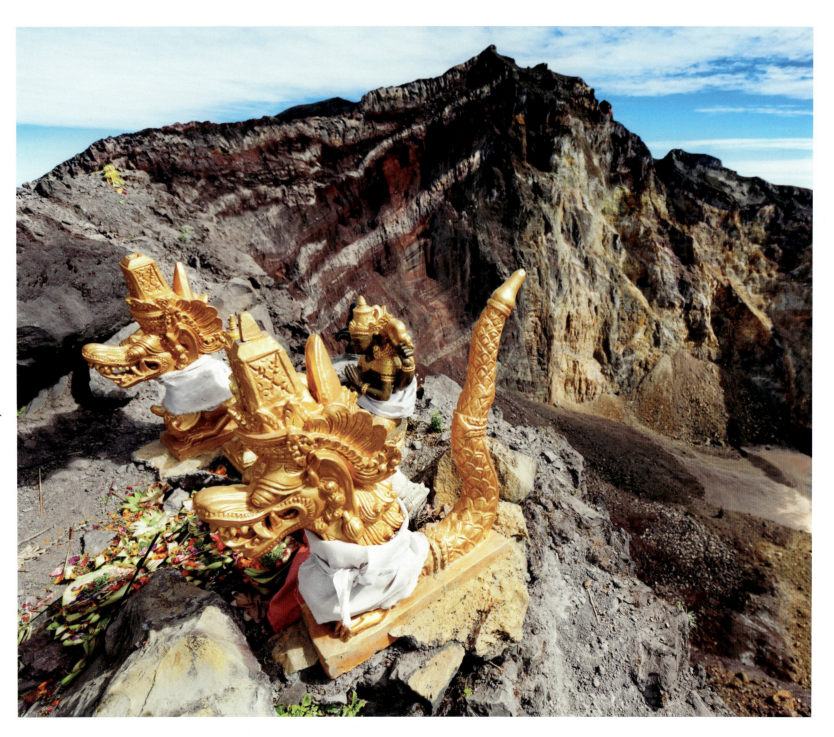

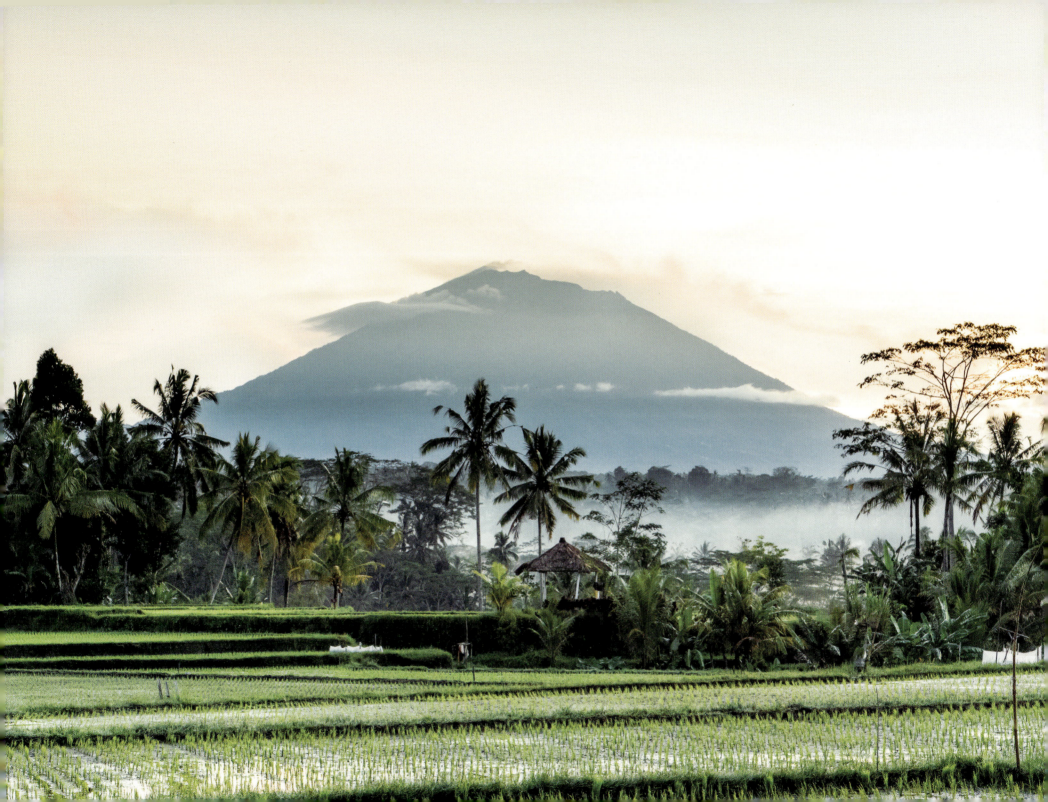

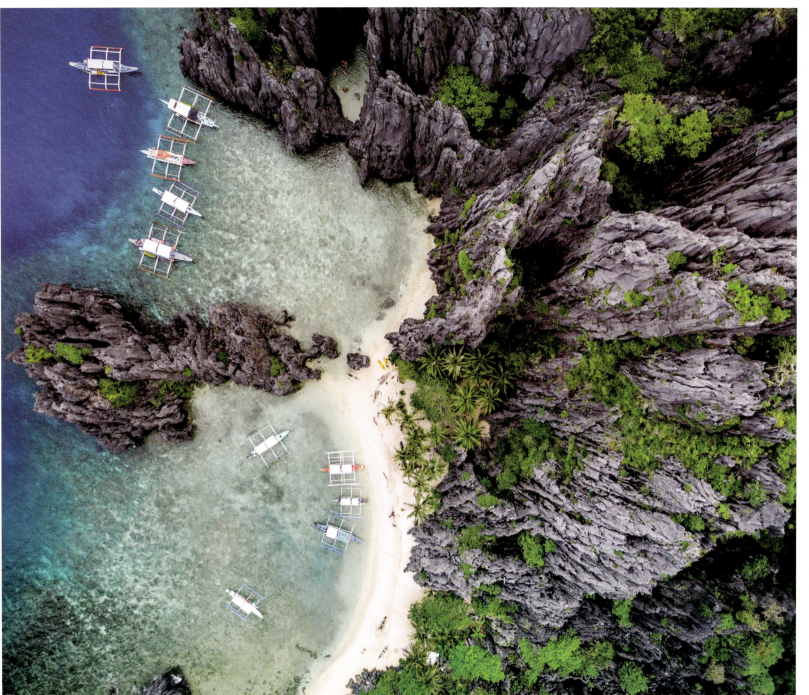

OPPOSITE:

Palawan, the Philippines
The province of Palawan is famous for its archipelago of paradisiacal islands, with forests rich in biodiversity and postcard-perfect beaches lapped by waters ranging from cyan to turquoise. The island of Palawan is the queen of them all, often voted the world's most beautiful.

LEFT:

El Nido, Palawan, the Philippines
With dramatic karst cliffs, pristine white-sand beaches, and seas crammed with coral reefs, fish, and turtles, El Nido is a dream beach destination. Visitors come for snorkelling, scuba diving, surfing, and paddle boarding in the crystal-clear waters, and hiking through the forests.

OVERLEAF:

Gili Islands, Indonesia
The seas around the gorgeous Gili island triplets – Gili Trawangan, Gili Meno, and Gili Air – just off the northwest coast of Lombok, are vibrant with coral reefs that attract a rich diversity of marine life, from turtles to whale sharks and big schools of fish, such as glassy cardinalfish (*Rhabdamia spilota*).

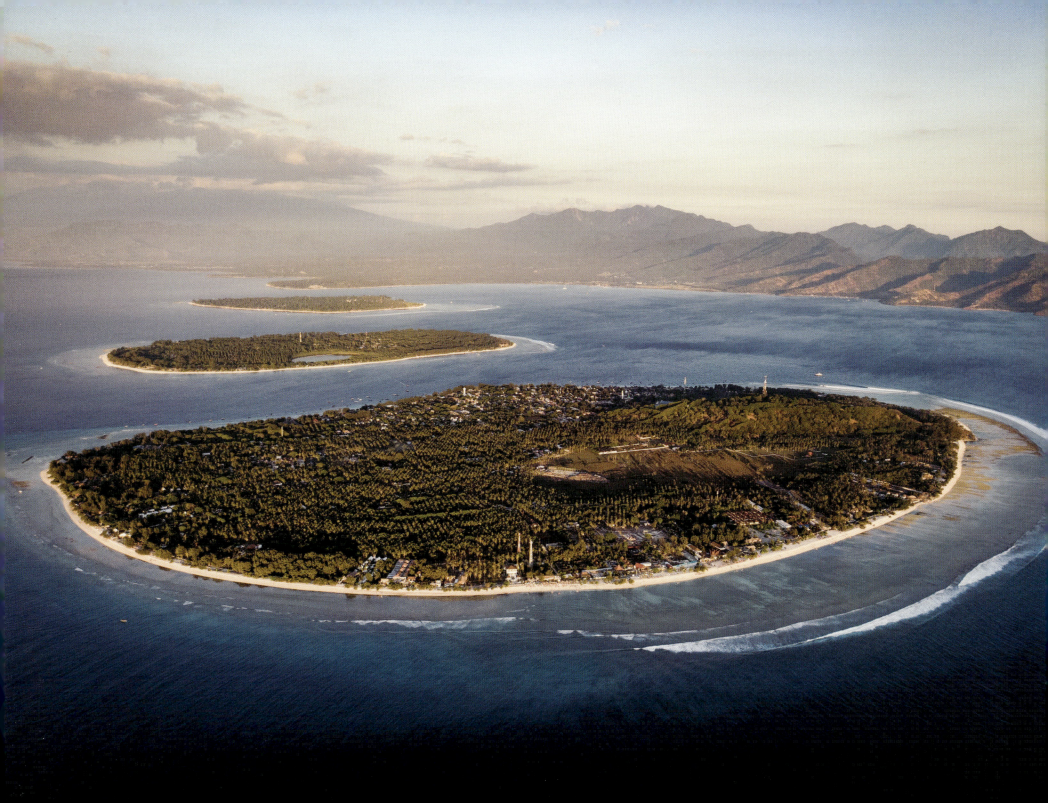

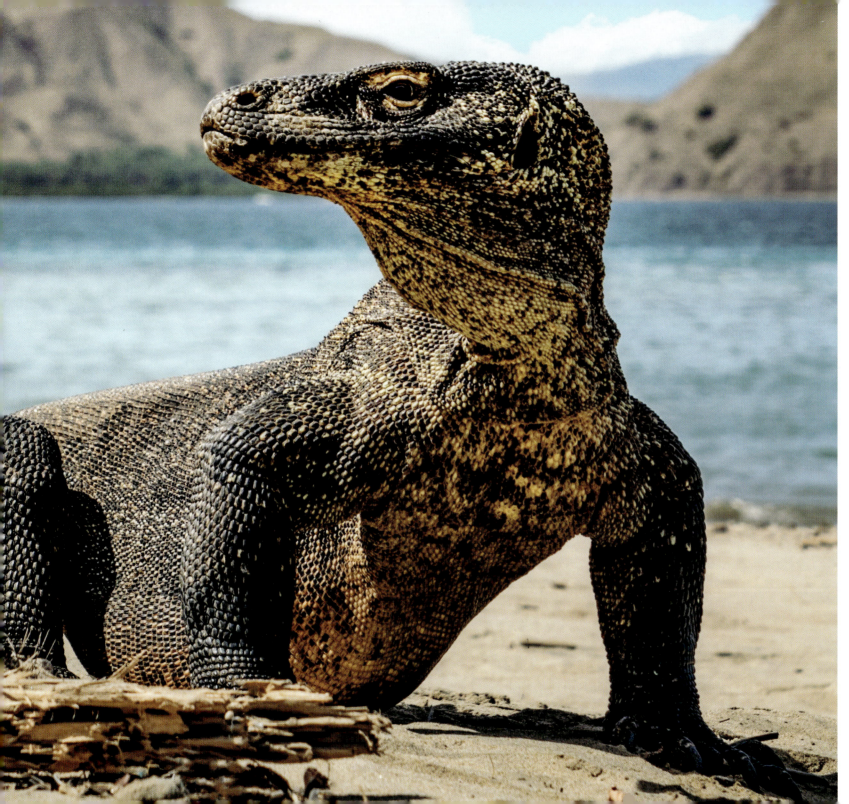

Komodo dragon, Komodo Island, Indonesia
Growing to 3m (9ft) and weighing up to 150kg (330lbs), the Komodo dragon is the largest lizard on Earth. Native to Komodo Island, as well as other nearby islands, the Komodo is an apex predator that dominates its ecosystem. The lizard is listed as endangered as climate models project 30–70 per cent of the species' habitat will be lost due to rising sea levels by 2040.

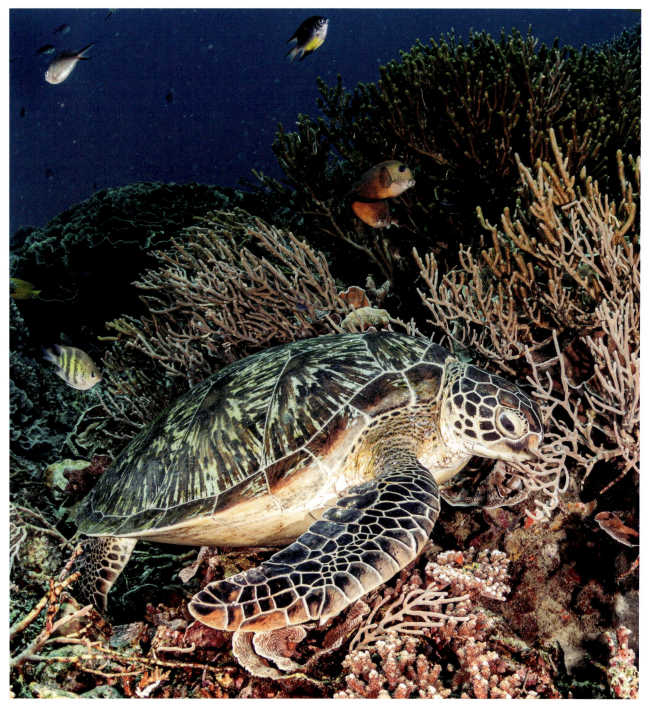

LEFT:
Komodo National Park, Lesser Sunda Islands, Indonesia
Covering the larger islands of Komodo, Padar, and Rinca, and 26 smaller ones, this park is considered one of the world's 25 top biodiversity hotspots. Along with Komodo dragons, and their favoured prey, the Sunda sambar deer, the park is known for its marine diversity, including corals, the endangered dugong, and even blue whale.

RIGHT:
Padar, Lesser Sunda Islands, Indonesia
Padar Island could easily be mistaken for the set of a dinosaur movie with its steep volcanic mountains and its four deep bays with beaches in different colours: white, grey, and pink (from single-celled organisms called foraminifera that have red shells). The island changes from verdant green to yellow savannah in the dry season.

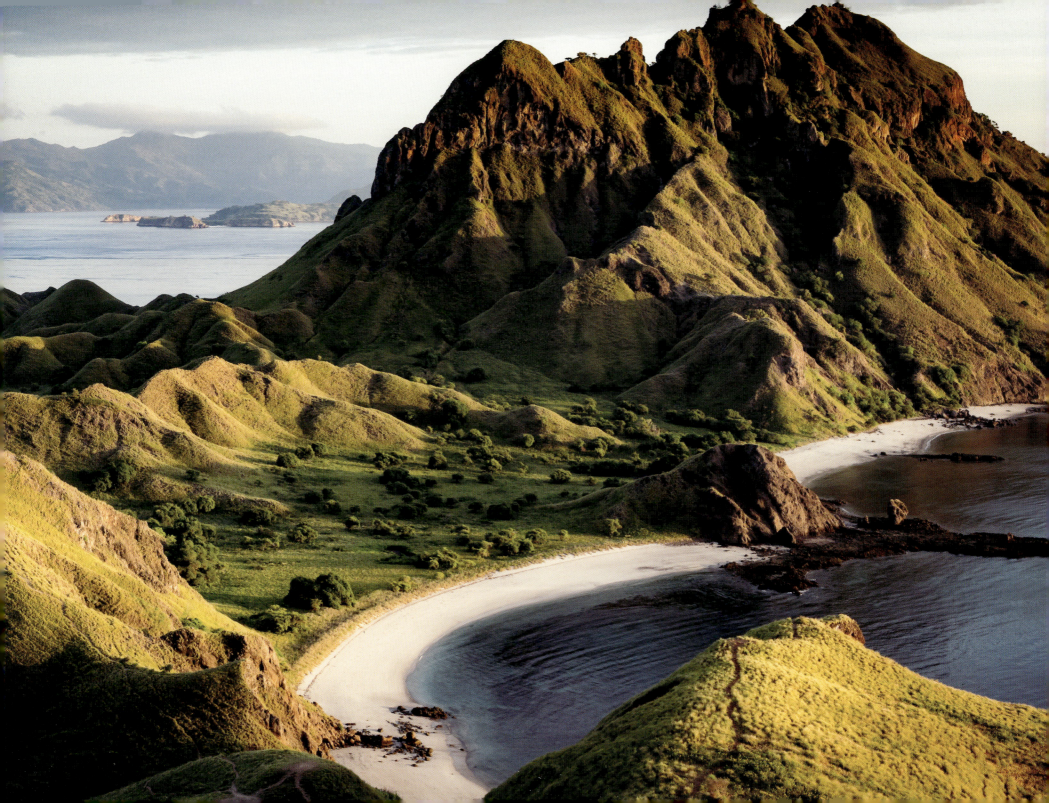

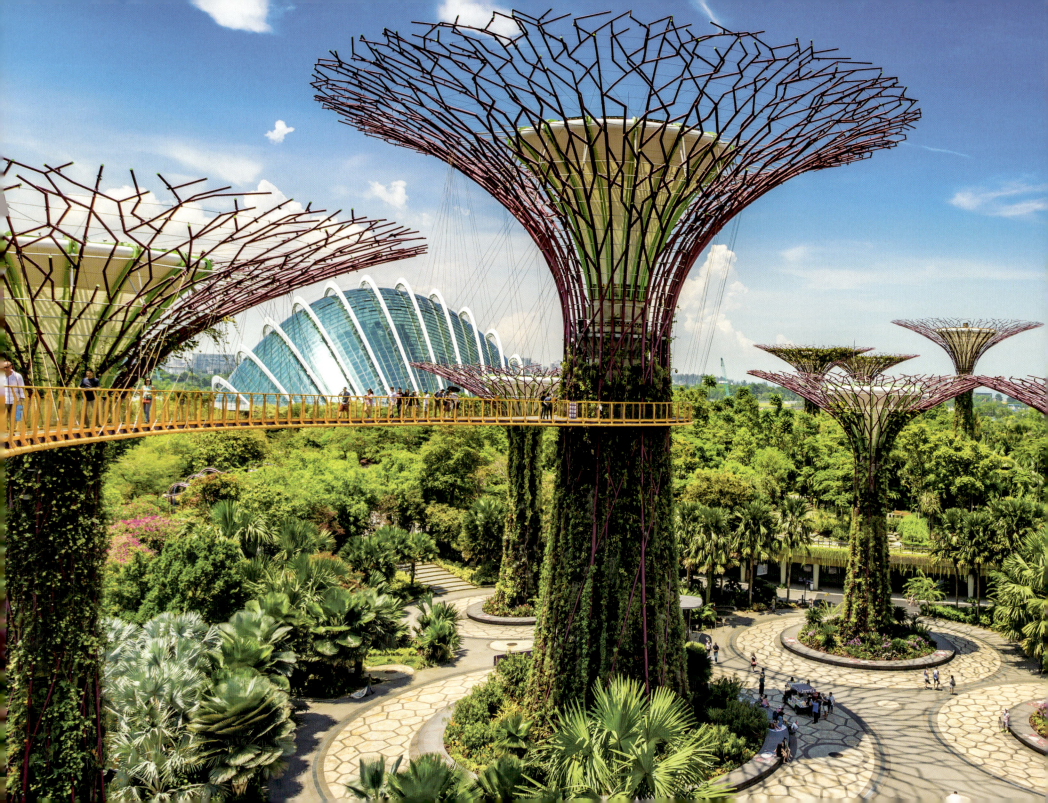

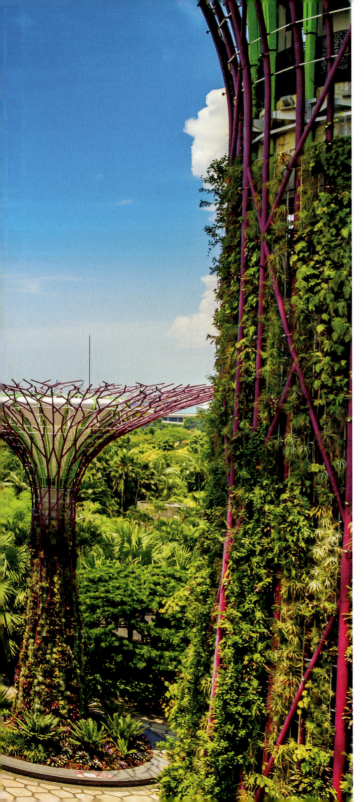

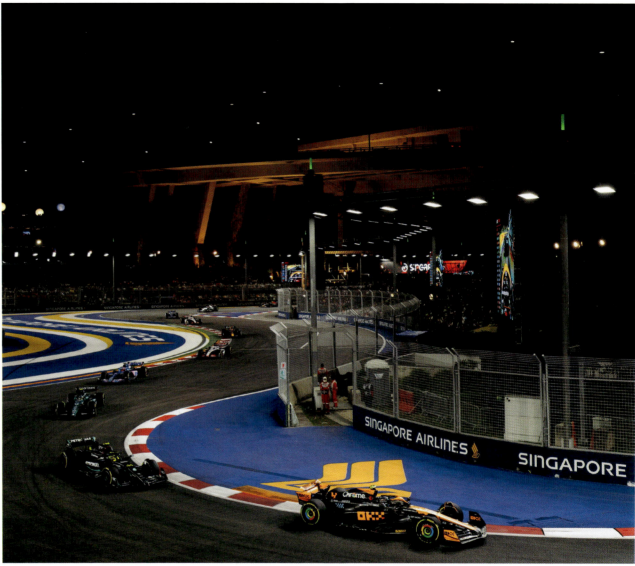

LEFT:
Supertree Grove, Gardens by the Bay, Singapore
The 18 tree-like structures that dominate the skyline of Gardens by the Bay are vertical gardens planted with ferns, orchids, bromeliads, and vines. These 'supertrees' imitate how trees function, using photovoltaic cells to harness solar energy for powering lights, mimicking photosynthesis, and absorbing rainwater as plants do, for irrigation and water fountains.

ABOVE:
Marina Bay Street Circuit, Singapore
Singapore hosted the first night-time race in Formula 1 history during the 2008 Grand Prix. The motor racing event was also F1's first street circuit in Asia. The Singapore Grand Prix today is frequently described by drivers as one of the most difficult races on the F1 calendar due to the high humidity and lengthy race duration.

RIGHT:
Iban longhouse, Borneo, Malaysia
The traditional homes of the Iban tribes of Sarawak, longhouses are built entirely from natural materials gathered from the surrounding forest. One side of the stilted house is divided into a row of separate family rooms, while the other end is a shared social area.

OPPOSITE:
Dayak dance, East Kalimantan, Borneo, Indonesia
The Dayak are indigenous peoples of Borneo, and at Pampang in East Kalimantan, visitors can watch colourful traditional dances and ceremonies and learn about the way of life of the Dayak Kenyahs, who live in the village and hold on to their age-old customs.

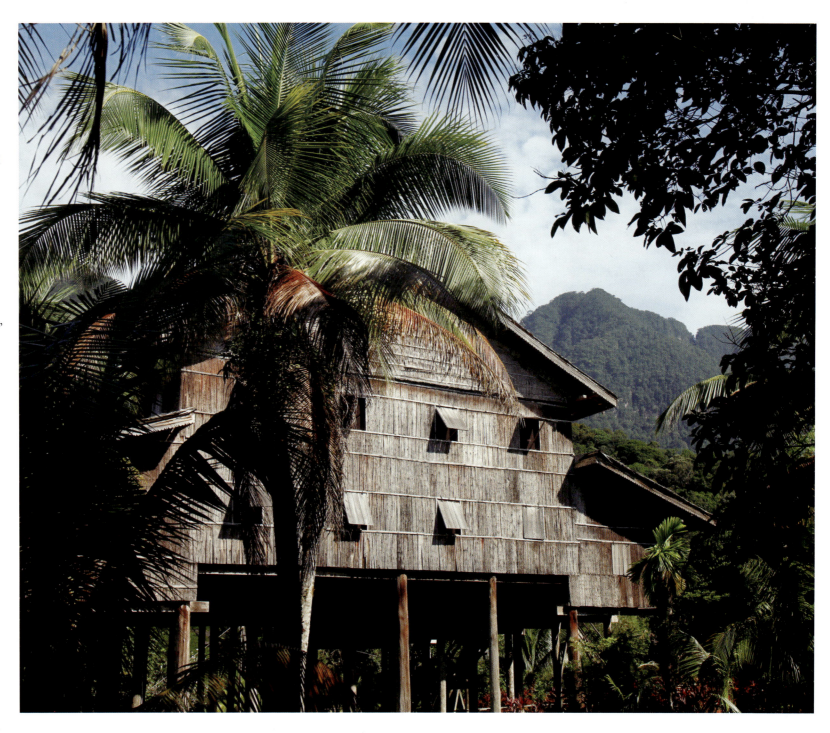

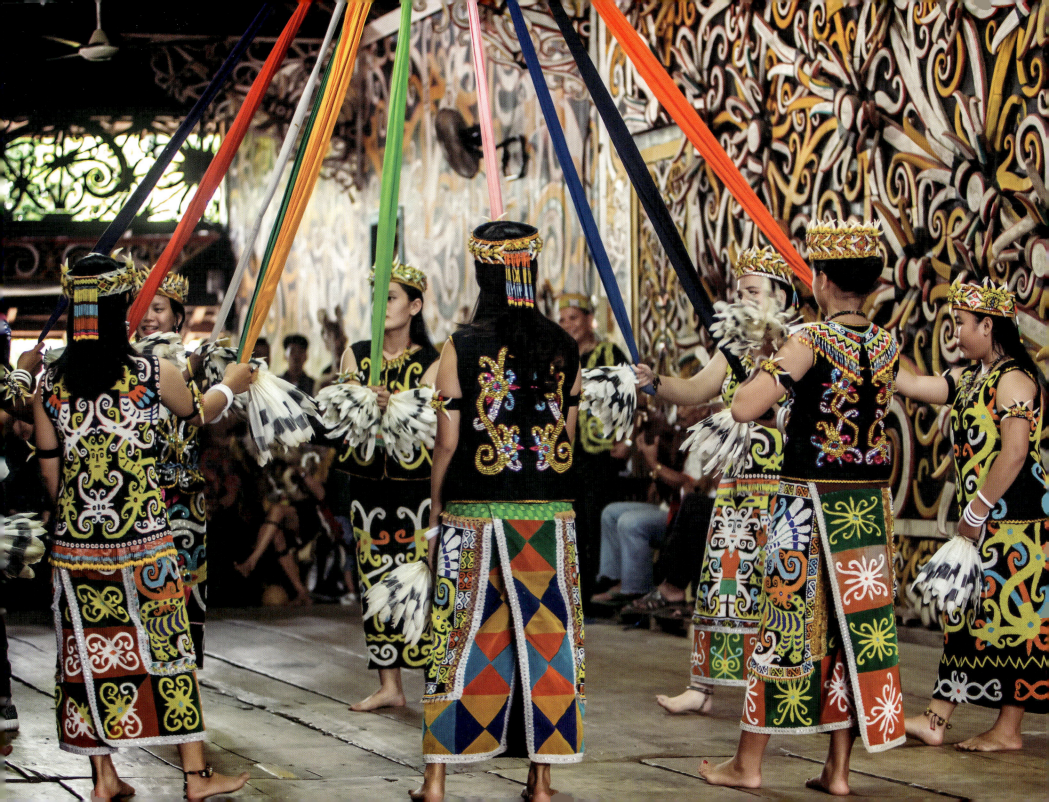

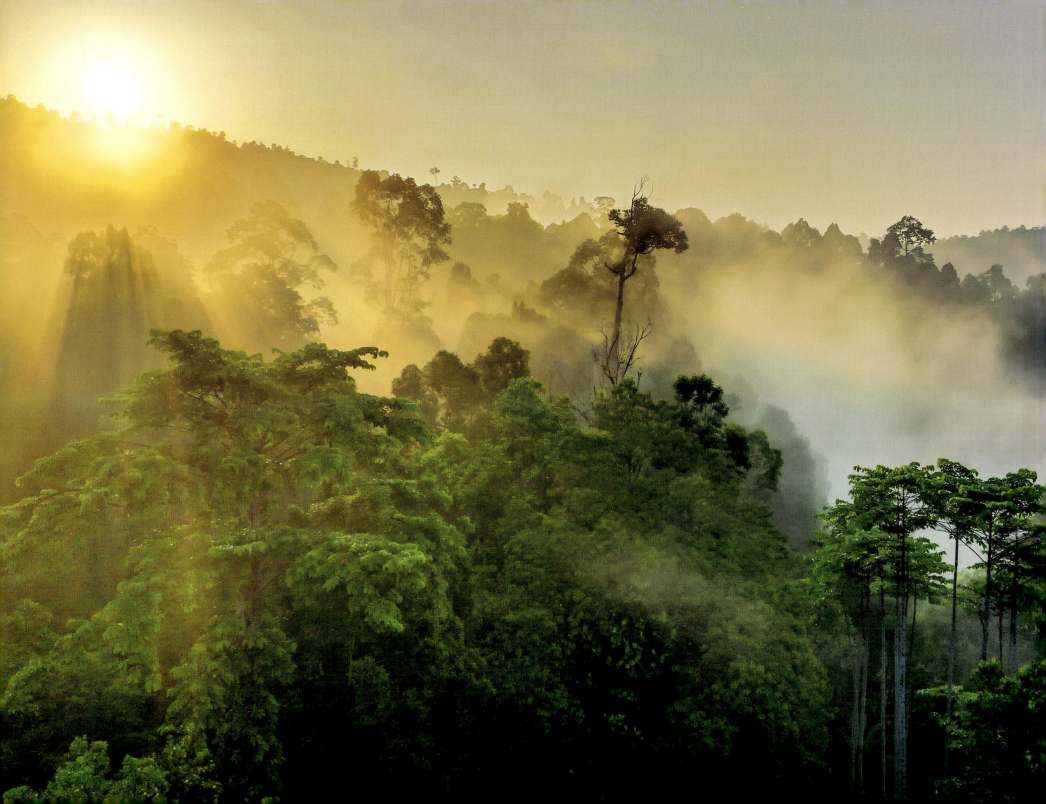

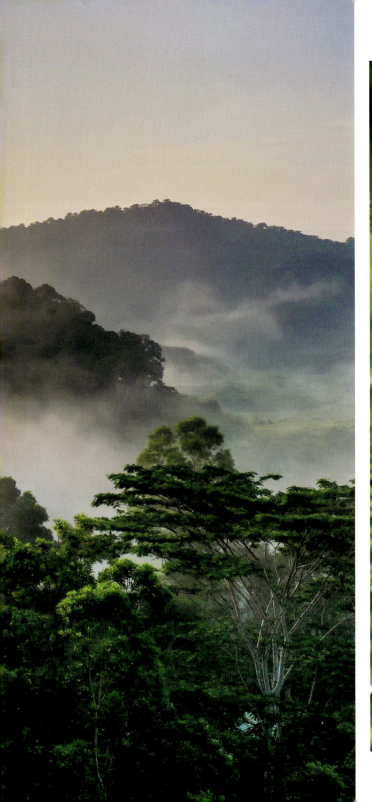
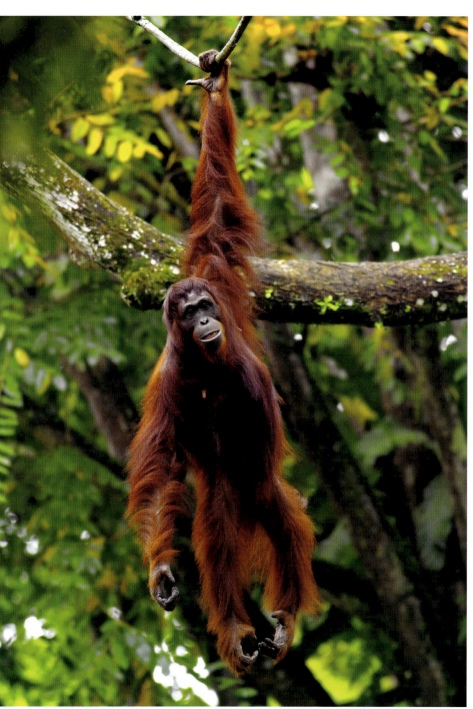

OPPOSITE:

Tropical rainforest, Borneo
Although only a fraction of the rainforests that once covered Borneo still stand after being felled for timber, peat, and palm oil plantations, they are some of the most biodiverse forests on the planet. Around 15,000 plant species have been recorded, along with more than 1400 amphibians, birds, fish, mammals, and reptiles.

LEFT:

Orangutan, Borneo, Malaysia
There are an estimated 105,000 wild orangutans on the island of Borneo, but they are considered critically endangered due to habitat loss from logging and agricultural expansion. Several organizations in Indonesia and Malaysia rescue and rehabilitate orangutans, one of the most intelligent non-human primates.

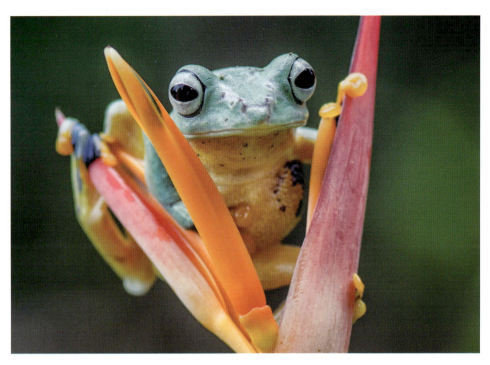
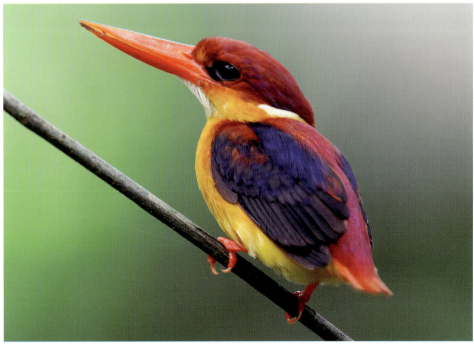

LEFT BOTH PHOTOGRAPHS:
Colourful characters, Borneo
Borneo's forests are teeming with wildlife, from flying frogs that spread their webbed toes to glide gracefully through forest canopies, to the rainbow-shaded rufous-backed kingfisher. There are an estimated 420 species of bird on Borneo, 37 of which are not found anywhere else in the world.

RIGHT:
Waterfall, Ulu Baram, Borneo, Malaysia
Waterfalls abound in the dense rainforests of remote Ulu Baram in Sarawak. The region includes the headwaters of the Baram River, which has created an encased alluvial plain, and which flows 400km to discharge into the South China Sea.

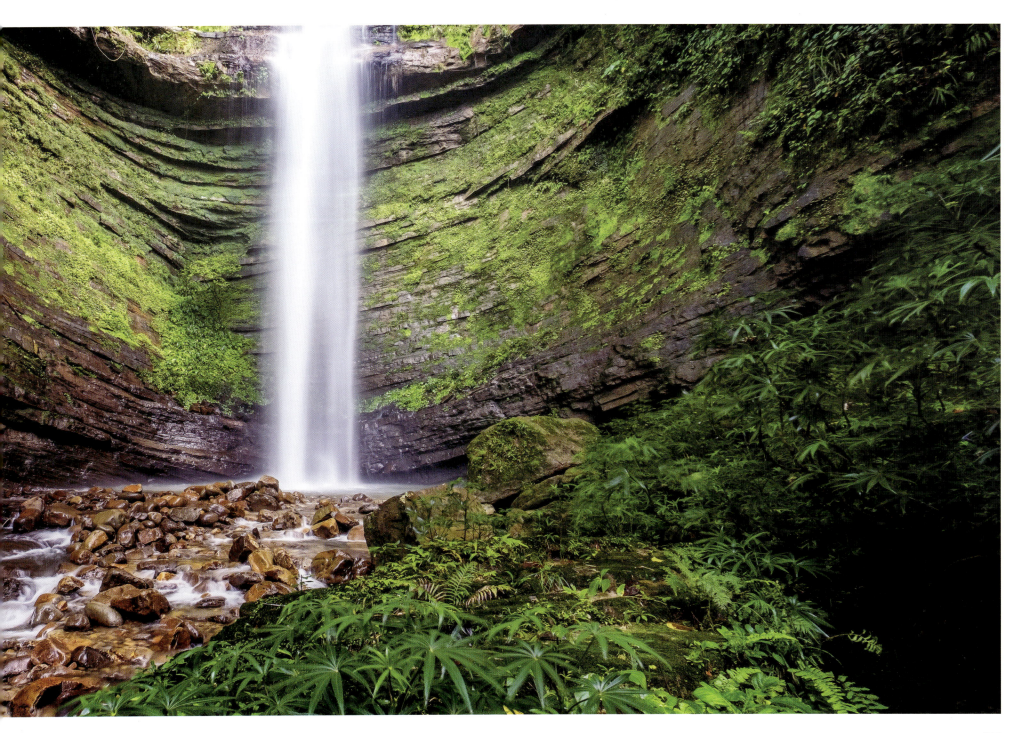

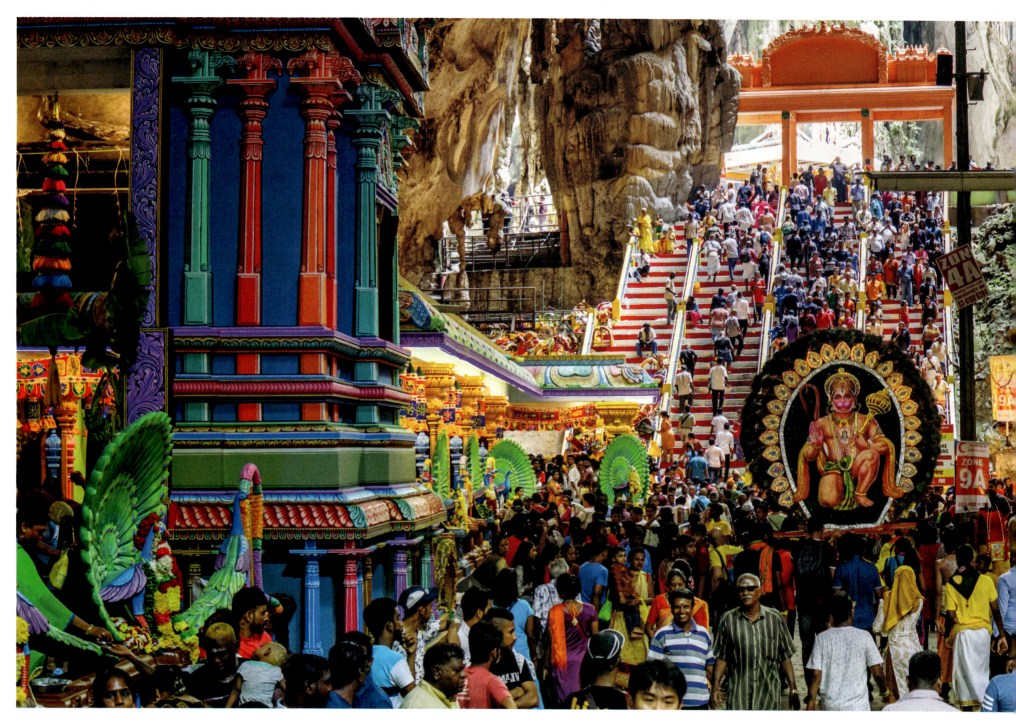

LEFT:

Thaipusam celebrations, Batu Caves, Kuala Lumpur, Malaysia

Every year, devotees throng the Tamil Hindu temples in the Batu Caves north of Malaysia's capital to celebrate Thaipusam – a commemoration of the victory of Hindu god Murugan over the demon Surapadman.

RIGHT:

A devotee balancing a pot of milk, Thaipusam, Batu Caves, Malaysia

During Thaipusam, Hindu devotees carry a physical burden on a procession to implore the god Murugan to heal a loved one or balance a spiritual debt. This can be as simple as carrying a pot of milk, although piercing the skin, tongue, or cheeks is common.

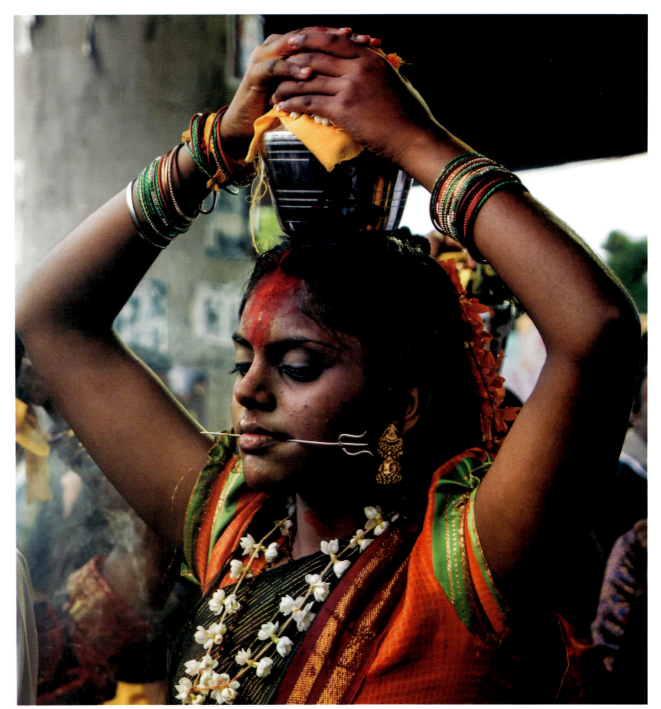

RIGHT:
Thaipusam pilgrimage, Batu Caves, Malaysia
The *kavadi* (burden) that especially male devotees carry on their shoulders during Thaipusam can be large structures of wood or steel decorated with flowers and peacock feathers weighing up to 30kg (66lbs). Sometimes, portable altars are attached to the skin on the chest or back by multiple *vels* (divine spears or hooks).

OPPOSITE:
Rawa Island, Johor, Malaysia
Named after the colloquial Malay word for white doves, which are abundant on this small coral island, Rawa is a blissfully quiet getaway. There are no roads and only two resorts, but a beautiful white sandy beach, colourful corals in knee-deep water, and sea so clear that fish are clearly visible.

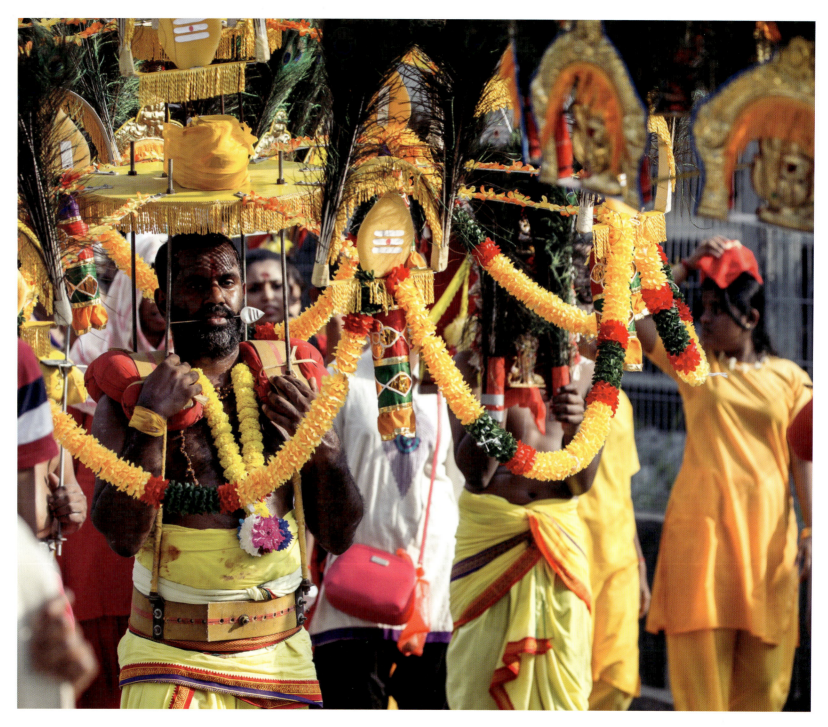

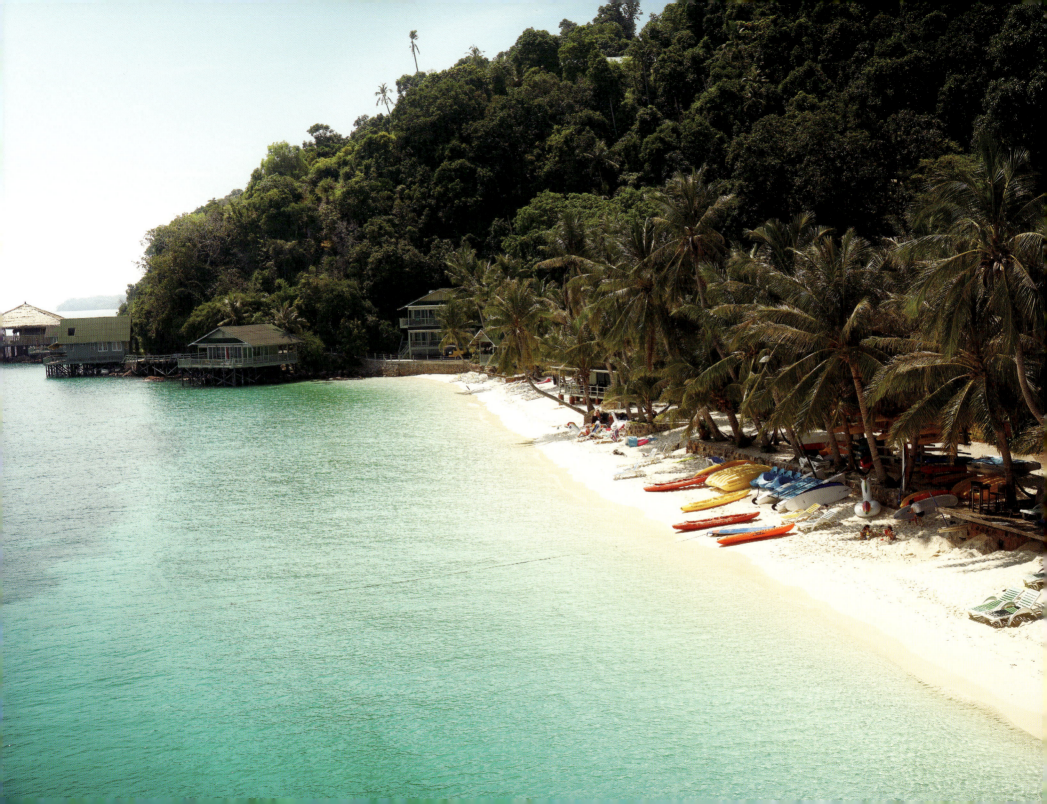

Index

Armenia
Khor Virap Monastery 10–11, 12–13
Mount Ararat 10–11

Azerbaijan
Gobustan 10

Bhutan
Punakha Dzong, Punakha 129–31
Tiger's Nest, Paro Valley 128

Borneo
Dayak dance, East Kalimantan 215
Iban longhouse 214
tropical rainforest 216–19

Cambodia
Angkor Wat, Siem Reap 174–5
Bayon, Angkor Thom 176
Ta Prohm, Siem Reap 177

China
Beijing 146–7, 152–3
Forbidden City, Beijing 146–7
Great Wall of China 144–5
Guangxi 149
Hong Kong 7, 159–63
Huangshan, Anhui province 154–5
Jinsha River, Yunnan 151
K2, Xinjiang 158
Shanghai 152
Taklamakan Desert, Xinjiang province 156–7
Terracotta Army, Xian 148
Tiananmen Square, Beijing 152–3
Yangtze River, Chongqing 150

Georgia
Gergeti Trinity Church 9
Koruldi Lakes, Svaneti 16–17
Svan Tower, Svaneti 17
Tbilisi 14–15
Ushguli, Scaneti 18–19

Hong Kong 7, 159–63

India
Amer Fort, Jaipur 96–7
Chapora Fort, Goa 105
Church of Saint Francis of Assisi, Goa 106
Devprayag, Uttarakhand 92
Diskit Monastery, Ladakh 118
Dudhsagar Waterfall, Goa 107
Global Vipassana Pagoda, Mumbai 112–13
Goa 102–9
Hawa Mahal, Jaipur, India 98–9
Jaipur 94–101
Jal Mahal, Jaipur 94–5
Kerala 114–15
Ladakh 117–19
Mumbai 110–13
Palolem Beach, Goa 102–5
Panaji, Goa 108–9
Taj Mahal, Agra 86, 88–9
Varanasi 6, 90–1, 93

Indonesia
Borobudur, Central Java 198–200
Dayak dance, East Kalimantan, Borneo 215
Gili Islands 206–7
Komodo Island 208–9
Komodo National Park, Lesser Sunda Islands 210
Mount Agung, Bali 202–3
orangutan 217
Padar, Lesser Sunda Islands 210–11
Pura Besakih, Bali 201
tropical rainforest, Borneo 216–19

Iran
Monastery of Saint Thaddeus, West Azerbaijan 48–9
Polour, Mazandaran 50
Saint Stepanos Monastery, East Azerbaijan 51
Sheikh Safi Al-Din Shrine complex, Ardabil 52–3
Zagros Mountains 48

Iraq
Babylon 38
Caliphal Palace, Samarra 40–1
Great Mosque, Samarra 38–9
Lake Qadisiyah 34
Ziggurat at Ur 56–7

Israel
Dome of the Rock, Jerusalem 26–7
Temple Mount, Jerusalem 24–5

Japan
Arashiyama Bamboo Grove, Kyoto 136
Chureito Pagoda, Fujiyoshida 132
Fushimi Inari-taisha, Kyoto 137–8
Kyoto 136–8
Lake Yamanaka 135
Mount Fuji 132, 134–5
Osaka Castle 141
Tōdai-ji Temple, Nara 139–40

Jordan
Petra 22–3

Kazakhstan
Big Almaty Lake, Ile-Alatau National Park 84
Charyn Canyon 83
Shymbulak, Almaty 85

Kyrgyzstan
Barskoon Valley, Issyk-Kul region 58
Cholpon-Ata, Issyk-Kul Region 66–7
Nomadic camp, Song-Köl 65
Tian Shan 60–3
traditional yurt 64

Laos
Kuang Si Falls, Luang Phrabang 178–9

Malaysia
Batu Caves, Kuala Lumpur 220–2
Iban longhouse, Borneo 214
Kuala Lumpur 220–2
orangutan 217
Rawa Island, Johor 223
Ulu Baram, Borneo 219

Mongolia
Gobi desert 164–5

Myanmar
Bagan, Mandalay Region 166, 168–9
Inle Lake, Shan State 170–1
Ko Yin Lay Monastery, Keng Tung 173
Shwedagon Pagoda, Yangon 172
Shwezigon Pagoda, Bagan 168–9

Nepal
Chitwan National Park 124–5
Mount Everest, Himalayas 126–7
Pashupatinath Temple, Kathmandu 122–3

Oman
Muscat 54–5
Sultan Qaboos Grand Mosque, Muscat 54
Wadi Shab 32

Pakistan
Hussaini Suspension Bridge, Gilgit-Baltistan 116–17

Philippines
Palawan 204–5

Saudi Arabia
Al-Masjid an-Nabawi, Madinah 30–1
Makkah 28–9

Singapore
Marina Bay Street Circuit 212–13
Supertree Grove, Gardens by the Bay 212–13

South Korea
Gyeongbokgung Palace, Seoul 142–3

Sri Lanka
Nine Arch Bridge, Ella 120
Sigiriya 121

Syria
Dura-Europos 34
Qal'at Ja'bar, Lake Al-Assad 33

Tajikistan
Pamir Highway, Karakul 82–3

Thailand
Ayutthaya Historical Park, Phra Nakhon Si Ayutthaya Province 193–5
banded kingfishers 188
Bangkok 191, 196–7
Chiang Mai 184–7, 190
Grand Palace, Bangkok 196–7
Koh Phi Phi, Krabi Province 189
long-tail boats 192
Phang Nga Bay, Phang Nga 182–3
Wat Pho, Bangkok 191
Wat Phra That Doi Suthep, Chiang Mai 190

Turkey
Halfeti 35
Rumkale Castle, Gaziantep 35–6
Selimiye Mosque, Edirne 20–1

Turkmenistan
Darvaza Gas Crater 80–1

United Arab Emirates
Dubai 42–5

Uzbekistan
Bibi Khanym Mosque, Samarkand 72–3
Bukhara 68–9
Chorsu Bazaar, Tashkent 76–9
Fayzulla Khodzhaev House, Bukhara 68–9
Gur-e-Amir, Samarkand 73
Khiva 70–1
Samarkand railway station 75
Tashkent 74, 76–9

Vietnam
Mu Cang Chai 179
Sapa 180–1

Yemen
Socotra 46–7